THE ORDER OF
THINGS

HIERARCHIES, STRUCTURES, AND PECKING ORDERS

BARBARA ANN KIPFER, Ph.D.

WORKMAN PUBLISHING • NEW YORK

Library of Congress Cataloging-in-Publication Data

Kipfer, Barbara Ann.
 The order of things : how the world is organized / by Barbara Ann Kipfer.
 p. cm.
 Includes bibliographical references and index.
 ISBN 978-0-7611-5044-2 (alk. paper)
 1. Handbooks, vade-mecums, etc. 2. Civilization--Miscellanea. I. Title.

 AG106.K55 2008
 902--dc22

 2008052507

Design by Katherine Tomkinson and Lisa Hollander
Illustrations by Neil Stewart

Photo Credits: Shutterstock: 8, 10–11, 83, 84 (top), 90 (both), 108 (center),
128 (top 3 and bottom 4), 178–179, 146–147, 187, 265, 306, 340, 415, 421, 525
(both), 526 (all), 539 (all); 542 (right); 545 (all); 546 (all); 547, 551, 570; clipart
.com: 230; courtesy of U.S. Army: 358.

Workman books are available at special discounts when purchased in bulk
for premiums and sales promotions as well as for fund-raising or educational
use. Special editions or book excerpts also can be created to specification. For
details, contact the Special Sales Director at the address below or send an e-
mail to specialmarkets@workman.com.

Workman Publishing Company, Inc.
225 Varick Street
New York, NY 10014-4381
www.workman.com

Printed in the United States of America

First printing October 2008
10 9 8 7 6 5 4 3 2

This book is dedicated to
the guys who put up with all my
"orders of things"
Paul
Kyle
and Keir
(in age order!)

And special thanks to
Randall Lotowycz, Suzie Bolotin,
and Peter Workman
for their tremendous help.

TABLE OF CONTENTS

PREFACE

The world is not to be put in order, the world is in order. It is for us to put ourselves in unison with this order

—Henry Miller

F rancis Bacon, seen by some as the first exponent of the scientific method, attempted to organize all of human knowledge, to prepare a thorough and detailed systematization of the whole range of human knowledge—from the ancient to the modern world. *The Order of Things* offers just that: a comprehensive schema, a storyboard of the world.

So many things in our world are related, but how often do we know how? So many subjects and things have a structure, but how often are we aware of what its hierarchy actually is? From the inner workings of the smallest things to the complex system of the universe, this book is an attempt to cover all those things that we have organized, or that we find naturally organized, into:

- **SUCCESSIONS**
- **STRUCTURES**
- **SEQUENCES**
- **SCALES**
- **RANKINGS**
- **ORDERS**
- **HIERARCHIES**
- **DIVISIONS**
- **CLASSIFICATIONS**
- **BRANCHES**

We know these orders exist, but have you ever tried to look one up? One can easily enough find the plant and animal kingdoms in the encyclopedias, but how about the organization of the Boy Scouts, the Mafia, or sumo wrestling ranks? Want to know the larg-

est islands in the world? Curious about what each line on a UPC code signifies? Would you like to learn the path of an e-mail message? Now you have a place to look.

The Order of Things contains orders from 13 general areas which may apply to one's work, studies, or personal interests. In the book, around 400 orders are covered so that the user may take a wide look at the universe, and at the same time choose to look at narrower views of particular subjects. The book puts the multilayered world into clearer focus by presenting the frameworks and orderings of the mass of information, and can even work as a creativity tool. Its logical structure and word associations can assist in brainstorming, aid in preliminary research, and provide a source of words and facts for writing or fun. *The Order of Things* helps make sense of a very complicated world.

THE EARTH

Here hills and vales, the woodland and the plain, Here earth and water seem to strive again . . . Where order in variety we see, And where, though all things differ, all agree.

—Alexander Pope, *Windsor Forest*

ATMOSPHERE

AIR QUALITY INDEX

(established by the Environmental Protection Agency as a measure of air pollutants: carbon monoxide, nitrogen dioxide, ozone, sulfur dioxide, and particulates)

- **0–50:** good, no cautionary status
- **51–100:** moderate, no cautionary status, however some pollutants may affect a very small number of people
- **101–150:** unhealthy for sensitive groups, no cautionary status
- **151–200:** unhealthy, alert for elderly or ill to stay indoors and reduce physical activity
- **201–300:** very unhealthy, alert for general population to stay indoors and reduce physical activity
- **301–500:** hazardous, emergency alert, all stay indoors, windows shut, no physical activity

ATMOSPHERIC LAYERS

Homosphere: lower of two portions of atmosphere, from surface to 50–62 mi (80–100 km)

Heterosphere: upper of two portions of atmosphere, above 50–62 mi (80–100 km)

Troposphere: 0–11 mi (18 km), where life and weather are concentrated

Tropopause: layer joining tropo- and stratospheres

Stratosphere: 11–30 mi (18–50 km); includes ozonesphere

Stratopause: layer joining strato- and mesosphere

Mesosphere: 31–50 mi (50–80 km); also called lower ionosphere; airglow and ozone band

Mesopause: layer joining meso- and thermosphere

Thermosphere: 50–250 mi (80–400 km)

Thermopause: layer joining thermo- and exosphere

Exosphere or magnetosphere: 250–40,000 mi (400–64,000 km)

D-layer or D-region: 35–55 mi (56–88 km); absorbs energy of
short-wave radio waves reflected by other layers
Kennelly-Heaviside layer, E-layer, or E region: 55–95 mi
(88–154 km); during the day, reflects radio waves
Appleton layer, F-layer, or F region: 95–250 mi (154–400 km);
reflects radio waves of up to 50 Mhz

FOUR WINDS OF GREEK MYTHOLOGY

Four Directions
Boreas: north
Notus: south
Eurus: east
Zephyr: west

In-Between Directions
Euroauster: southeast
Afer: southwest
Caurus: northwest
Euroclydon: northeast

HUMIDEX HUMIDITY SCALE
*(A scale devised to measure comfort layers in extreme heat,
based on the temperature and relative humidity.)*
20–29: comfortable
30–39: some discomfort
40–45: uncomfortable for everyone
 46+: many types of work must be stopped

SMOG ALERT STAGES
Stage 1: up to .20 parts per million (caution to those with heart
and respiratory conditions)
Stage 2: up to .35 parts per million (caution against strenuous
exercise)
Stage 3: over .35 parts per million (emergency: schools close,
people remain indoors)

CAVES

DEEPEST CAVES

(The deepest cave was discovered in 2001.)

Cave	Location	Depth, ft
Krubera-Voronja	Georgian Republic	7,119
Lamprechtsofen-Vogelschacht	Austria	5,354
Gouffre Mirolda	France	5,335
Réseau Jean Bernard	France	5,256
Torca del Cerro del Cuevon (Torca de las Saxifragas)	Spain	5,213
Sarma	Georgian Republic	5,062
Shakta Vjacheslav Pantjukhina	Georgian Republic	4,948
Cehi 2	Slovenia	4,928
Sistema Cheve	Mexico	4,869
Sistema Huautla	Mexico	4,839

CITIES

LARGEST URBAN CENTERS

City	Location	Population
Tokyo	Japan	35,197,000
Mexico City	Mexico	19,411,000
New York City–Newark	U.S.	18,718,000
São Paulo	Brazil	18,333,000
Jakarta	Indonesia	18,215,000
Mumbai (Bombay)	India	18,196,000
Delhi	India	15,048,000
Shanghai	China	14,503,000
Calcutta	India	14,277,000
Buenos Aires	Argentina	12,550,000
Dhaka	Bangladesh	12,430,000

City	Location	Population
Los Angeles–Long Beach–Santa Ana, CA	U.S.	12,550,000
Karachi	Pakistan	11,608,000
Rio de Janeiro	Brazil	11,469,000

LARGEST U.S. CITIES
(per the 2000 census; figures rounded up to nearest hundred thousand)

City	State	Population
New York	New York	8,000,000
Los Angeles	California	3,900,000
Chicago	Illinois	2,900,000
Houston	Texas	2,100,000
Philadelphia	Pennsylvania	1,500,000
Phoenix	Arizona	1,500,000
San Antonio	Texas	1,300,000
San Diego	California	1,300,000
Dallas	Texas	1,200,000
San Jose	California	900,000

CLIMATES AND CLIMATIC REGIONS

BIOMES
(A biome consists of several different ecosystems found together in a single geographical zone, sharing the same climatic conditions.)

Deciduous Forest
Desert
Grasslands/Savannah
Rainforest
Taiga/Coniferous Forest
Tundra

CLIMATE ZONES *(A climate zone is any of the geographical regions loosely divided according to prevailing climate and latitude; listed here coldest to warmest.)*

Polar ice cap (Antarctica)
Polar tundra (western Greenland)
Boreal (Siberia)
Temperate (United States, northern Europe)
Cold temperate (northern Canada)
Cool temperate maritime (London)
Cool coastal desert (Lima, Peru)
Highland (Quito, Ecuador)
Middle-latitude dry (North Dakota)
Warm temperate (Greece)
Temperate oceanic (Paris)
Temperate continental (Montreal; New York)
Tropical-subtropical humid (Charleston, South Carolina)
Subtropical dry (Perth, Australia)
Tropical-subtropical dry (Phoenix, Arizona)
Tropical desert (Egypt)
Tropical wet-and-dry (Calcutta)
Tropical wet; monsoon (Myanmar; Singapore)

DESERTS

Desert	Location	Size, sq mi
Sahara	Africa	3,320,000
Great Australian	Australia	1,470,000
Arabian	Arabia	900,000
Gobi	Asia	500,000
Kalahari	Africa	360,000
Taklamakan	China	270,000
Patagonian	Argentina	260,000
Great Basin	U.S.	190,000
Chihuahuan	Mexico	175,000
Namib	Africa	135,000

Desert	Location	Size, mi
Sonoran	U.S. and Mexico	120,000
Kyzylkum	Asia	115,000
Thar	India and Pakistan	77,000

RAIN FOREST LAYERS

Emergent layer, 200 feet above ground: isolated trees that tower above canopy

Canopy, 100–165 feet: tall straight trees form dense, unbroken region

Lower canopy/Understory layer, 40–100 feet: larger leaves, home to many birds, snakes, lizards, big cats, insects

Understory, 10–20 feet: young trees, small conical trees, shrubs

Ground layer: floor vegetation

VEGETATION ZONES

(A vegetation zone is an extensive, sometimes transcontinental, band of similar vegetation on the earth's surface, listed here coldest to warmest.)

Polar and tundra

Boreal forest or taiga (cold forest)

Mountain regions

Temperate forest

Mediterranean (hot dry summers, cool wet winters)

Steppes or dry grassland (hot dry summers, very cold winters)

Tropical rain forest

Desert (hot)

Tropical grassland (always hot, with a wet and a dry season)

ZOOGEOGRAPHICAL REGIONS

(These six geographical divisions of the world have been devised for the study of the distribution of land animals.)

Palaearctic: Europe, northern Africa, northern Middle East, north and central Asia

Nearctic: North America and Greenland
Neotropical (also Neogea): Central and South America to
 central Mexico, Caribbean
Afrotropical (also Metagea): sub-Saharan Africa, Madagascar,
 southern Middle East
Oriental: southern Asia and adjacent islands
Australian (also Australasian, Notogea): Australia, Oceania
Antarctic: Antarctica

CONTINENTS

SURFACE AREA OF CONTINENTS *(in sq mi)*

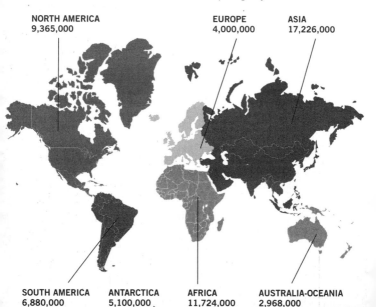

NORTH AMERICA
9,365,000

EUROPE
4,000,000

ASIA
17,226,000

SOUTH AMERICA
6,880,000

ANTARCTICA
5,100,000

AFRICA
11,724,000

AUSTRALIA-OCEANIA
2,968,000

POPULATION OF CONTINENTS

Asia	3,879,000,000	South America	379,500,000
Africa	877,500,000	North America	501,000,000
Europe	727,000,000	Australia/Oceania	32,000,000

DEPRESSIONS IN THE EARTH'S SURFACE

DEEPEST DEPRESSIONS *(maximum depth below sea level)*

Depression	Location	Depth, ft
Dead Sea	Jordan and Israel	1,378
Turfan Depression	China	505
Qattara Depression	Egypt	436
Poluostrov Mangyshlak	Kazakhstan	433
Danakil Depression	Ethiopia	383
Death Valley	California, U.S.	282
Salton Sink	California, U.S.	235
Zapadnyy Chink Ustyurta	Kazakhstan	230
Prikaspiyskaya Nizmennost	Russia and Kazakhstan	220
Ozera Sarykamysh	Uzbekistan and Turkmenistan	148

LARGEST METEORITE CRATERS

Crater	Location	Diameter, mi
Vredefort	South Africa	186
Sudbury	Ontario, Canada	155
Chicxulub	Yucatan, Mexico	106
Popigai	Siberia, Russia	62
Manicouagan	Quebec, Canada	62
Acraman	South Australia	56
Chesapeake Bay	Virginia, U.S.	56
Puchezh-Katunki	Russia	50
Morokweng	South Africa	45
Kara	Russia	40
Beaverhead	Idaho	37

EARTHQUAKES

MERCALLI SCALE

Number	Intensity	Effects	Number on Richter Scale
I	Instrumental	Detected by seismographs and some animals	< 3.5
II	Feeble	Noticed by sensitive people at rest	3.5
III	Slight	Vibration similar to passing truck; hanging objects swing	4.2
IV	Moderate	Felt generally indoors; things rattle and parked cars rock	4.5
V	Rather strong	Felt generally; most sleepers wake up	4.8
VI	Strong	Trees shake; chairs fall over; some damage	5.4
VII	Very strong	General alarm; walls crack; plaster falls	6.1
VIII	Destructive	Chimneys, columns, monuments, weak walls fall	6.5
IX	Ruinous	Some houses collapse as ground cracks	6.9

EARTH SCIENCES

BRANCHES OF EARTH SCIENCE

Atmospheric Sciences

Aeronomy: study of earth's and other planets' atmosphere

Meteorology: study of atmosphere and its phenomena

Climatology: study of physical state of atmosphere

Number	Intensity	Effects	Number on Richter Scale
X	Disastrous	Many buildings destroyed; railway lines bend	7.3
XI	Very disastrous	Few buildings survive; landslides and floods	8.1
XII	Catastrophic	Total destruction; ground forms waves	> 8.1

RICHTER SCALE

Number	Effects
2.0–2.9	Not felt by many; perceived by sensitive seismographic machines
3.0–3.9	Slight vibration; hanging objects swing
4.0–4.9	Vibration; small objects move and rattle
5.0–5.9	Furniture moves; masonry cracks and falls
6.0–6.9	Difficulty standing; walls and chimneys collapse partially
7.0–7.9	Buildings collapse; cracks in ground; landslides
8.0–8.9	Damage to underground structures; rock masses moved

Geological Sciences

Astrogeology: application of geology, geochemistry, geophysics to moon and other planets

Economic geology: geology applied to engineering and materials usage

Engineering geology: geology applied to civil engineering

Environmental geology: geology applied to environmental concerns

Petroleum geology: geology applied to hydrocarbon fuel technology

Urban geology: geology applied to urban concerns

Geobotanical prospecting: use of plants to locate ore deposits

Geobotany: study of plants in relation to geologic environment

Geochemistry: study of chemical makeup of earth and its processes

Geochronology: dating of events in earth's history

Radiometric dating: using radioisotopes to date events

Geochronometry: study of absolute age of rocks by measuring radioactive decay

Geocosmogony: study of the origin of the earth

Geomorphology: study of the origin of secondary topographic features of the earth

Geophysics: physics of the earth and its environment

Geodesy: study of size, shape, gravitational field, etc., of the earth

Glacial geology: study of land features resulting from glaciation

Mineralogy: study of minerals

Crystallography: study of geometric description of crystals

Structural geology: study of form, arrangement, and internal structure of rocks

Paleontology: study of life as recorded in fossils

Invertebrate paleontology: fossils of invertebrates

Micropaleontology: fossils of microorganisms

Paleobotany: fossils of plants

Palynology: fossils of spores, pollen, microorganisms

Vertebrate paleontology: fossils of vertebrates

Petrology: study of origin, history, structure, etc., of rocks

Igneous petrology

Metamorphic petrology

Sedimentary petrology

Physical geology: study of composition of earth and its physical changes

Seismology: study of earthquakes
Stratigraphy: study of rock strata
 Historical geology: study of bedded rocks
Volcanology: study of volcanoes

Hydrologic Sciences
Glaciology: study of glaciers
Hydrology: study of the waters of the earth
Limnology: study of lakes
Oceanography: study of oceans

HIERARCHY OF LIVING SYSTEMS

Individual: a plant or animal of a particular species

Population: coexisting group of individuals of the same species

Community: coexisting populations of different species

Ecosystem: several different communities coexisting in a characteristic way

Biome: different ecosystems found together in a single geographical zone, sharing the same climatic conditions

Biosphere: the sum total of all the earth's biomes; the thin life-bearing layer that forms the outer surface of the planet

EARTH STRUCTURES

EARTH LAYERS

Continental crust: thin layer of hard rock 4–44 mi thick; temperature at bottom of crust about 1,900°F; consists of calcium-iron-magnesium silicates below and aluminum-sodium-potassium silicates above.

Oceanic crust: large, water-filled hollows in crust; average depth 2.2 mi; same composition as lower continental crust

Mantle: dense, semimolten layer of iron-magnesium silicates about 1,800 mi thick, temperature rises to 6,700°F; thicker under oceans than continents

Outer core: molten; 90% iron, 9% nickel, and 1% sulfur; about 1,240 mi thick; temperature approx. 4,000°F

Inner core: dense, hot layer of 90% iron, 9% nickel, and 1% sulfur; about 1,712 mi thick; temperature approx. 8,100°F

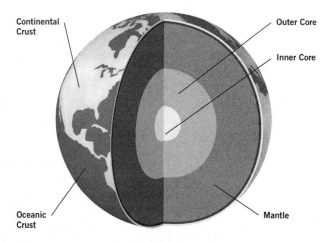

Continental Crust

Outer Core

Inner Core

Oceanic Crust

Mantle

CHEMICAL ELEMENTS OF THE EARTH'S CRUST

(percentage, from most to least common)

Oxygen	46.6
Silicon	27.7
Aluminum	8.1
Iron	5.0
Calcium	3.6
Sodium	2.8
Potassium	2.59
Magnesium	2.1

OPENINGS IN THE EARTH'S CRUST

Canyon: very deep valley

Gorge: narrow canyon with steep walls

Valley (col): depression between mountains or raised land

Crater: a bowl-shaped depression

Dale: broad valley

Ravine: deep valley

Glen: narrow valley

Dell: small valley, often wooded

Dingle: narrow dell

Hollow (notch): small valley

Fissure: narrow opening created by land mass movement, as from an earthquake

Vent or Volcano: a fissure emitting lava and/or gases.

Fault: a crack in the earth's crust

Trench: long hole or ditch, often created by running water

Gully: deep trench

Fumarole: a hole or spot in a volcanic region

FOSSIL FUELS

COAL SIZES

Large coal	6 inches	Double	1–2 inches
Large cobble	3–6 inches	Single	½–1 inch
Cobble	2–4 inches	Pea	¼–½ inch
Treble	2–3 inches	Grain	⅛–¼ inch

TYPES OF COAL *(degree of coalification from highest to the lowest heat-producing capacity)*

Anthracite (greatest carbon content)
Bituminous coal
Subbituminous coal
Lignite (brown) coal

GEOGRAPHY

EARTH COORDINATE SYSTEM

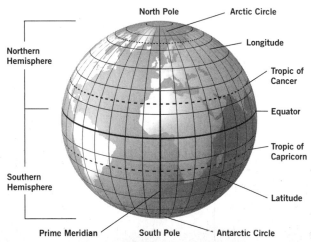

GEOLOGICAL TIME

ERAS AND PERIODS
(formation of the earth as a planet; approximate dates)

Precambrian Era: 4.6 billion to 542 million years ago
Archaen Era: 4.6 billion to 2.5 billion years ago
Proterozoic Era: 2.5 billion to 542 million years ago

Paleozoic Era: 542 million to 250 million years ago
Cambrian Period: 542 million to 490 million years ago
Ordovician Period: 490 million to 440 million years ago
Silurian Period: 440 million to 400 million years ago
Devonian Period: 400 million to 350 million years ago
Carboniferous Period: 350 million to 250 million years ago
 Mississippian Period (Lower Carboniferous): 350 million
 to 300 million years ago
 Pennsylvanian Period (Upper Carboniferous): 300 million
 to 290 million years ago
Permian Period: 300 million to 250 million years ago

Mesozoic (Secondary) Era: 251 million to 65 million years ago
Triassic Period: 250 million to 200 million years ago
Jurassic Period: 200 million to 145 million years ago
 Lower Jurassic (Lias): 200 million to 175 million years ago
 Middle Jurassic (Dogger): 175 million to 161 million years ago
 Upper Jurassic (Malm): 161 million to 145 million years ago
Cretaceous Period: 145 million to 65 million years ago

Cenozoic Era: 65 million years ago to present
Tertiary Period: 65 million to 1.6 million years ago
 Paleogene Period: 65 million to 23.8 million years ago
 Paleocene Epoch: 65 million to 54.8 million years ago
 Eocene Epoch: 54.8 million to 33.7 million years ago
 Oligocene Epoch: 33.7 million to 23.8 million years ago

Neogene Period: 23.8 million to 1.8 million years ago
 Miocene Epoch: 23.8 million to 5.3 million years ago
 Pliocene Epoch: 5.3 million to 1.8 million years ago
Quarternary Period: 1.8 million years ago to present
 Pleistocene Epoch: 1.8 million to 10,000 years ago
 Holocene, or Recent, Epoch: 10,000 years ago to present

GEOLOGICAL TIME SPANS

Eon: largest division of geological time; several eras
Era: several periods or suberas
Subera: division of an era
Period: large division of geological time; corresponds to a
 system—a major stratigraphical division
Epoch: part of a period
Age: part of an epoch, corresponds to a stage—a stratigraphical
 division within a series
Chron: part of an age; smallest division of geological time

GEOLOGICAL COLUMN

*(A geological column is the chronological arrangement of rocks,
with the oldest at the bottom and youngest at the top.)*
System: all the rocks that formed in a geological period
Series: rocks deposited during an epoch
Stage: rocks deposited during an age
Chronozone: rocks deposited during a chron, a subdivision of
 time based on the direction of magnetization preserved in
 the rocks

ICE AGES

CLASSIFICATION OF GLACIERS *(smallest to largest)*
Ice caps: glaciers that extend in continuous sheets, moving
 outward in all directions
Mountain glaciers: glaciers confined within a path that directs
 the ice movement

Piedmont glaciers: glaciers that spread out on level ground at the foot of mountain ranges

Ice shelves: glaciers that spread out on the ocean at the foot of glaciated regions

Ice sheets or continental glaciers: glaciers that cover large expanses of a continent and are slow-moving

GLACIATIONS, INTERGLACIALS, INTERSTADIALS
(in chronological order)
Gunz (Early Glaciation) Phase I
Gunz (Early Glaciation) Phase II
Prepenultimate Interglacial
Mindel (Prepenultimate Glaciation) Phase I
Mindel (Prepenultimate Glaciation) Phase II
Riss (Penultimate Glaciation) Phase I
Riss (Penultimate Glaciation) Phase II
Last Interglacial Würm (Last Glaciation) Phase I
First Würm Interstadial
Würm (Last Glaciation) Phase II
Final Interstadial
Würm (Last Glaciation) Phase III
Final recession of ice
Arctic or Dryas Phase (flora) with warmer
 Allerod oscillation
Preboreal Phase (flora)
Boreal Phase (flora)
Atlantic Phase
Sub-boreal

MAJOR ICE AGES
Huronian: earliest known ice age (2.4 to 2.1 billion years ago)
Sturtian/Marinoan: (710 to 640 million years ago)
Varangian: final phase of late Precambrian ice age
 (570 million years ago)

Ardean/Saharan ice age: glaciers covering much of the southern hemisphere (460 to 430 million years ago)
Karoo ice age: (350 to 260 million years ago)

PLEISTOCENE EPOCH OR GREAT ICE AGE
(most recent ice age)
Lower Pleistocene (Nebraskan glacial phase): 1.8 million to 780,000 years ago
Middle Pleistocene (Aftonian pluvial, Kansanian glacial, Yarmouthian pluvial, Illinoian glacial phases): 780,000 to 126,000 years ago
Upper Pleistocene (Sangamonian pluvial, Early Wisconsin, Mid-Wisconsin, Late Wisconsin glacial phases): 126,000 to 10,000 years ago

PLEISTOCENE GLACIATIONS, INTERGLACIATIONS
(Large areas of the Northern Hemisphere were covered with ice, and there were successive glacial advances and retreats.)

North American Stage	Northern European Stage	Central European Stage	Approximate End
Late Wisconsin	Weichselian	Würm	10,000 years ago
Mid Wisconsin	Eemian	Riss-Würm	Interstadials
Early Wisconsin	Saalian	Riss	45,000 years ago
Sangamonian	Holsteinian	Mindel-Riss	Interglacial
Illinoian	Elsterian	Mindel	125,000 years ago
Yarmouth	Cromerian	Günz-Mindel	Interglacial
Kansan	Menapian	Günz	690,000 years ago
Aftonian	Waalian	Danube-Günz	Interglacial
Nebraskan	Eburonian	Danube	1,600,000 years ago

ISLANDS

LARGEST ISLANDS IN FRESHWATER LAKES

Island	Location	Area, sq mi
Manitoulin	Lake Huron	1,068
Vozrozhdeniya	Aral Sea	888
René-Lavasseur	Manicouagan Reservoir	780
Ol'khon	Lake Baikal	282
Samosir	Toba	243
Isle Royale	Lake Superior	209
Ukerewe	Lake Victoria	205
St. Joseph	Lake Huron	141
Drummond	Lake Huron	134
Idjwi	Lake Kivu	110
Ometepe	Lake Nicaragua	107

LARGEST ISLANDS IN OCEANS

Island	Location	Area, thousands of sq mi
Greenland	Denmark	822
New Guinea	Papua New Guinea and Indonesia	309
Borneo	Indonesia, Malaysia, Brunei	283
Madagascar	Malagasy	227
Baffin Island	Canada	196
Sumatra	Indonesia	168
Honshu	Japan	88
Great Britain	United Kingdom	88
Victoria Island	Canada	84
Ellesmere Island	Canada	76
Celebes	Indonesia	69
South Island	New Zealand	59

Island	Location	Area, thousands of sq mi
Java	Indonesia	49
North Island	New Zealand	44
Newfoundland	Canada	42
Cuba	Cuba	41
Luzon	Philippines	40
Iceland	Iceland	40
Mindanao	Philippines	37
Ireland	Ireland	33
Hokkaido	Japan	30

MOUNTAINS

CLASSIFICATIONS OF MOUNTAINS

Dome: comparatively flat, dissected surface that gradually slopes toward lowlands (e.g., Black Hills, South Dakota)

Fault-block: segments uplifted along linear fracture zones (Sierra Nevada)

Fold: formed by lateral compression and uplift, occurring near basins of sedimentary rock layers (parts of Appalachian system)

Volcanic: usually in fault zones and subduction zones built by active volcano (Mount Fuji, Japan) or built by residual products of volcano (Devils Tower, Wyoming)

HIGHEST MOUNTAIN ON EACH CONTINENT

Mountain	Location	Height, thousands of ft
Mount Everest	Asia	29.0
Aconcagua	South America	22.8

Mount McKinley	North America	20.3
Kilimanjaro	Africa	19.3
Elbrus	Europe	18.5
Vinson Massif	Antarctica	16
Mount Kosciusko	Australia	7.3

MOUNTAIN STRUCTURE

(top to bottom)

Summit or peak: top

Alpine zone: end of treeline; hardy mosses and some flora

Foothills: at base of mountain, but not part of peak;
three altitudes—high, middle, and low—where plants and
trees grow

Base: lowest point from which horizontal plane can be
measured

PRESIDENTS ON MOUNT RUSHMORE

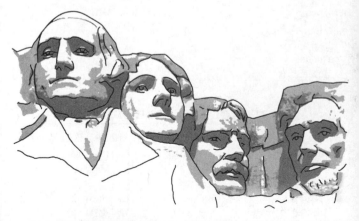

George Washington Thomas Jefferson Theodore Roosevelt Abraham Lincoln

MOUNTAIN RANGES

Range	Location	Length, mi
Cordillera de Los Andes	South America	5,500
Rocky Mountains	North America	3,000
Himalaya-Karakoram Hindu Kush	Central Asia	2,400
Great Dividing Range	Australia	2,250
Trans-Antarctic Mountains	Antarctica	2,200
West Sumatran-Javan Range	Sumatra and Java	1,800
Brazilian Atlantic Coast Range	Brazil	1,600
Tien Shan	Kyrgyzstan and China	1,500
Central New Guinea Range	Papua New Guinea	1,250
Aleutian Range	Alaska and Pacific Northwest	600

SEVEN HILLS OF ROME *(north to south)*

Aventine
Caelian
Palatine
Capitoline
Esquiline
Viminal
Quirinal

NATIONS OF THE WORLD

(classified by the United Nations; each group is largest to smallest)

AFRICA

Eastern Africa

Ethiopia
United Republic
 of Tanzania
Mozambique
Zambia
Somalia
Madagascar
Kenya
Zimbabwe
Uganda
Malawi
Eritrea
Burundi
Rwanda
Djibouti

Réunion
Comoros
Mauritius
Seychelles
Mayotte

Middle Africa
Democratic
 Republic of
 the Congo
Chad
Angola
Central African
 Republic
Cameroon
Congo
Gabon
Equatorial Guinea
Sao Tome and
 Principe

Northern Africa
Sudan
Algeria
Libyan Arab
 Jamahiriya
Egypt
Morocco
Western Sahara
Tunisia

Southern Africa
South Africa
Namibia

Botswana
Lesotho
Swaziland

Western Africa
Mali
Niger
Mauritania
Nigeria
Cote d'Ivoire
Burkina Faso
Guinea
Ghana
Senegal
Benin
Liberia
Sierra Leone
Togo
Guinea-Bissau
Gambia
Cape Verde
Saint Helena

AMERICAS
Caribbean
Cuba
Dominican
 Republic
Haiti
Bahamas
Jamaica
Puerto Rico
Trinidad and
 Tobago

Guadeloupe
Martinique
Netherlands
 Antilles
Dominica
St. Lucia
Antigua and
 Barbuda
Barbados
Turks and Caicos
St. Vincent and the
 Grenadines
Grenada
United States
 Virgin Islands
St. Kitts and Nevis
Cayman Islands
Aruba
British Virgin
 Islands
Anguilla
Montserrat
French St. Martin
St. Barthélemy

Central America
Mexico
Nicaragua
Honduras
Guatemala
Panama
Costa Rica
Belize
El Salvador

South America
Brazil
Argentina
Peru
Colombia
Bolivia
Venezuela
(Bolivarian
Republic of)
Chile
Ecuador
Paraguay
Guyana
Uruguay
Suriname
French Guiana
Falkland Islands
(Malvinas)

North America
Canada
United States of
America
Greenland
Saint Pierre and
Miquelon
Bermuda

ASIA

Central Asia
Kazakhstan
Turkmenistan
Uzbekistan

Kyrgyzstan
Tajikistan

Eastern Asia
China
Mongolia
Japan
Democratic
People's
Republic of
Korea
Republic of
Korea
Hong Kong
Macao

Southern Asia
India
Iran, Islamic
Republic of
Pakistan
Afghanistan
Bangladesh
Nepal
Sri Lanka
Bhutan
Maldives

Southeast Asia
Indonesia
Myanmar
Thailand
Malaysia

Viet Nam
Philippines
Lao People's
Democratic
Republic
Cambodia
Timor-Leste
Brunei
Darussalam
Singapore

Western Asia
Saudi Arabia
Turkey
Yemen
Iraq
Oman
Syrian Arab
Republic
Jordan
Azerbaijan
United Arab
Emirates
Georgia
Armenia
Kuwait
Israel
Qatar
Lebanon
Cyprus
Occupied
Palestinian
Territory
Bahrain

EUROPE

Eastern Europe
Russian
 Federation
Ukraine
Poland
Romania
Belarus
Bulgaria
Hungary
Czech Republic
Slovakia
Moldova

Northern Europe
Sweden
Norway
Finland
United Kingdom
 of Great
 Britain and
 Northern
 Ireland
Iceland
Ireland
Lithuania
Latvia
Svalbard and Jan
 Mayen Islands
Estonia
Denmark
Åland Islands
Faeroe Islands

Isle of Man
Channel Islands
 Jersey
 Guernsey

Southern Europe
Spain
Italy
Greece
Portugal
Serbia
Croatia
Bosnia and
 Herzegovina
Albania
The former
 Yugoslav
 Republic of
 Macedonia
Slovenia
Montenegro
Andorra
Malta
San Marino
Gibraltar
Holy See

Western Europe
France
Germany
Austria
Switzerland
Netherlands
Belgium

Luxembourg
Liechtenstein
Monaco

OCEANIA

Australia and
New Zealand
Australia
New Zealand
Norfolk Island

Melanesia
Papua New
 Guinea
Solomon Islands
New Caledonia
Fiji
Vanuatu

Micronesia
Micronesia,
 Federated
 States of
Kiribati
Guam
Northern Mariana
 Islands
Palau
Marshall Islands
Nauru

Polynesia
French Polynesia

Samoa	Niue	Tuvalu
Tonga	Cook Islands	Tokelau
Wallis and Futuna Islands	American Samoa	
	Pitcairn	

NATIONS WITH THE LONGEST COASTLINES

Canada	125,548 mi
Indonesia	33,999 mi
Russia	23,396 mi
Japan	18,486 mi
Australia	16,006 mi
Norway	15,626 mi
United States	12,255 mi
China	7,146 mi

NATIONS WITH THE SHORTEST COASTLINES

Monaco	2.5 mi	Congo, Democratic Republic of the	23 mi
Bosnia	12 mi	Togo	35 mi
Jordan	16 mi	Iraq	36 mi
Slovenia	16 mi	Belgium	41 mi
Nauru	18.6 mi		

ROCKS

MOHS SCALE OF MINERAL HARDNESS
(The German mineralogist Friedrich Mohs [1773–1839] created this scale of hard to soft.)

Cannot be scratched by knife or file
 10: diamond (revised scale, garnet)
 9: corundum, sapphire, ruby
 (revised scale, topaz)
 8: topaz (revised scale, quartz)

Can be scratched by streak plate—an unglazed piece of porcelain with a hardness of 6.5 on Mohs scale
 7: quartz, rock crystal (revised scale, vitreous pure silica)

Can be scratched by glass plate or steel needle
 6: orthoclase, feldspar

Can be scratched by knife or file
 5: apatite
 4: fluorite

Can be scratched by copper penny
 3: calcite

Can be scratched by fingernail
 2: gypsum, rock salt
 1: talc

ROCK CLASSES
Magma: molten rock
Igneous rock: formed from molten magma
 Extrusive: ejected by volcanoes
 Intrusive: beneath surface
 Pyroclastic: from deposits of explosive volcanic eruptions
 Plutonic: mineral grain sizes visible to naked eye
 Volcanic/hypabyssal: too fine-grained or glassy to be observed without microscope
Sedimentary rock: weathered, eroded, or biologically reconstituted remains of igneous or metamorphic rock
 Clastic/crystalline: made of broken bits of preexisting rocks
 Carbonate/organic/biogenic: built up from the remains of living things
 Noncarbonate/chemical: forms when salt and other substances dissolved in water are separated from the solution

Metamorphic rock: igneous or sedimentary rock reformed
under intense heat or pressure
 Regional/dynamic: deep in crust, at heart of mountain
ranges
 Thermal/contact: made by heat from nearby igneous rock

ROCK SIZES

*(largest to smallest in size and grain, according to
Wentworth-Udden scale)*

Boulder	10 in
Cobblestone (cobble)	2.5–10 in
Pebble	1.5–2.5 in
Granule (gravel)	.75–1.5 in
Sand (very coarse, coarse, medium, fine, very fine)	.0625 in
Silt (coarse, medium, fine, very fine)	.0039 in
Clay	less than .0002 in
Colloid	less than .0001 in

ROCK STRATA

(oldest to youngest)
Metamorphic rock
Conglomerate
Sandstone
Limestone
Alluvium

ROCK TYPES *(by situation)*

Basement rock: igneous or metamorphic, usually precambrian
that is overlain by sedimentary rock
Bedrock: rock underlying soil or other surface material
Country rock: rock that surrounds and is penetrated by
mineral veins
Source rock: rock from which a sediment is derived

ROCKY SHORE ZONES
(often clearly marked by the types of seaweed)

Upper shore: green seaweeds and animals that can survive out of the water the longest

Middle shore: darker seaweeds and animals that cannot survive long out of the water

Lower shore: brown seaweeds and animals that cannot survive out of the water

SOILS

CLASSIFICATION OF SOILS
(also called the NRCS Soil Classification System by the U.S. Dept. of Agriculture)

Alfisol: soil with clay argillic and ochric epipedon (a subsurface soil horizon)

Andisol: a thick, dark soil with volcanic ash horizons

Aridisol: dry soil with salic, calcic, and gypsic horizon

Entisol: young soils lacking horizons (a specific layer or stratum of soil/subsoil)

Gelisol: a dark soil with an argillic or spodic horizon and a layer of permafrost

Histosol: wet soils made of decaying plants

Inceptisol: young soils with poor horizons (as in rice paddies)

Mollisol: fertile soil with mollic epipedon

Oxisol: mature, well-leached soils with distinct oxic horizon

Spodosol: podozolized soil with albic and spodic horizon

Ultisol: red soil, less leached, with clay argillic horizon

Vertisol: dark soil with deep vertical cracks

SOIL TEXTURES

Clay soils: smallest grains	**Sandy soils:** largest grains
Silty soils: medium-sized	**Loam soils:** mixture of the three

LAYERS OF SOIL *(top to bottom)*

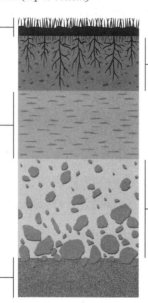

Humus: horizon O—decaying plant material and leaves

Subsoil: horizon B—middle layer including iron oxides, clay, and other insoluble substances, touched by deep-rooted plants such as trees

Rock zone: horizon D—underlying bedrock, layer of crumbled rocks

Topsoil: horizon A—top layer where moisture seeps downward, dissolving chemical elements; minerals in the moisture enter streams, rivers, eventually the seas

Parent rock: horizon C—bottom layer, combination of decomposed rock and shaly materials

VOLCANOES

TALLEST VOLCANOES

Volcano	Location	Elevation, ft
Ojos del Salado	Chile	22,595
Llullaillaco	Chile	22,109
Tipas	Argentina	21,850
Nevado de Incahuasi	Chile	21,722
Cerro el Cóndor	Argentina	21,430
Coropuna	Peru	20,922
Parinacota	Chile	20,827

Volcano	Location	Elevation, ft
Chimborazo	Ecuador	20,702
Pular	Chile	20,449
El Solo	Chile	20,308
San Pedro	Chile	20,161
Sierra Nevada	Chile	20,101
Aracar	Argentina	19,954
Guallatiri	Chile	19,918
Nevado Chachani	Peru	19,872

VOLCANO CLASSIFICATION
Active
Dormant
Extinct

WATER

BODIES OF WATER

Arroyo	Draw	Moat	Strait
Bayou	Estuary	Ocean	Stream
Beck	Fjord	Pond	Subglacial
Bight	Gulf	Pool	pond
Brook	Harbor	Puddle	Swamp
Channel	Inlet	Rapid	Tide pool
Canal	Lagoon	Reservoir	Vernal pool
Cover	Lake	Run	Wash
Creek	Loch	Sea	Wetland
Dam	Marsh	Sound	

DEEPEST FRESHWATER LAKES

Lake	Location	Depth, ft
Lake Baikal	Russia	5,315
Lake Tanganyika	Burundi, Tanzania, Congo, and Zambia	4,710

Lake	Location	Depth, ft
Lake Malawi	Malawi, Mozambique, and Tanzania	2,316
Great Slave Lake	Canada	2,014
Crater Lake	Oregon	1,949
Lake Matana	Indonesia	1,936
Toba Lake	Indonesia	1,736
Hornindals	Norway	1,686
Lake Sarezskoye and Lake Sarez	Tajikistan	1,657
Lake Tahoe	California and Nevada	1,643

GREAT LAKES MNEMONIC: HOMES

H—Huron
O—Ontario
M—Michigan
E—Erie
S—Superior

LARGEST LAKES

Lake	Location	Area, sq mi
Caspian Sea	Asia	149,200
Lake Superior	Canada and U.S.	31,700
Lake Victoria	Kenya, Tanzania, and Uganda	26,828
Aral Sea	Kazakhstan and Uzbekistan	26,300
Lake Huron	Canada and U.S.	23,010
Lake Michigan	U.S.	22,300
Lake Baikal	Russia	12,200
Lake Tanganyika	Zaire and Tanzania	12,700
Great Bear Lake	Canada	12,096
Great Slave Lake	Canada	11,030

Lake	Location	Area, sq mi
Lake Malawi	Malawi, Mozambique, and Tanzania	11,000
Lake Chad	Chad, Niger, and Nigeria	10,000
Lake Erie	Canada and U.S.	9,910
Lake Winnipeg	Southern Manitoba	9,416
Lake Ontario	Canada and U.S.	7,340
Lake Balkhash	Kazakhstan	7,115
Lake Ladoga	Russia	6,700
Lake Maracaibo	Venezuela	5,150
Lake Onega	Russia	3,753
Lake Turkana	Kenya and Ethiopia	2,473

LAYERS OF A LAKE

(in freshwater, saltwater, and volcanic lakes)

LITTORAL ZONE:
shallower area with higher forms
of aquatic vegetation

LIMNETIC ZONE:
open-water area with plankton,
bacteria, blue-green algae

**BENTHIC (OR PROFUNDAL)
ZONE:** organic community of
the lake bottom

DEEPEST OCEANS AND SEAS
(average depth)

Pacific Ocean	14,040 feet
Indian Ocean	12,760 feet
Atlantic Ocean	10,925 feet
Caribbean Sea	8,448 feet
Sea of Japan	5,748 feet
Gulf of Mexico	5,297 feet
Mediterranean Sea	4,926 feet
Bering Sea	4,893 feet
South China Sea	3,976 feet
Black Sea	3,906 feet

INTERTIDAL ZONES
(top to bottom)

Supralittoral zone: above the high-tide mark, receives both the splash of the waves and seawater misting

Supralittoral fringe: the upper level of the high-tide zone, receives regular splashing of the waves when the high tides are in

Midlittoral zone: the major part of the intertidal zone below the high-tide mark

Infralittoral fringe: the lowest level exposed by extreme spring tides; the base of the fringe marks the point of the lowest tide and beginning of the marine environment below the tides

Infralittoral zone: the marine environment below the tides

LARGEST SEAS
(in millions of sq mi)

Coral Sea	1.85	Bay of Bengal	0.84
Arabian Sea	1.49	Sea of Okhotsk	0.61
South China Sea	1.42	Gulf of Mexico	0.60
Caribbean Sea	1.06	Gulf of Guinea	0.59
Mediterranean Sea	0.97	Barents Sea	0.54
Bering Sea	0.89		

OCEAN ZONES

(layers by biological habitat in the pelagic zone)

Euphotic zone: sunlit, to 656 feet

Mesopelagic zone: 656–3,280 feet

Bathyal zone: 3,280–13,120 feet

Abyssal zone: 13,120 feet to the ocean floor
(approximately 16,400 feet)

Hadal zone: deeper than 16,400 feet, in the ocean trenches

THE OCEAN FLOOR

A. Continental shelf: the gently sloping shallow sea bed
surrounding a continent

B. Continental slope: the steep descent of the seabed from the
continental shelf to the abyssal zone

C. Continental rise: the wide, gentle incline from an ocean bottom
to a continental slope

D. Abyssal plain: a smooth and nearly flat area that covers
nearly 40% of the deep ocean-basin floor

E. Trenches: deep, steep-sided canyons that represent the
deepest parts of the ocean floor

F. Mid-ocean ridge: a continuous range of mountains that
winds around the earth

G. Oceanic Volcano: mountains on the abyssal plain that extend
above the ocean's surface, creating volcanic islands

H. Seamounts: mountains on the abyssal plain that remain
completely submerged

THE SEVEN SEAS *(modern classification)*

Antarctic
Arctic
Indian
North Atlantic
North Pacific
South Atlantic
South Pacific

WAVE CLASSIFICATION *(most to least destructive)*

Tsunami, or seismic, waves: result of undersea earthquakes;
often catastrophic
Destructive waves: remove more material seaward than
toward land
Constructive waves: deposit sediments on beaches
Capillary waves: tiny waves at the surface of the water

WAVE HEIGHT SCALE *(state of the sea code for mariners)*

Code 0: 0 feet, glassy
Code 1: 0–1 feet, calm
Code 2: 1–2 feet, rippled
Code 3: 2–4 feet, slight
Code 4: 4–8 feet, moderate
Code 5: 8–13 feet, rough
Code 6: 13–20 feet, very rough
Code 7: 20–30 feet, high
Code 8: 30–45 feet, very high
Code 9: 45+ feet, phenomenal

LONGEST RIVERS

River	Location	Length, thousands of mi
Nile	Africa	4.1
Amazon	South America	4.0

River	Location	Length, thousands of mi
Yangtze Kiang	China	3.9
Ob-Irtysh	Russia	3.5
Huang Ho (Yellow River)	China	2.9
Congo	Africa	2.9
Amur	Russia	2.8
Lena	Russia	2.6
Mackenzie	Canada	2.6
Mississippi	North America	2.5

RIVER STAGES

Glacier to spring to tributary: vigorous erosion by water cutting downward

Floodplain: formed by deposit of sediment; meandering with erosion and deposition

Delta: formed when river sheds much sediment at the mouth

RIVERS STAGES OF EROSION

Youth: river cuts deep V-shaped valleys

Maturity: river meanders and wide valley forms

Late maturity: floodplain widens, oxbow lakes develop, and meanders are pronounced

STREAMS

First-order stream: from head to the first confluence with another stream

Second-order stream: two first-order streams converge

Third-order stream: two second-order streams converge

TALLEST WATERFALLS

Waterfall	Location	Height, feet
Angel Falls	Venezuela	3,212
Tugela	South Africa	3,110

Waterfall	Location	Height, feet
Tres Hermanas, Cataratas de	Peru	3,000
Olo'upena Falls	U.S.	2,953
Yumbilla, Catarata	Peru	2,938
Vinnufossen	Norway	2,822
Baläifossen	Norway	2,788
Pu'uka'oku Falls	U.S.	2,756
James Bruce Falls	Canada	2,755
Browne Falls	New Zealand	2,744

WATERWAYS

River: water flowing downhill in a channel
Stream: small river
Brook: small freshwater stream
Rivulet: small saltwater stream
Creek: even smaller stream
Rill: smallest waterway

WEATHER AND METEOROLOGY

CLOUD CLASSIFICATION

High-level: 3–8 mi
Cirrus
Cirrocumulus
Cirrostratus (also noctilescent)

Middle-level: 1.25–4.3 mi
Altocumulus
Altostratus
Nimbostratus

Low-level: 0–1.25 mi
Stratocumulus

Stratus
Cumulus
Cumulonimbus

CLOUD COVER
Clear
Scattered
Broken (or partly overcast): clouds block sunlight for several
minutes at a time
Partly obscured: more clouds than clear sky
Overcast: continual haze
Obscured: complete cloud cover

PRECIPITATION INTENSITY *(inches per hour)*

Fog	0.005	Moderate rain	0.15
Mist	0.002	Heavy rain	0.60
Drizzle	0.01	Excessive rain	1.60
Light rain	0.04	Cloudburst	4.00

PRECIPITATION TYPES
(warmest air to coldest)
Drizzle
Rain
Freezing drizzle
Freezing rain
Sleet
Hail
Snow

SEASONS
March 20–21
 Northern Hemisphere: spring (vernal equinox)
 Southern Hemisphere: autumn

June 21–22
 Northern Hemisphere: summer (summer solstice)
 Southern Hemisphere: winter
September 22–23
 Northern Hemisphere: autumn (autumnal equinox)
 Southern Hemisphere: spring
December 22–23
 Northern Hemisphere: winter (winter solstice)
 Southern Hemisphere: summer

BEAUFORT SCALE FOR WIND STRENGTH

Beaufort Number	Description	Speed, mph
0	calm	1
1	light air	1–3
2	light breeze	4–7
3	gentle breeze	8–12
4	moderate breeze	13–18
5	fresh breeze	19–24
6	strong breeze	25–31
7	moderate gale	32–38
8	gale	39–46
9	strong gale	47–54
10	storm	55–63
11	violent storm	64–73
12–17	hurricane	74+

STORMS

Cyclone: 0–200 mph winds; 50–600 miles wide; a week or more in duration

Hurricane: 74–200 mph winds; 300–600 miles wide; up to a week in duration

Thunderstorm: 20–30 mph winds; 1–2 miles wide; under an hour

Tornado: 200–250 mph winds; ⅛ mile; touches down for a few minutes

FUJITA TORNADO SCALE
(indicates the intensity of tornadoes)

F0, gale tornado: 40–72 mph; light damage; some damage to chimneys; branches broken off trees; shallow-rooted trees pushed over; sign boards damaged

F1, moderate tornado: 73–112 mph; moderate damage; peels surface off roofs; mobile homes pushed off foundations or overturned; moving autos pushed off the roads; attached garages may be destroyed

F2, significant tornado: 113–157 mph; considerable damage; roofs torn off frame houses; mobile homes demolished; boxcars overturned; large trees snapped or uprooted; light-object missiles generated

F3, severe tornado: 158–206 mph; severe damage; roofs and some walls torn off well-constructed houses; trains overturned; most trees in forest uprooted; heavy cars lifted off the ground and thrown

F4, devastating tornado: 207–260 mph; devastating damage; well-constructed houses leveled; structures with weak foundations blown away some distance; cars thrown and large missiles generated

F5, incredible tornado: 261–318 mph; incredible damage; strong frame houses lifted off foundations and carried considerable distances to disintegrate; automobile-size missiles fly through the air in excess of 109 yd; trees debarked; steel-reinforced concrete structures badly damaged; incredible phenomena will occur

F6, inconceivable tornado: 319–379 mph; causing the afflicted area to become unrecognizable

SAFFIR-SIMPSON HURRICANE SCALE

(scale of intensity based on wind speed)

Category 1
Winds: 74–95 mph
Storm Surge: 4 to 5 feet
Damage: Minimal; some plant and
home damage

Category 2
Winds: 96–110 mph
Storm Surge: 6 to 8 feet
Damage: Moderate; trees down;
some roof damage

Category 3
Winds: 111–130 mph
Storm Surge: 9 to 12 feet
Damage: Extensive; large trees uprooted;
small buildings weakened

Category 4
Winds: 131–155 mph
Storm Surge: 13 to 18 feet
Damage: Extreme; signs destroyed; windows,
doors, roofs heavily damaged; flooding to 6 mi
inland; major damage to shoreline buildings

Category 5
Winds: more than 155 mph
Storm Surge: more than 18 feet
Damage: Catastrophic; shoreline buildings
razed; small buildings overturned; roofs and
and walls of large buildings severely damaged

NATIONAL WEATHER SERVICE SMALL-CRAFT ADVISORY SYSTEM

(1 knot = 1.15 mph)

Light wind	6 knots or less
Gust	7–16 knots
Squall	16–32 knots
Special marine warning	32–34 knots
Gale warning	34–47 knots
Tropical storm warning	47–63 knots
Storm warning	48+ knots
Hurricane warning	64+ knots

WIND BAROMETER TABLE

(wind direction, barometer normalized to sea level, weather indication)

SW to NW, 30.10–30.20 and steady: fair with slight temperature changes for 1–2 days

SW to NW, 30.10–30.20 and rising rapidly: fair and followed within 2 days by rain

SW to NW, 30.20 or above and stationary: fair with no decided temperature change

SW to NW, 30.20 or above and falling slowly: slowly rising temperature and fair for 2 days

S to SE, 30.10–30.20 and falling slowly: rain within 24 hours

S to SE, 30.10–30.20 and falling rapidly: wind increasing and rain within 12–24 hours

SE to NE, 30.10–30.20 and falling slowly: rain in 12–18 hours

SE to NE, 30.10–30.20 and falling rapidly: wind increasing and rain within 12 hours

E to NE, 30.10 or above and falling slowly: light wind, rain anywhere from 24 hours to several days

E to NE, 30.10 or above and falling rapidly: rain (snow in winter) within 12–24 hours

SE to NE, 30.00 or below and falling slowly: rain 1–2 more days

SE to NE, 30.00 or below and falling rapidly: rain with high wind clearing within 36 hours (colder temperatures follow in winter)

S to SW, 30.00 or below and rising slowly: clearing within hours and fair for several days

S to E, 29.80 or below and falling rapidly: severe storm coming followed by clearing within 24 hours (colder temperatures follow in winter)

E to N, 29.80 or below and falling rapidly: severe gale and heavy precipitation (heavy snow and cold wave in winter) going to W, 29.80 or below and rising rapidly: clearing and colder

Going to W, 29.80 or below and rising rapidly: clearing and colder

THE NATURAL WORLD

If in the least particular one could derange the order of nature,—who would accept the gift of life?

—Ralph Waldo Emerson, "Fate,"
The Conduct of Life (1860)

ANIMALS

AMPHIBIANS
(by order, primitive to modern)

Trachystomata
 Sirens

Gymnophiona
 Caecilians

Urodela or Caudata
 Hynobiidae: Asiatic salamanders
 Cryptobranchidae: giant salamanders
 Sirenidae: sirens and dwarf sirens
 Proteidae: olm
 Necturidae: mud puppies
 Amphiumidae: congo eels
 Salamandridae: salamanders and newts
 Ambystomatidae: mole salamanders
 Plethodontidae: lungless salamanders

Anura
 Leiopelmatidae: primitive frogs
 Discoglossidae: fire-bellied and midwife toads
 Rhinophrynidae: burrowing toads
 Pipidae: tongueless frogs
 Pelobatidea: spadefoots
 Myobatrachidae: terrestrial, arboreal, and aquatic frogs
 Rhinodermatidae: mouth-breeding frogs
 Leptodactylidae: terrestrial neotropical frogs
 Bufonidae: true toads
 Brachycephalidae: terrestrial toads
 Dendrobatidae: arrow-poison frogs
 Pseudidae: fully aquatic frogs

Centrolenidae: leaf frogs
Hylidae: tree frogs
Ranidae: true frogs
Sooglossidae: terrestrial frogs
Microhylidae: narrow-mouthed frogs

ANCIENT CLASSIFICATION OF ANIMALS
(The Greek philosopher Aristotle divided animals into these two groups.)

Animals containing blood	Animals that are bloodless
Birds	Cephalopods
Amphibians	Higher crustaceans
Reptiles	Insects
Fishes	Testaceans (a collection of
Whales	all lower animals)

ANIMAL CLASSIFICATION
(by phylum, simplest to most complex)
Placozoa: simplest animal, no tissues, organs, or symmetry
Porifera: sponges
Mesozoa: mesozoans
Cnidaria/Coelenterata: true jellyfish, corals, sea anemones, coelenterates
Ctenophora: comb jellies, sea gooseberries
Platyhelminthes: flatworms, flukes, tapeworms
Nemertea: ribbon worms, proboscis worms
Introverta: filter feeders (includes Acanthacephala and Kinorhyncha)
Aschelminthes: rotifers, nematodes
Gastrotricha: gastrotrichs
Nematoda: nematodes, roundworms
Nematomorpha: horsehair worms, Gordian worms
Rotifera: rotifers, wheel animals

Priapulida: priapulids
Annelida: annelids, segmented worms, earthworms, leeches
Tardigrada: water bears, tardigrades
Onychophora: velvet worms, onychophorans
Arthropoda
 Insecta: insects
 Chilopoda: centipedes
 Diplopoda: millipedes
 Crustacea: crustaceans
 Arachnida: spiders
Mollusca: mollusks, gastropods, bivalves, cephalopoda
Bryozoa: moss animals
Phoronida: horseshoe worms, phoronids
Brachiopoda: lamp shells
Sipuncula: peanut worms
Chaetognatha: arrow worms
Echiura: spoon worms
Echinodermata: echinoderms, starfish, sea urchins,
 sea cucumbers
Hemichordata: hemichordates
Pogonophora: beard worms
Chordata: chordates
 Tunicata: sea squirts, appendicularians, thaliaceans
 Cephaldochordata: amphioxus, lancelet
 Vertebrata: vertebrates
 Cyclostomata/Agnatha: jawless fish
 Chondrichthyes: cartilaginous fish
 Osteichthyes: bony fish
 Amphibia: amphibians
 Reptilia: reptiles
 Aves: birds
 Mammalia: mammals

ANTS

(phylum Arthropoda, class Insecta, order Hymenoptera,
superfamily Vespoidea, family Formicidae)
Cerapachyinae
Dolichoderinae
Dorylinae
Formicinae
Leptanillinae
Myrmeciinae
Myrmicinae
Ponerinae
Pseudomyrmecinae
Sphecomyrminae

BEES

Bee Colony Hierarchy

Queen bee: fertile mated female that lays
 all the eggs
Drones: males that fertilize the queen
Workers: sterile females that do all the work
 Hive workers: stay and work in the hive
 Foragers: go to the flowers to get food for the colony

Bee Families

(phylum Arthropoda, class Insecta, order Hymenoptera,
suborder Apocrita, superfamily Apoidea)
Adrenidae; burrowing bees
Anthophoridae; mining bees
Apidae; bumblebees, digger bees, cuckoo bees, honeybees
Colletidae; plasterer bees, yellow-faced bees
Halictidae; mining bees
Megachilidae; leaf-cutter bees
Meliponidae Melittidae; melittids
Oxaeidae; large, fast-flying bees that resemble Adrenidae

BIRDS *(arranged based on the work of the biologist Carolus*
Linnaeus [1707–1778]; by order, family; common name)
Struthioniformes, Struthionidae; ostrich
Rheiformes, Rheidae; rheas
Casuariiformes
 Casuariidae; cassowaries
 Dromaiidae; emu
Apterygiformes, Apterygidae; kiwis
Tinamiformes, Tinamidae; tinamous
Sphenisciformes, Spheniscidae; penguins
Gaviformes, Gaviidae; divers and loons
Podicipediformes, Podicipedidae; grebes
Procellariiformes
 Diomedeidae; albatrosses
 Procellariidae; petrels and fulmars
 Hydrobatidae; storm petrels
 Pelecanoididae; diving petrels
Pelecaniformes
 Pelecanidae; pelicans
 Sulidae; gannets and boobies
 Phaethontidae; tropicbirds
 Phalacrocoracidae; cormorants
 Fregatidae; frigatebirds
 Anhingidae; darters
Ciconiiformes
 Ardeidae; herons and bitterns
 Scopidae; hammerhead
 Balaenicipitidae; whale-headed stork
 Ciconiidae; storks
 Threskiornithidae; spoonbills and ibises
 Phoenicopteridae; flamingos
Anseriformes
 Anatidae; ducks, geese, and swans
 Anhimidae; screamers

Falconiformes
 Cathartidae; New World vultures
 Sagittariidae; secretary bird
 Pandionidae; osprey
 Falconidae; falcons and caracaras
 Accipitridae; kites, harriers, hawks, eagles, buzzards
Galliformes
 Megapodidae; megapodes
 Cracidae; curassows
 Tetraonidae; grouse
 Phasianidae; pheasants, quails, and partridges
 Numididae; guineafowl
 Meleagrididae; turkeys
Gruiformes
 Mesitornithidae; mesites
 Turnicidae; buttonquails and hemipodes
 Perdionomidae; plains wanderer
 Gruidae; cranes
 Aramidae; limpkin
 Psophiidae; trumpeters
 Rallidae; rails
 Heliornithidae; finfoots
 Rhynochetidae; kagu
 Eurypygidae; sunbittern
 Cariamidae; seriemas
 Otididae; bustards
Charadriiformes
 Charadrii (suborder)
 Jacanidae; jacanas and lily-trotters
 Rostratulidae; painted snipe
 Charadriidae; plovers and lapwings
 Scolopacidae; sandpipers
 Phalaropodidae; phalaropes
 Dromadidae; crab plover

Burhinidae; stonecurlews and thick-knees
Glareolidae; pratincoles and coursers
Thinocoridae; seed snipe
Chionididae; sheathbills
Laridae; gulls
Sternidae; terns and noddies
Rynchopidae; skimmers
Alcae (suborder), Alcidae; auks
Columbiformes
Pteroclididae; sandgrouse
Columbidae; pigeons and doves
Psittaciformes, Psittacidae; parrots, lovebirds,
and cockatoos
Cuculiformes
Musophagidae; turacos
Cuculidae; cuckoos, anis, and roadrunners
Opisthocomidae; hoatzin
Strigiformes
Strigidae; owls
Tytonidae; barn owls
Caprimulgiformes
Caprimulgidae; nightjars and goatsuckers
Podargidae; frogmouths
Aegothelidae; owlet and nightjars
Nyctibiidae; potoos
Steatornithidae; oilbird
Apodiformes
Apodidae; swifts
Hemiprocnidae; crested swifts
Trochilidae; hummingbirds
Coliiformes, Coliidae; mousebirds and colies
Trogoniformes, Trogonidae; trogons
Coraciiformes
Alcedinidae, kingfishers

Todidae; todies
Momotidae; motmots
Meropidae; bee-eaters
Leptosomatidae; cuckoo-rollers
Upupidae; hoopie
Phoeniculidae; woodhoopoes
Bucerotidae; hornbills
Coraciidae; rollers
Piciformes
Galbulidae; jacamars
Bucconidae; puffbirds
Capitonidae; barbets
Indicatoridae; honeyguides
Ramphastidae; toucans
Picidae; woodpeckers
Passeriformes
Eurylaimi (suborder), Eurylaimidae; broadbills
Menurae (suborder)
Menuridae; lyrebirds
Atrichornithidae; scrub-birds
Tyranni (suborder)
Furnariidae; ovenbirds
Dendrocolaptidae; woodcreepers
Formicariidae; antbirds
Tyrannidae; tyrant flycatchers
Pittidae; pittas
Pipridae; manakins
Cotingidae; cotingas
Conopophagidae; gnat eaters
Rhinocryptidae; tapaculos
Oxyruncidae; sharpbill
Phytotomidae; plantcutters
Xenicidae; New Zealand wrens
Philepittidae; sunbird astites

Oscines (suborder)
 Hirundinidae; swallows and martins
 Alaudidae; larks
 Motacillidae; wagtails and pipits
 Pycnonotidae; bulbuls
 Laniidae; shrikes
 Campephagidae; cuckoo-shrikes
 Irenidae; leafbirds
 Prionopidae; helmet shrikes
 Vangidae; vanga shrikes
 Bombycillidae; waxwings
 Dulidae; palmchat
 Cinclidae; dippers
 Troglodytidae; wrens
 Mimidae; mockingbirds
 Muscicapidae (subfamily)
 Prunellidae; accentors
 Turdinae; thrushes
 Timaliinae; babblers
 Sylviinae; Old World warblers
 Muscicapinae; Old World flycatchers
 Malurinae; fairy wrens
 Paradoxornithinae; parrotbills
 Monarchinae; monarch flycatchers
 Orthonychinae; logrunners
 Acanthizinae; Australian warblers
 Rhipidurinae; fantail flycatchers
 Pachycephalinae; thickheads
 Paridae; tits
 Aegithalidae; long-tailed tits
 Remizidae; penduline tits
 Sittidae; nuthatches
 Climacteridae; Australasian treecreepers
 Certhiidae; holartic treecreepers

Rhabdornithidae; Philippine treecreepers
Zosteropidae; white-eyes
Dicaeidae; flowerpeckers
Pardalotidae; pardalotes and diamond eyes
Nectariniidae; sunbirds and spiderhunters
Meliphagidae; honeyeaters
Ephthianuridae; Australian chats
Emberizidae (subfamily)
 Emberizinae; Old World buntings and
 New World sparrows
 Catamblyrhynchinae; plush-capped finch
 Thraupinae; tanagers and honeycreepers
 Cardinalinae; cardinal grosbeaks
 Tersininae; swallow tanagers
 Parulidae; wood warblers
 Vireonidae; vireos and pepper shrikes
 Icteridae; blackbirds
Fringillidae (subfamily)
 Fringillinae; fringilline finches
 Carduelinae; cardueline finches
 Drepanidinae; Hawaiian honeycreepers
 Estrildidae; waxbills
Ploceidae (subfamily)
 Ploceinae; true weavers
 Viduinae; widow birds
 Bubalornithinae; buffalo weavers
 Passerinae; sparrow weavers and sparrows
Sturnidae; starlings
Oriolidae; orioles and figbirds
Dicruridae; drongos
Callaeidae; New Zealand wattlebirds
Grallinidae; magpie larks
Corcoracidae; Australian mudnesters
Artamidae; wood swallows

Cracticidae; bell magpies
Ptilonorhynchidae; bowerbirds
Paradisaeidae; birds of paradise
Corvidae; crows, magpies, and jays

DINOSAURS

(All dinosaurs are grouped into one of two orders based on hip structure; meaning of common name.)
Saurischia (lizard-hipped)
 Sauropodomorphs (lizard feet)
 Theropods (beast feet)
Ornithischia (bird-hipped)
 Marginocephalians (fringed heads)
 Ornithopods (bird feet)
 Thyreophorans (shield bearers)

FISHES

(by class, subclass; common name)
Class Agnatha (jawless fishes)
 Cyclostomata; lampreys and hagfishes
Class Chondrichthyes
 (cartilage skeleton fishes)
 Batoidei; rays, skates, and stingrays
 Selachii; sharks
Class Osteichthyes (bony-skeleton
 fishes)
 Acipenseriformes; sturgeons and
 paddlefishes
 Anguilliformes; eels
 Atheriniformes; flying fishes, needlefishes, garfishes,
 and cyprinodonts
 Characiformes; tetras and piranhas
 Clupeiformes; herrings and anchovies
 Dipnoi; lungfishes

Elopiformes; bonefishes, tarpons, and ladyfish
Gasterosteiformes; sticklebacks, tub snout, and
 sea horses
Ostariophysi; carps, minnows, suckers, and catfishes
Osteoglossiformes; bony tongues and freshwater
 butterfly fish
Paracanthopterygii; toadfishes, trout, perches,
 and codfishes
Perciformes; perches, tunas, and marlins
Pleuronectiformes; flatfishes, flounders, and soles
Polypteriformes; bichirs and reedfishes
Salmoniformes; salmons, trouts, smelts, and whitefishes
Scorpaeniformes; scorpion fishes, rockfishes, redfishes,
 and gunards
Tetraodontiformes; box fishes, puffer fishes,
 ocean sunfishes

INSECTS
(by order; common name)
Blattaria; cockroaches
Coleoptera; beetles and weevils
Collembola; springtails
Dermaptera; earwigs
Diplura; diplurans
Diptera; true flies
Embioptera; web spinners
Ephemeroptera; mayflies
Hemiptera; true bugs
Homoptera; cicadas, hoppers, aphids, and scale insects
Hymenoptera; ants, bees, and wasps
Isoptera; termites and white ants
Lepidoptera; butterflies, moths, and skippers
Mantodea; mantids and mantises
Mecoptera; scorpion flies

Neuroptera; alderflies, dobsonflies, lacewings,
 and snakeflies
Odonata; dragonflies and damselflies
Orthoptera; grasshoppers, locusts, and crickets
Phasmida (Phasmoptera); stick insects, and leaf insects
Phthiraptera; sucking lice, biting lice, book lice,
 and bark lice
Protura; proturans
Siphonaptera; fleas
Strepsiptera; stylopids
Thysanoptera; thrips
Thysanura; bristletails and silverfish
Trichoptera; caddisflies
Zoraptera; zorapterans

MAMMALS
(by complexity of order, family; common name)

Monotremes (egg-laying mammals)
Ornithorhynchidae; platypus
Tachyglossidae; echidna and spiny anteater

Marsupialia (pouched mammals)
Burramyidae; feathertail gliders
Caenolestidae; rat opossums
Dasyuridae; native cats and marsupial mice
Didelphidae; opossums
Macropodidae; kangaroos and wallabies
Myrmecobiidae; numbat
Notoryctidae; marsupial moles
Peramelidae; bandicoots
Petauridae; gliding phalangers
Phalangeridae; phalangers, cuscuses
Phascolarctidae; koala
Tarsipedidae; honey possum

Thylacinidae; Tasmanian wolf
Thylacomyidae; burrowing bandicoots
Vombatidae; wombats

Insectivora (insect eaters)

Chrysochloridae; golden moles
Erinaceidae; hedgehogs
Macroscelididae; elephant shrews
Potamogalidae; otter shrews
Solenodontidae; solenodon and almiqui
Soricidae; shrews
Talpidae; moles
Tenrecidae; tenrecs
Tupaiidae; tree shrews

Chiroptera (bats)

Craseonycteridae; hog-nosed bats/
 butterfly bats
Desmodontidae; vampire bats
Emballonuridae; sheath-tailed and
 sac-winged bats
Furipteridae; smoky bats
Hipposideridae; Old World leaf-nosed bats
Megadermatidae; false vampires
Molossidae; free-tailed bats
Mormoopidae; insectivorous bats
Mystacinidae; New Zealand short-tailed bats
Myzopodidae; Old World sucker-footed bats
Natalidae; funnel-eared bats
Noctilionidae; bulldog bats
Nycteridae; slit-faced and hollow-faced bats
Phyllostomatidae; American leaf-nosed bats
Pteropodidae; Old World fruit bats and flying foxes
Rhinolophidae; horseshoe bats

Rhinopomatidae; mouse-tailed bats
Thyropteridae; disk-wing bats
Vespertilionidae; common bats

Rodentia (gnawing mammals)
Abrocomidae; abrocomes and chinchilla rats
Anomaluridae; scaly-tailed squirrels
Aplodontidae; mountain beaver and sewellel
Bathyergidae; blesmols and African mole rats
Capromyidae; hutias and coypus
Castoridae; beavers
Caviidae; cavies, guinea pigs, and maras
Chinchillidae; chinchillas and viscachas
Cricetidae; field mice, deer mice, voles, and muskrats
Ctenodactylidae; gundis
Ctenomyidae; tuco-tucos
Dasyproctidae; pacas and agoutis
Dinomyidae; pacarana and Branick's paca
Dipodidae; jerboas
Echimyidae; spiny rats and rock rats
Erethizontidae; New World porcupines
Geomyidae; pocket gophers
Gliridae; dormice
Heteromyidae; mice and kangaroo rats
Hydrochoeridae; capybaras
Hystricidae; Old World porcupines
Muridae; Old World rats and Old World mice
Octodontidae; octodonts and degus
Pedetidae; cape jumping hare and springhaas
Petromuridae; rock rat and dassie rat
Rhizomyidae; bamboo rats and African mole rats
Sciuridae; squirrels and chipmunks/marmots
Seleveniidae; jumping dormouse
Spalacidae; mole rats

Thryonomyidae; cane rats
Zapodidae; jumping mice and birch mice

Dermoptera (colugos and flying lemurs)
Cynocephalidae; colugos and flying lemurs

Edentata (toothless)
Bradypodidae; tree sloths
Dasypodidae; armadillos
Myrmecophagidae; anteaters

Hyracoidae (hyrax, dassie)
Procaviidae; African rock hyrax

Lagomorpha (pikas, hares, rabbits)
Ochotonidae; pikas
Leporidae; hares and rabbits

Carnivora (meat eaters)
Canidae; dogs, foxes, wolves, and jackals
Felidae; cats
Hyaenidae; hyenas
Mustelidae; weasels, otters, skunks, and badgers
Otariidae; eared seals and walrus
Phocidae; earless seals
Procyonidae; raccoons
Ursidae; bears and giant pandas
Viverridae; civets, mongooses, and genet

Cetacea (whales and porpoises)
Balaenidae; right whales
Balaenopteridae; rorquals and humpbacks
Delphinidae; dolphins and killer whales
Eschrichtiidae; gray whales

Hyperoodontidae; beaked whales
Monodontidae; beluga and narwhals
Phocoenidae; porpoises
Physeteridae; sperm whales
Platanistidae; river dolphins
Stenidae; long-snouted dolphins

Proboscidea (elephants)
Elephantidae; African and Asian elephants

Pholidata (pangolins)
Manidae; pangolins

Pinnipedia (seals and walruses)
Odobenidae; walrus
Otariidae; eared seal and sea lion
Phocidae; earless seal

Sirenia (dugongs and manatees)
Dugongidae; dugong
Trichechidae; manatees

Perissodactyla (odd-toed hoofed)
Equidae; horses, asses, zebras, and donkeys
Rhinocerotidae; rhinoceroses
Tapiridae; tapirs

Tubulidentata (aardvarks)
Orycteropodidae; aardvarks

Artiodactyla (even-toed hoofed)
Antilocapridae; pronghorn
Bovidae; cattle, goats, sheep, antelopes, and gazelles
Camelidae; camels and llamas

Cervidae; deer
Giraffidae; giraffe, okapi
Hippopotamidae; hippopotamuses
Suidac; pigs
Tayassuidae; peccaries
Tragulidae; chevrotains

Primates (primates)
Callitrichidae; tamarins and marmosets
Cebidae; New World monkeys
Cercopithecidae; Old World monkeys
Cheirogaleidae; dwarf lemurs and lemurs
Daubentoniidae; aye aye
Galagidae; galagos
Hominidae; humans
Hylobatidae; gibbons and siamang
Indriidae; indri, sifaka, and avali
Lemuridae; lemurs
Lepilmuridae; sportive lemurs
Lorisidae; lorises, pottos, and bushbabies
Pongidae; gorilla, chimpanzee, and orangutan
Tarsiidae; tarsiers
Tupaiidae; tree shrews

REPTILES
(order, family; common name)

Chelonia
Carettochelyidae; New Guinea plateless turtle
Cheloniidae; sea turtles
Chelydridae; alligators and snapping turtles
Chelyidae; snake-necked turtles
Dermochelyidae; leatherback turtles
Dermatemydidae; American river turtle
Emydidae; common turtle

Kinosternidae; mud and musk turtles
Pelomedusidae; side-necked turtles
Platysternidae; big-headed turtles
Testudinae; tortoises
Trionychidae; soft-shelled turtles

Crocodilia
Alligatoridae; alligators and caimans
Crocodilidae; true crocodile
Gavialidae; gavial and gharial

Rhynchocephalia
Sphenodontidae; tuatara

Squamata
Amphisbaenia (suborder)
 Amphisbaenidae; worm lizards
Sauria (suborder)
 Agamidae; agamid lizard
 Anguidae; glass and alligator
 lizards

 Anniellidae; California legless
 lizards
 Chameleontidae; Old World chameleons
 Cordylidae; girdle-tailed lizards
 Dibamidae; burrowers
 Gekkonidae; geckos
 Helodermatidae; gila monster and bearded lizard
 Iguanidae; iguanas
 Lacertidae; Old World terrestrial lizards
 Lanthanotidae; earless monitor lizard
 Pygopodidae; flap-footed lizards
 Scincidae; skinks
 Teiidae; whiptail lizards

Varanidae; monitor lizards
Xantusiidae; night lizards
Xenosauridae; platyceps
Serpentes (suborder)
Acrochordidae; wart snakes
Boidae; pythons, boas, and woodsnakes
Colubridae; terrestrial, arboreal, and aquatic snakes
Elapidae; cobras and coral snakes
Hydrophiidae; sea snakes
Letotyphlopidae; slender blind snakes
Typhlopidae; blind and worm snakes
Uropeltidae; shieldtail snakes
Viperidae; vipers, rattlesnakes, and moccasins
Xenopeltidae; sunbeam snake

WHALES
(largest to smallest)

Blue	avg. 80 feet
Finback	59–88 feet
Bowhead	50–60 feet
Right	50–54 feet
Sperm	50–60 feet
Humpback	39–52 feet
Gray	45–50 feet
Sei	39–52 feet
Bryde's	45–55 feet
Orca or killer whale	27–33 feet
Minke	25–30 feet
Beluga	15 feet
Narwhal	11–16 feet

BIOLOGY

BIOLOGICAL CLASSIFICATION *(extended taxonomy with capitalization guide; intermediate taxonomic levels created between each by using the prefixes* super-, sub-, *and* infra-*)*

Domain
Kingdom
 Subkingdom
Phylum
 Subphylum
 Superclass
Class
 Subclass
 Infraclass
 Cohort
 Superorder
Order
 Suborder
 Superfamily (suffix -oidea)
Family (suffix -idae)
 Subfamily (suffix -inae)
 Tribe (suffix -ini)
Genus
 Subgenus
Species
 Subspecies

BIOLOGICAL SCIENCES

Biology
Anatomy (structure of animals)
 Cytology (cells)
 Gnotobiosis (organisms or conditions free of germs)
 Histology (tissues)

Microbiology (microscopic organisms)
 Bacteriology (bacteria)
 Virology (viruses)
Morphology (form and structure of organisms)
Organology (organs)
Artificial biology (advancement of technology)
Biochemistry (biology within the context of chemistry)
Bioecology (interrelations of organisms with environment)
 Limnology (bodies of freshwater)
 Marine biology (bodies of salt water)
 Parasitology (parasites)
 Synecology (relations between natural communities and
 environments)
 Biometry (calculations of human life)
Biophysics (physics applied to biological problems)
Ecology (relations between organisms and environment)
Embryology (formation and development of organisms)
Eugenics (improving species or breeds)
Evolution (changes in the gene pool through generations)
Exobiology (potential life beyond earth's atmosphere)
Genetics (study of heredity)
Molecular biology (DNA, RNA)
Ontogeny (development of an orgnism)
Physiology (processes and functioning of organisms)
 Biodynamics (energy of living organisms)
 Biostatistics (statistics in biological and medical data)
Population biology (study of interbreeding in native population)
 Biogeography (distribution of plants, animals)
 Population genetics (hereditary makeup of populations)
Taxonomy (classification)

Botany

Applied botany
 Agriculture
 Forestry

Hydroponics (plant cultivation in liquid)
Plant breeding
Pomology (fruit growing)
Research botany
Algology (algae)
Agronomy (crop production)
Bacteriology (bacteria)
Bryology (bryophytes)
Dendrology (trees and shrubs)
Economic botany (study of plants for profit)
Genetics (study of heredity)
Geobotany (geographic distribution of plants)
Horticulture (cultivated plants)
Mycology (fungi)
Paleobotany (fossil plants)
Palynology (pollen and spores)
Phycology (algae)
Plant anatomy (cell and tissues)
Plant cytology (plant cells)
Plant ecology (relations between plants, environment)
Plant geography (distribution of plants)
Plant morphology (external structure of plants)
Plant pathology (plant disease)
Plant physiology (functions of plants)
Plant taxonomy (classification of plants)
Pteridology (ferns and related plants)

Medicine
Medical specializations
Anesthesiology (pain relief)
Aviation medicine (disorders due to flight)
Cardiology (heart)
Chemotherapy (treatment of cancer)
Dentistry (teeth)

Dermatology (skin)
Diagnostic medicine (causes of disease)
Epidemiology (epidemics)
Geriatrics (old age)
Gastroenterology (alimentary tract)
Hematology (blood)
Hygiene (cleanliness)
Immunology (immune system)
Intensive care (life-threatening disease or injury)
Internal medicine (internal organ systems)
Nephrology (kidneys)
Neurology (nervous system)
Obstetrics and Gynecology (childbirth and female reproductive)
Oncology (cancer)
Opthamology (vision)
Orthopedics (skeletal system)
Osteopathy (manipulation of muscles and bones)
Otalarynology (head and neck)
Palliative care (symptom relief)
Pathology (diseases)
Pediatrics (children)
Pharmacology (drugs)
Physiotherapy (therapy employing physical agents)
Plastic surgery (repair of structural defects)
Proctology (rectum, anus, colon)
Psychiatry (mental illness)
Psychology (mental health)
Pulmonology (respiratory)
Radiology (radiologic imaging)
Rheumatology (joints)
Space medicine (effects of space flight)
Surgery (operative procedures)
Urology (urinary and reproductive organs)
Toxicology (poisons)

Zoology

Applied zoology

 Animal genetics (heredity in animals)

 Apiculture (beekeeping)

 Veterinary medicine (medical treatment of animals)

 Wildlife management (maintaining desirable populations of wildlife)

Research zoology

 Apiology (bees)

 Arachnology (spiders)

 Cetology (marine mammals)

 Comparative anatomy (anatomical features of different animals)

 Comparative physiology (functional features of different animals)

 Conchology (shells of mollusks)

 Embryology (formation and development of animals)

 Entomology (insects)

 Ethology (animal behavior)

 Helminthology (worms, especially parasitic)

 Herpetology (reptiles and amphibians)

 Ichthyology (fishes)

 Malacology (mollusks)

 Mammalogy (mammals)

 Myrmecology (ants)

 Ornithology (birds)

 Parasitology (parasites)

 Plankology (plankton)

 Paleozoology (multicellular animal remains)

 Primatology (primates)

 Protozoology (earliest forms)

 Zoogeography (geographical distribution of animals)

CELLS
Animal Cell

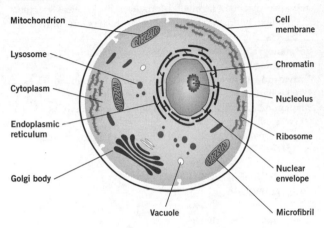

Mitochondrion

Lysosome

Cytoplasm

Endoplasmic reticulum

Golgi body

Cell membrane

Chromatin

Nucleolus

Ribosome

Nuclear envelope

Microfibril

Vacuole

Plant Cell

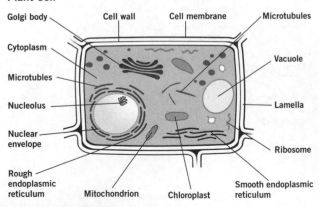

Golgi body

Cytoplasm

Microtubles

Nucleolus

Nuclear envelope

Rough endoplasmic reticulum

Cell wall

Mitochondrion

Cell membrane

Chloroplast

Microtubules

Vacuole

Lamella

Ribosome

Smooth endoplasmic reticulum

CLASSIFICATION OF TYPES OF HIBERNATION OR INACTIVITY

Diapause: a state of metabolic dormancy that requires specific stimuli to be triggered and released, which occurs only in insects

Dormancy: a period when development is temporarily suspended

Estivation (aestivation): a state of dormancy similar to hibernation, except it occurs in the summer

Suspended animation: similar to hibernation, but induced artificially

Torpor: regulated hypothermia for less than a day, often used by birds

DURATION OF GESTATION (PREGNANCY)

Elephant	660 days
Rhinoceros	560 days
Camel	406 days
Horse	330 days
Cow	285 days
Human	275 days
Chimpanzee	237 days
Goat	151 days
Sheep	144 days
Pig	114 days
Dog	61 days
Cat	61 days
Rabbit	31 days
Mouse	20 days
Opossum	13 days

FIVE KINGDOMS OF LIVING THINGS

Animals

Fungi

 Mildews

 Molds

 Mushrooms

 Yeasts

Monera

 Bacteria

 Blue-green algae

Plants

Protists

 Amoeba

 Diatoms

 Euglena

 Paramecium

MITOSIS PHASES

(Mitosis is cell division in which the nucleus divides into nuclei containing equal numbers of chromosomes.)

Prophase: strands of chromatin form into chromosomes

Metaphase: chromosomes line up

Anaphase: chromosomes move to opposite ends of the nuclear spindle

Telophase: two groups of chromosomes form two new nuclei

ORGANISM STRUCTURE

(Some living things do not have organs and are single-celled.)

Cell: made of protoplasm

Tissue: made of cells

Organ: made of tissues

System: made of organs

Organism: made of systems

PLANKTON CLASSIFICATION *(These small animals are measured in microns; 1 micron = 1 millionth of a meter.)*

Picoplankton: less than 5 microns in size (88% of euphotic layer chlorophyll)

Nanoplankton: 5–50 microns (protozoans)

Microplankton: 50–500 microns (invertebrate eggs and larvae)

Mesoplankton: 500–5,000 microns (1 mm to 1 cm in length)

Macroplankton: 5,000–50,000 microns (copepods)

Megaloplankton: larger than 50,000 microns (large jellyfish)

ECOLOGY

AREAS OF STUDY

Applied ecology (problem solving)

Biogeochemistry (cycles of matter and energy)

Chemical ecology (biological chemicals)

Community ecology (collective properties of organisms in an area)

Conservation ecology (species extinction)

Ecological succession (vegetation change)

Ecophysiology (abiotic enviornments)

Ecosystem ecology (regulation of energy flow and material in ecosystems)

Landscape ecology (interactions within environment)

Macroecology (large-scale phenomena)

Marine ecology (water ecology)

Microbial ecology (microorganisms)

Microecoogy (small-scale phenomena)

Paleoecology (fossils)

Physiological ecology (interactions between individual organisms and environment)

Population biology (regulation of population growth and population size, and interactions among populations

Soil ecology (earth)

Urban ccology (urban areas)

BIOSPHERE

Biosphere: total assemblage of plants, animals, and other living things on earth

Biome: large biogeographical area containing plants and animals adapted to survive there

Ecosystem: distinct area of interacting living organisms and their surroundings, e.g., forest; largest ecosystems are called biomes, e.g., rain forests and deserts

Habitat (address): natural home of a group of plants and animals, also known as community

Species: group of living things that can breed together in the wild and produce offspring

Flora: vegetation of a particular area

Niche (profession): the role of a living thing within an ecosystem (where it lives, what it absorbs or eats, how it behaves, how it relates to other living things)

BIOSPHERE LEVELS

(highest to lowest)

Biosphere: region of the surface and atmosphere where living organisms exist

Ecosystems: complex of a community of organisms and its environment functioning as an ecological unit

Communities: an interacting population of various kinds of individuals, i.e., species

Populations: species

Organisms
 Organ systems
 Organs
 Tissues

Cells

Molecules

Atoms and energy

FOOD CHAIN
Producer
Consumer
Herbivore
Carnivore
Omnivore
Decomposer

FOOD WEB
*(A food web is a community of organisms where there
are several interrelated food chains.)*
Producers: water plants and plant plankton
Predators: the herbivores (plant eaters) such as animal
plankton, snails, insects, and some fish
Predators: the carnivores (meat eaters) such as insects, fish,
and mammals

TROPHIC LEVELS PYRAMID
*(Trophic levels are steps on a food chain or food pyramid
of a community of organisms; trophic level is based on the
numbers or mass of living things at the same level in a food
web or on the amount of energy stored by a group of living
things at one level.)*
Trophic level 1: plants, flowers, fungi
(producers)
Trophic level 2: animals, butterflies, worms
(primary consumer)
Trophic level 3: reptiles, arthropods, birds
(secondary consumer)
Trophic level 4: owl, fox, weasel
(tertiary consumer)
Trophic level 5: millipedes, woodlice, dung beetles
(decomposers)

EVOLUTION

EVENTS

Earth formed	4.6 billion years ago
First life	4 billion years ago
First animals	570 million years ago
Crustaceans	570 million years ago
Fossils formed	570 million years ago
First plants	505 million years ago
Fish	450 million years ago
Land plants	438 million years ago
Amphibians	360 million years ago
Seed plants	360 million years ago
Mammals	354 million years ago
Insects	350 million years ago
Reptiles	280 million years ago
Birds	144 million years ago
Flowering plants	144 million years ago
Human ancestors	5.3 million years ago
Homo sapiens	200,000 years ago

HOMINID DEVELOPMENT

Sehelanthropus (6 to 7 million years ago)
Ardipithecus kadabba (5.2 to 5.8)
Ardipithecus ramidus (4.4 to 4.5)
Australopithecus anamensis (4.2 to 3.9)
Australopithecus afarensis (3.7 to 2.6)
Australopithecus africanus (3.3 to 2.4)
Australopithecus boisei (2.5 to 1.3)
Australopithecus robustus (1.9 to 1.6)
Homo habilis (2 to 1.8)
Homo georgicus (1.8 to 1.6)
Homo erectus (1.6 to 0.4)
Homo ergaster (1.9 to 1.4)

Homo antecessor (1.2 to 0.8)
Homo sapiens (0.4 to 0.125)
Homo sapiens neanderthalensis (0.125 to 0.030)
Homo florensiensis (.09 to .018)
Homo sapiens sapiens (.2 to present)

HUMAN LIFE

BLOOD PRESSURE LEVELS

Diastolic (minimum during cardiac cycle)
Normal: less than 85 millimeters of mercury (mm Hg)
High normal: 85–89
Mild hypertension: 90–104
Moderate hypertension: 105–114
Severe hypertension: 115+

Systolic (ventricle contraction)
(when diastolic is less than 90)
Normal: less than 140
Borderline isolated systolic hypertension: 140–159
Isolated systolic hypertension: 160+

BONE FRACTURE SEVERITY SCALE
(from mildest to worst)
Hairline: bone splits in a line, often lengthwise
Pathological: caused by disease
Greenstick: incomplete, often lengthwise
Fatigue: bone splits
Depressed: bone splits, is pushed inward
Simple (closed): bone snaps, does not break skin
Comminuted (multi-fragmented): part of bone shattered
Compound or open fracture: broken bone pushes through
 skin

BRAIN WAVES

(Brain waves have been grouped according to their frequencies and labeled with Greek letters.)

Gamma (26–100 hertz): certain cognitive and motor functions

Beta (13–30 hertz): alert and awake

Alpha (8–13 hertz): awake but relaxed, meditative

Theta (4–8 hertz): drowsy, alert, or aroused

Delta (1–4 hertz): deep, dreamless sleep

BURN DEGREES

First-degree: affects epidermis; as from sunburn, steam

Second-degree: affects dermis; from scalding water, holding hot metal

Third-degree: full layer of skin destroyed; fire burn

CHOLESTEROL CLASSIFICATION

High-density lipoprotein (HDL; "good" cholesterol)

Low-density lipoprotein (LDL; "bad" cholesterol)

CHOLESTEROL LEVELS

(ratios of total cholesterol to high-density lipoprotein levels in blood)

240 milligrams/deciliter (mg/dL) and above: high

200–239 mg/dL: medium

Less than 200 mg/dL: desirable level

HIGH-DENSITY LIPOPROTEIN (HDL)

(also known as good cholesterol)

60 mg/dL and above: high HDL cholesterol, considered protective against heart disease

Less than 40 mg/dL (for men), less than 50 mg/dL (for women): low HDL cholesterol, a major risk factor for heart disease

DAILY CALORIC EXPENDITURE

(calories burned per hour in various activities;
by a man, woman)

Sleeping	65, 55
Sitting	90, 70
Standing	120, 100
Walking (2 mph)	228, 183
Walking (3.5 mph)	346, 277
Running (8 mph)	1,229, 986

One Day's Energy Expenditures

8 hours of sleep	480 calories
8 hours of moderate labor	1,200 calories
4 hours of reading, writing, watching TV	320 calories
1 hour of heavy exercise	450 calories
3 hours for dressing, eating	300 calories

DRUGS

(addiction potential)

Nicotine	100.0%
Methamphetamine smoked	98.5%
Crack	97.6%
Methamphetamine snorted	94.0%
Valium (diazepam)	85.6%
Alcohol	81.8%
Heroin	81.8%
Cocaine	73.1%
Caffeine	72.0%
Marijuana	21.1%
Ecstasy (MDMA)	20.1%
Psilocybin mushrooms	17.1%
LSD	16.7%

EYE CHART

(The Snellen chart, placed at a standard distance of twenty feet in the U.S., measures visual acuity in fraction values.)

E	1	20/200
F P	2	20/100
T O Z	3	20/70
L P E D	4	20/50
P E C F D	5	20/40
E D F C Z P	6	20/30
F E L O P Z D	7	20/25
D E F P O T E C	8	20/20
L E F O D P C T	9	20/15
F D P L T C E O	10	20/13
P E Z O L C F T D	11	20/10

HUMAN BRAIN

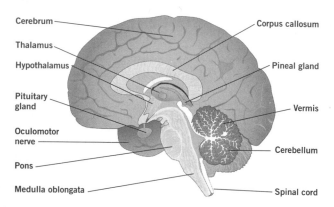

Cerebrum

Thalamus

Hypothalamus

Pituitary gland

Oculomotor nerve

Pons

Medulla oblongata

Corpus callosum

Pineal gland

Vermis

Cerebellum

Spinal cord

HUMAN HEART

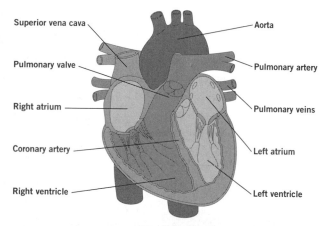

Superior vena cava

Pulmonary valve

Right atrium

Coronary artery

Right ventricle

Aorta

Pulmonary artery

Pulmonary veins

Left atrium

Left ventricle

HUMAN SKELETON

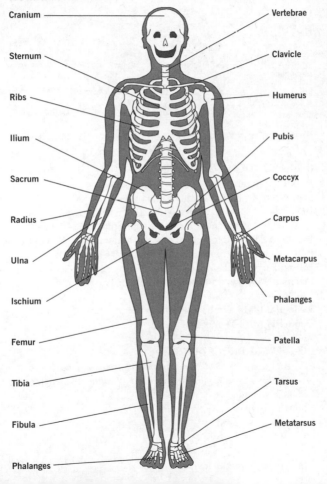

Cranium

Sternum

Ribs

Ilium

Sacrum

Radius

Ulna

Ischium

Femur

Tibia

Fibula

Phalanges

Vertebrae

Clavicle

Humerus

Pubis

Coccyx

Carpus

Metacarpus

Phalanges

Patella

Tarsus

Metatarsus

HUMAN SKULL

Frontal bone

Sphenoid bone

Eye socket

Nasal bone

Zygomatic bone

Maxilla

Mandible

Parietal bone

Temporal bone

Zygomatic arch

Styloid process

Occipital bone

Mastoid process

IMMUNIZATION SCHEDULE

Hepatitis B: birth, 1–2 months, 6–18 months

Rotavirus: 2 months, 4 months, 6 months

DtP: 2 months, 4 months, 6 months, 15–18 months, 4–6 years

HiB: 2 months, 4 months, 6 months (optional), > 12–15 months

Pneumoncoccal: 2 months, 4 months, 6 months, 12–15 months

Polio: 2 months, 4 months, 6–18 months, 4–6 years

Influenza: yearly, 6–59 months

Measles, Mumps, and Rubella (MMR): 12–15 months,
 4–6 years

Varicella: 12–15 months, 4–6 years

Hepatitis A: 12–23 months

LIFESAVING PROCEDURES

*(The American Medical Association recommends priority be
given to these when a person is injured or suddenly becomes ill.)*

Maintain breathing

Maintain circulation

Prevent loss of blood

Prevent further injury

Prevent shock

Summon professional medical services

PERIODS OF SLEEP
Light sleep: short irregular periods that buffer the longer periods of deep sleep; stage one
Sleep spindles: spikes of brain waves occur; stage two
Deep sleep: known for slow-wave, or delta, sleep; stages three and four
REM sleep: within deep sleep, time of dreams or "rapid eye movement"; stage five

PHASES OF SEXUAL RESPONSE
(as defined by William Masters and Virginia Johnson in the books Human Sexual Response *and* Human Sexual Inadequacy*)*
Excitement phase (initial arousal)
Plateau phase (at full arousal, but not yet at orgasm)
Orgasmic phase
Resolution phase (after orgasm)

POISON CLASSIFICATION
(Poisons are of such diverse natures that they are classified by origin, physical form, chemical nature, chemical activity, target site, or use.)
Animal
Microbial (produced by bacteria or fungi)
Plant
Synthetic (manufactured chemicals)

POISON TOXICITY RATING SCALE
(according to the Enviromental Protection Agency)
I Highly toxic; marked "Danger Poison"; a few drops to one teaspoon will kill a person
II Moderately toxic; marked "Warning"; one teaspoon to one ounce will kill a person
III Slightly toxic; marked "Caution"; over one ounce will kill a person
IV Not toxic

SENSES CLASSIFICATION

Deep senses: muscle, tendon, joint, deep pain, and pressure
Skin senses: touch, skin pain, temperature
Special senses: vision, hearing, smell, taste, equilibrium
Visceral senses: conveyance of information about organic and
 visceral events

SENSING ORDER OF THE EARS

1. Sound waves are gathered by the ear and passed to the
 auditory canal
2. Sound waves cause eardrum to vibrate
3. Vibrations are passed on and strengthened by the three
 ossicles: malleus (hammer), incus (anvil), and stapes (stirrup)
4. The oval window vibrates, and vibrations pass into the cochlea
5. Vibrations are detected by special cells in the cochlea
6. Vibrations are converted into nerve impulses
7. Information is sent via the auditory nerve to the brain

SENSING ORDER OF THE EYES

1. Light rays pass through cornea, pupil lens, aqueous humor, and
 vitreous humor and are bent and partially focused
2. Iris dilates in dim light and contracts in bright light
3. Light focused onto retina by lens produces an image; rods and
 cones on retinal surface produce nerve signals
4. Optic nerve carries signals to the brain

SENSING ORDER OF THE NOSE

1. Molecules are breathed into the roof of the nasal cavity
2. Molecules dissolved on olfactory membrane made up of
 receptor cells with tiny sensitive "hairs"
3. Scent molecules react with hairs to stimulate nerve impulses
 in receptor cells
4. Factory nerves transmit these signals to olfactory bulbs, then
 via olfactory tracts to other regions of the brain

SKIN LAYERS

Sebaceous gland — Epidermls

Blood vessel — Dermis

Hair follicle — Subcutaneous tissue

Sweat gland

TASTING AREAS OF TONGUE

(Saliva carries food particles to taste buds, which register the different flavors.)

Bitter

Sour

Salty

Sweet

TEETH DEVELOPMENT

Central incisors	6–8 months
Lateral incisors	7–8 months
First molars	1 year
Cuspids (canines)	16 months
Second molars	20–24 months
Second incisors	7–9 years
Cuspids or canines	9–12 years
First and second premolars or bicuspids	10–12 years
Second molars	11–13 years
Third molars (wisdom teeth)	20 years

TOOTH MAP
(diagram on right)

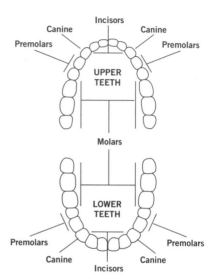

TOOTH INTERIOR

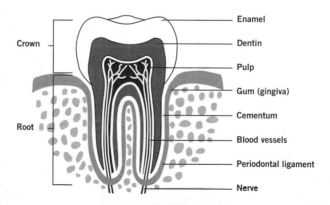

PLANTS AND NONANIMAL ORGANISMS

FLOWER STRUCTURE

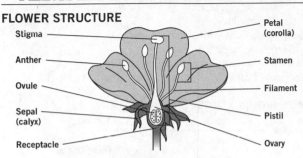

Stigma

Anther

Ovule

Sepal
(calyx)

Receptacle

Petal
(corolla)

Stamen

Filament

Pistil

Ovary

FRUIT CLASSIFICATION

Simple Fruits (from one ovary)

 Dry

 Dehiscent (splitting to emit seeds or spores)

 Capsule (lily, iris)

 Follicle (milkweed, columbine)

 Legume (pea, bean)

 Silique (mustard)

 Silicle (sweet alyssum)

 Indehiscent (not splitting to emit seeds or spores)

 Achene (buttercup, grasses, sunflower, elm, maple)

 Caryopsis (corn)

 Samara (hoptree, elm)

 Schizocarp (carrot, parsnip)

 Loment (radish, sainfoin)

 Nut

 Fleshy

 Berry

 Hesperidium (orange, grapefruit)

 Pepo (watermelon, squash, cucumber)

 True berry (tomato, blueberry)

Drupe (peach, cherry)
Pome (apple, pear)
Hip (rose hips)
Compound Fruits (from multiple ovaries)
 Aggregate (raspberry)
 Multiple (pineapple, mulberry)
Accessory Fruits (from other parts of the flower or stalk)

MUSHROOM STRUCTURE

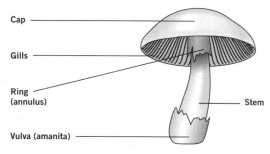

Cap

Gills

Ring
(annulus)

Stem

Vulva (amanita)

NONANIMAL CLASSIFICATION
(simplest to most complex)
Monerans (bacteria, algae, viruses)
Protists (one-celled organisms)
 Algae
 Protozoans
 Slime molds
Fungi
Plants
 Bryophytes (simple nonvascular plants)
 Hornworts
 Liverworts
 Mosses
 Psilotophytes (whisk ferns)

Lycophytes (club mosses and allies)
Sphenophytes (horsetails)
Filicophytes (ferns)
 Filicopsids (thin-walled sporangia, more strengthening tissues)
 Marattiopsids (terrestrial with huge sporangia)
 Ophioglossopsids (adder's tongue ferns)
Conifers (cone-bearing trees)
Ginkgos (ginkgo and maidenhair trees)
Cycads (gymnosperms)
Gnetophytes
Angiosperms (flowering plants)
 Liliopsids (monocots)
 Magnoliopsids (dicots)

PLANT TAXONOMY
(with suffixes)

Kingdom	Family (-aceae)	Series
Division (-phyta)	Subfamily (-oideae)	Subseries
Subdivision	Tribe (-eae)	species
(-phytina)	Subtribe (-inae)	subspecies
Class (-opsida)	Genus	variety
Subclass (-idae)	Subgenus	subvariety
Order (-ales)	Section	form
Suborder (-ineae)	Subsection	subform

POISONOUS PLANTS
(common species by toxicity level; toxicity may refer just to parts of plant, such as seeds, juice, sap, or thorns)

Extremely Toxic

Castor bean	Cocklebur	Yew
White snakeroot	Pigweed	Red maple
Senecio, ragwort	Jimson weed	Easter lily
Water hemlock	Johnson grass	Oleander
Poison hemlock	Cherry	Rosary pea

Moderately Toxic

Dumbcane (Aroid family)
Bulbs
Lupine
Rhubarb
Azalea, rhododendron
Oats
Ergot
Fescue
Yellow, white sweetclover
Tobacco
Larkspur

Brackenfern
Green false hellebore
Milkweed
Horsetail
Mustards
Spurges
Nightshades
Buckeye, horsechestnut
Black walnut
Red oak
Black locust

Minimally Toxic

Foxtail barley
Common burdock
English ivy
Catnip
Poinsettia, Christmas plant
Tansy
Alsike clover
Jack-in-the-pulpit

Dutchman's breeches
Buttercups
Stinging nettle
Marijuana
St. John's wort
Star of Bethlehem
Pokeweed

ROOT STRUCTURES

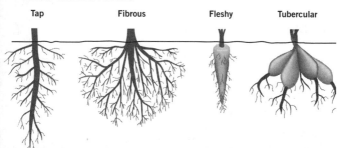

Tap Fibrous Fleshy Tubercular

TREES

COMMON LEAF SHAPES AND MARGINS

Linear	Oblong	Elliptic	Ovate	Obovate
Lanceolate	Spatulate	Orbicular	Deltoid	Reniform
Hastate	Cordate	Sagittate	Peltate	Perfoliate
Palmate	Odd-Pinnate	Even-Pinnate	Bipinnate	Trifoliate
Entire	Crenate	Serrate	Lobed	Parted

TREE CLASSIFICATION
(by method of reproduction)

Angiosperms (flowering, broad-leaved trees)

monocotyledons
 (one-seed leaf; palms, aloes, yuccas)
dicotyledons (two-seed leaf)
 Amentiferae (catkin-bearing trees)
 Fagaceae (beech, chestnut, oak)
 Betulaceae (birch, alder, hornbeam, hazel)
 Leitneriaceae (corkwood)
 Myricaceae (sweet gale, bayberry)
 Juglandaceae (walnut, hickory, pecan)
 Salicaceae (willow, poplar, aspen, cottonwood)
 Floriferae (flower-bearing trees)
 Apetalous (lacking petals)
 Ulmaceae (elm, hackberry)
 Moraceae (mulberry, osage orange, fig)
 Sympetalous/Gamopetalous
 (petals united in a tube)
 Oleaceae (olive, ash)
 Ebenaceae (persimmon)
 Ericaceae (sourwood)
 Polypetalous (many-petaled flowers)
 Rosaceae (apples, pears, peaches, plums)
 Hippocastanaceae (buckeye)
 Cornaceae (dogwood)
 Aquifoliaceae (holly)
 Lauraceae (laurel, sassafras)
 Leguminosae (locust)
 Magnoliaceae (magnolia, tulip tree)
 Meliaceae (mahogany)
 Aceraceae (maple)
 Platanaceae (sycamore)
 Hamamelidaceae (witch hazel, red gum)

Gymnosperms (cone-bearing)
Coniferales (conifers)
 Cupressaceae (cedar and cypress)
 Pinaceae (pine, larch, spruce, fir, hemlock,
 Douglas fir)
 Taxodiaceae (redwood, sequoia, bald cypress)
 Taxaceae (yew)
Cycadales (cycads)
Gnetales (desert shrubs, woody climbers)
Ginkgoales (ginkgo and maidenhair trees)

Pteridophytes (seedless vascular plants)
Lycopsida (club mosses)
Psilosida (whisk ferns)
Pteropsida (true ferns)
Sphenopsida (horsetails)

Alternative Classification:
Deciduous (loses leaves once during the year)
Evergreen (retains foliage year-round)

LAYERS OF A TREE TRUNK
(inner to outer)
Heartwood (core of inactive cells)
 Pith (spongelike central cylinder)
 Wood ray (vascular portion of xylem)
Sapwood (food for seed production and tree growth)
Annual rings (reveal tree age)
Cambium (cells that produce new layer of bark and wood
 between old bark and wood each year)
Inner bark (carries food made in leaves)
Outer bark (protects tree)

TREE STRUCTURE

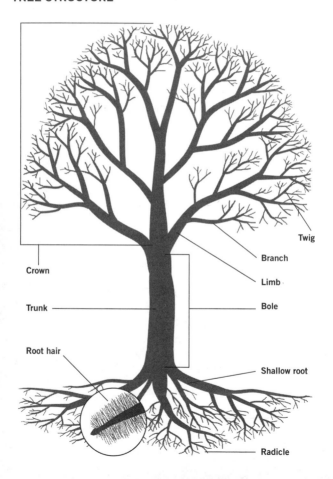

Crown

Trunk

Root hair

Twig

Branch

Limb

Bole

Shallow root

Radicle

WOODY STEM LAYERS

(inner to outer)

Xylem (cells that carry water to leaves)

Cambium (makes phloem and xylem cells)

Phloem (cells carrying food from leaves to roots)

Cortex (food-storing cells)

Cork (dead outer protection)

Heartwood (cell pipes that are discarded and pushed in to form
the tree's core)

Sapwood (cells that form pipes that carry sap)

Cambium (outside generates new bark; inside makes sapwood)

Bark (hard, dead exterior protection)

VEGETABLES

VEGETABLE FAMILIES

Amaryllis (Amaryllidaceae): onion, leek, garlic, shallot, chive

Buckwheat (Polygonaceae): rhubarb, soybean

Carpetweed (Aizoaceae): New Zealand spinach

Composite (Compositae): lettuce, chicory, endive,
dandelion, artichoke

Goosefoot (Chenopodiaceae): beet, chard, spinach

Gourd (Cucurbitaceae): muskmelon, watermelon, pumpkin,
squash, cucumber

Grass (Gramineae): sweet corn

Lily (Liliaceae): asparagus

Mallow (Malvaceae): okra

Morning glory (Convolvulaceae): sweet potato

Mustard (Cruciferae): mustard, turnip, rutabaga, cabbage,
cauliflower, Brussels sprouts, broccoli, watercress, radish

Nightshade (Solanaceae): potato, tomato, eggplant, peppers

Parsley (Umbelliferae): parsley, carrot, celery, fennel

Pea (Leguminosea): lima bean, pea, broad bean, snap bean

VEGETABLE TYPES

Bulb and stalk vegetables (celery)
Cabbage family (cauliflower)
Leaf vegetables (lettuce, spinach, chard)
Root and tuber vegetables (carrot)
Seed vegetables (beans)
Vegetable fruits (cucumber)

TRANSPORTATION & TECHNOLOGY

There is nothing more perilous to take in hand, more perilous to conduct, or more uncertain in its success, than to take the lead in the introduction of a new order of things.

—Niccolò Machiavelli, *The Prince*

AERONAUTICS

CLOSE ENCOUNTERS
(according to J. Allen Hynek's The UFO Experience:
A Scientific Enquiry*)*
Close encounter of the first kind: sighting of a UFO
Close encounter of the second kind: physical evidence
of UFO or alien
Close encounter of the third kind: contact with UFO
or alien

MERCURY AND APOLLO MISSION SEQUENCE

Mercury Missions
(the manned flights of Project Mercury)
Mercury-Redstone 3: May 5, 1961
Mercury-Redstone 4: July 21, 1961
Mercury-Atlas 6: February 20, 1962
Mercury-Atlas 7: May 24, 1962
Mercury-Atlas 8: October 3, 1962
Mercury-Atlas 9: May 15, 1963

Earth and Lunar Orbital Missions
(the manned flights of the Apollo program)
Apollo 1: January 27, 1967 (unlaunched)
Apollo 7: October 11, 1968
Apollo 8: December 21, 1968
Apollo 9: March 3, 1969
Apollo 10: May 18, 1969

Lunar Landing Missions
Apollo 11: July 16, 1969
Apollo 12: November 14, 1969
Apollo 13: April 11, 1970
Apollo 14: January 31, 1971

Apollo 15: July 26, 1971
Apollo 16: April 16, 1972
Apollo 17: December 7, 1972

SUCCESSFUL MOON MISSIONS
Ranger 7: July 31, 1964, first unmanned hard landing
Surveyor 1: June 2, 1966, first unmanned soft landing
Apollo 11: July 16, 1969, first manned landing, July 20
Apollo 12: November 14, 1969, first precise manned landing on
 the moon, within walking distance of Surveyor 3
Apollo 14: January 31, 1971, including putting on the moon
Apollo 15: July 26, 1971, first mission with the Lunar Rover
 vehicle
Apollo 16: April 16, 1972, first landing in the lunar highlands
Apollo 17: December 7, 1972, final Apollo lunar mission,
 first night launch, only mission to include a professional
 geologist

AIRCRAFT

AIRCRAFT HIERARCHY
(smallest to largest)
Glider
Sailplane
V/STOL (vertical/short takeoff and landing)
STOL (short takeoff and landing)
Civil helicopter
Single-engine piston
Multiengine piston
Multiengine turboprop (airliners of 20–99 seats;
 commuter aircraft)
Multiengine turbofan (business jets)
Commercial turbojet (commercial airliners)

AIR FORCE AIRCRAFT *(smallest to largest)*
Helicopter gunship
Transport helicopter
Fighter
Transport aircraft
Bomber

MACH NUMBERS *(Mach is the ratio of the speed of a moving body to the speed of sound measured in dry air at sea level.)*
Mach 1 = 763.67 mph
Mach 2 = 1,527.3 mph (twice speed of sound)
Mach 3 = 2,291 mph (3 times speed of sound)

ASTRONOMY

ASTEROID IMPACT HAZARD SCALE *(The Torino Scale categorizes the impact hazard of asteroids and comets.)*

0—White, No Hazard: The likelihood of a collision is zero, or is so low as to be effectively zero. Also applies to small objects such as meteors and bodies that burn up in the atmosphere as well as infrequent meteorite falls that rarely cause damage.

1—Green, Normal: A routine discovery in which a pass near the earth is predicted that poses no unusual level of danger. Current calculations show the chance of collision is extremely unlikely with no cause for public attention or public concern. New telescopic observations very likely will lead to reassignment to Level 0.

2—Yellow, Meriting Attention: A discovery, which may become routine with expanded searches, of an object making a somewhat close but not highly unusual pass near the earth. While meriting attention by astronomers, there is no cause for public attention or public concern as an actual collision is very unlikely. New telescopic observations very likely will lead to reassignment to Level 0.

3—Yellow, Meriting Attention: A close encounter, meriting attention by astronomers. Current calculations give a 1% or greater chance of collision capable of localized destruction. Most likely, new telescopic observations will lead to reassignment to Level 0. Attention by public and by public officials is merited if the encounter is less than a decade away.

4—Yellow, Meriting Attention: A close encounter, meriting attention by astronomers. Current calculations give a 1% or greater chance of collision capable of regional devastation. Most likely, new telescopic observations will lead to reassignment to Level 0. Attention by public and by public officials is merited if the encounter is less than a decade away.

5—Orange, Threatening: A close encounter posing a serious but still uncertain threat of regional devastation. Critical attention by astronomers is needed to determine conclusively whether or not a collision will occur. If the encounter is less than a decade away, governmental contingency planning may be warranted.

6—Orange, Threatening: A close encounter by a large object posing a serious but still uncertain threat of a global catastrophe. Critical attention by astronomers is needed to determine conclusively whether or not a collision will occur. If the encounter is less than three decades away, governmental contingency planning may be warranted.

7—Orange, Threatening: A very close encounter by a large object, which if occurring this century, poses an unprecedented but still uncertain threat of a global catastrophe. For such a threat in this century, international contingency planning is warranted, especially to determine urgently and conclusively whether or not a collision will occur.

8—**Red, Certain Collision:** A collision is certain, capable of causing localized destruction for an impact over land or possibly a tsunami if close offshore. Such events occur on average between once per 50 years and once per several thousand years.

9—**Red, Certain Collision:** A collision is certain, capable of causing unprecedented regional devastation for a land impact or the threat of a major tsunami for an ocean impact. Such events occur on average between once per 10,000 years and once per 100,000 years.

10—**Red, Certain Collision:** A collision is certain, capable of causing global climatic catastrophe that may threaten the future of civilization as we know it, whether impacting land or ocean. Such events occur on average once per 100,000 years, or less often.

BRANCHES OF ASTRONOMY

Applied Astronomy
Celestial navigation (for navigation through space using stars)
Nautical astronomy (for navigation in water)

Research Astronomy
Astrometry (measurements of celestial bodies)
Astronautics (navigation through space)
Astrophysics (physical and chemical properties of celestial bodies)
 Celestial mechanics (application of Newton's laws of motion to celestial bodies)
Chronometry (time measurement)
Cosmogony (origin of universe)
Radar astronomy (analysis of the return of radio waves directed at celestial bodies)
Radio astronomy (detection and study of the radio waves emitted by celestial bodies)
Theoretical astronomy (formation and development of the universe)

BIG BANG SEQUENCE

(The Big Bang was a rapid expansion, not a violent explosion.)

1. Gravity separated from three other forces—electromagnetic and the strong and weak nuclear forces (took 10^{43} seconds; before 10^{43} seconds is called Planck time)
2. Strong and weak nuclear forces and electromagnetic force separated (took 10^{10} seconds)
3. Cosmic inflation occurred
4. Quarks combined to form particles (took 10 microseconds)
5. The nuclei of light atoms formed (took 3 minutes)
6. The first true complex atoms formed (took 500,000 years)
7. Gaseous clouds of hydrogen and helium began to condense into protogalaxies and stars (several hundred million to a billion years)

CELESTIAL COORDINATE SYSTEM

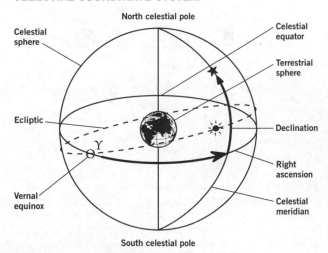

DISTANCES

Astronomical unit/AU = 92,955,630 mi (average distance from
 the earth to the sun)
Light year = 62,240 AU (astronomical units: 993 million miles)
Parsec = 3.26 light years
Kiloparsec = 1,000 parsecs
Megaparsec = 1,000,000 parsecs

EARTH'S MOON

Phases

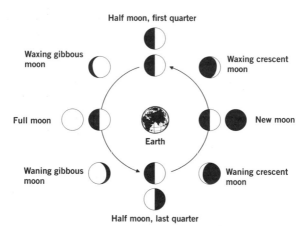

PLANETS *(closest to farthest from the sun, in AU)*

Mercury	.39 AU	Jupiter	5.20 AU
Venus	.72 AU	Saturn	9.54 AU
Earth	1 AU	Uranus	19.18 AU
Mars	1.52 AU	Neptune	30.06 AU

Planets by Size *(diameter in miles)*

Jupiter	88,700	Earth	7,921
Saturn	74,000	Venus	7,700
Uranus	32,500	Mars	4,220
Neptune	30,700	Mercury	3,032

SATELLITES (MOONS) AND RINGS
(closest to farthest from respective planet, with year of first observation)

Jupiter's Satellites
(Jupiter has nearly fifty more small satellites in its orbit.)
Inner satellites
Metis (1980) Amalthea (1892)
Adrastea (1980) Thebe (1980)
Galilean satellites
Io (1610) Ganymede (1610)
Europa (1610) Callisto (1610)
Outer satellites
Leda (1974) Ananke (1951)
Himalia (1904) Carme (1938)
Lysithea (1938) Pasiphae (1908)
Elara (1905) Sinope (1914)

Mars's Satellites
Deimos (1877)
Phobos (1877)

Neptune's Rings
Galle Ring
Le Verrier Ring
Lassell Ring
Argo Ring
Galatea Ring
Adams Ring

Neptune's Satellites

Naiad (1989)

Thalassa (1989)

Despina (1989)

Galatea (1989)

Larissa (1989)

Proteus (1989)

Triton (1846)

Nereid (1949)

Halimede (2002)

Sao (2002)

Laomedeia (2002)

Psamathe (2003)

Neso (2002)

Saturn's Rings *(major subdivisions)*

Saturn radius
 D Ring inner edge
 C Ring inner edge, outer edge
 B Ring inner edge, outer edge
Cassini division
 A Ring inner edge, outer edge
 Roche Division
 F Ring center
 Janus/Epimethus Ring
 G Ring center
 Pallene Ring
 E Ring inner edge, outer edge

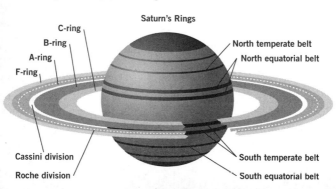

Saturn's Rings

C-ring
B-ring
A-ring
F-ring

North temperate belt
North equatorial belt

Cassini division
Roche division

South temperate belt
South equatorial belt

Saturn's Satellites *(There are approximately 40 more small confirmed and unconfirmed satellites.)*

Pan (1990)

Atlas (1980)

Prometheus (1980)

Pandora (1980)

Epimetheus (1980)

Janus (1966)

Mimas (1789)

Enceladus (1789)

Tethys (1684)

Telesto (1980)

Calypso (1980)

Dione (1684)

Helene (1980)

Polydeuces (2004)

Rhea (1672)

Titan (1655)

Hyperion (1848)

Iapetus (1671)

Phoebe (1898)

Uranus's Rings

Uranus radius

1986 U2R edge

6 center

5 center

4 center

Alpha center

Beta center

Eta center

Gamma center

Delta center

Lambda center/1986 U1R

Epsilon center

Uranus's Satellites

Cordelia (1986)

Ophelia (1986)

Bianca (1986)

Cressida (1986)

Desdemona (1986)

Juliet (1986)

Portia (1986)

Rosalind (1986)

Belinda (1986)

1986 UIO (1986)

Puck (1985)

2003 U1 (2003)

Miranda (1948)

Ariel (1851)

Umbriel (1851)

Titania (1787)

Oberon (1787)

2001 U3 (2003)

Caliban (1997)

Stephano (1999)

Sycorax (1997)

2003 U3 (2003)

Prospero (1999)

Setebos (1999)

2002 U2 (2003)

SPACE LAYERS AROUND EARTH

Earth's atmosphere: approx. 100 miles
Cislunar space: approx. 24,800–240,000 miles above earth
Translunar space: approx. 761,000 miles above earth
Interplanetary space: approx. 1 trillion miles above earth
Interstellar space: approx. 1 quintillion miles above earth
Intergalactic space: reaches to infinity

BRIGHTEST STARS IN THE NIGHT'S SKY

(most to least, with constellation)
Sirius
 (Canis Major)
Canopus
 (Carina)
Arcturus
 (Boötes)
Alpha Centauri
 (Centaurus)
Vega
 (Lyra)
Capella
 (Auriga)
Rigel
 (Orion)
Procyon
 (Canis Major)
Achernar
 (Eridanus)
Betelgeuse
 (Orion)
Beta Centauri
 (Centaurus)

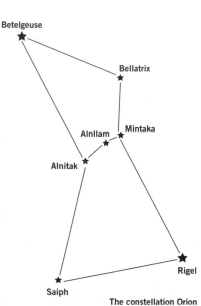

The constellation Orion

STAR BRIGHTNESS AND MAGNITUDE
(brightest to dimmest)
0: Extremely luminous supergiant star
Ia: Luminous supergiant
Ib: Lower luminosity supergiant
II: Bright giant
III: Ordinary giant
IV: Subgiant
V: Dwarf
VI: Subdwarf

STAR DISTANCES FROM THE EARTH *(in light years)*

Proxima Centauri	4.22
Alpha Centauri	4.35
Barnard's Star	5.98
Wolf 359	7.75
Lalande 21185	8.22
Luyten 726.8	8.43
Sirius	8.65
Ross 154	9.45
Ross 248	10.40
Epsilon Eridani	10.80

STAR TEMPERATURE CLASSIFICATION
(warm to cool; each spectral type is subdivided into 10 grades or subclasses, from 0 [early] to 9 [late]; luminosity may also be classified from I to VII)
O: super-hot blue star, 25,000 degrees Kelvin
B: hot blue star, 11,000–25,000
A: blue-white star, 7,500–11,000
F: white star, 6,000–7,500
G: yellow star (Sun is G2), 5,000–6,000
K: orange star, 3,500–5,000
M: cool red star, 3,500

STAR TYPES
(largest to smallest)

Red supergiant: 400 times larger and 15,000 times brighter than the sun

Blue-white giant: 80 times larger and 60,000 times brighter than the sun

Yellow giant: 16 times larger and 150 times brighter than the sun

Yellow dwarf: same size as the sun

Red dwarf: $\frac{1}{10}$ the size of the sun

White dwarf: $\frac{1}{100}$ the size of the sun

SUN'S LAYERS
(outermost to innermost)

Outer Layers

Corona: average temperature is 1–3 million°Kelvin; the luminous envelope is the inner part

Transition region: a few hundred km thick, around 40,000–2 million°Kelvin

Chromosphere: reddish layer above sun's surface, around 45,000–20,000°Kelvin

Photosphere: the sun's surface, around 4,000–6,000°Kelvin

Inner Layers

Convection zone: temperature about 1 million°Kelvin; hot gas currents rise to photosphere

Radiation zone: temperature about 2–7 million°Kelvin; radiation passes through this zone

Core: temperature about 15 million°Kelvin; nuclei of atoms fuse, releasing high-energy radiation

AUTOMOBILES

AUTOMOBILE CLASSIFICATION
(smallest to largest)

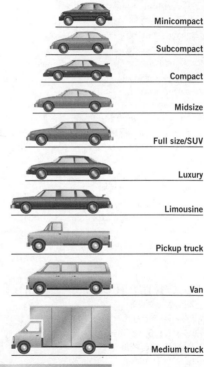

Minicompact

Subcompact

Compact

Midsize

Full size/SUV

Luxury

Limousine

Pickup truck

Van

Medium truck

Heavy truck

AUTOMOBILE STRUCTURE AND SUBSYSTEMS

Body
 Engine compartment
 Passenger space
 Storage space
Braking system
Chassis (framework, underbody)
Cooling system
Electrical system
 Alternator
 Battery
 Devices for starting engine
 Devices for vehicle operation (e.g., headlights)
Exhaust system (muffler)
Fuel system
Lubrication system
Power plant
 Engine (pistons)
 Transmission (shafts, gears, clutch)
Steering system
Suspension system
Wheels and tires

TRAILER HITCH CLASSIFICATION

Class I: 2,000 lb
Class II: 3,500 lb
Class III: 5,000 lb
Class IV: 7,500 lb
Class V: 10,000 lb

VEHICLE IDENTIFICATION NUMBER (VIN)

1st character: where the vehicle was built
 (example: 1, 4, 5 is USA)

2nd, 3rd characters: the manufacturer

4th–8th characters: portrait of the vehicle, identifying brand, body style, engine size, and type

9th character: security code that identifies the VIN as being authorized by the manufacturer and alerts law enforcement officers if VIN is not authentic

10th character: model year of the car

11th character: tells which plant assembled the vehicle

12th–17th characters: serial number of the vehicle

BOATS AND NAVIGATION

BOAT AND SHIP CLASSIFICATION

(smallest to largest)

Kayaks

Canoes

Sailboats

Junks

Yachts

Tugboats

Hydrofoils

Ferries

Riverboats

Barges

Dredgers

Icebreakers

Passenger liners

Cargo vessels

Tankers

Submarines

Destroyers

Aircraft carriers

COAST GUARD CLASSIFICATION

(by length)

Class A: Under 16 feet
Class 1: 16–26 feet
Class 2: 26–40 feet
Class 3: 40–65 feet
Class 4: 65+ feet

MARINERS' WATCHES AT SEA

(Strikes of the bell indicate the change in shift for the sailors.)

8 P.M.–midnight: first watch
midnight–4 A.M.: middle watch or midwatch
4–8 A.M.: morning watch
8 A.M.–noon: forenoon watch
noon–4 P.M.: afternoon watch
4–6 P.M.: first dog watch
6–8 P.M.: second or last dog watch (dog watches combined
 are called evening watch)

NAVAL VESSELS

(smallest to largest)

Patrol craft
Submarine
Frigate
Destroyer
Aircraft carrier

PANAMA CANAL LOCKS

*(east to west, from the Atlantic entrance to the
Pacific entrance)*

Gatún
Pedro Miguel
Miraflores

SHIP'S BELLS

(Rung every hour, the bells regulate the sailors' duty watches.)

1 bell: 12:30 A.M.	**1 bell:** 8:30 A.M.	**1 bell:** 4:30 P.M.
2 bells: 1 A.M.	**2 bells:** 9 A.M.	**2 bells:** 5:00 P.M.
3 bells: 1:30 A.M.	**3 bells:** 9:30 A.M.	**3 bells:** 5:30 P.M.
4 bells: 2 A.M.	**4 bells:** 10 A.M.	**4 bells:** 6:00 P.M.
5 bells: 2:30 A.M.	**5 bells:** 10:30 A.M.	**5 bells:** 6:30 P.M.
6 bells: 3 A.M.	**6 bells:** 11 A.M.	**6 bells:** 7:00 P.M.
7 bells: 3:30 A.M.	**7 bells:** 11:30 A.M.	**7 bells:** 7:30 P.M.
8 bells: 4 A.M.	**8 bells:** 12 noon	**8 bells:** 8:00 P.M.
1 bell: 4:30 A.M.	**1 bell:** 12:30 P.M.	**1 bell:** 8:30 P.M.
2 bells: 5 A.M.	**2 bells:** 1:00 P.M.	**2 bells:** 9:00 P.M.
3 bells: 5:30 A.M.	**3 bells:** 1:30 P.M.	**3 bells:** 9:30 P.M.
4 bells: 6 A.M.	**4 bells:** 2:00 P.M.	**4 bells:** 10:00 P.M.
5 bells: 6:30 A.M.	**5 bells:** 2:30 P.M.	**5 bells:** 10:30 P.M.
6 bells: 7 A.M.	**6 bells:** 3:00 P.M.	**6 bells:** 11:00 P.M.
7 bells: 7:30 A.M.	**7 bells:** 3:30 P.M.	**7 bells:** 11:30 P.M.
8 bells: 8 A.M.	**8 bells:** 4:00 P.M.	**8 bells:** 12 midnight

COMMUNICATIONS
AND
TELECOMMUNICATIONS

GENERAL COMMUNICATIONS CHAIN

Information source
Message
Transmitter
Transmitted signal
Channel (with noise source)
Received signal
Receiver
Message
Destination

LONG-DISTANCE SYSTEM SETUP

Message source
Transmitter
 Coder
 Modulator
Channel (transmission medium)
Receiver
 Demodulator
 Decoder
 Destination (processor)

COMPUTERS

ASCII BINARY CODE ALPHABET

A	1000001	J	1001010	S	1010011
B	1000010	K	1001011	T	1010100
C	1000011	L	1001100	U	1010101
D	1000100	M	1001101	V	1010110
E	1000101	N	1001110	W	1010111
F	1000110	O	1001111	X	1011001
G	1000111	P	0010000	Y	1011001
H	1001000	Q	0010001	Z	1011010
I	1001001	R	1010010		

COMPUTER DISPLAY BY NUMBER OF PIXELS

(standard display resolutions)

VGA 0.3 megapixels: 640×480
SVGA 0.5 megapixels: 800×600
XGA 0.8 megapixels: $1,024 \times 768$ (sometimes called XVGA)
SXGA 1.3 megapixels: $1,280 \times 1,024$
WXGA 1.0 megapixels: $1,280 \times 800$
SXGA+ 1.4 megapixels: $1,400 \times 1,050$
WXGA+ 1.3 megapixels: $1,440 \times 900$
WSXGA+ 1.7 megapixels: $1,680 \times 1,050$

UXGA 1.9 megapixels: $1{,}600 \times 1{,}200$
WUXGA 2.3 megapixels: $1{,}920 \times 1{,}200$
QXGA 3.1 megapixels: $2{,}048 \times 1{,}536$
WQXGA 4.1 megapixels: $2{,}560 \times 1{,}600$
QSXGA 5.2 megapixels: $2{,}560 \times 2{,}048$
WQSXGA 6.6 megapixels: $3{,}200 \times 2{,}048$
QUXGA 7.7 megapixels: $3{,}200 \times 2{,}400$
WQUXGA 9.2 megapixels: $3{,}840 \times 2{,}400$
WHXGA 12.6 megapixels: $4{,}096 \times 3{,}072$
WHSXGA 26 megapixels: $5{,}120 \times 4{,}096$
HUXGA 31 megapixels: $6{,}400 \times 4{,}800$
WHUXGA 37 megapixels: $7{,}680 \times 4{,}800$

COMPUTER OPERATING SYSTEMS

UNIX (late 1960s)
DOS (1981)
Mac operating system (1984)
Microsoft's and IBM's OS/2
 (late 1980s)
Windows NT/3.1 (1993)

Windows 1995 (1995)
Windows 98 (1998)
Windows 2000 (2000)
Windows XP (2001)
Mac OS X (2001)
Vista (2006)

COMPUTER SIZE AND CAPACITY *(smallest to largest)*

Nanocomputer
Smartdust
Wireless sensor network
Embedded computer
Wearable computer
Handheld computer
Portable computer (laptop or notebook)
Microcomputer (personal computer)
Desktop computer (tower)
Minicomputer
Mainframe
Supercomputer

DATA STORAGE
1 bit = on/off (0 or 1)
1 byte = 8 bits
1 kilobyte = 1,024 bytes
1 megabyte = 1,048,576 bytes (1,000,000 bits)
1 gigabyte = 1 billion bytes (1,000,000,000 bits)
1 terabyte = 1 trillion bytes (1,000,000,000,000 bits)
1 petabyte = 100,000,000,000,000 bits

EBAY FEEDBACK STARS
(A point is awarded for each positive transaction.
The color of stars represent status on eBay.)
Yellow star: 10 to 49 points
Blue star: 50 to 99 points
Turquoise star: 100 to 499 points
Purple star: 500 to 999 points
Red star: 1,000 to 4,999 points
Green star: 5,000 to 9,999 points
Yellow shooting star: 10,000 to 24,999 points
Turquoise shooting star: 25,000 to 49,999 points
Purple shooting star: 50,000 to 99,999 points
Red shooting star: 100,000 points or more

GENERATIONS OF COMPUTERS
First generation: earliest, most primitive model of a machine
 or equipment; computers built between 1948 and 1956
Second generation: an improved version of a machine or model;
 computers built between the mid-1950s and the mid-1960s
Third generation: computers built between 1966 and 1979, in
 which integrated circuits replaced transistors
Fourth generation: computers built during the 1980s
Fifth generation: computers built after the mid-1980s; even more
 advanced and capable of performing several functions
 simultaneously

INTERNET HOSTS
(generic top level domains, by year of introduction)

.com: commercial (1995)
.edu: education (1995)
.gov: government (1995)
.mil: military (1995)
.net: network (1995)
.org: organization (1995)
.int: international treaty-based organizations (1998)
.aero: aviation industry (2001)
.biz: businesses (2001)
.coop: cooperatives (2001)
.info: informational (2001)
.museum: museums (2001)
.name: families and individuals (2001)
.pro: professional (2002)
.cat: Catalan language and culture (2005)
.jobs: employment-related sites (2005)
.mobi: for mobile devices (2005)
.travel: travel industry (2005)
.tel: telecommunication services (2006)
.asia: companies, organizations, and individuals in Asian-Pacific region (2007)

CONSTRUCTION

MORTAR GRADES
(strength and use)

M: vigorous exposure, load-bearing, below grade, 2,500 psi (pound per inch load)
S: severe exposure, load-bearing, below grade, 1,800 psi
N: mild exposure, light loads, above grade, 750 psi
O: interiors, light loads, 350 psi
K: nonbearing walls, or very light loads, 75 psi

STEEL SKYSCRAPER CONSTRUCTION

(bottom to top)

Footings
Concrete foundation
Base
Plate
Anchor
Bolt

Column
Girder
Floor beams
Poured concrete
Floors
Roof

ELECTRICITY AND POWER

BATTERY COMPONENTS

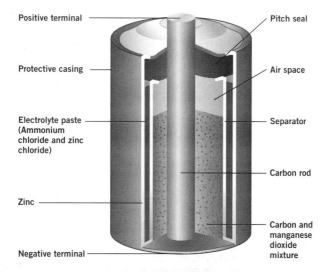

Positive terminal

Protective casing

Electrolyte paste
(Ammonium
chloride and zinc
chloride)

Zinc

Negative terminal

Pitch seal

Air space

Separator

Carbon rod

Carbon and
manganese
dioxide
mixture

BATTERY VOLTAGES

Alkaline

AAAA	1.5 volt
AAA	1.5 volt
AA	1.5 volt
C	1.5 volt
D	1.5, 6 volt
G	6.0 volt
N	3, 4.5, 6, 9 volt

Carbon Zinc

AAA	1.5 volt
AA	1.5 volt
C	1.5 volt
D	1.5 volt
N	1.5 volt
WO	1.5, 3.0, 4.5, 6.0 volt
109 or 127	9 volt
117	9, 12, 22.5, 45, 90 volt

EFFECTS OF CURRENT ON HUMAN BODY

(by number of amperes)

less than 0.01 amp: imperceptible, or tingling sensation

0.02 amp: painful, cannot let go of object conducting current

0.03 amp: breathing disturbed

0.07 amp: breathing very difficult

0.1 amp: death due to fibrillation

0.2 amp+: no fibrillation but severe burning and no breathing

ELECTRIC SHOCK

(current in milliamperes [Ma]/60 Hz;
AC = alternating current; DC = direct current)

AC	DC	Effect
0–1	0–4	Perception
1–4	4–15	Surprise (over 5 can be lethal)
4–21	15–80	Reflex action
21–40	80–160	Muscular inhibition
41–100	160–300	Respiratory block
over 100	over 300	Usually fatal

ELECTRONIC RESISTOR COLOR CODE MNEMONIC

(for determining standard and precision resistor value, i.e.,
the values or ratings of electronic components)

Bad **B**ooze **R**ots **O**ur **Y**oung **G**uts **B**ut **V**odka **G**oes **W**ell

B: black, 0	**G:** green, 5
B: brown, 1	**B:** blue, 6
R: red, 2	**V:** violet, 7
O: orange, 3	**G:** gray, 8
Y: yellow, 4	**W:** white, 9

ESTIMATED CURRENT USAGE OF COMMON MACHINES

(average annual kilowatt-hours [kWh] use for common
appliances in the U.S.; a kilowatt-hour is 1,000 watts' usage
for an hour)

Electric toothbrush	5 kWh
Electric carving knife	8 kWh
VCR	10–70 kWh
Hair dryer	14 kWh
Blender	15 kWh
Clock	17 kWh
Shaver	18 kWh
Computer	25–400 kWh

Garbage disposal	30 kWh
Toaster	39 kWh
Vacuum cleaner	46 kWh
Radio	86 kWh
Automatic clothes washer	103 kWh
Iron	144 kWh
Electric blanket	147 kWh
Humidifier	163 kWh
Microwave oven	200 kWh
Attic fan	291 kWh
Dehumidifier	377 kWh
Television	502 kWh
Dishwasher	512 kWh
Air conditioner	950 kWh
Refrigerator-freezer	1,000–1,500 kWh
Clothes dryer	1,080 kWh
Range	1,175–1,205 kWh
Water heater	4,811 kWh

ENGINEERING

AREAS OF STUDY

Acoustical engineering
Aeronautical engineering
Aerospace engineering
Agricultural engineering
Biochemical engineering
Biomedical engineering
Chemical engineering
Civil engineering
Computer engineering
Electrical and electronics
 engineering
Environmental engineering

Industrial engineering
Mechanical engineering
Military engineering
Mining engineering
Naval engineering
Nuclear engineering
Optical engineering
Petroleum engineering
Production engineering
Safety engineering
Software engineering

FIRE SAFETY

FIRE EXTINGUISHER TYPES

(Fire extinguishers are marked as to what type of fire they are designed to extinguish. Some are marked for multiple types.)

Classes of Fires	Types of Fires	Picture Symbol
A	Wood, paper, cloth, trash, and other ordinary materials	
B	Gasoline, oil, paint, and other flammable liquids	
C	May be used on fires involving live electrical equipment without danger to the operator	
D	Combustible metals and combustible metal alloys	
K	Cooking media (vegetable or animal oils and fats)	

WATER
(2 white lines)

POWDER
(thick blue line)

FOAM
(thick yellow line)

CO_2
(thick black line)

NATIONAL FIRE RATING SYSTEM

Flammability

(depicted as red top square of a diamond illustration on buildings and trucks)

4—Very flammable gases or very volatile flammable liquids

3—Can be ignited at all normal temperatures

2—Ignites if moderately heated

1—Ignites after considerable preheating

0—Will not burn

Health

(blue left square of diamond)

4—Can cause death or major injury despite medical treatment

3—Can cause serious injury despite medical treatment

2—Can cause injury; requires prompt treatment

1—Can cause irritation if not treated

0—No hazard

Reactivity
(Danger of Explosion, Not Dependent on Ignition)

(yellow right square of diamond)

4—Readily detonates or explodes

3—Can detonate or explode but requires strong initiating force or heating under confinement

2—Normally unstable but will not detonate

1—Normally stable; unstable at high temperature and pressure; reacts with water

0—Normally stable; not reactive with water

Specific Hazard Designations

(white bottom square of diamond)

OX—Oxidizing agent

Water reactive

Radioactive

Biohazard

LUMBER

GRADES
Softwood (trees with cones)
Hardwood (trees with leaves)

GRADES OF HARDWOOD LUMBER
(from the National Hardwood Lumber Association)
First and Second (FAS)
Select-No. 1 Common
Select-No. 2 Common
Select-No. 3 Common

GRADES OF LUMBER USED IN CONSTRUCTION
(from the American Softwood Lumber Standard)
No. 1 (construction grade): Many knots,
 all under 2 inches
No. 2 (standard grade): Many knots, up to 3½ inches
No. 3 (utility grade): Allows open knots, splits, pitch
No. 4 (economy grade): Numerous splits and knotholes
No. 5 (economy grade): Larger waste areas and coarser defects

GRADES OF PLYWOOD AND PANELING
(from the American Plywood Association)

Basic Grades
Grade N: Smooth surface "natural finish"
Grade A: No blemishes, smooth, paintable
Grade B: Few blemishes, knots plugged and sanded; solid surface
Grade C Plugged: splits and small knots and knotholes;
 improved veneer, some broken grain
Grade C: Splits and small knots and knotholes;
 tight knots to half inch
Grade D: Large knots and knotholes to 2½ inches

Exterior and Interior Sides Graded
A-A: no blemishes
A-B: face is without blemishes, back is solid, for signs and
cabinets
A-C: no blemishes on one side and small knots on the other
for trays, roofs, and farm buildings
B-B: two solid, sanded sides for panels
B-C: veneered face, sanded for exterior surfaces
C-C Plugged: smooth surface for carpet or decking
C-D Plugged: smooth surface for tile backing and
storage units

Additional Markings on Stock
G: Good side for finishing
I: For interior use
S: Side
AC1: one side A, one side C, for interior use
G1S: one good side, one utility side
G2S: both sides good
SH: Sheathing
WB: Wallboard
U: Underlaying material
X: For exterior use

GRADES OF SOFTWOOD LUMBER
*(developed by the U.S. Department of Commerce American
Lumber Standards)*
Rough lumber: sawn, trimmed, edged but with rough faces
Surfaced lumber: dressed rough lumber that has been
smoothed
Worked lumber: surfaced lumber that has been matched,
patterned, or shiplapped
Shop and factory lumber: millwork lumber for doors,
windows, etc.

Yard or structural lumber: for house framing, concrete forms, etc.

 Boards: Up to 1 inch thick and 4–12 inches wide
 Planks: Over 1 inch thick and more than 6 inches wide
 Timbers: Width and thickness greater than 5 inches

Select and finish materials: for trim, cabinets, etc.

Boards: general building, crafts, flooring, etc.

 Select merchantable
 Construction
 Standard
 Utility
 Economy

Dimension lumber: surfaced 2–4 inches thick for framing components

 Light framing
 Structural light framing
 Studs
 Structural joists and planks
 Timber
 Appearance framing

GRADES OF WHITE PINE WOOD

Clear Grades

C Select: the highest pine grade, some pieces are clear but most have minor blemishes on one side
D Select: slight blemishes on both sides

Common Grades

Finish
Premium
Standard
Industrial

WOOD DURABILITY CLASSIFICATION

Very durable: black locust, red cedar, live oak, black walnut, cypress, redwood, white cedar, Lawson cypress

Durable: white oak, black ash, cherry, red elm, persimmon, longleaf pine, larch, slash pine, ironwood

Intermediate: white pine, Norway pine, shortleaf pine, red oak, red ash, yellow poplar, butternut, sugar pine

Perishable: white elm, beech, hickory, hard maple, red gum, white ash, Loblolly pine, hemlock, spruce, yellow birch

Very perishable: black gum, basswood, buckeye, paper birch, aspen, willow, sycamore, lodgepole pine, balsam fir, jack pine

WOOD TYPES

Hardness

Very hard: hickory, hard maple, black locust, rock elm, persimmon, Osage orange

Hard: oak, beech, birch, black gum, longleaf pine, ash

Intermediate: Douglas fir, red gum, tamarack, white elm, cottonwood

Soft: Ponderosa pine, hemlock, chestnut, yellow poplar, cypress, cedar

Very soft: white pine, sugar pine, spruce, redwood, basswood, willow

Splitting

Difficult to split: elm, black gum, beech, sycamore, dogwood, red gum

Intermediate: birch, maple, hickory, oak, ash, cottonwood

Easy to split: chestnut, all pines, redwood, cedar, fir, western larch

PAPER

PAPER SIZES

Non-ISO (International Organization for Standardization)

Atlas	26 × 34 inches
Imperial	22 × 30 inches
Elephant	23 × 28 inches
Royal	20 × 25 inches
Small royal	19 × 25 inches
Medium	18 × 23 inches
Demy	17½ × 22½ inches
Crown	15 × 20 inches
Foolscap	13½ × 17 inches
Pott	12½ × 15½ inches

Paper Sizes Used in Printing, United States

Bond	8½ × 11, 8½ × 14, 11 × 17, 17 × 22, 17 × 28, 19 × 24, 19 × 28, 22 × 34 inches
Book	25 × 38 inches
Coated	25 × 38 inches
Text	25 × 38 inches
Offset	25 × 38 inches
Cover	20 × 26 inches
Bristol	22½ × 28½ inches (also called printing bristol)
Tag	24 × 36 inches
Index	25½ × 30½ inches (also called index bristol)

Paper Sizes Used in Printing, U.K.

(ISO standard sizes)

A0	841 × 1,189 millimeters
A1	594 × 841 millimeters
A2	420 × 594 millimeters
A3	297 × 420 millimeters
A4	210 × 297 millimeters

A5	148 × 210 millimeters
A6	105 × 148 millimeters
A7	74 × 105 millimeters
A8	52 × 74 millimeters
A9	37 × 52 millimeters
A10	26 × 37 millimeters
B0	1,000 × 141 millimeters
B1	707 × 1,000 millimeters
B2	500 × 700 millimeters
B3	353 × 500 millimeters
B4	250 × 353 millimeters
B5	176 × 250 millimeters
B6	125 × 176 millimeters
B7	88 × 125 millimeters
B8	62 × 88 millimeters
B9	44 × 62 millimeters
B10	31 × 44 millimeters

PAPER WEIGHTS

(fixed weight of 500 sheets)

Onionskin: 9 lb.
Mimeograph paper: 16 lb.
Standard typing paper: 20 lb.
Standard letterhead paper: 24 lb.
Business cards and postcards: 65 lb.
Coated magazine stock: 100 lb.
Poster board: 120 lb.

Art Paper Weights

Tracing paper: 8–48 lb.
Bond paper: 13–20 lb.
Ledger paper: 28–32 lb.
Commercial cover paper: 65–80 lb.
Watercolor paper: 90–400 lb.

RADIO

FREQUENCIES

EHF (extremely high frequency): 30–300 GHz, experimental and amateur radio

SHF (super high frequency): 3–30 GHz; satellite communication

UHF (ultra high frequency): 300–3,000 MHz; radar and UHF television

VHF (very high frequency): 30–300 MHz; FM broadcast, police radio

HF (high frequency): 3–30 MHz; CB radio

MF (medium frequency): 300–3,000 kHz; AM broadcast

LF (low frequency): 30–300 kHz; maritime and aeronautical communication

VLF (very low frequency): 3–30 kHz

ULF (ultralow frequency): 300 Hz–3 kHz

SLF (superlow frequency): 30 Hz–300 Hz

ELF (extremely low frequency): 3 Hz–30 Hz

TYPES OF RADIO WAVES

(from highest frequency [hertz] and shortest wavelength to lowest frequency and longest wavelength)

Microwaves (communication devices)

Microwave radar (communication and detection devices)

Radar (communication and detection devices)

Video (television, FM radio)

Mobile phones

GPS

Short wave (shortwave radio)

Medium wave (AM radio)

Long wave (long-wave radio)

Submarine communication

ROADS AND HIGHWAYS

BRIDGE TYPES

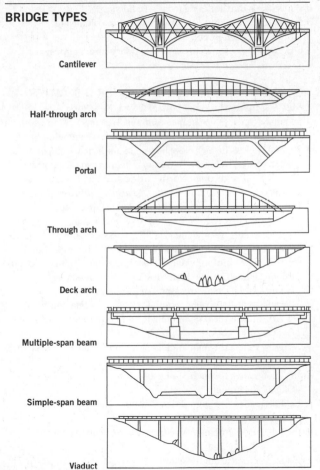

Cantilever

Half-through arch

Portal

Through arch

Deck arch

Multiple-span beam

Simple-span beam

Viaduct

FUNCTIONS OF ROAD AND HIGHWAY

Expressways that serve major traffic flows
Primary highways that carry relatively high volumes of
 traffic between population centers
Collector and feeder roads, and secondary rural highways
Local roads and city streets

LONGEST HIGHWAYS SERVING MAJOR U.S. CITIES

I-90: 3,021 miles; through Massachusetts, New York,
 Pennsylvania, Ohio, Indiana, Illinois, Wisconsin, Minnesota,
 South Dakota, Wyoming, Montana, Idaho, Washington State
I-80: 2,900 miles; through New Jersey, Pennsylvania, Ohio, Indiana,
 Illinois, Iowa, Nebraska, Wyoming, Utah, Nevada, California
I-40: 2,560 miles; through North Carolina, Tennessee, Arkansas,
 Oklahoma, Texas, New Mexico, Arizona, California
I-10: 2,460 miles; through Florida, Alabama, Mississippi,
 Louisiana, Texas, New Mexico, Arizona, California
I-70: 2,153 miles; through Maryland, Pennsylvania, West Virginia,
 Ohio, Indiana, Illinois, Missouri, Kansas, Colorado, Utah
I-95: 1,920 miles; through Maine, New Hampshire, Massachusetts,
 Rhode Island, Connecticut, New York, New Jersey,
 Pennsylvania, Delaware, Maryland, District of Columbia,
 Virginia, North Carolina, South Carolina, Georgia, Florida
I-75: 1,787 miles; through Michigan, Ohio, Kentucky, Tennessee,
 Georgia, Florida
I-94: 1,585 miles; through Michigan, Indiana, Illinois, Wisconsin,
 Minnesota, North Dakota, Montana
I-35: 1,568 miles; through Minnesota, Iowa, Missouri, Kansas,
 Oklahoma, Texas
I-20: 1,539 miles; through South Carolina, Georgia, Alabama,
 Mississippi, Louisiana, Texas
I-15: 1,434 miles; through Montana, Idaho, Utah, Arizona,
 Nevada, California
I-5: 1,382 miles; through Washington, Oregon, California

MAJOR CITIES ON ROUTE 66

(east to west)

Chicago, IL
St. Louis, MO
Springfield, MO
Tulsa, OK
Oklahoma City, OK
Amarillo, TX
Albuquerque, NM
Flagstaff, AZ
Los Angeles, CA

MAJOR TYPES OF HIGHWAY INTERCHANGES

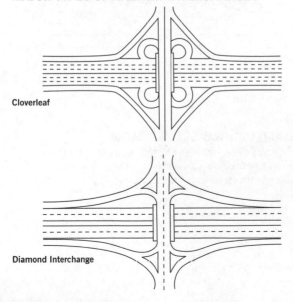

Cloverleaf

Diamond Interchange

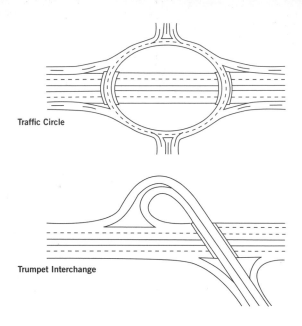

Traffic Circle

Trumpet Interchange

ROAD AND HIGHWAY CLASSIFICATION
Superhighway (interstates and high-capacity highways)
Expressway or highway (divided and undivided)
 Urban (such as toll roads, turnpikes, parkways)
 Rural
Road
Secondary road
Collector route
Street
Unsurfaced road
Pathway

ROAD LAYERS
(from bottom to top)
Drains installed
Compressed soil
One or more layers of crushed stone
Concrete or blacktop (tar and stone chips)

Other Road Components
(from bottom to top)
Granular subbase (rolled aggregate 12–24 inches thick)
Lower road base (10-inch layer of concrete)
Upper road base (3-inch layer of rolled macadam [tar and stones])
Wearing surface (1.5-inch layer of rolled asphalt)
Concrete haunch (finishes and supports edge of road surface)
Hard shoulder (for breakdown lane)

TRANSPORTATION

AIR TRANSPORT
Air-cushion machines
Aircraft
Spacecraft

GROUND- AND UNDERGROUND-BASED TRANSPORT
Motor vehicles
Railroads
Urban mass transport

WATER TRANSPORT
Boats
Ships
Submarines

WEAPONS

FIREARMS CALIBERS

.17 caliber gun, .17-inch bore, .17-inch bullets
.22 caliber gun, .22-inch bore, .22-inch bullets
.38 caliber gun, .38-inch bore, .38-inch bullets
.44 magnum, .44-inch bore, .44-inch bullets
.45 caliber gun, .45-inch bore, .45-inch bullets
.50 caliber gun, .50-inch bore, .50-inch bullets
.68 caliber gun, .68-inch bore, .68-inch bullets

NUCLEAR-WEAPON RANGE

(farthest to shortest range)
Intercontinental Ballistic Missiles (ICBMs)
Long-range bombers
Medium-range bombers
Submarine launched ballistic missiles (SLBMs)
Intermediate and medium-range ballistic missiles (IRBMs)
Short-range aircraft
Short-range ballistic missiles (SRBMs)
Artillery

SHOTGUN GAUGE

32-gauge shotgun, .526-inch bore
20-gauge shotgun, .615-inch bore
12-gauge shotgun, .729-inch bore
10-gauge shotgun, .775-inch bore

MATHEMATICS & MEASUREMENTS

A s far as the laws of mathematics refer to reality, they are not certain, and as far as they are certain, they do not refer to reality.

—Albert Einstein

ANCIENT MEASURES

BIBLICAL
Cubit = 18 inches
Omer = 0.41 peck = 3.64 liters = 3.84 quarts
Ephah = 10 omers = 38.4 quarts
Bath = 9.4 omers = 36 quarts
Shekel = 0.497 ounce = 14.1 grams

EGYPTIAN
Shekel = 180 grains
Great Mina = 60 shekels
Talent = 60 great minas

GREEK
Cubit = 18.3 inches
Stadion = 607.2 feet
Obol = 0.57 milligrams = 0.02 ounces
Drachma = 4.2923 grams = 6 obols
Mina = 0.9463 pound = 94 drachmas
Talent = 60 mina

ROMAN
Cubit = 17.5 inches
Stadium = 625 feet = 429 cubits
Libra = 327.168 grams = 0.7213 pound

APOTHECARIES' WEIGHT MEASURES
*(a version of the troy weight system [used for weighing gold]
formerly used by apothecaries)*
1 grain = 0.0020833 troy ounce = 0.06479899 gram
20 grains = 1 scruple = 0.04166 troy ounce
3 scruples = 1 drachm = 0.125 troy ounce
24 scruples = 1 troy ounce = 480 grains

1 ounce apoth. = 1.09709 avoirdupois ounce = 437.5 grains = 28.34952 grams

1 ounce avoirdupois (avdp) = 0.9115 ounce apothecaries' weight (apoth.) = 437.5 grains

12 ounces apoth. = 1 pound apoth. = 373.2417 grams = 13.1657 ounces avdp = 0.82286 pound avdp

CHEMISTRY

BRANCHES OF CHEMISTRY

Applied Chemistry

Agricultural chemistry (chemistry in agricultural production)

Chemical engineering (chemistry in engineering)

Petroleum chemistry (chemistry in petroleum production)

Pharmaceutical chemistry (chemistry in pharmaceutical production)

Synthetic chemistry (chemistry to produce synthetics)

Textile chemistry (chemistry in textile production)

Research Chemistry

Analytical chemistry (chemical components of substances)

Qualitative analysis

Quantitative analysis

Astrochemistry

Electrochemistry

Biochemistry (compounds and processes in living organisms)

Inorganic chemistry (compounds that do not contain hydrocarbon radicals)

Materials chemistry

Mathematical chemistry

Organic chemistry (compounds containing carbon)

Physical chemistry (physical properties of chemical substances)

Electrochemistry (chemical action of electricity)

Nuclear chemistry (chemical action of radioactive substances)
Photochemistry (chemical action of light)
Quantum chemistry
Thermochemistry (chemical action of heat)
Theoretical chemistry

PERIODIC TABLE

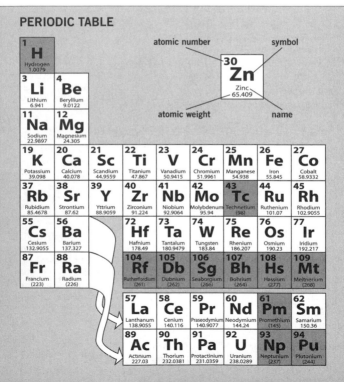

PARTS OF THE ATOM

- ● Electron

- ○ Protron

- ● Neutron

								2 **He** Helium 4.0026
5 **B** Boron 10.881	6 **C** Carbon 12.0107	7 **N** Nitrogen 14.0067	8 **O** Oxygen 15.9994	9 **F** Fluorine 18.9984	10 **Ne** Neon 20.1797			
13 **Al** Aluminum 26.9815	14 **Si** Silicon 28.0855	15 **P** Phosphorus 30.9738	16 **S** Sulfur 32.065	17 **Cl** Chlorine 35.453	18 **Ar** Argon 39.948			

28 **Ni** Nickel 58.6934	29 **Cu** Copper 63.546	30 **Zn** Zinc 65.409	31 **Ga** Gallium 69.723	32 **Ge** Germanium 72.64	33 **As** Arsenic 74.9216	34 **Se** Selenium 78.96	35 **Br** Bromine 79.904	36 **Kr** Krypton 83.798
46 **Pd** Palladium 106.42	47 **Ag** Silver 107.8682	48 **Cd** Cadmium 112.411	49 **In** Indium 114.818	50 **Sn** Tin 118.71	51 **Sb** Antimony 121.76	52 **Te** Tellurium 127.6	53 **I** Iodine 126.9045	54 **Xe** Xenon 131.293
78 **Pt** Platinum 195.078	79 **Au** Gold 196.9665	80 **Hg** Mercury 200.59	81 **Tl** Thallium 204.3833	82 **Pb** Lead 207.2	83 **Bi** Bismuth 208.9804	84 **Po** Polonium (209)	85 **At** Astatine (210)	86 **Rn** Radon (222)
110 **Ds** Darmstadtium (271)	111 **Rg** Roentgenium (272)	112 **Uub** Ununbium (277)						

63 **Eu** Europium 151.964	64 **Gd** Gadolinium 157.25	65 **Tb** Terbium 158.9253	66 **Dy** Dysprosium 162.5	67 **Ho** Holmium 164.9303	68 **Er** Erbium 167.259	69 **Tm** Thulium 168.9342	70 **Yb** Ytterbium 173.04	71 **Lu** Lutetium 174.967
95 **Am** Americium (243)	96 **Cm** Curium (247)	97 **Bk** Berkelium (247)	98 **Cf** Californium (251)	99 **Es** Einsteinium (252)	100 **Fm** Fermium (257)	101 **Md** Mendelevium (258)	102 **No** Nobelium (259)	103 **Lr** Lawrencium (262)

PERIODIC TABLE—CHEMICAL GROUPS

Alkali metals (sodium family): Li, Na, K, Rb, Cs, Fr
Alkaline earth metals (calcium family):
 Be, Mg, Ca, Sr, Ba, Ra
Nonmetals: H, C, N, O, F, P, S, Cl, Br, I, At, Se
Semimetals: B, Si, Ge, As, Se, Sb, Te, At, Po
Nitrogen family: N, P, As, Sb, Bi
Oxygen family: O, S, Se, Te, Po
Halogen family: F, Cl, Br, I, At
Inert (noble) gases: He, Ne, Ar, Kr, Xe, Rn
Lanthanide series: La, Ce, Pr, Nd, Pm, Sm, Eu, Gd, Tb, Dy, Ho,
 Er, Tm, Yb, Lu
Actinide series: Ac, Th, Pa, U, Np, Pu, Am, Cm, Bk, Cf, Es, Fm,
 Md, No, Lr
Transition elements: Sc, Ti, V, Cr, Mn, Fe, Co, Ni, Cu, Zn; Y, Zr,
 Nb, Mo, Tc, Ru, Rh, Pd, Ag, Cd; Hf, Ta, W, Re, Os, Ir, Pt, Au,
 Hg; Unq, Unp, Unh, Uns, Uno, Une

pH VALUES *(acid to base)*

0: hydrochloric acid, battery acid
1: stomach acid
2: lemon, soda pop, vinegar
3: grapefruit, orange juice
4: tomato, shampoo, beer
5: bread, black coffee, acid rain
6: cow's milk, unpolluted rain
7: pure water
8: sea water, human blood, egg white
9: soap
10: milk of magnesia
11: ammonia
12: cleaning fluids
13: caustic soda, lye
14: antacids, drain cleaner, potassium hydroxide

RADIOACTIVITY TYPES
Alpha decay
Beta-minus decay
Beta-plus decay
Electron capture
Gamma decay
Heavy-ion radioactivity
Isomeric transitions
Proton radioactivity
Special beta-decay processes
Spontaneous fission

STATES OF MATTER
Solid: has a stable definite shape
Liquid: does not have a stable shape, defined by container
Gas: has an indefinite, unstable shape
Plasma: mixture of free electrons and ions of atomic nuclei
Bose-Einstein condensate: atoms have quantum levels, temp
 close to absolute zero

DECIBEL SCALE

 0 decibels: absolute silence
10 decibels: light whisper, leaves rustling
20 decibels: quiet conversation, 10 times louder than
 10 decibels
30 decibels: normal conversation, 100 times louder than
 10 decibels
40 decibels: light traffic, quiet room in home
50 decibels: restaurant, office, loud conversation
60 decibels: noisy office or restaurant
70 decibels: normal traffic, loud telephone ring, quiet train,
 lawn mower

80 decibels: automobile interior, subway

90 decibels: bus or truck interior, heavy traffic, thunder

100 decibels: chain saw

110 decibels: loud orchestral music

120 decibels: amplified rock music, very close thunder clap

130 decibels: artillery fire at close range, air raid siren

140+ decibels: jet taking off

EQUIVALENT MEASURES

CAPACITIES OR VOLUMES

1 barrel liquid = 31 to 42 gallons

1 barrel, standard (for fruits, vegetables, and other dry commodities except dry cranberries) = 7,161 cubic inches = 105 dry quarts = 3.281 bushels, struck measure*

1 barrel, standard (dry cranberries) = 5,826 cubic inches = 86⁴⁵⁄₆₄ dry quarts = 2.709 bushels, struck measure

1 board foot = a foot-square board 1 inch thick

1 bushel (U.S.; struck measure) = 2,150.42 cubic inches = 35.239 liters

1 bushel, heaped (U.S.) = 2,747.715 cubic inches = 1.278 bushels, struck measure

1 bushel (British Imperial; struck measure) = 1.032 U.S. bushels struck measure = 2,219.36 cubic inches

1 cord firewood = 128 cubic feet

1 cubic centimeter = 0.061 cubic inch

1 cubic decimeter = 61.024 cubic inches

1 cubic inch = 0.554 fluid ounce = 4.433 fluid drams = 16.387 cubic centimeters

1 cubic foot = 7.481 gallons = 28.317 cubic decimeters

1 cubic meter = 1.308 cubic yards

1 cubic yard = 0.765 cubic meter

1 measuring cup = 8 fluid ounces = ½ liquid pint

*A measure, esp. of grain, level with the top of a receptacle.

1 dram, fluid (British) = 0.961 U.S. fluid dram = 0.217 cubic inch
 = 3.552 milliliters
1 dekaliter = 2.642 gallons = 1.135 pecks
1 U.S. gallon = 231 cubic inches = 3.785 liters = 0.833 British
 gallon = 128 U.S. fluid ounces
1 British Imperial gallon = 277.42 cubic inches = 1.201 U.S.
 gallons = 4.546 liters = 160 British fluid ounces
1 gill = 7.219 cubic inches = 4 fluid ounces = 0.118 liter
1 hectoliter = 26.418 gallons = 2.838 bushels
1 liter = 1.057 liquid quarts = 0.908 dry quart = 61.025 cubic inches
1 milliliter = 0.271 fluid dram = 16.231 minims = 0.061 cubic inch
1 ounce liquid (U.S.) = 1.805 cubic inches = 29.573 milliliters =
 1.041 British fluid ounces
1 ounce, fluid (British) = 0.961 U.S. fluid ounce = 1.734 cubic
 inches = 28.412 milliliters
1 peck = 8.810 liters
1 pint, dry = 33.600 cubic inches = 0.551 liter
1 pint, liquid = 28.875 cubic inches = 0.473 liter
1 quart dry (U.S.) = 67.201 cubic inches = 1.01 liters =
 0.969 British quart
1 quart liquid (U.S.) = 57.75 cubic inches = 0.946 liter =
 0.833 British quart
1 quart (British) = 69.354 cubic inches = 1.032 U.S. dry quarts =
 1.201 U.S. liquid quarts
1 tablespoon = 3 teaspoons = 4 fluid drams = ½ fluid ounce
1 teaspoon = ⅓ tablespoon = 1⅓ fluid drams

LENGTHS
1 angstrom = 0.1 nanometer = 0.0001 micrometer = 0.0000001
 millimeter = .000000004 inch
1 cable's length = 120 fathoms = 720 feet = 220 meters
1 centimeter = 0.3937 inch
1 chain (Gunter's or surveyor's) = 66 feet = 20.1168 meters
1 chain (engineer's) = 100 feet = 30.48 meters

1 decimeter = 3.937 inches
1 degree (geographical) = 364,566.929 feet = 69,047 miles =
 111.123 kilometers
1 degree of latitude = 68.708 miles at equator; 69.403 miles at poles
1 degree of longitude = 69.171 miles at equator
1 dekameter = 32.808 feet
1 fathom = 6 feet = 1.8288 meters
1 foot = 0.3048 meter
1 furlong = 10 chains (surveyor's) = 660 feet = ⅛ statute mile =
 201.168 meters
1 hand = 4 inches
1 inch = 2.54 centimeters
1 kilometer = 0.621 mile = 3,281.5 feet
1 league = 3 survey miles = 4.828 kilometers
1 link (Gunter's or surveyor's) = 7.92 inches = 0.201 meter
1 link (engineer's) = 1 foot = 0.305 meter
1 meter = 39.37 inches = 1.094 yards
1 micrometer = 0.001 millimeter = 0.00003937 inch
1 mil = 0.001 inch = 0.0254 millimeter
1 mile = 5,280 feet = 1.609 kilometers
1 international nautical mile = 1.852 kilometers = 1.150779
 survey miles = 6,076.11549 feet
1 millimeter = 0.03937 inch
1 nanometer = 0.001 micrometer = 0.00000003937 inch
1 pica = 12 PostScript points
1 PostScript point = 0.013837 inch = 0.351 millimeter
1 rod, pole, or perch = 16½ feet = 5.029 meters
1 yard = 0.9144 meter

SURFACE AREAS
1 acre = 43,560 square feet = 4,840 square yards = 0.405 hectare
1 are = 119.599 square yards = 0.025 acre
1 bolt length = 100 yards
1 bolt width = 45 or 60 inches

1 hectare = 2.471 acres
1 square (building) = 100 square feet
1 square centimeter = 0.155 square inch
1 square decimeter = 15.500 square inches
1 square foot = 929.030 square centimeters
1 square inch = 6.4516 square centimeters
1 square kilometer = 247.104 acres = 0.386 square mile
1 square meter = 1.196 square yards = 10.764 square feet
1 square mile = 258.999 hectares
1 square millimeter = 0.002 square inch
1 square rod, square pole, or square perch =
 25.293 square meters
1 square yard = 0.836 square meter

WEIGHTS OR MASSES

1 assay ton = 29.167 grams
1 bale = 500 pounds (U.S.) = 750 pounds (Egypt)
1 carat = 200 milligrams = 3.086 grains
1 dram (avoirdupois) = 27.344 grains = 1.772 grams
1 gamma = 1 microgram
1 grain = 64.799 milligrams
1 gram = 15.432 grains = 0.035 ounce (avoirdupois)
1 hundredweight (gross, or long) = 112 pounds = 50.802 kilograms
1 hundredweight (net, or short) = 100 pounds = 45.359 kilograms
1 kilogram = 2.205 pounds
1 microgram = 0.000001 gram
1 milligram = 0.015 grain
1 ounce (avoirdupois) = 437.5 grains = 0.911 troy ounce =
 28.350 grams
1 ounce (troy) = 480 grains = 1.097 ounces (avoirdupois) =
 31.103 grams
1 pennyweight = 1.555 grams
1 pound (avoirdupois) = 7,000 grains = 1.215 pounds (troy) =
 453.59237 grams

1 pound (troy) = 5,760 grains = 0.823 pound (avoirdupois) = 373.242 grams

1 ton (gross or long) = 2,240 pounds = 1.12 tons (net) = 1.016 tons (metric)

1 ton (metric) = 2,204.623 pounds = 0.984 ton (gross) =1.102 tons (net)

1 ton (net or short) = 2,000 pounds = 0.893 ton (gross) = 0.907 ton (metric)

FOOD AND COOKING MEASURES

CAN SIZES
No. 300 = 14–16 fluid oz
No. 303 = 16–17 fluid oz
No. 1 tall = 16–17 oz fluid oz
No. 2 = 1 lb. 4 oz or 1 pint 2 fluid oz
No. 2½ = 1 lb. 13 oz or 28 fluid oz
No. 3 = 51 fluid oz
No. 10 = 109 fluid oz

CONTAINER SIZES
8 ounce can = 1 cup
10½ ounce can = 1¼ cups
12 ounce vacuum packed can = 1½ cups
14 to 16 ounce can (No. 300) = 1¾ cups
16 to 17 ounce can (No. 303) = 2 cups
20 ounce can (No. 2) = 2½ cups
29 ounce can (No. 2½) = 3½ cups
46 fluid ounce can (No. 3 cylinder) = 5¾ cups
6½ pound or 7 pound, 5 ounce can (No. 10) = 12 to 13 cups
6 ounce can frozen juice concentrate = ¾ cup
10 ounce package frozen vegetables = 1½ to 2 cups
16 ounce package frozen vegetables – 3 to 4 cups

1 pound package brown sugar (packed) = 2⅓ cups
1 pound package powdered sugar (unsifted) = 3¼ cups
5 pound bag sugar = 11¼ cups
5 pound bag all-purpose flour (unsifted) = 17½ cups
1 pound can coffee = 5 cups

COOKING EQUIVALENTS TABLE

1 teaspoon = ⅓ tablespoon = 60 drops
3 teaspoons = 1 tablespoon
48 teaspoons = 1 cup
½ tablespoon = 1½ teaspoons
1 tablespoon = 3 teaspoons = ½ fluid ounce = ⅟₁₆ cup
2 tablespoons = ⅛ cup = 1 fluid ounce
3 tablespoons = 1½ fluid ounces = 1 jigger
4 tablespoons = ¼ cup = 2 fluid ounces
5⅓ tablespoons = ⅓ cup
8 tablespoons = ½ cup = 4 fluid ounces
10⅔ tablespoons = ⅔ cup
12 tablespoons = ¾ cup
16 tablespoons = 1 cup = 8 fluid ounces = ½ pint
⅛ cup = 2 tablespoons = 1 fluid ounce
¼ cup = 4 tablespoons = 2 fluid ounces
⅓ cup = 5 tablespoons plus 1 teaspoon
⅜ cup = ¼ cup plus 2 tablespoons
½ cup = 8 tablespoons = 4 fluid ounces
⅔ cup = 10 tablespoons plus 2 teaspoons
⅝ cup = ½ cup plus 2 tablespoons
¾ cup = 12 tablespoons = 6 fluid ounces
⅞ cup = ¾ cup plus 2 tablespoons
1 cup = 16 tablespoons = ½ pint = 8 fluid ounces
2 cups = 1 pint = 16 fluid ounces
4 cups = 1 quart = 2 pints = 32 fluid ounces
1 pint = 2 cups = 16 fluid ounces
2 pints = 1 quart = 4 cups = 32 fluid ounces

1 quart = 2 pints = 4 cups = 32 fluid ounces
2 quarts = ½ gallon = 4 pints = 8 cups = 64 fluid ounces
4 quarts = 1 gallon = 8 pints = 16 cups = 128 fluid ounces
8 quarts = 1 peck
1 gallon = 4 quarts = 8 pints = 16 cups = 128 fluid ounces
2 gallons = 1 peck
4 pecks = 1 bushel
1 ounce = 28.35 grams
1 pound = 453.59 grams
1 gram = 0.035 ounce
1 kilogram = 2.2 pounds
1 liter = 1.06 quarts

U.S. TO METRIC CONVERSIONS
(from U.S. customary system)
⅕ teaspoon = 1 milliliter
1 teaspoon = 5 milliliters
1 tablespoon = 15 milliliters
⅕ cup = 50 milliliters
1 cup = 240 milliliters
2 cups (1 pint) = 470 milliliters
4 cups (1 quart) = 0.95 liter
4 quarts (1 gallon) = 3.8 liters

METRIC TO U.S. CONVERSIONS
1 milliliter = ⅕ teaspoon
5 milliliters = 1 teaspoon
15 milliliters = 3 tablespoons
34 milliliters = 1 fluid ounce
100 milliliters = 3.4 fluid ounces
240 milliliters = 1 cup
1 liter = 34 fluid ounces = 4.2 cups = 2.1 pints = 1.06 quarts =
 0.26 gallon

LIQUOR MEASURES

BEER MEASURES

1 nip = ¼ pint
1 small = ½ pint
1 large = 1 pint
1 flagon = 1 quart
1 firkin = 9.8 gallons
1 anker = 10 gallons
1 barrel = 31½ gallons
1 hogshead = 2 barrels
1 butt = 2 hogsheads
1 tun = 2 butts, 252 gallons

CHAMPAGNE BOTTLE SIZES

Split = ¼ bottle
Pint = ½ bottle
Quart = 800 ml
Bottle = .75 l, 26 fl oz
Magnum = 1.5 l, 2 bottles
Jeroboam = 3 l, 4 bottles
Rehoboam = 4.5 l, 6 bottles
Methuselah = 6 l, 8 bottles
Salmanazar = 9 l, 12 bottles
Balthazar = 12 l, 16 bottles
Nebuchadnezzar = 15 l, 20 bottles

DRINKING GLASS MEASURES

stein (liter) mug = 33.8 fl oz
pint mug = 16.9 fl oz
burgundy glass = 14 fl oz
highball glass = 13.9 fl oz
water glass = 13 fl oz
white wine glass = 11.5 fl oz, also 8–12 fl oz

red wine glass = 9.6 fl oz, also 12–14 fl oz
half-pint mug = 9.6 fl oz
old-fashioned glass = 9.6 fl oz
champagne saucer = 8.7 fl oz
short glass = 7.7 fl oz
champagne flute = 6–7 fl oz
sherry schooner = 5.75–7.7 fl oz
port glass = 2.875–5.75 fl oz
cordial glass = 2 fl oz
liqueur glass = 1.92–3.8 fl oz

SPIRITS BOTTLE SIZES

Miniature = 20–50 mL
Small = 200 mL (formerly half pint)
Medium = 500 mL (formerly pint)
Regular = 750 mL (formerly fifth)
Large = 1 L (formerly quart)
Extra large = 1.75 L (formerly half gallon)

SPIRITS MEASURES

1 pony = 0.5 jigger = 1 fl oz
1 shot = 0.666 jigger = 1.0 shot
1 jigger = 1.5 shot
1 pint = 16 shots = 0.625 fifth
1 fifth = 25.6 shots = 1.6 pints = 0.8 quart = 0.75706 liter
1 quart = 32 shots = 1.25 fifth
1 wine bottle (standard) = 0.800633 quart = 0.7576778 liter

WINE BOTTLE SIZES

Miniature = 20–50 mL
Picolo = 250 mL (formerly split)
Medium or split = 375 mL (formerly tenth)
Regular or standard = 750 mL (formerly fifth)
Large = 1 L (formerly quart)

Magnum = 1.5 L
Extra large = 3 L (formerly jeroboam)

WINE MEASURES
Tun = 252 gallons
Butt or pipe = 126 gallons
Puncheon or Firkin = 84 gallons
Hogshead = 63 gallons
Anker = 10 gallons

GEOMETRY

ANGLES BY DEGREE
acute = 1–89 degrees
right = 90 degrees
obtuse = 91–179 degrees
straight = 180 degrees
reflex = 180–359 degrees

CIRCULAR MEASURE UNITS
Minute = 60 seconds
Degree = 60 minutes
Right angle = 90 degrees
Straight angle = 180 degrees
Circle = 360 degrees

DIMENSIONS
First dimension: a line with no width
Second dimension: a plane, flatland
Third dimension: depth, thickness of common objects

POLYGONS
Triangle = 3 sides
Quadrilateral = 4 sides
Pentagon = 5 sides
Hexagon = 6 sides
Heptagon = 7 sides
Octagon = 8 sides
Nonagon = 9 sides
Decagon = 10 sides
Dodecagon = 12 sides
Quindecagon = 15 sides

TRIANGLES
Equilateral: three equal sides, three equal angles
Isosceles: two equal sides, two equal angles
Obtuse triangle: one angle greater than 90 degrees
Right triangle: one angle of 90 degrees
Scalene: no equal sides, no equal angles

REGULAR POLYHEDRONS
(by number of sides)
Tetrahedron: 4 faces
Hexahedron, or cube: 6 faces
Octahedron: 8 faces
Dodecahedron: 12 faces
Icosahedron: 20 faces

IRREGULAR SOLIDS
(Irregular solids do not have clear dimensions that can be measured; volume must be determined by means of the principle of liquid displacement.)

A. Dymaxion
B. Mecon
C. Square spin
D. Snub cube
E. Icosidodeca-
hedron
F. Truncated
cuboctahedron

G. Truncated
icosahedron
H. Rhombicosi-
dodecahedron
I. Snub
dodecahedron
J. Truncated ico-
sidodecahedron

SEMIREGULAR SOLIDS

(by number of sides)

Cuboctahedron, or dymaxion: 12 corners, 14 faces
Truncated octahedron, or mecon: 24 corners, 14 faces
Rhombicuboctahedron, or square spin: 24 corners, 26 faces
Snub cube: 24 corners, 38 faces
Icosidodecahedron: 30 corners, 32 faces
Truncated cuboctahedron: 48 corners, 26 faces
Truncated icosahedon: 60 corners, 32 faces
Rhombicosidodecahedron: 60 corners, 62 faces
Snub dodecahedron: 60 corners, 92 faces
Truncated icosidodecahedron: 120 corners, 62 faces

MATHEMATICS

ABACUS

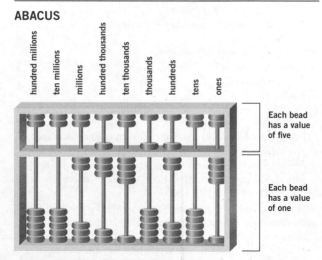

Abacus: The number shown here is 2,845,704

BRANCHES OF MATHEMATICS

Applied Mathematics

Chaos theory (behavior of complex systems in which tiny changes can have major effects, and which therefore seem unpredictable)

Computer science (theory and methods of processing information in digital computers)

Operations research (mathematical analysis of problems for improving efficiency)

Probability (measuring the likelihood of an event)

Statistics (the collection, classification, analysis, and interpretation of numerical facts or data)

Stochastic processes (effect of a random function)

Pure Mathematics

Algebra (operations of arithmetic)

 Algebraic topology (application of algebraic methods to topology)

Arithmetic (fundamental operations)

Calculus (calculating with special system of algebraic notations)

Field theory

Geometry (sets of points in a plane or in space)

 Analytical geometry (geometry through algebraic methods)

 Differential geometry (geometry through calculus methods)

 Euclidean geometry (geometry based on Euclid's axioms)

 Fractal geometry (geometry of fractals)

 Non-Euclidean geometry (geometry based on axioms different from Euclid's)

 Topology (generalized elements and properties)

Logic (system of principles used in mathematics)

Number theory (integers and prime numbers)

Set theory (deals with the nature and relations of sets)

Trigonometry (computing distances)

METRIC SYSTEM

AREA MEASURE
100 square millimeters = 1 square centimeter
10,000 square centimeters = 1 square meter – 1,000,000 square
 millimeters
100 square meters = 1 are
100 ares = 1 hectare = 10,000 square meters
100 hectares = 1 square kilometer =
 1,000,000 square meters

CUBIC MEASURE
1,000 cubic millimeters = 1 cubic centimeter
1,000 cubic centimeters = 1 cubic decimeter = 1,000,000 cubic
 millimeters
1,000 cubic decimeters = 1 cubic meter = 1 stere = 1,000,000
 cubic centimeters = 1,000,000,000 cubic millimeters

DISTANCE *(longest to shortest)*
Kilometer = 1,000 meters
Hectometer = 100 meters
Dekameter = 10 meters
Meter = 1.094 yards
Decimeter = .1 meter
Centimeter = .001 meter
Millimeter = .0001 meter

LINEAR MEASUREMENTS
10 angstroms = 1 nanometer
1,000 nanometers = 1 micrometer
1,000 micrometers = 1 millimeter
10 millimeters = 1 centimeter
10 centimeters = 1 decimeter = 100 millimeters
10 decimeters = 1 meter = 1,000 millimeters

10 meters = 1 dekameter
10 dekameters = 1 hectometer = 100 meters
10 hectometers = 1 kilometer = 1,000 meters

METRIC EQUIVALENTS OF TRADITIONAL MEASUREMENTS

Ancient Roman mile = 1,476 meters
Ancient Scottish mile = 1,814 meters
Danish mile = 7,532 meters
English statute mile = 1,609 meters
Flanders league = 6,276 meters
French league = 4,444 meters
French posting league = 3,898 meters
Geographical mile = 1,855 meters
German geographical mile = 7,419 meters
German long mile = 9,259 meters
German new imperial mile = 7,500 meters
German short mile = 6,272 meters
Irish mile = 2,048 meters
Italian mile = 1,855 meters
Modern Roman mile = 1,489 meters
Old Prussian mile = 7,532 meters
Portuguese league = 6,181 meters
Spanish league (common) = 6,781 meters
Spanish league (judicial) = 4,238 meters
Swedish mile = 10,698 meters
Swiss mile = 8,370 meters
Tuscan mile = 1,653 meters

VOLUME MEASURE, FLUIDS

10 milliliters = 1 centiliter
10 centiliters = 1 deciliter = 100 milliliters
10 deciliters = 1 liter = 1,000 milliliters
10 liters = 1 dekaliter

10 dekaliters = 1 hectoliter = 100 liters
10 hectoliters = 1 kiloliter = 1,000 liters
1 kiloliter = 1 cubic meter

WATER WEIGHTS
(at 4°C)
1 cubic centimeter = 1 gram
1 liter = 1 kilogram
1 cubic meter = 1 metric ton

WEIGHT
10 milligrams = 1 centigram
10 centigrams = 1 decigram = 100 milligrams
10 decigrams = 1 gram = 1,000 milligrams
10 grams = 1 dekagram
10 dekagrams = 1 hectogram = 100 grams
10 hectograms = 1 kilogram = 1,000 grams
1,000 kilograms = 1 metric ton

NUMERALS

NUMBER PREFIXES
Yocto- = 1 septillionth
Zepto- = 1 sextillionth
Atto- = 1 quintillionth
Femto- = 1 quadrillionth
Pico- = 1 trillionth
Nano- = 1 billionth
Micro- = 1 millionth
Milli- = 1 thousandth
Centi- = 1 hundredth
Deci- = 1 tenth
Demi-, hemi-, semi- = 1 half

uni- = 1
Bi-, di- = 2
Ter-, tri- = 3
Quadr-, quadri-, tetr-, tetra-, tessera- = 4
Pent-, penta-, quinqu-, quinque-, quint- = 5
Hex-, hexa-, sex-, sexi- = 6
Hept-, hepta-, sept-, septem-, septi- = 7
Oct-, octa-, octo- = 8
Ennea-, non-, nona- = 9
Dec-, deca-, deka- = 10
Hendeca-, undec-, undeca- = 11
Dodeca- = 12
Quindeca- = 15
Icos-, icosa-, icosi- = 20
Hect-, hecti-, hecto- = 1 hundred
Kilo- = 1 thousand
Myria- = 10 thousand
Mega- = 1 million
Giga- = 1 billion
Tera- = 1 trillion
Peta- = 1 quadrillion
Exa- = 1 quintillion
Zetta- = 1 sextillion
\qquad $(1,000,000,000^7)$
Yotta- = 1 septillion
\qquad $(1,000,000,000^8)$

POWERS OF TEN

(numeral system by zeros)
one = 10^0
10 (one zero)
1 hundred (2 zeros)
1 thousand (3 zeros)
1 million (6 zeros)

1 billion (9 zeros)
1 trillion (12; British billion is a million million,
 or 1 followed by 12 zeros, the same as a
 U.S. trillion)
1 quadrillion (15)
1 quintillion (18)
1 sextillion (21)
1 septillion (24)
1 octillion (27)
1 nonillion (30)
1 decillion (33)
1 undecillion (36)
1 duodecillion (39)
1 tredecillion (42)
1 quattuordecillion (45)
1 quindecillion (48)
1 sexdecillion (51)
1 septendecillion (54)
1 octodecillion (57)
1 novemdecillion (60)
1 vigintillion (63)
1 googol (100)
1 quintoquadagintillion (138)
1 centillion (303)
1 googolplex (googol)

FRACTIONS OF NUMBERS
BASED ON POWER OF TEN

$1/10^1$ = one tenth
$1/10^2$ = one hundredth
$1/10^3$ = one thousandth
$1/10^6$ = one millionth
$1/10^9$ = one billionth
$1/10^{10}$ = one trillionth

ROMAN NUMERAL SYSTEM

I	1	C	100
V	5	CC	200
X	10	CCC	300
XX	20	CCCC	400
XXX	30	D	500
XL	40	DC	600
L	50	DCC	700
LX	60	DCCC	800
LXX	70	CM	900
LXXX or XXC	80	M	1,000
XC	90	MM	2,000

PHYSICS

BRANCHES OF PHYSICS

Acoustics (sound)
 Ultrasonics (sound waves above human perception)
Astrophysics (the physics of stars and nebulae)
Atomic physics (atomic attributes of matter)
Biophysics (the physics of biological structures)
Chemical physics (chemical attributes of matter)
Condensed-matter physics (properties of solid and liquid
 substances)
Electromagnetism (interaction of magnetism and electricity)
 Electronics; solid-state physics (electrical charges in
 various media)
 Optics (light)
Geophysics (physics of earth, air, and waters)
Health physics (protection from hazards)
Mechanics (motion; internal and external forces)
 Dynamics (action of forces in motion or equilibrium)
 Aerodynamics (motion of gases)
 Hydrodynamics (motion of water)

Statics (matter at rest)
 Aerostatics (equilibrium of elastic fluids)
 Hydrostatics (mechanical properties of fluids not in motion)
Kinematics (description of motion)
Molecular physics (physics of molecules)
Nuclear physics (structure of atomic nucleus and radiation from
 unstable nuclei)
Particle physics (fundamental subatomic constituents of matter)
Quantum mechanics (energy and momentum are quantized;
 the effects at atomic and subatomic levels)
Statistical mechanics (macroscopic behavior of systems)
Thermal physics (physics' interrelation with temperatures)
 Cryogenics (processes at extremely low temperatures)
 High-temperature research
 Thermodynamics (energy and heat transfer)
Tribology (friction, lubrication, and wear)

BOILING STAGES *(first three seen in water boiling in pan or
teakettle; last is seen only in special cases)*
Convection: asccension of heated water
Bubble collapse: reaching of boiling point causes bubbles to
 eject steam
Smooth boiling: top bubbles burst but are immediately replaced
 by new bubbles
Bumping: violent boiling caused by super heating

CLASSIFICATIONS OF ENERGY

Forms of Energy	**Alternative Classification of Energy**
Free	Nonrenewable energy (fossil fuels)
Kinetic, or dynamic	
Potential, or static	Renewable energy (wind, water, solar, heat from inside earth)
Radiant, or electromagnetic	
Zero-point	

Types of Energy

Chemical	Solar
Electrical	Steam
Geothermal	Thermal (heat)
Hydraulic	Tidal
Internal	Water
Magnetic-field energy	Wind
Nuclear	

EFFECTS OF ACCELERATIONS IN G-FORCES (G'S)

In Downward Direction *(in a rocket taking off)*

1 G: no noticeable effect to persons in erect or seated position

2 G's: increase in weight, pressure on buttocks, drooping face and soft tissues

2.5 G's: difficult to raise oneself

3–4 G's: impossible to raise oneself, difficult to raise arms and legs, movements at right angles impossible, progressive dimming of vision after 3 to 5 seconds, progressive tunneling of vision

4.5–6 G's: blackout after 5 seconds, bizarre dreams, convulsion possible, cramps, tingling, difficulty breathing, loss of orientation in time and space

In Upward Direction *(during rocket reentry)*

1 G: unpleasant but tolerable

2–3 G's: facial congestion, throbbing headache, blurring or reddening of vision after 5 seconds, puffy eyes, skin hemorrhages

5 G's: pass out in 5 seconds

During Forward or Backward Acceleration

2–3 G's: increased weight and abdominal pressure

3–6 G's: progressive tightening in chest, loss of peripheral vision, chest pain, difficulty breathing and talking

6–9 G's: increased difficulty breathing, chest pain, seeing

9–12 G's: severe breathing difficulty, fatigue, chest pain, loss of peripheral vision, tearing

15+ G's: extreme difficulty breathing and speaking, viselike pain, loss of tactile sensations, recurrent and complete loss of vision

ELECTROMAGNETIC WAVELENGTHS

Extremely low frequency (ELF)	0–3 KHz
Very low frequency (VLF)	3–30 KHz
Radio navigation and maritime mobile	9–540 KHz
Low frequency (LF)	30–300 KHz
Medium frequency (MF)	300–3,000 KHz
AM radio	540–1,630 KHz
Travelers' information service	1,610 KHz
High frequency (HF)	3–30 MHz
Short-wave radio	5.95–26.1 MHz
Very high frequency (VHF)	30–300 MHz
Low-band TV, channels 2–6	54–88 MHz
Mid-band FM radio	88–174 MHz
High-band TV, channels 7–13	174–216 MHz
Super-band mobile; fixed radio and TV	216–600 MHz
Ultra-high frequency (UHF)	300–3,000 MHz
TV channels 14–70	470–806 MHz
L-Band	500–1,500 MHz
Personal communications services (PCS)	1,850–1,990 MHz
Unlicensed PCS devices	1,910–1,930 MHz
Superhigh frequencies/microwave (SHF)	3–30 GHz
C-band	3.6–7.025 GHz
X-band	7.25–8.40 GHz
Ku-band	10.7–14.5 GHz
Ka-band	17.3–31.0 GHz
Extremely high frequencies (EHF)	30.0–300 GHz

Additional fixed satellite	38.6–275 GHz
Infrared radiation	300–430 THz
Visible light	430–750 THz
Ultraviolet radiation	1.62–30 PHz
X-rays	30 PHz–30 EHz
Gamma rays	30–3,000 EHz

FLIGHT FORCES
(factors of the equation of equalizing and adjusting that makes flight possible)

Lift (upward motion)	Weight (downward motion)
Thrust (forward motion)	Drag (backward motion)

LAWS OF THERMODYNAMICS
Conservation of energy: The free change in the internal energy of a kinetic or dynamic system is equal to the sum of the potential or static heat added to the system and the radiant or electromagnetic work done on it.

Entropy: (measure of disorder of molecules and atoms) of disordered solids reaches zero at absolute zero, i.e., there will be no disorder at all.

Heat always flows from a higher temperature to a lower: It is impossible for any self-acting machine, without any other agent, to transfer heat to another body at a higher temperature.

NATURAL FORCES
(forces that bind matter together and direct the motion of all matter, strong to weak)

Strong nuclear force
Electromagnetic force
Weak nuclear force
Gravitational force; gravity

VISIBLE COLOR SPECTRUM

(measured in nanometers [nm], a wavelength of 1 billionth of a meter)

Red: 740–620 nm **Blue:** 500–445 nm
Orange: 620–585 nm **Indigo:** 445–425 nm
Yellow: 585–575 nm **Violet:** 450–350 nm
Green: 575–500 nm

SPEED

SPEED EQUIVALENCIES

10 mph = 16.1 kmh	20 kmh = 12.4 mph
15 mph = 24.1 kmh	30 kmh = 18.6 mph
20 mph = 32.2 kmh	40 kmh = 24.9 mph
30 mph = 48.3 kmh	50 kmh = 31.1 mph
40 mph = 64.4 kmh	55 kmh = 34.2 mph
50 mph = 80.4 kmh	60 kmh = 37.3 mph
60 mph = 96.5 kmh	70 kmh = 43.5 mph
70 mph = 112.6 kmh	80 kmh = 49.7 mph
80 mph = 128.7 kmh	100 kmh = 62.1 mph
90 mph = 144.8 kmh	110 kmh = 68.4 mph
100 mph = 160.9 kmh	120 kmh = 74.6 mph

TIME

CHINESE CALENDAR

(The Chinese calendar assigns an animal to each year on the basis of astrological cycles.)

1996, 2008	Rat	2002, 2014	Horse
1997, 2009	Ox	2003, 2015	Sheep
1998, 2010	Tiger	2004, 2016	Monkey
1999, 2011	Hare	2005, 2017	Rooster
2000, 2012	Dragon	2006, 2018	Dog
2001, 2013	Serpent or Snake	2007, 2019	Boar or Pig

GREGORIAN CALENDAR

(solar calendar based on the movement of the earth around the sun; months' names derive from Latin)

January (Januarius or Ianuarius)

February (Februarius)

March (Martius)

April (Aprilis)

May (Maius)

June (Junius)

July (Julius)

August (Augustus)

September (from Latin for seven; originally it was the seventh month)

October (from Latin for eight)

November (from Latin for nine)

December (from Latin for ten)

INCA CALENDAR

Capac Raimi, or Capac Quilla: equivalent to December; month of rest; the lord festival

Zarap Tuta Cavai Mitan: time to watch corn growing

Paucar Varai: time to wear loincloths

Pacha Pucuy Quilla: month of land's maturation

Camai Quilla, or Inti Raymi: month of harvest and rest

Zara Muchuy Quilla Aymoray Quilla: dry corn is stored

Papa Allai Mitan Pacha: potato harvest

Haucai Cusqui: rest from harvesting

Chacra Conaqui Quilla: month of land redistribution

Chacra Yapuy Quilla Hailly: month to open lands coming into cultivation with songs of triumph

Zara Tarpuy Quilla, or Coia Raymi Quilla: month for planting; Festival of the Queen

Chacramanta Pisco Carcoy: time to scare birds from newly planted fields

Chacra Parcay: time to irrigate fields

MAYA CALENDAR
(This sophisticated calendar was also adopted by the Aztecs and the Toltec.)

Longer Cycles
(The tzolkin is combined with another 365-day calendar known as the haab to form a synchronized cycle called the Calendar Round, which lasts for 52 haabs.)

Tzolkin: 260-day sacred year of a combination of the numbers 1–13 with 20 day names

Haab: solar year of eighteen 20-day months (numbered 0–19) followed by a five-day unlucky period (Uayeb)

Other Cycles
(Cycles of 13 days and 20 days were important components of the tzolkin and haab cycles, respectively.)

Trecena (13 days)
Uinal, or Veintena (20 days)
Tun (360 days)
Katun (7,200 days)
Baktun (144,000 days)
Alautun (23,040,000,000 days)

Names of Months
(Each month had 20 days, except Ch'en, which has only 5.)

Pop	Zac
Uo	Ceh
Zip	Mac
Tzoz	Kankin
Tzec	Muan
Xul	Pax
Yaxkin	Kayab
Mol	Cumhu
Ch'en	Uayeb
Yax	

DAYS OF THE WEEK
(with origins of names)
Sunday: sun day
Monday: moon day
Tuesday: day of Tiw, god of battle
Wednesday: day of Woden, or Odin, god of poetry
 and the dead
Thursday: day of Thor, god of thunder
Friday: day of Frigg, goddess of married love
Saturday: day of Saturn, god of fertility
 and agriculture

INTERVALS OF TIME

Semidiurnal: twice a day
Diurnal: daily
Biweekly: twice a week
 or every 2 weeks
Semiweekly: twice a week
Weekly: once a week
Bimonthly: twice a month
 or every 2 months
Triweekly: three times a
 week or every 3 weeks
Semimonthly: twice a month
Monthly: once a month
Trimonthly: every 3 months
Quarterly: four times a year
Biannual: twice a year
Semiannual: every 6 months
Annual: yearly
Perennial: occurring year
 after year
Biennial: 2 years
Triennial: 3 years

Quadrennial: 4 years
Quinquennial: 5 years
Sexennial: 6 years
Septennial: 7 years
Octennial: 8 years
Novennial: 9 years
Decennial: 10 years
Undecennial: 11 years
Duodecennial: 12 years
Quindecennial: 15 years
Vicennial: 20 years
Tricennial: 30 years
Quadricennial: 40 years
Semicentennial: 50 years
Centennial: 100 years
Sesquicentennial: 150 years
Bicentennial: 200 years
Quadricentennial: 400 years
Quincentennial: 500 years
Millennial: 1,000 years

PERIODS OF TIME

Millennium: 1,000 years
Half millennium: 500 years
Century: 100 years
Half century: 50 years
Score: 20 years
Decade: 10 years
Lustrum, half decade: 5 years
**Quadrenniumm or
 Olympiad:** 4 years
Triennium: 3 years
Biennium: 2 years

Leap year: 366 days
Year: 12 months; 52 weeks;
 365 days
Trimester: 3 months
Month: 28–31 days
Fortnight: 2 weeks
Week: 7 days
Day: 24 hours
Hour: 60 minutes
Minute: 60 seconds
Second: ¹⁄₆₀ minute

SECONDS

terasecond: 31,689 years
gigasecond: 31.7 years
megasecond: 11.6 days
kilosecond: 16.67 minutes
millisecond: 0.001 second
microsecond: 0.000001 second
nanosecond: 0.000000001 second
picosecond: 0.000000000001 second
femtosecond: 0.000000000000001 second
attosecond: 0.000000000000000001 second

TIMES OF THE DAY

Midnight: 12 A.M., official
 beginning of new day
Twilight: first glow of sunlight
Daybreak: first appearance
 of sun
Dawn: gradual increase of
 light after daybreak
Morning
Noon: 12 P.M.

Afternoon
Dusk: gradual decrease of light
Sunset: last sight of sun
Twilight: last glow of sunlight
Evening: approximately
 between sunset and
 bedtime
Night: darkness from sunset
 to midnight

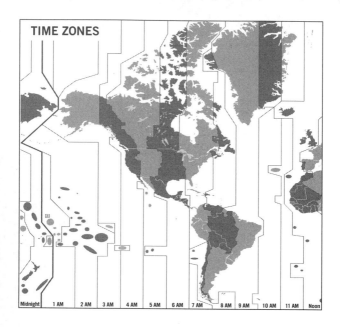

U.S. MEASURES

AREA MEASURE

144 square inches = 1 square foot

9 square feet = 1 square yard = 1,296 square inches

1 square rod = 30.25 square yards = 272.25 square feet

40 square rods = 1 rood

160 square rods = 1 acre = 4,840 square yards =
 43,560 square feet

640 acres = 1 square mile

1 mile square = 1 section (of land)

6 miles square = 1 township = 36 sections = 36 square miles

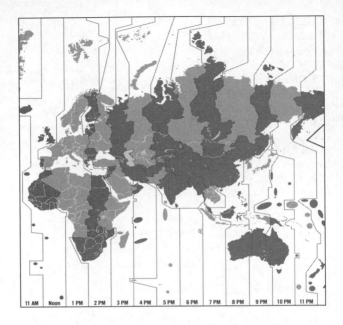

AVOIRDUPOIS WEIGHT *(French system based on a pound)*
27$\frac{11}{32}$ grains = 1 dram
16 drams = 1 ounce = 437$\frac{1}{2}$ grains
16 ounces = 1 pound = 256 drams = 7,000 grains
100 pounds = 1 hundredweight
20 hundredweights = 1 ton = 2,000 pounds

CHAIN MEASURE—GUNTER'S OR SURVEYOR'S
(geodetic system, formerly popular in Britain)
7.92 inches = 1 link
100 links = 1 chain = 4 rods = 66 feet
80 chains = 1 survey mile = 320 rods = 5,280 feet

CUBIC MEASURE
1 cubic foot = 1,728 cubic inches
27 cubic feet = 1 cubic yard

DRY MEASURE *(for dry commodities such as fruit or grain)*
2 pints = 1 quart = 57.75 cubic inches
8 quarts = 0.86 peck = 462 cubic inches = 16 pints
4 pecks = 1 bushel = 2,150.42 cubic inches = 37.24 quarts

LINEAR MEASURES
12 inches = 1 foot
3 feet = 1 yard
1 rod (pole, or perch) = 5½ yards = 16½ feet
4 rods = 1 chain
40 rods = 1 furlong = 220 yards = 660 feet
8 furlongs = 1 statute mile = 1,760 yards = 5,280 feet
3 miles = 1 league = 5,280 yards = 15,840 feet
6076.11549 feet = 1 international nautical mile

LIQUID MEASURE
4 gills = 1 pint = 28.875 cubic inches
2 pints = 1 quart = 57.75 cubic inches
4 quarts = 1 gallon = 231 cubic inches = 8 pints = 32 gills

TROY WEIGHT *(for weighing precious metals and gemstones)*
24 grains = 1 pennyweight
20 pennyweights = 1 ounce troy = 480 grains
12 ounces troy = 1 pound troy = 240 pennyweights = 5,760 grains

WEIGHT OF WATER *(at 68°F)*

1 cubic inch = 0.0361 lb.	35.96 cubic feet = 2,240.0 lb.
12 cubic inches = 0.433 lb.	1 U.S. gallon = 8.34 lb.
1 cubic foot = 62.4 lb.	13.45 U.S gallons = 112.0 lb.
1.8 cubic feet = 112.0 lb.	269 U.S. gallons = 2,240.0 lb.

RELIGION

O rder is Heaven's first law.

—Alexander Pope, *An Essay on Man*

ANGELS

NINE ORDERS OF ANGELS IN THREE HIERARCHIES
(Various hierarchies for angels exist; this list presents the most agreed-upon order, compiled by Gregory the Great, 6th century A.D., listed by rank.)

First hierarchy
Seraphim: highest angels, of love, light, and fire
Cherubim: angels who pray or intercede
Thrones: angels in charge of justice

Second hierarchy
Dominations (Dominions): regulate angel duties
Virtues: work miracles on earth
Powers: impose order on heavenly pathways

Third hierarchy
Principalities: protectors of religion, kingdom, people
Archangels: minister and make propitiation for people's sins
Angels: those from which guardians of humans and nations are selected; messengers between God and humans

ZODIAC AND ASSOCIATED ANGELS
(from Gustav Davidson's A Dictionary of Angels, 1971)

Capricorn: Hanael
Aquarius: Gabriel
Pisces: Barchiel
Aries: Machidiel
Taurus: Asmodel
Gemini: Ambriel

Cancer: Muriel
Leo: Verchiel
Virgo: Hamaliel
Libra: Urielw
Scorpio: Barbiel
Sagittarius: Adnachiel

THE BIBLE

BOOKS OF THE OLD TESTAMENT

Law (Pentateuch, Torah)
- Genesis
- Exodus
- Leviticus
- Numbers
- Deuteronomy

Prophets, Former
- Joshua
- Judges
- Samuel 1, Samuel 2
- Kings 1, Kings 2

Prophets, Latter
- Isaiah
- Jeremiah
- Ezekiel

"Book of Twelve Prophets"
- Hosea
- Joel
- Amos
- Obadiah
- Jonah
- Micah
- Nahum
- Habakkuk
- Zephaniah
- Haggai
- Zechariah
- Malachi

Writings
- Psalms
- Proverbs
- Job
- Song of Songs (Solomon)
- Ruth
- Lamentations
- Ecclesiastes
- Esther
- Daniel
- Ezra
- Nehemiah
- Chronicles 1, Chronicles 2

BOOKS OF THE NEW TESTAMENT

Gospels

Matthew	Luke
Mark	John

Epistles

(21 books starting with Romans and ending with Jude)

Acts of the Apostles (13 Letters Attributed to Paul)
- Romans
- Corinthians 1, Corinthians 2
- Galatians

 Ephesians
 Philippians
 Colossians
 Thessalonians 1, Thessalonians 2
 Timothy 1, Timothy 2
 Titus
 Philemon
 Letter to the Hebrews
7 General, or "Catholic," Letters
 James
 Peter 1, Peter 2
 John 1, John 2, John 3
 Jude
 Book of Revelation (the Apocalypse)

BOOKS OF THE APOCRYPHA

*(writings in Greek version of Hebrew Bible; they are
canonical only in Catholicism, filling in some of the gaps
left by the indisputably canonical books)*
Baruch
Additions to the Book of Daniel
Book of Ecclesiasticus by Sirach
Additions to the Book of Esther
Books of Esdras
Letter of Jeremiah
Book of Judith
Books of the Maccabees
Book of Tobit (Tobias)
Wisdom of Solomon

BOOKS OF THE BIBLE BY TYPE

Historical Books of the Bible *(composed at different times and
places, but arranged in a sequence that tells the story of God's
people from the occupation of Canaan through the rise and fall*

of the northern and southern kingdoms, and the return and rebuilding of Jerusalem in the Persian period)

Joshua
Judges
Ruth
1 Samuel
2 Samuel
1 Kings
2 Kings
1 Chronicles
2 Chronicles
Ezra
Nehemiah
Tobit (Catholic and Orthodox only)
Judith (Catholic and Orthodox only)
Esther
1 Maccabees (Catholic and Orthodox only)
2 Maccabees (Catholic and Orthodox only)

Prophetical Books of the Bible
(continue the story of Israel in the Promised Land, describe the establishment and development of the monarchy, and present the messages of the prophets to the people)

Isaiah
Jeremiah
Lamentations
Baruch
 (Catholic and Orthodox
 only)
Ezekiel
Daniel
Hosea
Joel

Amos
Obadiah
Jonah
Micah
Nahum
Habakkuk
Zephaniah
Haggai
Zechariah
Malachi

Wisdom or Poetic Books of the Bible

(writings that speculate on the place of evil and death in the scheme of things, the poetical works, and some additional historical books)

Job

Psalms

Proverbs

Ecclesiastes

Song of Solomon

Wisdom (Catholic and Orthodox only)

Sirach (Catholic and Orthodox only)

ENGLISH-LANGUAGE BIBLES

(the best-known translations and revisions)

John Wycliffe, the Latin Vulgate, 1382

William Tyndale, translation of New Testament, 1525–1526

Miles Coverdale, 1535

Thomas Matthew (aka John Rogers), 1537

Taverner's Bible, 1539

Archbishop Cranmer's Great Bible, 1539

Geneva Bible, 1560

Bishops' Bible, 1568

Douay-Rheims Bible, 1582–1609

Roman Catholic Authorized, 1609–1610

King James's Version
 (Authorized Version), 1611

English Revised Version, 1881–1885

Revised Standard Version, 1952

The Living Bible, 1971

Revised King James Version, 1982

New Revised Standard Version, 1989

The Revised English Bible, 1989

English Standard Version, 2001

World English Bible, in progress

BUDDHISM

CALENDAR *(begins in April)*

Citta	Sâvana	Maggasira
Vesâkha	Potthapâda	Phussa
Jettha	Assayuia	Mâgha
Âsâlha	Kattikâ	Phagguna

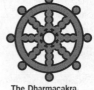

The Dharmacakra, or Wheel of Dharma, represents the teachings of Buddha.

DHARMA *(teachings of Buddha)*

Four Noble Truths
Life is full of suffering.
Suffering is caused by attachment, greed, or desire.
Suffering ends when we see the impermanence of everything.
There is a path to peace and contentment, the eightfold noble path.

Eightfold Noble Path
Right understanding: seeing the world as it really is
Right intentions: kindness and compassion
Right speech: not lying, criticizing, hurting with words
Right action: not harming, not stealing, not overindulging
Right livelihood: earning a living by not harming others
Right effort: attempting to do meritorious things
Right mindfulness: being aware and alert
Right concentration: meditation and avoidance of excess

FIVE HINDRANCES
(negative mental states that impede success)
Sensual desire: seeking worldly advantage
Anger: desiring to hurt others
Sloth: slackness of mind
Restlessness: worry
Doubt: uncertainty of mind

FIVE MORAL PRECEPTS *(basic Buddhist code of ethics)*
Do not take life, including that of animals
Do not steal
No wrong sexual relations
No wrong use of speech (lying, malicious gossip)
Abstinence or moderate use of alcohol and drugs

FOUR SIGNS *(the four encounters with suffering and impermanence experienced by Siddhartha, the Buddha)*

Old age	Death
Sickness	Austerity

SCHOOLS AND SECTS
Theravada
Mahayana Sects
Avatamsaka
Dhyana (Zen)
Madhyamika
Pure Land
Vajrana (tantric)
Yogacara
Hinayana Sects
Abhidharma-Kosa
Dharmaguptaka
Dharma-Laksana
Insight Meditation
Lokottaravada
Mantra
Sammatiya
Sarvastivada
Satyasiddhi
Sukhavati
Tibetan
Vinaya

CHRISTIANITY

BEATITUDES OF JESUS
(Matthew 5:3–12, Jesus' Sermon on the Mount)
Blessed are the poor in spirit, for theirs is the kingdom
 of heaven.
Blessed are those who mourn, for they shall be comforted.
Blessed are the meek, for they shall inherit the earth.
Blessed are those who hunger and thirst after righteousness,
 for they shall be satisfied.
Blessed are the merciful, for they shall obtain mercy.
Blessed are the pure in heart, for they shall see God.
Blessed are the peacemakers, for they shall be called sons of God.
Blessed are those who are persecuted for righteousness' sake,
 for theirs is the kingdom of heaven.
Blessed are you when men shall revile you and persecute you
 and utter all kinds of evil against you falsely on my account.
 Rejoice and be glad, for your reward is great in heaven,
 for so men persecuted the prophets who were before you.

CANONICAL HOURS
*(Psalms 119:164, the seven hours of psalms of praise each day
for God's righteous ordinances)*
Matins (or Mattins) with Lauds: midnight or 2 A.M.,
 and often at sunrise
Prime: first hour of the day, or 6 A.M.
Tierce: third hour after sunrise
Sext: sixth hour of the day, or noon
Nones: ninth hour after sunrise
Vespers: late afternoon or in the evening
Complin (or Compline): just before bedtime

CHURCH OF ENGLAND ORGANIZATION
Monarch: official head of church

Archbishop of Canterbury: the Primate of All England
General Synod: made up of bishops, clergy, and lay people
Dioceses: governed by bishops
Parishes: governed by clergy

CHRISTIAN CHURCH HISTORY
Early Church
Great Schism, 1054: Eastern Orthodox and Western
 Catholic churches

Eastern Orthodox

Albanian Orthodox	Romanian Orthodox
Coptic	Russian Orthodox
Greek Orthodox	Serbian Orthodox
Polish Orthodox	

Western Catholic
 (Church of Rome)
 Roman Catholic

Reformation: Protestant churches

Adventists	Methodist
Baptist	Pentecostal
Church of England	Presbyterian (Calvinist)
(Anglican)	Quakers
Congregational	Other Protestant
Lutheran	denominations

CHURCH OF JESUS CHRIST OF LATTER-DAY SAINTS (MORMONS) HIERARCHY
First Presidency: President and two counselors
Council of the Twelve Apostles
Patriarch
First Quorum of the Seventy
Presiding Bishopric: three members
Stakes: collection of several wards
Wards: 400–600 members each

CROSSES

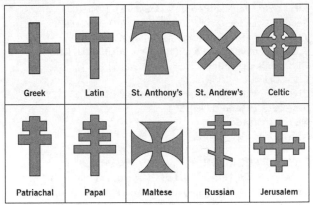

| Greek | Latin | St. Anthony's | St. Andrew's | Celtic |
| Patriachal | Papal | Maltese | Russian | Jerusalem |

COVENANTS

Edenic Covenant: God promises to provide everything Adam and Eve will need provided they do not eat from the tree of knowledge (Genesis 1:26–31; 2:16–17)

Adamic Covenant: God declares the curses pronounced against mankind for the sin of Adam and Eve (Genesis 3:16–19)

Noahic Covenant: God promises never again to destroy the world by flood (Genesis 9:8–17)

Abrahamic Covenant: God promises Abraham a great land and blesses his descendants, who will become a great nation (Genesis 12:1–3)

Mosaic Covenant: God swears to be Israel's God and Israel swears to worship no other lord (Exodus 19:5–6)

Davidic Covenant: God promises David's house and kingdom shall endure forever (2 Samuel 7:8–16)

New Covenant: Through Christ, God's law will be written on men's and women's hearts (Jeremiah 31:31–34)

CRUSADES
First Crusade (the People's Crusade): 1096–1099
Second Crusade (the Monks' Crusade): 1147–1149
Third Crusade (the Kings' Crusade): 1187–1192
Fourth Crusade (the Knights' Crusade): 1202–1204
Children's Crusade: 1212
Fifth Crusade: 1217–1221
Sixth Crusade (the Pope's Crusade): 1228–1229
Seventh Crusade: 1248–1254
Eighth Crusade: 1270
Ninth Crusade: 1271–1272

DAYS OF CREATION *(Genesis 1:1–31; 2:1–3)*
In the beginning God created the heavens and the earth.
On the first day, He created light and dark, Day and Night.
On the second day, He made the firmament, dividing the waters,
 the firmament He called Heaven.
On the third day, He made the Earth, and the Seas, and grasses,
 herbs, and trees upon the earth.
On the fourth day, He made the Stars and the Sun and the Moon.
On the fifth day, God created the creatures of the sea and
 the air, the fish and the fowl.
On the sixth day, God created the living creatures and He created
 man.
On the seventh day, He rested.

EPISCOPAL CHURCH LITURGICAL CALENDAR
Ash Wednesday (February)
First Sunday in Lent
Passion (Palm) Sunday
Good Friday
Easter Day
Ascension Day
The Day of Pentecost

Trinity Sunday
First Sunday of Advent (November or December)

FIVE TENETS OF CALVIN
*(Calvin's doctrine of predestination came from his belief
in human sinfulness and God's sovereign mercy in Christ;*
Institutes of the Christian Religion, *1536.)*
The transcendence of God
The total depravity of natural man
The predestination of particular election (God chose some
 for salvation)
The sole authority of the scriptures and the Holy Spirit
The community must enforce the discipline of the church

Alternative Wording
God as majesty
Christ as prophet, priest, and king
Holy Spirit as giver of faith
The Bible as the final authority
The Church as the holy people of God

FRANCISCAN ORDERS
*(Founded by St. Francis of Assisi in the 11th century,
these Roman Catholic and Anglican religious orders follow
a body of regulations known as the Rule of St. Francis.)*
Friars Minor (Franciscans; First Order): missionaries
 and educators
Poor Clares (Clarisse; Second Order): women's order
 named for Saint Clare
Brothers and Sisters of Penance (Third Order)

GIFTS OF THE HOLY SPIRIT *(1 Corinthians 12:4–11)*
To each is given manifestation of the Spirit for the common good
 then, to one is given:

The utterance of wisdom
The utterance of knowledge
Faith
Gifts of healing
The working of miracles
Prophecy
The ability to distinguish between spirits
To distinguish between various kinds of tongues
To interpret various kinds of tongues

HISTORICAL HIERARCHY OF ORTHODOX CHURCHES

Autocephalous Churches
(governed by its own head bishop)

Constantinople	Serbia
Alexandria	Romania
(Egypt)	Bulgaria
Antioch or Damascus	Greece
(Syria)	Albania
Jerusalem	Rome
Russia	Serbia
Republic of Georgia	Cyprus

Nonpatriarchal Churches *(in order of precedence)*
Cyprus
Athens
Tirana (Albania)
Poland
Czech Republic
Slovakia
America

ORTHODOX CALENDAR HOLIDAYS
January 1: St. Basil's Day; Circumcision of the Lord
January 6: Epiphany

February 2: Hypapante (Christ's meeting with Simeon)
March 25: Annunciation
March: Orthodox Sunday
March or April: Palm Sunday
March or April: Easter
April or May: Ascension Day
May: Pentecost
July 17: St. Marina's Day
August 6: Transfiguration
August 15: Assumption
September 8: Nativity of Blessed Virgin
September 14: Exaltation of Holy Cross
October 26: St. Demetrius' Day
November 21: Presentation of Blessed
 Virgin Mary in Temple
November 30: St. Andrew's Day
December 25: Christmas Day

ORTHODOX CHURCH HIERARCHY

Synod (bishops in an ecclesiastical territory, presided over
 by an archbishop or metropolitan; or archbishops and
 metropolitans form synod, headed by patriarch)
Council (presbyters)
Archbishop (chief bishop)
Metropolitans (bishop of a chief city)
Patriarch (leading bishop in a great region or
 national church)
Bishop (leader of diocese, a church for a region)
Presbyter (leader of parish, a local congregation)
Monks
Deacon
Subdeacon
Reader
Acolyte

PLAGUES OF EGYPT

(The Lord set ten plagues upon Egyptians after Pharaoh refused Moses's plea to free the Hebrews from slavery [Exodus 7–11].)

Blood

Frogs

Lice

Flies

Murrain, by which all cattle of Egypt were killed

Boils

Hail

Locusts

Darkness

Slaying of the firstborn of Egypt

POPES

Popes with Longest Reigns

Pius IX (1846–1878): 31 years, 7 months, and 23 days (11,560 days)

John Paul II (1978–2005): 26 years, 5 months, and 18 days (9,666 days)

Leo XIII (1878–1903): 25 years, 5 months, and 1 day (9,281 days)

Pius VI (1775–1799): 24 years, 6 months, and 15 days (8,962 days)

Adrian I (772–795): 23 years, 10 months, and 25 days (8,729 days)

Pius VII (1800–1823): 23 years, 5 months, and 7 days (8,560 days)

Alexander III (1159–1181): 21 years, 11 months, and 24 days (8,029 days)

St. Sylvester I (314–335): 21 years, 11 months, and 1 day (8,005 days)

St. Leo I (440–461): 21 years, 1 month, and 13 days
(7,713 days)
Urban VIII (1623–1644): 20 years, 11 months, and 24 days
(7,664 days)

Popes with Shortest Reigns

Urban VII (September 15–September 27, 1590): reigned
for 13 calendar days, died before consecration
Boniface VI (April, 896): reigned for 16 calendar days
Celestine IV (October 25–November 10, 1241): reigned
for 17 calendar days, died before consecration
Theodore II (December, 897): reigned for 20 calendar days
Sisinnius (January 15–February 4, 708): reigned for
21 calendar days
Marcellus II (April 9–May 1, 1555): reigned for 22
calendar days
Damasus II (July 17–August 9, 1048): reigned for 24
calendar days
Pius III (September 22–October 18, 1503): reigned for 27
calendar days
Leo XI (April 1–April 27, 1605): reigned for 27 calendar days
Benedict V (May 22–June 23, 964): reigned for 33 calendar
days

PRESBYTERIAN HIERARCHY

Presbyters (or elders): manage spiritual conduct of
church
Deacons and trustees: handle temporal affairs
Courts: composed of clerical and lay presbyters
(highest to lowest)
 General assembly: presided over by moderator or Synod
 Presbytery or colloquy
 Court of the congregation or session

ROMAN CATHOLIC ADMINISTRATION

Pope

The Synod of Bishops (elected representatives from the
 episcopate)

The National and Regional Conferences of Bishops

The College of Cardinals (the senate of the pope; cardinal is a
 largely honorary title)

Roman Curia (complex of congregations, offices, tribunals,
 and secretariates through which the pope directs the
 church's central government)

 Cardinal vicar general of Rome

 Chamberlain

 Major penitentiary

 Congregation

 Cardinal prefect

 Secretary

 Undersecretary

 Papal appointees

 7 bishops assigned from various countries

 Lesser officials and consultors

 Council of the Laity

 Papal Commission for Promoting Justice and Peace

The Sacred Congregations

 The Sacred Congregation for the Teaching of the Faith

 The Sacred Congregation for the Oriental Churches

 The Sacred Congregation for Bishops

 The Sacred Congregation for the Sacraments and for
 Divine Worship

 The Sacred Congregation for the Causes of Saints

 The Sacred Congregation for Religious and Secular Institutes

 The Sacred Congregation for Catholic Education

 The Sacred Congregation for the Evangelization of the Nations
 or Propaganda Fide

The Secretariats
 The Papal Secretariat and the Papal Council for the Church's
 Public Affairs
 The Secretariat for Promoting Christian Unity
 The Secretariat for Non-Christians
 The Secretariat for Nonbelievers

The Sacred Tribunals
 The Supreme Tribunal of the Apostolic Signature
 The Sacred Roman Rota
 The Sacred Apostolic Penitentiary

The Sacred Offices
 The Apostolic Chancery
 The Prefecture of the Holy See's Economic Affairs
 The Apostolic Chamber (The Administration of the Patrimony
 of St. Peter)
 The Prefecture of the Apostolic Palace
 The Central Statistics Office

ROMAN CATHOLIC CALENDAR

January 1: Solemnity of Mary, Mother of God
January 6: Epiphany
February: Ash Wednesday
March 19: St Joseph's Day
March 25: The Annunciation
March: Palm Sunday
April: Holy Week
April: Easter (calculated according to the moon's phases;
 falls on different dates)
May: Ascension Day
May: Pentecost
June: Trinity Sunday
June: Corpus Christi

June 29: St. Peter and Paul Day
August 6: Transfiguration
August 15: Assumption of Blessed Virgin Mary
September 8: Nativity of the Virgin
November 1: All Saints' Day
December 8: Immaculate Conception
December 25: Christmas Day

ROMAN CATHOLIC HIERARCHY AND ORGANIZATION

Supreme Pontiff (Pope): elected by College of Cardinals
College of Cardinals
Cardinal
Archbishop: bishop of highest rank, heading archdiocese or province

Archdiocese/province/metropolitan see (ecclesiastical province of "suffragen" dioceses)

Bishop: high-ranking cleric, head of diocese, territory of large number of parishes

Chancery (curia): assists bishop; comprise vicar general, officialis, chancellor, consultors, synodal examiners, promotor of justice, defender of the bond

Parish priest or pastor: cleric of second grade, just below a bishop

Deacon: cleric just below a priest

Parish: local community

Abbot: superior of a monastery

Abbey: abbey nullius

ROMAN CATHOLIC MASS

Introductory Rites
Antiphon at the Entrance
Salutation (greeting) of Altar and People
Penitential Act
Appeal for Mercy (Kyrie)

Gloria in Excelsis (Praise)
Collect
Liturgy of the Word
Scripture readings
Responsorial Psalm or Gradual
Alleluia
Homily
Profession of Faith (Creed)
Prayer for the Faithful (General Intercession or Bidding Prayer)
Liturgy of the Eucharist
Preparation of the Gifts
Eucharistic Prayer—Thanksgiving, Acclamation, Epiclesis,
Institution: Narrative and Consecration, Anamnesis,
Oblation, Intercessions, Doxology
Communion Rite—Lord's Prayer, Rite of Peace, Breaking
of Bread, Commingling, Agnus Dei, Private Preparation
of the Priest, Invitation, Distribution of Communion,
Singing at Communion, Pause, Postcommunion
Concluding Rites
Blessing of the People
Dismissal

ROMAN CATHOLIC SEVEN HOLY SACRAMENTS

Baptism
Reconciliation (Penance)
Eucharist (Holy Communion)
Confirmation
Holy Matrimony

Holy Orders
Anointing of the Sick
(also Extreme Unction
or Last Rites)

SEVEN DEADLY (CAPITAL) SINS

Pride
Covetousness
Lust
Anger

Gluttony
Envy
Sloth

SEVEN JOYS OF MARY

The Annunciation, when the Angel Gabriel announced that she
would be with child (Luke 1:26–38)

The Visitation, the visit of the Virgin Mary to her cousin
Elizabeth, who was also with child (Luke 1:39–56)

The Nativity, or the birth of Christ (Luke 2:1–7)

The Adoration of the Magi, when the Three Wise Men arrived
bearing gifts for the King of the Jews (Matthew 2:11)

The Finding of the Lost Child Jesus in the temple where he had
been astonishing the elders with his learning (Luke 2:42–51)

The Resurrection of Christ (Luke 24:1–8)

The Assumption, when the Virgin Mary arose bodily into Heaven
(Luke 1:46–55)

SEVEN SORROWS OF MARY

The Prophecy at the Temple, made by Simeon (Luke 2:25–59)

The Flight into Egypt to escape Herod's slaughter of the children
of Bethlehem (Matthew 2:13–21)

Jesus Lost in the Temple, when he was missing from his parents
for three days (Luke 2:25–93)

The Betrayal by Judas Iscariot (Luke 22:1–53)

The Crucifixion

The Taking Down from the Cross (Mark 15:42–47)

The Burial of Jesus (Luke 23:50–56)

STATIONS OF THE CROSS *(typical arrangement)*

Pilate's condemnation and sentencing of Jesus

Christ receives his Cross

Christ falls to the ground the first time

Christ meets His mother

Simon of Cyrene takes the cross

Veronica wipes Christ's face

Christ falls a second time

Christ tells the women of Jerusalem not to weep for him

Christ falls a third time

Christ is stripped of clothing

Christ is nailed to the cross

Christ dies on the cross

Christ's body is taken down from the cross and placed in arms of
his mother

Christ's body is entombed

SYMBOLS OF CHRISTIANITY

*(Creeds served an important role in stabilizing the early
Christian church.)*

Apostles' Creed (12 apostles)

Nicene Creed (Council of Nicaea, A.D. 325)

Niceno-Constantinopolitan Creed (Council of Chalcedon, A.D. 451)

Athanasian Creed (Athanasius, A.D. 670)

TEN COMMANDMENTS

(Revised Standard Version, Exodus 20)

I am the Lord your God, who brought you out of the land of
Egypt, out of the house of bondage.

You shall have no other gods before me. You shall not make for
yourself a graven image, or any likeness of anything that
is in heaven above, or that is in the earth beneath, or that
is in the water under the earth; you shall not bow down to
them or serve them; for I the Lord your God am a jealous
God, visiting the iniquity of the father upon the children to
the third and fourth generation of those who hate me, but
showing steadfast love to thousands of those who love me
and keep my commandments.

You shall not take the name of the Lord your God in vain; for the
Lord will not hold him guiltless who takes his name in vain.

Remember the sabbath day, to keep it holy. Six days you shall
labor, and do all your work; but the seventh day is a sabbath
to the Lord your God; in it you shall not do any work,

you, or your son, or your daughter, your manservant, or
your maidservant, or your cattle, or the sojourner who is
within your gates; for in the six days the Lord made heaven
and earth, the sea, and all that is in them, and rested the
seventh day; therefore the Lord blessed the sabbath day and
hallowed it.

Honor your father and your mother, that your days may be long
in the land which the Lord your God gives you.

You shall not kill.

You shall not commit adultery.

You shall not steal.

You shall not bear false witness against your neighbor.

You shall not covet your neighbor's house; you shall not covet
your neighbor's wife, or his manservant, or his maidservant,
or his ox, or his ass, or anything that is your neighbor's.

THREE GRACES
*(also known as Three Virtues, Cardinal Virtues,
Christian Values)*
Faith
Hope
Charity, or Love

THREE MYSTERIES
*(the things that cannot be explained, but must be accepted
on faith)*
The Trinity
Original Sin
The Incarnation

THREE-TIERED CROWN OF POPE
(representing the pope's three spheres of power)
Spiritual power
Temporal power
Ecclesiastical power

THREE VOWS OF BENEDICTINE MONKS
(original vows of order founded in 529 by Saint Benedict in Italy)
To remain at the monastery
To labor until death in order to attain perfection
To obey one's superiors

TRINITY (GOD)
The Father
The Son
The Holy Spirit

TWELVE DAYS OF CHRISTMAS *(the 12 gifts that are given over a succession of 12 days to one's true love)*
December 25: a partridge in a pear tree
December 26: two turtledoves
December 27: three French hens
December 28: four calling birds
December 29: five golden rings
December 30: six geese a-laying
December 31: seven swans a-swimming
January 1: eight maids a-milking
January 2: nine ladies dancing
January 3: ten lords a-leaping or ten drummers drumming
January 4: eleven pipers piping
January 5: twelve drummers drumming or twelve lords a-leaping

WEDDING SERVICE
Processional
Best man and bridegroom
Ushers
Flower girl
Bridesmaids
Maid and matron of honor
Bride with father
Pages carrying bride's train

Recessional
Ushers and bridesmaids (paired off)
Flower girl
Maid or matron of honor and best man
Bride and groom

ZUCCHETTO (SKULLCAP) COLORS
Pope: white
Cardinals: red
Bishops: violet
Priests: black

DANTE ALIGHIERI

THE INFERNO

Circles of Hell
Portal: entranceway
Acheron: river separating this world from underworld
Circle 1 (Limbo): home of unbaptized
Circle 2: home of "carnal sinners"
Circle 3: home of the gluttonous
Circle 4: home of the prodigal and avaricious
Circle 5 (Styx): home of the wrathful
Dis: walled city containing the remainder of Hell
Circle 6: heretics
Circle 7
i. Phlegethon: those who were violent to their neighbors
ii. Those who were violent to themselves
iii. Those who were violent to nature and God
Abyss
Circle 8 (Malebolge): has 10 deeper bastions or bolgie
 i. Bolgia: panderers and seducers
 ii. Flatterers

 iii. Buyers and sellers of pardons and powers
 (simoniacs)
 iv. Fortune-tellers
 v. Grafters
 vi. Hypocrites
 vii. Robbers
 viii. Evil counselors
 ix. Scandalmongers
 x. Liars

Circle 9 (Cocytus): a frozen lake
 i. Pit of Giants
 ii. Traitors
 a. Traitors to family
 b. Traitors to country
 c. Traitors to guests
 d. Traitors to employers or masters
 f. Center of the earth, home of Lucifer,
 Hell's monarch

*(Virgil and Dante emerge through a tunnel into the opposite
hemisphere, which is covered with water, to approach the
island of the mountain of Purgatory.)*

THE DIVINE COMEDY

Dante's Ten Heavens of Paradise

Heaven of the Moon: fortitude, inhabited by the
 inconstant in vows
Heaven of Mercury: justice, inhabited by the ambitious
Heaven of Venus: temperance, inhabited by lovers
Heaven of the Sun: prudence; inhabited by theologians,
 teachers, historians
Heaven of Mars: fortitude, inhabited by warriors
Heaven of Jupiter: justice, inhabited by the just
Heaven of Saturn: temperance, inhabited by contemplatives

Starry Heaven (Zodiac): faith, hope, charity; inhabited by
Christ, Mary, divine persons
Crystalline Heaven: Primum Mobile
Empyrean

EASTERN MYSTICISM

ENNEAGRAM

*(believed to derive from a 2,500-year-old system of Eastern
mysticism; shows nine different personality types and the
correlations between each type)*

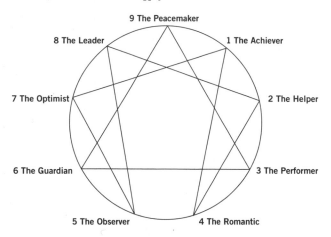

Type 1: The Reformer-Perfectionist is principled, purposeful,
self-controlled, and a perfectionist.
Type 2: The Helper-Giver is demonstrative, generous, people-
pleasing, and possessive.
Type 3: The Achiever-Performer is adaptive, excelling, driven,
and image-conscious.

Type 4: The Individualist-Romantic is expressive, dramatic, self-absorbed, and temperamental.

Type 5: The Investigator-Observer is perceptive, innovative, secretive, and isolated.

Type 6: The Loyalist-Trooper is engaging, responsible, anxious, and suspicious.

Type 7: The Enthusiast-Epicure is spontaneous, versatile, distractible, and scattered.

Type 8: The Challenger-Boss is self-confident, decisive, willful, and confrontational.

Type 9: The Peacemaker-Mediator is receptive, reassuring, agreeable, and complacent.

HAND TYPES

(Palmists, studying chiromancy, believe these reveal much about basic personality.)

Air hand: square palm and long fingers
Earth hand: square palm and short fingers
Fire hand: oblong palm and short fingers
Water hand: oblong palm and long fingers

Another Categorization

Conical: inspirational **Pointed:** idealistic
Elementary: stupidity **Square:** orderliness
Mixed: adaptable **Spatulate:** energetic

TAROT CARDS

(Tarot cards came to be utilized primarily for divinatory purposes. The trump cards, along with the Fool card comprise the 22 major arcana cards, and the pips and courts epresent the 56 minor arcana cards.)

Major Arcana

The Chariot
Death

The Devil
The Emperor
The Empress
The Fool
The Hanged Man
The Hermit
The Hierophant
The High Priestess
Judgment
Justice
The Lovers
The Magician
The Moon
The Star
Strength
The Sun
Temperance
The Tower
Wheel of Fortune
The World

Minor Arcana
Cups: Ace, 2–10, Page, Knight, Queen, King
Pentacles: Ace, 2–10, Page, Knight, Queen, King
Swords: Ace, 2–10, Page, Knight, Queen, King
Wands: Ace, 2–10, Page, Knight, Queen, King

EGYPTIAN RELIGION

EGYPTIAN TRINITIES (TRIADS)
(The Egyptians had a number of Trinities, worshiped by different peoples at different times.)

Abydos Triad, Early Version
Osiris: god of the underworld
Isis: goddess of creation, wife and sister of Osiris
Horus: son of Isis and Osiris

Abydos Triad, Later Version
Osiris: god of the underworld
Isis: goddess of creation, wife and sister of Osiris
Harpocrates: god of silence

Edfu Triad
Horus: god of the sun
Hathod: goddess of love
Harpocrates: god of silence

Elephantine Triad
Khnum: god of creation
Anukis: goddess of fertility
Satis: daughter of Khnum and Anukis

Memphite Triad, Early Version
Ptah: god of creation
Sekhmet: goddess of war
Nefertem: youthful god of lotus blossom

Memphite Triad, Later Version
Ptah: god of creation
Sekhmet: goddess of war
Imhotep: ancient architect

Theban Triad
Amen-Ra or Amon: sun god
Mut: consort of Amen-Ra
Khonsu: son of Amen-Ra and Mut

GREEK AND ROMAN MYTHOLOGY

LABORS OF HERCULES

(Hercules performed 12 labors assigned him by King Eurystheus of Tiryns; for 12 years, he traveled the world over to complete these incredible tasks.)

Kill and flay the Nemean lion
Destroy the Lernaean hydra
Capture the Arcadian stag (alternatively, Cerynian hind)
Capture the boar of Erymanthus
Clean the stables of King Augeas
Kill the carnivorous birds near Lake Stymphalis
Capture the bull ravaging Crete
Capture the man-eating mares of Diomedes of Thrace
Steal the Amazon queen Hippolyte's girdle
Capture the carnivorous oxen of the three-bodied
 monster Geryon
Bring back the golden apples from Hesperides' garden
Capture the three-headed dog Cerberus, the guardian
 of Hades

NINE MUSES

(The Muses represented the nine arts and were the daughters of Mnemosyne, goddess of memory.)

Calliope: muse of epic poetry
Clio: muse of history
Erato: muse of lyric poetry, love poetry
Euterpe: muse of music
Melpomene: muse of tragedy
Polyhymnia: muse of sacred song
Terpsichore: muse of dancing
Thalia: muse of comedy
Urania: muse of astronomy

TRIADS IN GREEK MYTHOLOGY

Three Fates
(personifications of the destinies of human beings, controlling the "thread" of life)
Clotho: spinner of the thread
Lachesis: drawer off or allotter of the thread
Atropos: cutter of the thread

Three Fortunae
(the Roman equivalents of the Three Fates)
Nona: spinner
Decuma: drawer off
Morta: cutter

Three Furies
(the punishers of wrongdoers)
Alecto: anger
Megaera: jealousy
Tisiphone: retaliation

Triad of Gods
Zeus: earth and sky
Poseidon: sea
Hades: underworld

Triad of Goddesses
Hebe: dance
Hera: marriage
Hecate: learning

Triad of Moon Deities
Hera: goddess of marriage
Artemis: goddess of the hunt
Hermes: messenger of the gods

Triple Goddess
Iambe: maiden
Demeter: mother
Baubo: the crone, or hag

TWELVE OLYMPIAN GODS
(Greek/Roman names)
Zeus/Jupiter: overlord, god of sky
Hera/Juno: goddess of the sky
Poseidon/Neptune: god of sea and earthquakes
Demeter/Ceres: goddess of harvest
Apollo/(No Roman equivalent): god of prophecy, music, medicine; no Roman equivalent)
Artemis/Diana: goddess of charity, childbirth, the young
Ares/Mars: god of war
Aphrodite/Venus: goddess of love and beauty
Hermes/Mercury: god of trade, travelers
Pallas Athena/Minerva: goddess of prudence, wise counsel
Hephaestus/Vulcan: god of fire, metalcraft
Hestia/Vesta: goddess of hearth, domesticity

HINDUISM

FESTIVALS
April: Hindu and Sikh New Year
April: Rama Navami, birth of Rama
August: Krishna Janmaashtami, Krishna's birthday
September: Ganesh Chaturthi, Ganesh's birthday
October: Durga Puja, celebration of goddesses
October: Vijaydashami, Rama's victory over Ravana
November: Divali, festival of lights
January: Kumbha Mela, pilgrim fairs
February–March: Mahashivaratri, festival for Shiva
March: Holi, spring harvest celebration

FOUR STAGES OF LIFE

(for twice-born)
Student (Brahmacarin)
Householder (Grhastha)
Forest dweller (Vanaprastha)
Renouncer (Sannyasin)

FOUR VARNA

*(the original social division
of Vedic people)*
Brahmins (priests)
Kshatriyas (noblemen)
Vaisyas (commoners)
Sudras (serfs)

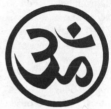

Aum (Om) is a Hindu
symbol representing the
essence of all mantras.

GATES TO HELL

(from the Bhagavad Gita, *Hindu scripture)*
Lust
Anger
Greed

GUNAS

(the three qualities or tendencies that pervade living things)
Rajas: activity, desire, fear, passion
Sattva: balance, harmony, intelligence, order, purity
Tamas: delusion, dullness, ignorance, inertia

HINDU LUNAR CALENDAR

Chaitra or Caitra (March–April)
Vaisakha (April–May)
Jyestha or Jyaistha (May–June)
Ashadha or Asadha (June–July)
Dvitiya Asadha (certain leap years)
Sravana (July–August)

Dvitiya Sravana (certain leap years)
Bhadrapada (August–September)
Asvina (September–October)
Karttika (October–November)
Margasirsha or Margasirsa or Margasivsa
 (November–December)
Pausa or Pansa (December–January)
Magha (January–February)
Phalguna (February–March)

THREEFOLD AUSTERITY
(from the Bhagavad Gita*)*
Austerity of the body: worship, cleanliness,
 nonviolence, celibacy
Austerity of speech: truthfulness, using pleasing
 speech, reciting scripture
Austerity of mind: simplicity, self-control

TILAKA
*(This mark in the center of the forehead—the "third eye"—
indicates the marital status of Hindu women.)*
Black: unmarried
Red: married
None: widowed

TRIMURTI (TRINITY)
Brahma: the Creator
Vishnu: the Preserver
Siva or Shiva: the Destroyer

TRIVARGA—THE THREE WORLDLY ATTAINMENTS
Dharma: virtue, right conduct, natural law
Artha: wealth, accumulation of material goods
Kama: pleasure or love, fulfillment of sexual desire

ISLAM

FIVE PILLARS OF ISLAM

(Sunni profession of faith to Allah and Muhammad as his prophet)

Salah or Prayer: five prayers a day, at designated times, facing Mecca

Zakat: almsgiving; giving a proportion of one's wealth to the needy

Sawm or Fasting: between dawn and dusk during Ramadan

Hajj: pilgrimage to Mecca once in one's lifetime

Shahadah: profession of faith

ISLAMIC CALENDAR

(movable in reference to Gregorian calendar)

Muharram (April–June, depending on the year and cycle)

Safar or Saphar

Rabi I or Rabia I

Rabi II or Rabia II

Jumad I or Jomada I or Jumada I

Jumad II or Jomada II or Jumada II

Rajab

Sha'ban or Sha'aban or Shaban

Ramadan (month of fasting)

Shawwal

Dhul-Quada or Dulkaada or Dhu al-Qadah

Dhul-Hijjah or Dulheggia or Dhu al-Hijjah

(March–May, depending on year and cycle)

The crescent moon and star represents the faith of Islam.

ISLAMIC HOLIDAYS

Muharram: Islamic New Year

Mawlid al-Nabi: Muhammad's birthday

Ramadan

Eid al-Fitr: Ramadan ends

Eid al-Adha: Festival of Sacrifice

ISLAMIC SACRED TEXTS

The Koran (Qur'an): revealed to Muhammad by Allah
through angel Gabriel Zabur, Psalms of David (Dawud)
Tawrat, Torah of Moses (Musa) Injil, Gospel of Jesus
(Isa) Suhufi Ibrahim, Scrolls of Abraham

The Hadith: what Muhammad said and did

The Sunnah: rules and regulations of Muslim life

ISLAMIC SECTS

Sunnite: traditional (largest group)

Shi'ite: emphasize sacrifice and martyrdom
(largest minority)

Wahhabis: puritanical, stressing the simplicity of
early Islam

Ismailite: allegiance to Ismail, the successor of the
sixth Imam

Sufism: Muslim mysticism

Black Muslims: American movement, also called
Nation of Islam

OTHER SECTS, SCHOOLS, BRANCHES

Alawite	Druze	Maturidiyah
Bohra	Ithna Ashariyah	Mutazilah
Deoband	Kharijite	Rafidah
Donme	Mahdist	Yazidi

PRAYER TIMES

Dawn prayer: from first light until sunrise

Noon prayer: from sun's zenith until an object's shadow equals
its height plus the length of whatever shadow was cast at
the zenith

Afternoon prayer: between end of preceding and sunset

Sunset prayer: immediately after sunset till darkness

Nighttime prayer: from end of twilight until just before dawn

SEQUENCE OF PRAYER

(Prior to prayer, a person must perform a physical purification.)

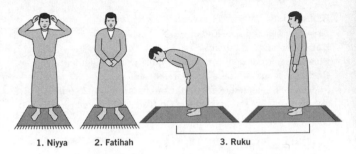

1. Niyya 2. Fatihah 3. Ruku

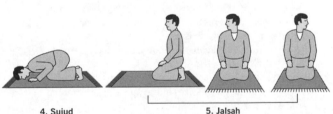

4. Sujud 5. Jalsah

JAINISM

JEWELS OF JAINISM

(comparable to the three virtues of other belief systems)

Samyak darshana: distinguish truth from untruth
Samyak jnana: have a sufficient knowledge of the real universe
Samyak charitra: avoid doing harm to living things

JUDAISM

BRANCHES OF JUDAISM

Biblical Judaism

Essenes: awaited the "End of Days"

Karaites: rejected rabbinic Oral Law

Pharisees: separated from ritual impurity and defilement

Rechabites: faithfulness and self-discipline

Sadducees: rejected resurrection and immortality of soul

Samaritans: Pentateuch, unique God, Moses as only
prophet, sanctity of Torah

Modern Judaism

Conservative Judaism: adapts traditional beliefs and
practices to contemporary knowledge and culture

Hasidism: strict observance of laws; follows charismatic
leader, tzaddik or rebbe

Kabbalism: Jewish mysticism

Orthodox Judaism: keeps traditional beliefs and ways
of life (halakhah), as in Torah and Talmud

Reconstructionist Judaism: articulates left-wing rationalism

Reform Judaism: emphasizes moral and ethical teachings
rather than ritual and tradition

Zionism: national movement to return to Israel

JEWISH CALENDAR

*(based on moon and sun; beginning around mid-September
on the Gregorian calendar)*

Nisan

Iyar

Sivan

Tammuz

Av or Ab

Elul

Tishri
Cheshvan or Heshvan
Kislev
Teveth or Tebet
Shevat or Shebat
Adar
Veadar (13th month in 3rd, 6th, 8th, 11th, 14th, 17th year
 of a 19-year cycle)

JEWISH HOLY DAYS *(festivals and fasts)*

Rosh Hashanah: New Year
Fast of Gedalya
Yom Kippur: Day of Atonement
Sukkot: Feast of Tabernacles
Shmini Atzeret: Eighth Day of Sukkot
Simchat Torah: Ninth Day of Sukkot
Chanukah: Feast of Lights
Fast of the 10th of Tevet
Tu Bishevat: New Year of Trees; Jewish Arbor Day
Ta'anit Esther: Fast of Esther
Purim
Passover
Lag Omer
Shavuot (Pentecost)
Fast of the 17th Day of Tammuz
Fast of the 9th Day of Av

SEDER QUESTIONS
(the four questions asked by youngest child at Passover meal)
1. Why is this night different from all other nights?
2. On all other nights, we eat all kinds of herbs. Why on this night
 do we eat only bitter herbs?
3. On all other nights, we do not dip our food into condiments at
 all. Why on this night do we dip it twice?

4. On all other nights, we eat sitting upright. Why on this night do we recline?

SYNAGOGUE HIERARCHY
Rabbi
Cantor
Gabbai (rituals official)
Shammash (beadle or sexton)
President, vice president(s)
Executive board
Men's club
Sisterhood (or ladies' auxiliary)
Congregants

THIRTEEN ARTICLES OF FAITH
("Ehad Mi Yodea" song)
Thirteen are the attributes of God
Twelve are the tribes of Israel
Eleven were the stars in Joseph's dream
Ten commandments were given on Sinai
Nine is the number of the holidays
Eight are the days to the service of the covenant
Seven days are there in a week
Six sections the Mishnah has
Five books there are in the Torah
Four is the number of the matriarchs
Three, the number of the patriarchs
Two are the tables of the commandments
One is our God, in heaven and on earth

THIRTEEN PRINCIPLES OF JEWISH FAITH
(formulated by the philosopher Moses Maimonides)
That God exists
That God is One alone

That God has no corporeal presence
That God is outside the scope of time
That God alone is to be worshipped
That God informs his prophets
That Moses was the greatest of the prophets
That the Torah is the work of God
That the Torah cannot change
That God apprehends the thoughts and acts of all people
That those who do good will receive their reward,
 and those who do evil will receive retribution
That the Messiah will come
That there will be a bodily resurrection of the dead,
 although only the soul may be eternal

TREE OF LIFE—THE CABALA *(Jewish mystic knowledge; by mastering its ten spheres, or sephirot, one can achieve greatness; listed from the roots to the crown)*

Malkhuth: physical body and health
Yesod: personality
Hod: logic and reason
Netsah: needs, passions, and senses
Tifereth/Rahamin: energy or life force
Geburah/Pachad/Din: our destructive nature
Hesed/Gedulah: love and mercy
Binah: soul
Hokhmah: creativity
Kether: ultimate unity of all aspects of human nature

WEDDING SERVICE

Processional

Rabbi (walks down aisle if wedding is not held in temple
 or synagogue)
Ushers
Best man

Bridegroom, flanked by parents
Bridesmaids
Maid or matron of honor
Flower girl
Bride, flanked by parents
Pages, carrying bride's train

Recessional
Rabbi
Ushers and bridesmaids
Flower girl
Maid or matron of honor and best man
Groom's parents
Bride's parents
Bride and groom

SATAN'S REALM

HIERARCHY OF DEVILS AND SINS
(from S. Michaelis's Admirable History, *1612)*

The Devil (Lucifer)

First Hierarchy
Beelzebub: sins of pride
Leviathan: sins against faith
Asmodeus: sins of luxuriousness and wantonness
Balberith: homicides, quarrels, and blasphemy
Astaroth: idleness, sloth
Verrine: impatience
Gressil: impurity, uncleanness
Sonneillon: hatred

Second Hierarchy
Carreau: hardheartedness

Carnivean: obscenity
Ocillet: temptation to break vow of poverty
Rosier: abandoning god for the flesh
Verrier: disobedience

Third Hierarchy
Belias: arrogance
Olivier: mercilessness
Iuvart: inactive

DEMONS WHO SERVE DEVIL HIERARCHY
(as presented in F. M. Guazzo's Compendium Maleficarum, *1608)*
Fire devils: live in upper air
Aerial devils: inhabit atmosphere
Terrestrial devils: inhabit woods, fields, forests
Aqueous devils: inhabit bodies of water and waterways
Subterranean devils: inhabit caves and mountains
Heliophobic devils: appear only at night

SIKHISM

FIVE KHANDS
(levels of spiritual reality, least to most important)
Dharam Khand: level of seeking moral duty
Gian Khand: level of wisdom and knowledge
Saram Khand: level of effort
Karam Khand: level of fulfillment and grace
Sach Khand: level of truth, permanent union with God

RELIGIOUS STRUCTURE
(threefold service)
Tan (physical): useful work
Man (mental): study of Adi Granth, share religion
Dhan (material): 10% of earnings given to charity

SIKH CALENDAR *(from beginning of Sikh year)*

Chet (March)
Vaisakh
Jeth
Harh
Sawan
Bhadar
Asu
Katik
Maghar
Poh
Magh
Phalgan (February)

SIKH HIERARCHY

Gurus: immortal souls in ten human bodies
Priests: any baptized Sikh can act as one
non-Jats: erstwhile Brahmans, Ksatriyas, and Vaisyas
Jats: agricultural tribes
Mazahabis: untouchables

TAOISM

JEWELS OF TAOISM

Compassion
Moderation
Humility or modesty

TAO TRINITY *(Tao entered into creation in three stages)*

1. The Celestial Venerable of the Mysterious Origin
2. The August Ruler of the Tao
3. The August Old Ruler (Lao-tzu was held to be an
 incarnation of this god)

VOODOO

PRIESTLY HIERARCHY
Loa: saints
Hungan: priest
Mambo: priestess

WITCHCRAFT AND WIZARDRY (WICCA)

GRADES OF WITCHES *(lowest to highest)*
Witch: one permitted to study witchcraft
Priestess or priest: has mastered basics and is initiated into a coven
Witch queen or magus: high-ranking member of coven
High priestess or high priest: leader of a coven, group of 13 witches

ORDERS AND GRADES OF WIZARDS
(least to most powerful)
Outer order
 Neophyte
 Zelator
 Theoricus
 Practicus
 Philosophus
Second order
 Adeptus Minor
 Adeptus Major
 Adeptus Exemptus
Third order
 Magister
 Magus
 Ipsissimus

STAGES OF A SÉANCE
Clearing: emptying of the mind
Slowing: relaxing the body
Withdrawing: soul of medium retreats
Phasing: spirit communicates through the medium's body
Dephasing: spirit departs
Restoring: medium is back to normal

WORLD RELIGIONS

NUMBER OF ADHERENTS
(lowest to highest; approximate)

Tenrikoists: 2,400,000
Zoroastrians: 2,500,000
Caodaists: 4,000,000
Shintoists: 4,000,000
Jains: 4,000,000
Baha'is: 6,000,000
Confucians: 6,000,000
Shamanists: 11,000,000
Jews: 14,000,000
Spiritists: 14,000,000
Juches: 19,000,000
Yorubas: 20,000,000
Sikhs: 23,000,000
**African, traditional
and diasporic:**
100,000,000

Chinese folk religionists:
225,000,000
Buddhists: 350,000,000
Hindus: 900,000,000
Muslims: 1,500,000,000
Christians: 2,000,000,000
Roman Catholics:
1,100,000,000
Protestants: 400,000,000
Orthodox: 200,000,000
Anglicans: 100,000,000
Other Christians:
200,000,000

WORLD RULERS

So work the honey-bees, / Creatures that by a rule in nature teach / The act of order to a peopled kingdom.

—William Shakespeare, *The Life of King Henry V*

ASSYRIA

Pairs of mythological winged bulls often adorned the palace entrances of Assyrian kings as guardians against misfortune.

MONARCH, KINGDOM OF ASSYRIA

1813–1780 B.C.	Shamshi-Adad I
1780–1741 B.C.	Ishme-Dagan I
1730–1720 B.C.	Mut-Ashkur
1720–1710 B.C.	Rimush
1710–1706 B.C.	Asinum
1706–1700 B.C.	Puzur-Sin
	Ashur-dugul
	Ashur-apla-idi
	Nasir-Sin
	Sin-namir
	Ipqi-Ishtar
	Adad-Shalulu
	Adasi
1700–1690 B.C.	Belubani
1690–1673 B.C.	Libaia
1673–1661 B.C.	Sharma-Adad I
1661–1649 B.C.	Iptar-Sin
1649–1621 B.C.	Bazaia
1621–1615 B.C.	Lullaia
1615–1601 B.C.	Shu-Ninua

1601–1598 B.C.	Sharma-Adad II
1598–1585 B.C.	Erishum III
1585–1579 B.C.	Shamshi-Adad II
1579–1563 B.C.	Ishme-Dagan II
1563–1547 B.C.	Shamshi-Adad III
1547–1521 B.C.	Ashur-nirari I
1521–1497 B.C.	Puzur-Ashur
1497–1484 B.C.	Enlil-nasir I
1484–1472 B.C.	Nur-ili
1472–1472 B.C.	Ashnur-shaduni
1472–1452 B.C.	Ashur-rabi I
1452–1432 B.C.	Ashur-nadin-ahhe I
1432–1426 B.C.	Enlil-nasir II
1426–1419 B.C.	Ashur-nirari II
1419–1410 B.C.	Ashur-bel-nisheshu
1410–1402 B.C.	Ashur-rim-nisheshu
1402–1392 B.C.	Ashur-nadin-ahhe II
1392–1365 B.C.	Eriba-Adad I
1365–1329 B.C.	Ashur-uballit I
1329–1319 B.C.	Enlil-nirari
1319–1307 B.C.	Arik-den-ili
1307–1274 B.C.	Adad-nirari I
1274–1244 B.C.	Shulmanu-ashared (Shalmaneser) I
1244–1207 B.C.	Tukulti-Ninurta I
1207–1203 B.C.	Ashir-nadin-apli
1203–1197 B.C.	Ashur-nirari III
1197–1192 B.C.	Enlil-kudurri-usur
1192–1179 B.C.	Ninurta-apil-Ekur
1179–1133 B.C.	Ashur-dan I
1133 B.C.	Ninurta-tukulti-Ashur
1133 B.C.	Mutakkil-Nusku
1133–1115 B.C.	Ashur-resh-ishi I
1115–1076 B.C.	Tukulti-apil-esharra (Tiglath-Pilesar) I
1076–1074 B.C.	Ashared-apil-Ekur

1074–1056 B.C.	Ashur-bel-kala
1056–1054 B.C.	Eriba-Adad II
1054–1050 B.C.	Shamshi-Adad IV
1050–1031 B.C.	Ashur-nasir-apli I
1031–1019 B.C.	Shulmanu-ashared (Shalmaneser) II
1019–1013 B.C.	Ashur-nirari IV
1013–972 B.C.	Ashur-rabi II
972–967 B.C.	Ashur-resha-ishi II
967–935 B.C.	Tukulti-apil-esharra (Tiglath-Pilesar) II
935–911 B.C.	Ashur-dan II
911–890 B.C.	Adad-nirari II
890–884 B.C.	Tukulti-Ninurta II
884–859 B.C.	Ashur-nasir-apli II
859–824 B.C.	Shulmanu-ashared (Shalmaneser) III
824–811 B.C.	Shamshi-Adad V
811–782 B.C.	Adad-nirari III-Sammu-ramat (Semiramis)
782–772 B.C.	Shulmanu-ashared (Shalmaneser) IV
772–754 B.C.	Ashur-dan III
754–745 B.C.	Ashur-nirari V
745–727 B.C.	Tukulti-apil-esharra (Tiglath-Pilesar) III Pulu
727–722 B.C.	Shulmanu-ashared (Shalmaneser) V
722–705 B.C.	Sharrukin (Sargon) II
705–681 B.C.	Sin-ahhe-eriba (Sennacherib)
681–669 B.C.	Ashur-ahhe-iddina (Esarhaddon)
669–626 B.C.	Ashur-bani-apli (Ashur-banipal; Sardanapalus)
626–621 B.C.	Ashur-etil-ilani
626–621 B.C.	Sin-shum-lishir
621–612 B.C.	Sin-shar-ishkun
612–609 B.C.	Ashur-uballit II

AUSTRALIA

Used since 1901, the Australian flag was not officially adopted until 1954.

PRIME MINISTERS

(upon formation of the Commonwealth of Australia)

1901–1903	Edmund Barton
1903–1904	Alfred Deakin
1904	John Christian Watson
1904–1905	George Houstoun Reid
1905–1908	Alfred Deakin
1908–1909	Andrew Fisher
1909–1910	Alfred Deakin
1910–1913	Andrew Fisher
1913–1914	Joseph Cook
1914–1915	Andrew Fisher
1915–1917	William Morris Hughes
1923–1929	Stanley Melbourne Bruce, Viscount Bruce of Melbourne
1929–1932	James Henry Scullin
1932–1939	Joseph Aloysius Lyons
1939	Earle Christian Grafton Page
1939–1941	Robert Gordon Menzies
1941–1941	Arthur William Fadden
1941–1945	John Curtin
1945–1945	Francis Michael Forde
1945–1949	Joseph Benedict Chifley
1949–1966	Robert Gordon Menzies
1966–1967	Harold Edward Holt

1967–1968	John McEwen
1968–1971	John Grey Gorton
1971–1972	William McMahon
1972–1975	Edward Gough Whitlam
1975–1983	John Malcolm Fraser
1983–1991	Robert James Lee Hawke
1991–1996	Paul John Keating
1996–2007	John Wilson Howard
2007–	Kevin Rudd

AUSTRIA

MARGRAVES

House of Babenburg

976–994	Leopold I
994–1018	Heinrich I
1018–1055	Adalbert
1055–1075	Ernest
1075–1095	Leopold II
1095–1136	Leopold III
1136–1141	Leopold IV
1141–1156	Heinrich II Jasomirgott

DUKES

House of Babenburg

1156–1177	Henry II Jasomirgott
1177–1194	Leopold V
1195–1198	Friedrich I
1198–1230	Leopold VI
1230–1246	Friedrich II
1246–1251	No duke
1251–1276	Ottokar II of Bohemia

House of Habsburg

1276–1291	Rudolf I
1282–1298	Albrecht (Albert) I, joint ruler
1282–1283	Rudolf II, joint ruler
1298–1307	Rudolf III, joint ruler
1298–1330	Friedrich II, joint ruler
1308–1330	Frederick I, joint ruler
1308–1326	Leopold I, joint ruler
1330–1358	Albrecht II, joint ruler
1330–1339	Otto, joint ruler
1365–1395	Albrecht III, joint ruler
1365–1386	Leopold III, joint ruler
1386–1411	Leopold IV, joint ruler
1395–1404	Albrecht IV
1402–1424	Ernest, joint ruler
1402–1439	Frederick IV, joint ruler
1404–1439	Albrecht V
1424–1463	Albrecht VI, joint ruler
1439–1490	Sigismund, joint ruler
1452–1493	Friedrich V (Frederick III, Holy Roman Emperor)
1508–1519	Maximilian I, Holy Roman Emperor elect

MONARCHS, THE AUSTRIAN EMPIRE

House of Habsburg

1804–1835	Franz I (Francis II, Holy Roman Emperor)
1835–1848	Ferdinand I
1848–1867	Franz Josef (Francis Joseph) I

EMPERORS, AUSTRO-HUNGARIAN EMPIRE

House of Habsburg

1867–1916	Franz Josef (Francis Joseph) I
1916–1918	Karl (Charles I)

PRESIDENTS, REPUBLIC OF AUSTRIA

1918–1920	Karl Seitz
1920–1928	Michael Hainisch
1928–1938	Wilhelm Miklas
1938–1945	Part of German Third Reich
1945–1950	Karl Renner
1950–1957	Theodor Körner
1957–1965	Adolf Schärf
1965–1974	Franz Jonas
1974–1986	Rudolf Kirchsläger
1986–1992	Kurt Waldheim
1992–2004	Thomas Klestil
2004–2004	Andreas Khol, Barbara Prammer, Thomas Prinzhorn (acting, 3 days)
2004–	Heinz Fischer

CHANCELLORS, REPUBLIC OF AUSTRIA

1918–1920	Karl Renner
1920–1921	Michael Mayr
1921–1922	Johann Schober
1922–1924	Ignaz Seipel
1924–1926	Rudolf Raimak
1926–1929	Ignaz Seipel
1929–1929	Ernst Streeruwitz
1929–1930	Johann Schober
1930–1930	Carl Vaugoin
1930–1931	Otto Ender
1931–1932	Karl Buresch
1932–1934	Engelbert Dollfuss
1934–1938	Kurt von Schuschnigg
1938–1945	Part of German Third Reich
1945–1945	Karl Renner
1945–1953	Leopold Figl
1953–1961	Julius Raab

1961–1964	Alfons Gorbach
1964–1970	Josef Klaus
1970–1983	Bruno Kreisky
1983–1986	Fred Sinowatz
1986–1997	Franz Vranitzky
1997–2000	Viktor Klima
2000–2007	Wolfgang Schüssel
2007–	Alfred Gusenbauer

BABYLON

(Dynasties I–III did not rule Babylon, but their numbering was continued by early Babylonian Kings.)

MONARCHS, KINGDOM OF BABYLON

Dynasty IV

1156–1138 B.C.	Marduk-kabit-ahheshu
1138–1130 B.C.	Itti-Marduk-balatsu
1130–1124 B.C.	Ninurta-nadin-shumi
1124–1102 B.C.	Nabu-kudurri-usur (Nebuchadrezzar) I
1102–1098 B.C.	Enlil-nadin-apli
1098–1080 B.C.	Marduk-nadin-ahhe
1080–1067 B.C.	Marduk-shapik-zeri
1067–1045 B.C.	Adad-apla-Addina
1045–1044 B.C.	Marduk-ahhe-eriba
1044–1032 B.C.	Marduk-zer
1032–1024 B.C.	Nabu-shumu-libur

Dynasty V

1024–1007 B.C.	Simbar-shikhu
1007–1006 B.C.	Ea-mukin-zeri
1006–1003 B.C.	Kashshu-nadin-akhi

Dynasty VI
1003–986 B.C.	E-ulmash-shakin-shumi
986–984 B.C.	Ninurta-kudurri-usur I
984–983 B.C.	Shirikti-shuqamuna

Dynasty VII
983–978 B.C.	Mar-biti-apla-usur

Dynasty VIII
978–943 B.C.	Nabu-mukin-apli

Dynasty IX
943–942 B.C.	Ninurta-kudurri-usur II
942–941 B.C.	Mar-biti-ahhe-iddina
941–900 B.C.	Shamash-mudammiq
900–885 B.C.	Nabu-shum-ukin I
885–852 B.C.	Nabu-apla-iddina
852–851 B.C.	Marduk-bel-usate
851–827 B.C.	Marduk-zakir-shumi I
827–814 B.C.	Marduk-balatsu-iqbi
814–811 B.C.	Bau-ahhe-iddina
811–? B.C.	Adad-shuma-ibni
? B.C.	Marduk-bel-zeri
?–802 B.C.	Marduk-apla-usur
802–? B.C.	Eriba-Marduk
?–747 B.C.	Nabu-shum-ukin II
747–735 B.C.	Nabu-nasir
735–732 B.C.	Nabu-nadin-zeri
732–732 B.C.	Nabu-shum-ukin III

Dynasty X
732–729 B.C.	Ukin-zer
729–722 B.C.	Assyrian rule
722–710 B.C.	Marduk-apla-iddina II (Merodach-Baladan)

710–703 B.C.	Assyrian rule
703–703 B.C.	Marduk-zakir-shumi II
703–702 B.C.	Marduk-apla-iddina II (Merodach-Baladan), restored
702–700 B.C.	Bel-ibni
700–694 B.C.	Ashur-nadin-shumi
694–693 B.C.	Nergal-ushezib
693–689 B.C.	Mushezib-Marduk
689–669 B.C.	Assyrian rule
669–648 B.C.	Shamash-shuma-ukin
648–627 B.C.	Kandalanu

MONARCHS, NEO-BABYLONIAN EMPIRE

626–605 B.C.	Nabu-apla-usur (Nabopolassar)
605–562 B.C.	Nabu-kudurri-usur (Nebuchadrezzar) II
562–559 B.C.	Awel-Marduk
559–556 B.C.	Nergal-shar-usur
556–556 B.C.	Labashi-Marduk
556–539 B.C.	Nabu-Na'id (Nabonidus)
538–522 B.C.	Cambyses II of Persia

BURGUNDY

DUKES

House of Valois

1363–1404	Philip "the Bold"
1404–1419	John II "the Fearless"
1419–1467	Philip III "the Good"
1467–1477	Charles I "the Bold"
1477–	(united with crown of Austria and later of Spain)

The family coat of arms used by Philip III "the Good" and son Charles I "the Bold."

BYZANTIUM

EMPERORS, THE EASTERN ROMAN EMPIRE

395–408	Arcadius
408–450	Theodosius II
450–457	Marcianus
457–474	Leo I
474–474	Leo II
474–491	Zeno
475–476	Basiliscus, joint Emperor
491–518	Anastasius I
518–527	Justin I
527–565	Justinian I
565–578	Justin II
578–582	Tiberius II Constantine
582–602	Maurice
602–610	Phocas
610–641	Heraclius
641–641	Constantine III
641–641	Heracleonas, joint Emperor
641–668	Constans II (Flavius Heraclius)
668–685	Constantine IV Pogonatus
685–695	Justinian II
695–698	Leontius
698–705	Tiberius III Apsimar
705–711	Justinian II, restored
711–713	Philippicus
713–715	Anastasius II
715–717	Theodosius III
717–741	Leo III Isauricus
741–775	Constantine V Copronymus
775–780	Leo IV "the Khazar"
780–789	Constantine VI
797–802	Irene

802–811	Nicephorus I
811–811	Stauracius
811–813	Michael I "the Rangabe"
813–820	Leo V "the Armenian"
820–829	Michael II
829–842	Theophilus
842–867	Michael III
867–886	Basil I "the Macedonian"
886–912	Leo VI "the Wise"
912–959	Constantine VII Porphyrogenitus, joint emperor, 913 or 920–959
912–913	Alexander, joint emperor
920–944	Romanus I Lecapenus, regent and joint emperor
959–963	Romanus II
963–969	Nicephorus II Phocas
969–976	John I Tzimisces
976–1028	Constantine VIII, joint ruler
976–1025	Basil II Bulgaroctonus, joint emperor
1028–1050	Zoe, joint empress
1028–1034	Romanus III Argyrus, joint emperor
1034–1041	Michael IV "the Paphlagonian," joint emperor
1041–1042	Michael V Calaphates, joint emperor
1042–1055	Constantine IX Monomachus, joint emperor
1042–1056	Theodora, joint empress until 1055
1056–1057	Michael VI Stratioticus
1057–1059	Isaac I Comnenus
1059–1067	Constantine X Ducas
1067–1071	Romanus IV Diogenes
1071–1078	Michael VII Ducas
1078–1081	Nicephorus III Botaneiates

COMNENIAN EMPERORS

| 1081–1118 | Alexius I Comnenus |
| 1118–1143 | John II Comnenus |

1143–1180	Manuel I
1180–1183	Alexius II
1183–1185	Andronicus I Comnenus
1185–1195	Isaac II Angelus
1195–1203	Alexius III
1203–1204	Isaac II Angelus, restored
1203–1204	Alexius IV, joint emperor
1204–1204	Alexius V Ducas

LATIN EMPERORS

1204–1205	Baldwin I
1205–1216	Henry
1216–1217	Peter of Courtenay
1217–1219	Yolande
1219–1228	Robert
1228–1261	Baldwin II

BYZANTINE EMPERORS AT NICAEA

1204–1205	Constantine Lascaris
1205–1222	Theodore I Lascaris
1222–1254	John III Vatatzes
1254–1258	Theodore II Lascaris
1258–1261	John IV, joint emperor from 1259
1259–1261	Michael VIII Palaeologus, regent and joint emperor

PALAEOLOGI EMPERORS AT BYZANTIUM

1261–1282	Michael VIII Palaeologus
1282–1328	Andronicus II Palaeologus, joint emperor 1295–1320
1295–1320	Michael IX, joint emperor
1328–1341	Andronicus III Palaeologus
1341–1391	John V, joint emperor 1347–1354 and from 1376

1347–1354	John VI Cantacuzene, regent and joint emperor
1376–1379	Andronicus IV, joint emperor
1390–1390	John VII, joint emperor
1391–1425	Manuel II, joint emperor
1399–1402	John VII, joint emperor
1425–1448	John VIII
1449–1453	Constantine XI

CANADA

Colloquially known as the Maple Leaf Flag, Canada's flag was adopted in 1965.

PRIME MINISTERS
(upon formation of Canadian Confederation)

1867–1873	Sir John A Macdonald
1873–1878	Alexander Mackenzie
1878–1891	Sir John A Macdonald
1891–1892	Sir John Abbott
1892–1894	Sir John Thompson
1894–1896	Sir Mackenzie Bowell
1896–1896	Sir Charles Tupper
1896–1911	Sir Wilfrid Laurier
1911–1920	Sir Robert Borden
1920–1921	Arthur Meighen
1921–1926	William Lyon Mackenzie King
1926–1926	Arthur Meighen
1926–1930	William Lyon Mackenzie King

1930–1935	Richard B Bennett
1935–1948	William Lyon Mackenzie King
1948–1957	Louis St. Laurent
1957–1963	John Diefenbaker
1963–1968	Lester (Mike) Pearson
1968–1979	Pierre Trudeau
1979–1980	Charles Joseph Clark
1980–1984	Pierre Trudeau
1984–1984	John Turner
1984–1993	Martin Brian Mulroney
1993–1993	Kim Campbell
1993–2003	Joseph Jean Chretien
2003–2006	Paul Martin
2006–	Stephen Harper

CHINA

EMPERORS

Prehistoric Dynasties

(The traditional dates for prehistoric dynasties are not generally considered to be reliable.)

1600–1046 B.C.	Shang (Yin) Dynasty, probable actual dates c. 1500–1027 B.C.
1046–256 B.C.	Chou Dynasty
1046–771 B.C.	Western Chou Dynasty, probable actual date 1027 B.C.
770–249 B.C.	Eastern Chou Dynasty
249–221 B.C.	Civil war

Ch'in Dynasty

221–210 B.C.	Shih Huang Ti
210–207 B.C.	Erh Shih Huang Ti
207–206 B.C.	Ch'in Wang

Western Han Dynasty

206–195 B.C.	Kao Tsu (Liu Pang)
195–188 B.C.	Hui Ti
188–180 B.C.	Kao Hou
180–157 B.C.	Wen Ti
157–141 B.C.	Ching Ti
141–87 B.C.	Wu Ti
87–74 B.C.	Chao Ti
74–48 B.C.	Hsuan Ti
48–33 B.C.	Yuan Ti
33–7 B.C.	Ch'eng Ti
7–1 B.C.	Ai Ti
1 B.C.–A.D. 6	P'ing Ti
6–8	Ju-Tzu Ying

Hsin Dynasty

9–23	Chia Huang Ti (Wang Mang)
23–25	Civil war

Eastern Han Dynasty

25–57	Kuang Wu Ti (Liu Hsiu)
57–75	Ming Ti
75–88	Chang Ti
88–106	Ho Ti
106–106	Shang Ti
106–125	An Ti
125–125	Shao Ti
124–144	Shun Ti
144–145	Ch'ung Ti
145–146	Chih Ti
146–168	Huan Ti
168–189	Ling Ti
189–189	Shao Ti
189–220	Hsien Ti
220–280	Civil war

Western Chin Dynasty

280–290	Wu Ti (Ssu-Ma Yen), Ruler of Western Chin from 266
290–307	Hui Ti
307–311	Huai Ti
311–313	No emperor
313–316	Min Ti

Eastern Chin Dynasty

317–323	Yuan Ti (Ssu-Ma Jui)
323–325	Ming Ti
325–342	Ch'eng Ti
342–344	K'ang Ti
344–361	Mu Ti
361–365	Ai Ti
365–372	Ti I (Hai Hsi Kung)
372–372	Chien Wen Ti
372–396	Hsaio Wu Ti
396–419	An Ti
419–420	Kung Ti

Liu-Song Dynasty

420–422	Wu Ti (Liu Yu)
422–424	Shao Ti
424–453	We Ti
453–464	Hsaio Wu Ti
464–466	Ch'ien Fei Ti
466–472	Ming Ti
472–477	Hou Fei Ti
477–479	Shun Ti

Southern Ch'i Dynasty

479–482	Kao Ti (Hsaio Tao-Ch'eng)
482–493	Wu Ti

493–494	Yu-Lin Wang
494–494	Hai-Ling Wang
494–498	Ming Ti
498–501	Tung-Hun Hou
501–502	Ho Ti

Southern Liang Dynasty

502–549	Wu Ti (Hsaio Yen)
549–551	Chien Wen Ti
551–552	Yu-Chang Wang
552–555	Yuan Ti
555–555	Chen-Yang Hou
555–557	Ching Ti

Southern Ch'en Dynasty

557–559	Wu Ti (Ch'en Pa-Hsien)
559–566	Wen Ti
566–568	Fei Ti
568–582	Hsuan Ti
582–589	Hou Chu

Sui Dynasty

| 589–605 | Wen Ti (Yang Chien) |
| 605–619 | Yang Ti |

T'ang Dynasty

619–627	Kao Tsu (Li Yuan)
627–650	T'ai Tsung (Li Shih-Min)
650–684	Kao Tsung
684–685	Chung Tsung
685–690	Jui Tsung
690–705	Wu Hou
705–710	Chung Tsung, restored
710–713	Jui Tsung, restored

713–756	Hsuan Tsung
756–762	Su Tsung
762–779	Tai Tsung
779–805	Te Tsung
805–805	Shun Tsung
805–820	Hsien Tsung
820–824	Mu Tsung
824–827	Ching Tsung
827–840	Wen Tsung
840–846	Wu Tsung
846–859	Hsuan Tsung
859–873	I Tsung
873–888	Hsi Tsung
888–904	Chao Tsung
904–907	Chao Hsuan Ti

Later Liang Dynasty

907–912	T'ai Tsu (Chu Wen)
912–913	Ying Wang
913–923	Mo Ti

Later T'ang Dynasty

923–926	Chuang Tsung (Li Ts'un-Hsu)
926–933	Ming Tsung
933–934	Min Ti
934–936	Mo Ti

Later Chin Dynasty

936–942	Kao Tsu (Shih Ching-T'ang)
942–947	Ch'u Ti

Later Han Dynasty

947–948	Kao Tsu (Liu Chih-Yuan)
948–951	Yin Ti

Later Chou Dynasty

951–954	T'ai Tsu (Kuo Wei)
954–959	Shih Tsung
959–960	Kung Ti

Northern Sung Dynasty

960–976	T'ai Tsu (Chao K'uang-Yin)
976–997	T'ai Tsung
997–1022	Chen Tsung
1022–1063	Jen Tsung
1063–1067	Ying Tsung
1067–1085	Shen Tsung
1085–1100	Che Tsung
1100–1126	Hui Tsung
1126–1127	Ch'in Tsung

Southern Sung Dynasty

1127–1162	Kao Tsung
1162–1189	Hsaio Tsung
1189–1194	Kuang Tsung
1194–1224	Ning Tsung
1224–1264	Li Tsung
1264–1274	Tu Tsung
1274–1276	Kung Tsung
1276–1278	Tuan Tsung
1278–1279	Ti Ping

Yuan (Mongol) Dynasty

1206–1227	T'ai Tsu (Genghis Khan)
1227–1229	Disputed succession
1229–1241	T'ai Tsung (Ogodei Khan)
1241–1246	Disputed succession
1246–1248	Ting Tsung (Guyuk Khan)
1248–1251	Disputed succession

1251–1259	Hsien Tsung (Mengu Khan)
1260–1294	Shih Tsu (Kublai Khan), emperor of all China from 1279
1294–1307	Ch'eng Tsung
1307–1311	Wu Tsung
1311–1320	Jen Tsung
1320–1323	Ying Tsung
1323–1328	T'ai Ting Ti
1328–1329	Wen Tsung
1329–1329	Ming Tsung
1329–1332	Wen Tsung, restored
1332–1332	Ning Tsung
1332–1368	Shun Ti

Ming Dynasty

1368–1398	T'ai Tsu (Hung Wu; Chu Yuan-Chang)
1398–1402	Hui Ti (Chien wen)
1402–1424	Ch'eng Tsu (Yung Lo)
1424–1425	Jen Tsung (Hung Hsi)
1425–1435	Hsuan Tsung (Hsuan Te)
1435–1449	Ying Tsung (Cheng T'ung)
1449–1457	Tai Tsung (Ching T'ai)
1457–1464	Ying Tsung (Cheng T'ung), restored
1464–1487	Hsien Tsung (Ch'eng Hua)
1487–1505	Hsiao Tsung (Hung Chih)
1505–1521	Wu Tsung (Cheng Te)
1521–1567	Shih Tsung (Chia Ching)
1567–1572	Mu Tsung (Lung Ch'ing)
1572–1620	Shen Tsung (Wan Li)
1620–1620	Kuang Tsung (T'ai Ch'ing)
1620–1627	Hsi Tsung (T'ien Ch'i)
1627–1644	Chuang Lieh Ti (Ch'ung Chen)

Ch'ing (Manchu) Dynasty

1616–1626	T'ai Tsu (T'ien Ming; Nurhachi)
1626–1643	T'ai Tsung (T'ien Ts'ung/Ch'ung Te)
1643–1661	Shih Tsu (Shun Chih)
1661–1722	Sheng Tsu (K'ang Hsi)
1722–1735	Shih Tsung (Yung Cheng)
1735–1796	Kao Tsung (Ch'ien Lung)
1796–1820	Jen Tsung (Chia Ch'ing)
1820–1850	Hsuan Tsung (Tao Kuang)
1850–1861	Wen Tsung (Hsien Feng)
1861–1875	Mu Tsung (T'ung Chih)
1875–1908	Te Tsung (Kuang-hsu)
1908–1912	Mo Ti (Xuantong; Pu-yi)

PRESIDENTS, REPUBLIC OF CHINA

1912–1912	Sun Yat-sen
1912–1916	Yuan Shikai
1916–1917	Li Yuanhoung
1917–1918	Feng Gouzhang
1918–1922	Xu Shichang
1921–1925	Sun Yixian, Canton Administration
1922–1923	Li Yuanhoung
1923–1924	Cao Kun
1924–1926	Duan Qirui
1926–1927	Civil disorder
1927–1928	Zhang Zuolin
1928–1931	Chiang Kai-shek (Jiang Jieshi)
1931–1943	Lin Sen
1940–1944	Wang Jingwei, in Japanese occupied territory
1943–1949	Chiang Kai-shek (Jiang Jieshi)
1945–1949	Civil war
1949–1949	Li Zongren

CHAIRMEN, OR PARAMOUNT LEADERS
PEOPLE'S REPUBLIC OF CHINA

The flag of the People's Republic of China was unveiled at Tiananmen Square in 1949.

1949–1959	Mao Zedong (Mao Tse-tung)
1959–1968	Liu Shaoqi
1968–1975	Dong Biwu
1975–1976	Zhu De
1976–1978	Song Qingling (honorary)
1978–1983	Ye Jianying
1983–1988	Li Xiannian
1988–1993	Yang Shangkun
1993–2003	Jiang Zemin
2003–	Hu Jintao

PRIME MINISTERS

1901–1903	Ronglu
1903–1911	Yikuang, Prince Qing
1912–1912	Lu Zhengxiang
1912–1912	Yuan Shikai
1912–1912	Tang Shaoyi
1912–1913	Zhao Bingjun
1912–1913	Xiong Xiling
1914–1914	Sun Baoyi
1914–1915	Xu Shichang
1915–1916	No prime minister
1916–1917	Duan Qirui
1917–1918	Wang Shizhen

1918–1918	Dun Qirui
1918–1919	Qian Nengxun
1919–1919	Gong Xinzhan
1919–1920	Jin Yunpeng
1921–1922	Liang Shiyi
1922–1922	Yan Huiqin
1922–1922	Zhou Ziqi
1922–1922	Yan Huiqin
1922–1922	Wang Chonghui
1922–1923	Wang Daxie
1923–1923	Zhang Shaozeng
1923–1924	Gao Lingwei
1924–1924	Sun Baoyi
1924–1924	Gu Weijun
1924–1924	Yan Huiqing
1924–1924	Huang Fu
1924–1925	Duan Qirui
1925–1926	Xu Shiying
1926–1926	Jia Deyao
1926–1926	Hu Weide
1926–1926	Yan Huiqing
1926–1926	Du Xigui
1926–1927	Gu Weijun
1927–1928	Pan Fu
1928–1930	Tan Yankai
1930–1930	Song Ziwen (T.V. Soong)
1930–1930	Wang Jingwei
1930–1931	Chiang Kai-shek (Jiang Jieshi)
1931–1932	Sun Fo
1932–1935	Wang Jingwei
1935–1938	Chiang Kai-shek (Jiang Jieshi)
1937–1938	Wang Chonghui
1938–1939	Kong Xiangxi
1939–1944	Chiang Kai-shek (Jiang Jieshi)

1944–1947	Song Ziwen (T.V. Soong)
1945–1949	Civil war
1948–1948	Wang Wenhao
1948–1949	Sun Fo
1949–1949	He Yingqin
1949–1949	Yan Xishan
1949–1976	Zhou Enlai (Chou En-lai)
1976–1980	Hua Guofeng
1980–1987	Zhao Ziyang (Chao Tzu-yang)
1987–1998	Li Peng
1998–2003	Zhu Rongji
2003–	Wen Jiabao

CHAIRMEN, COMMUNIST PARTY

1935–1976	Mao Zedong (Mao Tse-tung)
1976–1981	Hua Guofeng
1981–1982	Hu Yaobang

GENERAL SECRETARIES, COMMUNIST PARTY

1982–1987	Hu Yaobang
1987–1989	Zhao Ziyang (Chao Tzu-yang)
1989–2002	Jiang Zemin
2002–	Hu Jiantao

CUBA

PRESIDENTS

1902–1906	Tomás Estrada Palma
1906–1909	U.S. rule
1909–1913	José Miguel Gómez
1913–1921	Mario García Menocal
1921–1925	Alfredo Zayas y Alfonso
1925–1933	Gerardo Machado y Morales
1933–1933	Carlos Manuel de Cespedes (acting)

1933–1934	Ramon Grau San Martin
1934–1935	Carlos Mendieta
1935–1936	Jose A. Barnet y Vinagres
1936–1936	Miguel Mariano Gómez y Arias
1936–1940	Federico Laredo Brú
1940–1944	Fulgencio Batista
1944–1948	Ramón Grau San Martin
1948–1952	Carlos Prio Socarras
1952–1959	Fulgencio Batista
1959–1959	Manuel Urrutia Lleó
1959–1976	Osvaldo Dorticós Torrado
1976–2008	Fidel Castro Ruz, also prime minister from 1959
2008–	Raúl Castro

EGYPT

OLD KINGDOM DYNASTIES AND RULERS
(The rulers of the Old Kingdom listed are the ones who have been confirmed by archaeologists, but the list is not complete.)

c. 2925–c. 2775 B.C.	I Dynasty—Menes, Djet, Qa'a
c. 2775–c. 2650 B.C.	II Dynasty—Hotepsekhemwy, Raneb, Nynetjer
c. 2650–c. 2575 B.C.	III Dynasty—Sanakhte, Djoser, Sekhemkhet, Khaba, Huni
c. 2575–c. 2465 B.C.	IV Dynasty—Sneferu, Khufu (Cheops), Khafra (Chephren), Djedefra, Menkaura, Shepseskaf
c. 2465–c. 2325 B.C.	V Dynasty—Userkaf, Sahure, Neferirkare Kakai, Shepseskare Isi, Neferefre, Menkauhor Kaiu, Djedkare Isesi, Unas
c. 2325–c. 2150 B.C.	VI Dynasty—Teti, Userkare, Pepi I, Merenre Nemtyemsaf I, Pepe II, Neferka, Nefer, Aba, Merenre Nemtyemsaf II, Neitqerty Siptah

c. 2150–c. 2130 B.C.	VII, VIII Dynasty—Neferkara I and then 16 others
c. 2130–c. 2080 B.C.	IX Dynasty—Meryibre Khety and then 12 others
c. 2080–c. 1970 B.C.	X Dynasty—Meryhathor, Neferkare IV, Wankare, Merykare, Courtnie

PHARAOHS, MIDDLE KINGDOM

XI Dynasty (Thebes)

c. 2081–c. 2065 B.C.	Mentuhotpe I, joint ruler
c. 2081–c. 2065 B.C.	Inyotef I, joint ruler
c. 2065–c. 2016 B.C.	Inyotef II
c. 2016–c. 2008 B.C.	Inyotef III
c. 2008–c. 1957 B.C.	Mentuhotpe II
c. 1957–c. 1945 B.C.	Mentuhotpe III
c. 1945–c. 1938 B.C.	Mentuhotpe IV

XII Dynasty

c. 1938–c. 1908 B.C.	Amenemhe I
c. 1918–c. 1875 B.C.	Senwosre I, joint ruler to 1862 B.C.
c. 1875–c. 1842 B.C.	Amenemhe II
c. 1844–c. 1837 B.C.	Senwosre II, joint ruler to 1842 B.C.
c. 1836–c. 1818 B.C.	Senwosre III
c. 1818–c. 1770 B.C.	Amenemhe III
c. 1770–c. 1760 B.C.	Amenemhe IV
c. 1760–c. 1756 B.C.	Sebeknofru

Minor Dynasties

c. 1756–c. 1630 B.C., XIII Dynasty
c. 1756–c. 1577 B.C., XIV Dynasty Western Delta
c. 1630–c. 1544 B.C., XV (Great Hyskos) Dynasty
c. 1630–c. 1544 B.C., XVI (Minor Hyskos) Dynasty
c. 1630–c. 1540 B.C., XVII Dynasty Upper Egypt

PHARAOHS, NEW KINGDOM

XVIII Dynasty

c. 1539–c. 1514 B.C.	Ahmose
c. 1514–c. 1493 B.C.	Amenhotpe I
1493–c. 1482 B.C.	Thutmose (Tuthmosis) I
c. 1482–1479 B.C.	Thutmose (Tuthmosis) II
1479–1424 B.C.	Thutmose (Tuthmosis) III
1479–1458 B.C.	Hashepsowe (Hatshepsut), Regent
1426–1400 B.C.	Amenhotpe (Amenhotep) II, joint ruler to 1424 B.C.
1400–1390 B.C.	Thutmose (Tuthmosis) IV
1390–1353 B.C.	Amenhotpe (Amenhotep) III
1353–1336 B.C.	Amenhotpe IV (Akhenaton)
1335–1332 B.C.	Smenkhare
1332–1323 B.C.	Tutankhamun
1323–1319 B.C.	Kheperkheprune Ay
1319–c. 1292 B.C.	Haremhab (Horemheb)

XIX Dynasty

c. 1292–1290 B.C.	Ramesse (Rameses) I
1290–1279 B.C.	Seti Merenptah
1279–1213 B.C.	Ramesse II Miamun (Rameses II "the Great")
1213–1204 B.C.	Meryamun Merenptah
1203–1200 B.C.	Amenemses
1203–1197 B.C.	Seti II Merenptah
1197–1193 B.C.	Merenptah Siptah
1193–1190 B.C.	Meryamun Tewosre

XX Dynasty

1190–1187 B.C.	Setnakhte
1187–1156 B.C.	Ramesse (Rameses) III
1156–1150 B.C.	Ramesse IV
1150–1145 B.C.	Ramesse V

1145–1137 B.C.	Ramesse VI
1137–1127 B.C.	Ramesse VII
1127–1126 B.C.	Ramesse VIII
1126–1108 B.C.	Ramesse IX
1108–1104 B.C.	Ramesse X
1104–c. 1078 B.C.	Ramesse XI

Minor Dynasties

c. 1075–c. 950 B.C.	XXI Dynasty Tanis
c. 950–730 B.C.	XXII Dynasty
832–730 B.C.	XXIII Dynasty
730–722 B.C.	Invasion from Libya
722–715 B.C.	XXIV Dynasty Delta
760–656 B.C.	XXV Dynasty Napata
667–525 B.C.	XXVI Dynasty
525–404 B.C.	XXVII Dynasty (Persian rule)
404–399 B.C.	XXVIII Dynasty
399–380 B.C.	XXIX Dynasty
380–343 B.C.	XXX Dynasty
343–332 B.C.	XXXI Dynasty (Persian rule)
332–305 B.C.	XXXII Dynasty (Macedonian rule)

An Alternative "Look" at Egypt's Dynasties

Dynasties 1–2, protodynastic (early) dynastic
(also estimated at 3110–2665 B.C.)
 I. 3110–2884 B.C. (major ruler: Menes)
 II. 2884–2780 B.C.

Dynasties 3–6, Old Kingdom (also estimated at 2664–2180 B.C.)
 III. 2780–2680 B.C. (major ruler: Snefru)
 IV. 2680–2565 B.C. (major rulers: Khufu [Cheops],
 Khafre, Menkaure)
 V. 2565–2420 B.C.
 VI. 2420–2258 B.C. (major rulers: Pepi I, II)

Dynasties 7–11, First Intermediate (also estimated at 2180–2052 B.C.)
VII, VIII. 2258–2225 B.C.
IX, X. 2225–2134 B.C.
XI. 2134–c. 2000 B.C (major ruler: Mentuhotep II)

Dynasty 12, Middle Kingdom
 (also estimated at 2052–1786 B.C.)
XII. 2000–1786 B.C. (major rulers: Amenemhet I, II, III, IV, Sesostris I, II)

Dynasties 13–17, Second Intermediate
 (also estimated at 1785–1554 B.C.)
XIII–XVII. 1786–1570 B.C. (major ruler: Hyksos)

Dynasties 18–20, New Kingdom
 (also estimated at 1554–1075 B.C.)
XVIII. 1579–c. 1342 B.C. (major rulers: Amenhotep I, Thutmose I, II, III, IV, Akhenaton, Tutankhamun)
XIX. c. 1342–1200 B.C. (major rulers: Ramses I, II)
XX. 1200–1085 B.C. (major ruler: Ramses III)

Dynasties 21–25, Late, 1075–664 B.C.
XXI. 1085–945 B.C.
XXII. 945–745 B.C. (major ruler: Sheshonk I)
XXIII. 745–718 B.C.
XXIV. 718–712 B.C.
XXV. 712–663 B.C. (major ruler: Taharka)

Dynasty 26, Saite
XXVI. 663–525 B.C. (major ruler: Necho)

Dynasty 27, First Persian
XXVII. 525–405 B.C. (major rulers: Achaemenids of Persia, Darius II)

Dynasties 28–30, Last Egyptian Kingdom
 (also estimated at 404–341 B.C.)
 XXVIII–XXX. 405–322 B.C. (major ruler: Nekhtnebf I)

Dynasty 31, Second Persian, 341–332 B.C.

MONARCHS, KINGDOM OF EGYPT

Ptolemies-Lagid Dynasty

305–283 B.C.	Ptolemy I Soter
285–246 B.C.	Ptolemy II Philadelphus
246–222 B.C.	Ptolemy III Eurgetes
222–204 B.C.	Ptolemy IV Philopator
204–181 B.C.	Ptolemy V Epiphanes
181–145 B.C.	Ptolemy VI Philometor
145–116 B.C.	Ptolemy VII Euergetes
131–127 B.C.	Cleopatra II (opposition to Ptolemy VIII)
116–108 B.C.	Ptolemy VIII Sotor
108–88 B.C.	Ptolemy IX Alexander
116–107 B.C.	Cleopatra III (joint ruler)
88–80 B.C.	Ptolemy VIII Sotor, restored
107–88 B.C.	Ptolemy X Alexander
107–101 B.C.	Cleopatra III (joint ruler)
80 B.C.	Ptolemy XI Alexander
81–80 B.C.	Berenice III Philopater
80–51 B.C.	Ptolemy XII Auletes
58–57 B.C.	Cleopatra V, joint ruler
58–55 B.C.	Berenice IV Epiphaneia, joint ruler
51–47 B.C.	Ptolemy XII, joint ruler
51–30 B.C.	Cleopatra VII Philopator, joint ruler
47–44 B.C.	Ptolemy XIII, joint ruler
47–44 B.C.	Ptolemy XIV, joint ruler
44–30 B.C.	Ptolemy XV Caesarion
30 B.C.–A.D. 642	Egypt under Roman rule
642–1250	Ruled by various Arab dynasties and states

SULTANS, SULTANATE OF EGYPT
UNDER THE MAMLUKS

Bahri Sultans

1250–1257	al-Muizz Izz-ud-Din Aibak
1257–1259	al-Mansur Nur-ud-Din Ali
1259–1260	al-Muzaffar Saif-ud-Din Qutuz
1260–1277	az-Zahir Rukn-ud-Din Baibars I
1277–1280	as-Said Nasir-ud-Din Baraka Khan
1280–1280	Al-Adil Badr-ud-Din Salamish
1280–1290	al-Mansur Saif-ud-Din Qalaun
1290–1294	al-Ashraf Salah-ud-Din Khalil
1294–1295	an-Nasir Nasi-ud-Din Muhammad
1295–1297	al-Adil Zain-ud-Din Kitbugha
1297–1299	al-Mansur Husam-ud-Din Lajin
1299–1309	an-Nasir Nasir-ud-Din Muhammad, restored
1309–1309	al-Muzaffar Rukn-ud-Din Baibars II
1309–1340	an-Nasir Nasir-ud-Din Muhammad, restored
1340–1341	al-Mansur Saif-ud-Din Abu-Bakr
1341–1342	al-Ashraf Ala-ud-Din Kujuk
1342–1342	an-Nasir Shihab-ud-Din Ahmad
1342–1345	as-Salih Imad-ud-Din Ismail
1345–1346	al-Kamil Saif-ud-Din Shaban I
1346–1347	al-Muzaffar Saif-ud-Din Hajji I
1347–1351	an-Nasir Nasir-ud-Din Hasan
1351–1354	as-Salih Salah-ud-Din Salih
1354–1361	an-Nasir Nasir-ud-Din Hasan, restored
1361–1363	al-Mansur Salah-ud-Din Muhammad
1363–1376	al-Ashraf Nasir-ud-Din Shaban II
1376–1382	al-Mansur Ala-ud-Din Ali
1382–1382	as-Salih Salah-ud-Din Hajji II

Burji Sultans

1382–1389	az-Zahir Saif-ud-Din Barquq

Bahri Sultans
(Restored)

1389-1390	as-Salih Salah-ud-Din Hajji II
1390–1399	az-Zahir Saif-ud-Din Barquq
1399–1405	an-Nasir Nasir-ud-Din Faraj
1405–1405	al-Mansur Izz-ud-Din Abdul-Aziz
1405–1412	an-Nasir Nasir-ud-Din Faraj
1412–1412	al-Adil al-Mustain
1412–1421	al-Muayyad Saif-ud-Din Tatar
1421–1421	al-Muzaffar Ahmad
1421–1421	az-Zahir Saif-ud-Din Tatar
1421–1422	as-Salih Nasir-ud-Din Muhammad
1422–1437	al-Ashraf Saif-ud-Din Barsbay
1437–1438	al-Aziz Jamal-ud-Din Yusuf
1438–1453	az-Zahir Saif-ud-Din Jaqmaq
1453–1453	al-Mansur Fakhr-ud-Din Uthman
1453–1461	al-Ashraf Saif-ud-Din Inal
1461–1461	al-Muayyad Shihab-ud-Din Ahmad
1461–1467	az-Zahir Saif-ud-Din Khushqadam
1467–1468	az-Zahir Saif-ud-Din Bilbay
1468–1468	az-Zahir Timurbugha
1468–1496	al-Ashraf Saif-ud-Din Qait Bay
1496–1498	an-Nasir Muhammad
1498–1500	az-Zahir Qansuh
1500–1501	al-Ashraf Janbalat
1501–1501	al-Adil Saif-ud-Din Tuman Bay
1501–1517	al-Ashraf Qansuh al-Ghawri
1517–1517	al-Ashraf Tuman Bay
1517–1805	Turkish rule

VICEROYS, PROVINCE OF EGYPT

1805–1848	Mehemet Ali Pasha
1848–1848	Ibrahim Pasha
1848–1854	Abbas I

| 1854–1863 | Said Pasha |
| 1863–1866 | Ismail Pasha |

KHEDIVES, PROVINCE OF EGYPT

1866–1879	Ismail Pasha
1879–1892	Mahmud Tawfiq (Tewfik Pasha)
1892–1914	Abbas II Helmi

MONARCHS, SULTANATE OF EGYPT

| 1914–1917 | Hussein Kamel |
| 1917–1922 | Ahmed Fouad |

MONARCHS, KINGDOM OF EGYPT

1922–1936	Ahmed Fouad I
1936–1952	Farouk I
1952–1953	Ahmed Fouad II

PRESIDENTS, REPUBLIC OF EGYPT

1953–1954	Mohammed Naguib
1954–1970	Gamal Abdel Nasser
1970–1981	Mohammed Anwar el-Sadat
1981–	Mohammed Hosni Mubarak

PRIME MINISTERS OF EGYPT

1878–1879	Nubar
1879–1879	Mahmud Tawfiq (Tewfik Pasha)
1879–1881	Mahmud Riyad
1881–1882	Mahmud Sharif
1882–1882	Mahmud Sami al-Barudi
1882–1882	Ahmad Arabi (Arabi Pasha)
1882–1884	Mahmud Sharif
1884–1888	Nubar
1888–1891	Mahmud Riyad
1891–1893	Mustafa Fahmy

1893–1893	Husayn Fakhri
1893–1894	Riyad Pasha
1894–1895	Nubar
1895–1908	Mustafa Fahmy
1908–1910	Butros Ghali
1910–1914	Mohammed Said
1914–1919	Hussein Rushdi
1919–1919	Mohammed Said
1919–1920	Yousuf Wahba
1920–1921	Mohammed Tewfiq Nazim
1921–1921	Adli Yegen
1922–1922	Abdel Khaliq Tharwat
1922–1923	Mohammed Tewfiq Nazim
1923–1924	Yehia Ibrahim
1924–1924	Saad Zaghloul
1924–1926	Ahmed Zaywan
1926–1927	Adli Yegen
1927–1928	Abdel Khaliq Tharwat
1928–1928	Mustafa an-Nahass
1928–1929	Mohammed Mahmoud
1929–1930	Adli Yegen
1930–1930	Mustafa an-Nahass
1930–1933	Ismail Sidqi
1933–1934	Abdel Fattah Yahya
1934–1936	Mohammed Tewfiq Nazim
1936–1936	Ali Maher
1936–1937	Mustafa an-Nahass
1937–1939	Mohammed Mahmoud
1939–1940	Ali Maher
1940–1940	Hassan Sabri
1940–1942	Hussein Sirry
1942–1944	Mustafa an-Nahass
1944–1945	Ahmed Maher
1945–1946	Mahmoud Fahmy el-Nuqrashi

1946–1946	Ismail Sidqi
1946–1948	Mahmoud Fahmy el-Nuqrashi
1948–1949	Ibrahim Abdel Hadi
1949–1950	Hussein Sirry
1950–1952	Mustafa an-Nahass
1952–1952	Ali Maher
1952–1952	Najib el-Hilali
1952–1952	Hussein Sirry
1952–1952	Najib el-Hilali
1952–1952	Ali Maher
1952–1954	Mohammed Najib
1954–1954	Gamal Abdel Nasser
1954–1954	Mohammed Najib
1954–1962	Gamal Abdel Nasser
1962–1965	Ali Sabri
1965–1966	Zakariya Mohyi ed-Din
1966–1967	Mohammed Sidqi Soliman
1967–1970	Gamal Abdel Nasser
1970–1972	Mahmoud Fawzi
1972–1973	Aziz Sidki
1973–1974	Mohamed Anwar el-Sadat
1974–1975	Abdel Aziz Hijazy
1975–1978	Mamdouh Salem
1978–1980	Mustafa Khalil
1980–1981	Mohammed Anwar el-Sadat
1981–1982	Mohammed Hosni Mubarak
1982–1984	Fouad Monyi ed-Din
1984–1984	Kamal Hassan Ali
1985–1986	Ali Lotfi
1986–1996	Atif Sidqi
1996–1999	Kamal Ganzouri
1999–2004	Atef Ebeid
2004–	Ahmed Nazif

Egypt's coat of arms features the Eagle of Saladin carrying a shield with the colors of the nation's flag: red, white, and black.

FRANCE

MONARCHS, KINGDOM OF THE FRANKS

House of Charlemagne
768–814	Charlemagne
814–840	Louis I "the Pious"
840–843	Civil war

MONARCHS, KINGDOM OF THE WEST FRANKS

House of Charlemagne
843–877	Charles I "the Bald"
877–879	Louis II "the Stammerer"
879–884	Carloman, joint ruler to 882
879–882	Louis III, joint ruler

MONARCHS, KINGDOM OF FRANCE

House of Charlemagne
884–887	Charles II "the Fat"

House of Capet
888–898	Eudes

House of Charlemagne (Restored)
893–922	Charles III "the Simple," rival king until 898

House of Capet (Restored)
922–923	Robert I
923–936	Raoul

House of Charlemagne (Restored)
936–954	Louis IV "d'Outre-Mer"
954–986	Lothaire
986–987	Louis V "le Fainéant"

House of Capet (Restored)

987–996	Hugh Capet
996–1031	Robert II
1031–1060	Henri I
1060–1108	Philippe I
1108–1137	Louis VI "the Fat"
1137–1180	Louis VII "the Young"
1180–1223	Philippe II (Philippe-Auguste)
1223–1226	Louis VIII "the Lion"
1226–1270	Louis IX (St. Louis)
1270–1285	Philippe III "the Bold"
1285–1314	Philippe IV "the Fair"
1314–1316	Louis X "the Quarrelsome"
1316–1316	Jean I
1316–1322	Philippe V "the Tall"
1322–1328	Charles IV "the Fair"

House of Valois

1328–1350	Philippe VI
1350–1364	Jean II "the Good"
1364–1380	Charles V "the Wise"
1380–1422	Charles VI "the Foolish"
1422–1461	Charles VII "the Victorious"
1461–1483	Louis XI "the Spider"
1483–1498	Charles VIII "the Affable"

House of Valois-Orléans

1498–1515	Louis XII

House of Valois-Angoulême

1515–1547	François I
1547–1559	Henri II
1559–1560	François II

France Moderne was the royal coat of arms used from 1376 to 1589.

| 1560–1574 | Charles IX |
| 1574–1589 | Henri III |

House of Bourbon

1589–1610	Henri IV (of Navarre)
1610–1643	Louis XIII
1643–1715	Louis XIV
1715–1774	Louis XV
1774–1793	Louis XVI
1793–1795	Louis XVII, not crowned

REVOLUTIONARY GOVERNMENT, FIRST REPUBLIC

1792–1795	National Convention
1795–1799	Directory (Directoire)
1799–1804	Consulate
	(Napoléon Bonaparte, First Consul)

MONARCHS, FIRST EMPIRE

| 1804–1814 | Napoléon I |
| 1815–1815 | Napoléon II, not crowned |

MONARCHS, KINGDOM OF FRANCE

House of Bourbon (restored)

| 1814–1824 | Louis XIII |
| 1824–1830 | Charles X |

House of Orléans

| 1830–1848 | Louis-Philippe |

PRESIDENT, SECOND REPUBLIC

| 1848–1851 | Charles Louis Napoléon Bonaparte |

MONARCH, SECOND EMPIRE

1852–1870 Napoléon III (Charles Louis Napoléon Bonaparte)

PRESIDENTS

Third Republic

1870–1871	Commune
1871–1873	Louis Adolphe Thiers
1873–1879	Marie Edmé de Mac-Mahon (Patrice)
1879–1887	Jules Grévy
1887–1894	Marie François Sadi Carnot
1894–1895	Jean Pierre Paul Casmir-Périer
1895–1899	François Felix Faure
1899–1906	Emile Loubet
1906–1913	Armand Fallières
1913–1920	Raymond Poincaré
1920–1920	Paul Deschanel
1920–1924	Alexandre Millerand
1924–1931	Gaston Doumergue
1931–1932	Paul Doumer
1932–1940	Albert Lebrun
1940–1945	German rule
1945–1947	No president

Fourth Republic

1947–1954	Vincent Auriol
1954–1959	René Coty

Fifth Republic

1959–1969	Charles de Gaulle
1969–1974	Georges Pompidou
1974–1981	Valéry Giscard d'Estaing
1981–1995	François Mitterrand
1995–2007	Jacques René Chirac
2007–	Nicolas Sarkozy

PRIME MINISTERS

1815–1815	Charles-Maurice, Prince de Talleyrand-Périgord
1815–1818	Armand-Emmanuel Vignerot-Duplessis, Duc de Richelieu
1818–1819	Jean Joseph, Marquis Dessolle
1819–1820	Élie, Comte Decazes
1820–1821	Armand Vignerot-Duplessis, Duc de Richelieu
1821–1829	Guillaume-Aubin, Comte de Villele
1829–1830	Jules Auguste, Prince de Polignac
1830–1831	Jacques Lafitte
1831–1832	Casimir Perier
1832–1834	Nicolas Soult
1834–1834	Etienne, Comte Gérard
1834–1834	Napoléon Joseph Maret, Duc de Bassano
1834–1835	Édouard Mortier, Duc de Tréviso
1835–1836	Achille, Duc de Broglie
1836–1836	Adolphe Thiers
1836–1839	Louis, Comte Molé
1839–1840	Nicolas Soult
1840–1840	Adolphe Thiers
1840–1847	Nicolas Soult
1847–1848	François Guizot
1848–1848	Jacques Charles Dupont de L'Eure
1848–1848	Louis-Eugene Cavaignac
1848–1849	Odilon Barrot
1849–1851	Alphonse Henri
1851–1851	Léon Faucher
1851–1869	No prime minister
1869–1870	Émile Olivier
1870–1870	Charles Cousin-Montduban
1870–1871	Jules Trochu
1871–1873	Jules Dufaure
1873–1874	Albert, Duc de Broglie

1874–1875	Ernest Louis Courtot de Cissey
1875–1876	Louis Buffet
1876–1876	Jules Dufaure
1876–1877	Jules Simon
1877–1877	Albert, Duc de Broglie
1877–1877	Gaëtan de Grimaudet de Rochebouët
1877–1879	Jules Dufaure
1879–1879	William H Waddington
1879–1880	Louis de Freycinet
1880–1881	Jules Ferry
1881–1882	Léon Gambetta
1882–1882	Louis de Freycinet
1882–1883	Eugène Duclerc
1883–1883	Armand Fallières
1883–1885	Jules Ferry
1885–1886	Henri Brisson
1886–1886	Louis de Freycinet
1886–1887	René Goblet
1887–1887	Maurice Rouvier
1887–1888	Pierre Tirard
1888–1889	Charles Floquet
1889–1890	Pierre Tirard
1890–1892	Louis de Freycinet
1892–1892	Émile Loubet
1892–1893	Alexandre Ribot
1893–1893	Charles Dupuy
1893–1894	Jean Casimir-Perier
1894–1895	Charles Dupuy
1895–1895	Alexandre Ribot
1895–1896	Léon Bourgeois
1896–1898	Jules Méline
1898–1898	Henri Brisson
1898–1899	Charles Dupuy
1899–1902	Pierre Waldeck-Rousseau

1902–1905	Émile Combes
1905–1906	Maurice Rouvier
1906–1906	Jean Sarrien
1906–1909	Georges Clemenceau
1909–1911	Aristide Briand
1911–1911	Ernest Monis
1911–1912	Joseph Caillaux
1912–1913	Raymond Poincaré
1913–1913	Aristide Briand
1913–1913	Jean Louis Barthou
1913–1914	Gaston Doumergue
1914–1914	Alexandre Ribot
1914–1915	René Viviani
1915–1917	Aristide Briand
1917–1917	Alexandre Ribot
1917–1917	Paul Painlevé
1917–1920	Georges Clemenceau
1920–1920	Alexandre Millerand
1920–1921	Georges Leygues
1921–1922	Aristide Briand
1922–1924	Raymond Poincaré
1924–1924	Frédéric François-Marsal
1924–1925	Édouard Herriot
1925–1925	Paul Painlevé
1925–1926	Aristide Briand
1926–1926	Édouard Herriot
1926–1929	Raymond Poincaré
1929–1929	Aristide Briand
1929–1930	André Tardieu
1930–1930	Camille Chautemps
1930–1930	André Tardieu
1930–1931	Theodore Steeg
1931–1932	Pierre Laval
1932–1932	André Tardieu

1932–1932	Edouard Herriot
1932–1933	Joseph Paul-Boncour
1933–1933	Edouard Daladier
1933–1933	Albert Sarrault
1933–1934	Camille Chautemps
1934–1934	Édouard Daladier
1934–1934	Gaston Doumergue
1934–1935	Pierre Étienne Flandin
1935–1935	Fernand Bouisson
1935–1936	Pierre Laval
1936–1936	Albert Sarraut
1936–1937	Léon Blum
1937–1938	Camille Chautemps
1938–1938	Léon Blum
1938–1940	Édouard Daladier
1940–1940	Paul Reynaud
1940–1942	Philippe Pétain
1942–1944	Pierre Laval
1944–1946	Charles de Gaulle
1946–1946	Félix Gouin
1946–1946	Georges Bidault
1946–1947	Léon Blum
1947–1947	Paul Ramadier
1947–1948	Robert Schuman
1948–1948	André Marie
1948–1948	Robert Schuman
1948–1949	Henri Queuille
1949–1950	Georges Bidault
1950–1950	Henri Queuille
1950–1951	René Pleven
1951–1951	Henri Queuille
1951–1952	René Pleven
1952–1952	Edgar Faure
1952–1953	Antoine Pinay

1953–1953	René Mayer
1953–1954	Joseph Laniel
1954–1955	Pierre Mendès-France
1955–1956	Edgar Faure
1956–1957	Guy Alcide Mollet
1957–1957	Maurice Bourgès-Maunoury
1957–1958	Félix Gaillard
1958–1958	Pierre Pflimin
1958–1959	Charles de Gaulle
1959–1962	Michel Debré
1962–1968	Georges Pompidou
1968–1969	Maurice Couve de Murville
1969–1972	Jacques Chaban Delmas
1972–1974	Pierre Mesmer
1974–1976	Jacques René Chirac
1976–1981	Raymond Barre
1981–1984	Pierre Mauroy
1984–1986	Laurent Fabius
1986–1988	Jacques Rene Chirac
1988–1991	Michel Rocard
1991–1992	Edith Cresson
1992–1993	Pierre Beregovoy
1993–1995	Edouard Balladur
1995–1997	Alain Juppé
1997–2002	Lionel Jospin
2002–2005	Jean-Pierre Raffarin
2005–2007	Dominique de Villepin
2007–	François Fillon

DUKES, LORRAINE

1697–1729	Léopold
1729–1736	Francis III
	(Holy Roman Emperor as Francis I)
1736–1766	Stanislas Leszczynski

DUKES, NORMANDY

(After 1204, possession of mainland Normandy was assumed by France.)

911–932	Ganger-Hrolf (Rollo)
932–942	William I
942–996	Richard I
996–1027	Richard II
1027–1028	Richard III
1028–1035	Robert I
1035–1087	William II (William I of England, "the Conqueror")
1087–1106	Robert Curthose
1106–1135	Henry I Beauclerk, William III Adelin
1135–1144	Stephen
1144–1150	Geoffrey of Anjou
1150–1204	Henry II

GERMANY

Used since 1949, the German flag is (in order) black, red, and gold.

ELECTORS, BRANDENBURG

House of Wittelsbach

1356–1365	Louis II
1365–1373	Otto V

House of Luxembourg

1373–1378	Wenceslaus
1378–1388	Sigismund
1388–1411	Jobst of Moravia
1411–1415	Sigismund

House of Hohenzollern

1415–1440	Friedrich I (of Nuremberg)
1440–1471	Friedrich II
1471–1486	Albrecht (III) Achilles
1486–1499	Johann Cicero
1499–1535	Joachim I
1535–1571	Joachim II
1571–1598	Johann Georg
1598–1608	Joachim Friedrich
1608–1620	Johann Sigismund
1620–1640	Georg Wilhelm
1640–1688	Friedrich Wilhelm "the Great Elector"
1688–1701	Friedrich III

KINGS, PRUSSIA

House of Hohenzollern

1701–1713	Friedrich I (Friedrich III of Brandenburg)
1713–1740	Friedrich Wilhelm I
1740–1786	Friedrich II "the Great"
1786–1797	Friedrich Wilhelm II
1797–1840	Friedrich Wilhelm III
1840–1861	Friedrich Wilhelm IV
1861–1871	Wilhelm I

MONARCHS (KAISERS), GERMAN EMPIRE

House of Hohenzollern

1871–1888	Wilhelm I

| 1888–1888 | Friedrich (Friedrich III of Prussia) |
| 1888–1918 | Wilhelm II |

CHANCELLORS, GERMAN EMPIRE

1871–1890	Otto von Bismarck
1890–1894	Georg Leo, Graf von Caprivi
1894–1900	Chlodwic, Prince von Hohenlohe-Schillingfurst
1900–1909	Bernhard Heinrich, Prince von Bulow
1909–1917	Theobald von Bethmann Hollweg
1917–1918	Georg von Hertling
1918–1918	Prince Max of Baden

HEADS OF STATE (CHANCELLORS), WEIMAR REPUBLIC

1919–1919	Philipp Scheidemann
1919–1920	Gustav Bauer
1920–1920	Hermann Müller
1920–1921	Konstantin Fehrenbach
1921–1922	Karl Joseph Wirth
1922–1923	Wilhelm Cuno
1923–1923	Gustav Stresemann
1923–1925	Wilhelm Marx
1925–1926	Hans Luther
1926–1928	Wilhelm Marx
1928–1929	Hermann Müller
1929–1932	Heinrich Brüning
1932–1932	Franz von Papen
1932–1933	Kurt von Schleicher
1933–1945	Adolf Hitler

PRESIDENT, GERMAN DEMOCRATIC REPUBLIC ("EAST GERMANY")

| 1949–1960 | Wilhelm Pieck |

CHAIRMEN OF THE COUNCIL OF STATE, GERMAN DEMOCRATIC REPUBLIC

1960–1973	Walter Ulbricht
1973–1976	Willi Stoph
1976–1989	Erich Honecker
1989–1989	Egon Krenz
1989–1990	Gregor Gysi, general secretary acting as chairman

PREMIERS, GERMAN DEMOCRATIC REPUBLIC

1949–1964	Otto Grotewohl
1964–1973	Willi Stoph
1973–1976	Horst Sindermann
1976–1989	Willi Stoph
1989–1990	Hans Modrow
1990–1990	Lothar de Maiziere

PRESIDENTS, GERMAN FEDERAL REPUBLIC (ALSO CALLED WEST GERMANY BEFORE 1990)

1949–1959	Theodor Heuss
1959–1969	Heinrich Lübke
1969–1974	Gustav Heinemann
1974–1979	Walter Scheel
1979–1984	Karl Carstens
1984–1994	Richard von Weizsäcker
1994–1999	Roman Herzog
1999–2004	Johannes Rau
2004–	Horst Köhler

The coat of arms for the Federal Republic of Germany was first introduced during the Weimar Republic.

CHANCELLORS, GERMAN FEDERAL REPUBLIC

1949–1963	Konrad Adenauer
1963–1966	Ludwig Erhard

1966–1969	Kurt Georg Kiesinger
1969–1974	Willy Brandt
1974–1982	Helmut Schmidt
1982–1998	Helmut Kohl
1998–2005	Gerhard Schröder
2005–	Dr. Angela Merkel

GERMANY
(STATES BEFORE 1871)

MARGRAVES, BADEN
(Baden was frequently divided into regions and had multiple margraves; the most notable rift occurred in 1535.)

House of Zähringen

1064–1073	Herman I
1073–1130	Herman II
1130–1160	Herman III
1160–1190	Herman IV
1190–1243	Herman V
1243–1250	Herman VI
1250–1268	Frederick I
1243–1288	Rudolf I
1288–1295	Rudolf II
1288–1297	Hesso
1297–1335	Rudolf Hesso
1288–1332	Rudolf III
1288–1291	Herman VII
1291–1333	Frederick II
1333–1353	Herman VIII
1291–1348	Rudolf IV
1348–1361	Rudolf V
1348–1353	Frederick III
1353–1372	Rudolf VI

1372–1391	Rudolf VII
1372–1431	Bernard I
1431–1453	James I
1453–1454	George
1453–1458	Bernard II
1453–1475	Charles I
1475–1515	Christopher I
1515–1533	Philip I
1515–1535	Bernard III
1515–1535	Ernest

MARGRAVES, BADEN-BADEN

House of Zähringen

1535–1536	Bernard III
1536–1556	Christopher II
1536–1569	Philibert
1569–1588	Philip II
1588–1594	Edward Fortunatus
1594–1622	No margrave
1622–1677	William
1677–1707	Louis William
1707–1761	Louis George
1761–1771	Augustus George

MARGRAVES, BADEN-DURLACH

House of Zähringen

1535–1552	Ernest
1552–1553	Bernard IV
1552–1577	Charles II
1577–1590	Ernest-Frederick
1577–1590	James III
1590–1591	Ernest James
1577–1622	George Frederick

1622–1659	Frederick V
1659–1677	Frederick VI
1677–1709	Frederick VII
1709–1738	Charles III William
1738–1771	Karl Friedrich

MARGRAVE, BADEN (RESTORED)

House of Zähringen
1771–1803	Karl Friedrich

ELECTOR, BADEN

House of Zähringen
1803–1806	Karl Friedrich

GRAND DUKES, BADEN

House of Zähringen
1806–1811	Karl Friedrich
1811–1818	Karl
1818–1830	Ludwig I
1830–1852	Leopold
1852–1858	Ludwig II
1858–1907	Friedrich I
1907–1918	Friedrich II

ELECTORS, BAVARIA

House of Wittelsbach
1623–1651	Maximilian I
1651–1679	Ferdinand Maria
1679–1706	Maximilian II Emanuel
1706–1714	No elector
1714–1726	Maximilian II Emanuel, restored

1726–1745	Charles VII Albert
	(Holy Roman Emperor as Charles VII)
1745–1777	Maximilian III Joseph
1777–1799	Karl Theodor
1799–1806	Maximilian IV Josef

KINGS, BAVARIA

House of Wittelsbach

1806–1825	Maximilian I Josef
1825–1848	Ludwig I Augustus
1848–1864	Maximilian II
1864–1886	Ludwig II
1886–1913	Otto
1913–1918	Ludwig III

DUKES, BRUNSWICK

House of Welf

| 1735–1780 | Karl I |
| 1780–1806 | Karl II |

House of Bonaparte

| 1807–1813 | Jerome Bonaparte |

House of Welf (Restored)

1813–1815	Friedrich-Wilhelm
1815–1830	Karl III
1830–1884	Wilhelm

ELECTORS, HANOVER

House of Welf

1692–1698	Ernst-August
1698–1714	Georg (King George I of Great Britain)
1714–1814	Under rule of Great Britain

KINGS, HANOVER

House of Welf

1814–1837	Under rule of Great Britain
1837–1851	Ernest Augustus
1851–1866	George V

LANDGRAVES, HESSE-DARMSTADT

1567–1596	George I
1596–1626	Ludwig V
1626–1661	George II
1661–1678	Ludwig VI
1678–1678	Ludwig VII
1678–1739	Ernst-Ludwig
1739–1768	Ludwig VIII
1768–1790	Ludwig IX
1790–1806	Ludwig X

GRAND DUKES, HESSE

1806–1830	Ludwig I (X)
1830–1848	Ludwig II
1848–1877	Ludwig III
1877–1892	Ludwig IV
1892–1918	Ernst-Ludwig

DUKES, MECKLENBURG

Mecklenburg-Schwerin

1611–1658	Adolf-Friedrich I
1658–1692	Christian-Ludwig I
1692–1713	Friedrich-Wilhelm
1713–1747	Christian-Ludwig II
1747–1756	Karl-Leopold
1756–1785	Friedrich
1785–1815	Friedrich-Franz I

Mecklenburg-Strelitz

1701–1708	Adolf-Friedrich II
1708–1752	Adolf-Friedrich III
1752–1794	Adolf-Friedrich IV
1794–1815	Karl

GRAND DUKES, MECKLENBURG

Mecklenburg-Schwerin

1815–1837	Friedrich-Franz I
1837–1842	Paul
1842–1883	Friedrich-Franz II
1883–1897	Friedrich-Franz III
1897–1918	Friedrich-Franz IV

Mecklenburg-Strelitz

1815–1816	Karl
1816–1860	George
1860–1904	Friedrich-Wilhelm
1904–1914	Adolf-Friedrich V
1914–1918	Adolf-Friedrich VI

DUKES, OLDENBURG

1777–1785	Friedrich-August I
1785–1823	Wilhelm
1823–1829	Peter I
1829–1853	August
1853–1900	Peter II
1900–1918	Friedrich-August II

COUNTS, PALATINE OF THE RHINE

House of Wittelsbach

1214–1227	Ludwig I
1227–1253	Otto

1253–1294	Ludwig II, joint ruler to 1255
1253–1255	Heinrich, joint ruler
1294–1329	Ludwig III, joint ruler to 1317
1294–1317	Rudolf I, joint ruler
1329–1353	Rudolf II
1353–1356	Rupprecht I

ELECTORS, PALATINE OF THE RHINE

House of Wittelsbach

1356–1390	Rupprecht I
1390–1398	Rupprecht II
1398–1410	Rupprecht III
1410–1435	Ludwig III
1435–1449	Ludwig IV
1449–1476	Friedrich I
1476–1508	Philipp
1508–1544	Ludwig VI
1544–1556	Friedrich II
1556–1559	Otto Heinrich
1559–1576	Friedrich III
1576–1583	Ludwig V
1583–1610	Friedrich IV
1610–1623	Friedrich V
1623–1649	Bavarian rule
1649–1680	Karl Ludwig
1680–1685	Karl
1685–1690	Philipp Wilhelm
1690–1716	Johann Wilhelm
1716–1742	Karl Philipp
1742–1799	Karl Theodor
1799–1918	Part of Bavaria

ELECTORS, SAXONY

House of Wettin

1423–1428	Friedrich I (of Meissen)
1428–1464	Friedrich II
1464–1486	Ernst, joint ruler to 1485
1464–1485	Albrecht (III), joint ruler
1486–1525	Friedrich III
1525–1532	Johann
1532–1547	Johann-Friedrich
1547–1553	Moritz
1553–1586	August
1586–1591	Christian I
1591–1611	Christian II
1611–1656	Johann-Georg I
1656–1680	Johann-Georg II
1680–1691	Johann-Georg III
1691–1694	Johann-Georg IV
1694–1733	Friedrich-August I
1733–1763	Friedrich-August II
1763–1763	Friedrich-Christian
1763–1806	Friedrich-August III

KINGS, SAXONY

House of Wettin

1806–1827	Friedrich-August I
1827–1836	Anton
1836–1854	Friedrich-August II
1854–1873	Johann
1873–1902	Albrecht
1902–1904	George
1904–1918	Friedrich-August III

COUNTS, WÜRTTEMBERG

1089–1110	Conrad I
1110–1143	Conrad II
1143–1158	Ludwig I
1166–1181	Ludwig II
1194–1240	Hartmann, joint ruler to 1226
1194–1226	Ludwig III, joint ruler
1241–1265	Ulrich I
1265–1279	Ulrich II
1279–1325	Eberhard I
1325–1344	Ulrich III
1344–1392	Eberhard II, joint ruler to 1366
1344–1366	Ulrich IV, joint ruler
1392–1417	Eberhard III
1417–1419	Eberhard IV
1419–1441	Ludwig IV
1441–1480	Ulrich V
1450–1459	Eberhard V, joint ruler to 1457
1450–1457	Ludwig V, joint ruler
1480–1495	Eberhard VI

DUKES, WÜRTTEMBERG

1495–1504	Eberhard VI, joint ruler to 1496
1495–1496	Eberhard V, joint ruler
1498–1519	Ulrich I
1520–1534	No duke
1534–1550	Ulrich I, restored
1550–1568	Christopher
1568–1593	Ludwig VI
1593–1608	Friedrich I
1608–1628	Johann-Friedrich
1628–1674	Eberhard III
1674–1677	Wilhelm-Ludwig
1693–1733	Eberhard-Ludwig

1733–1737	Karl-Alexander
1737–1793	Karl-Eugen
1793–1795	Ludwig-Eugen
1795–1797	Friedrich-Eugen
1797–1806	Friedrich I

KINGS, WÜRTTEMBERG

1806–1816	Friedrich I
1816–1864	Wilhelm I
1864–1891	Karl
1891–1918	Wilhelm II

GREECE (ANCIENT)

KINGS, SPARTA

(Sparta had a double kingship—at any one time there were two kings, usually one from each family.)

Agiad Dynasty

c. 815–c. 785 B.C.	Agesilaus I
c. 785–c. 760 B.C.	Archilaus
c. 760–c. 740 B.C.	Teleclus
c. 740–c. 700 B.C.	Alcmenes
c. 700–c. 665 B.C.	Polydorus
c. 665–c. 640 B.C.	Eurycrates
c. 640–c. 615 B.C.	Anaxander
c. 615–c. 590 B.C.	Eurycratides
c. 590–c. 560 B.C.	Leon
c. 560–c. 520 B.C.	Anaxandridas
c. 520–c. 489 B.C.	Cleomenes I
c. 489–480 B.C.	Leonidas I
480–c. 458 B.C.	Pleistarchus
c. 458–409 B.C.	Pleistoanax
409–394 B.C.	Pausanias

394–380 B.C.	Agesipolis I
380–371 B.C.	Cleombrotus I
371–369 B.C.	Agesipolis II
369–309 B.C.	Cleomenes II
309–264 B.C.	Areus I
264–c. 262 B.C.	Acrotatus
c. 262–254 B.C.	Areus II
254–235 B.C.	Leonidas II
235–241 B.C.	Cleombrotus III
241–235 B.C.	Leonidas II, restored
235–221 B.C.	Cleomenes III
227–221 B.C.	Euclidas
219–215 B.C.	Agesipolis III

Eurypontid Dynasty

c. 930–? B.C.	Arlendius
c. 890–? B.C.	Soos
c. 890–c. 860 B.C.	Eurypon
c. 860–c. 800 B.C.	Prytanis
c. 830–c. 800 B.C.	Polydectes
c. 800–c. 780 B.C.	Eunomas
c. 800–c. 750 B.C.	Charillus
c. 750–c. 720 B.C.	Nicander
c. 720–c. 675 B.C.	Theopompus
c. 675–c. 645 B.C.	Anaxandridas I
c. 645–c. 625 B.C.	Zeuxidamus
c. 625–c. 600 B.C.	Anaxidamus
c. 600–c. 575 B.C.	Archidamus I
c. 575–c. 550 B.C.	Agasicles
c. 550–c. 515 B.C.	Ariston
c. 515–c. 491 B.C.	Demaratus
c. 491–469 B.C.	Leotychidas
469–427 B.C.	Archidamus II
427–398 B.C.	Agis II

398–361 B.C.	Agesilaus II
361–338 B.C.	Archidamus III
338–331 B.C.	Agis III
331–c. 300 B.C.	Eudamidas I
c. 300–c. 270 B.C.	Archidamus IV
c. 270–c. 245 B.C.	Eudamidas II
c. 245–241 B.C.	Agis IV
241–228 B.C.	Eudamidas III
228–227 B.C.	Archidamus V

KINGS, MACEDONIA

Argead Dynasty

c. 650–c. 630 B.C.	Perdiccas I
c. 630–c. 620 B.C.	Argaeus I
c. 620–c. 590 B.C.	Philip I
c. 590–c. 570 B.C.	Aeropus I
c. 570–c. 540 B.C.	Alcetas
c. 540–c. 495 B.C.	Amyntas I
c. 495–c. 452 B.C.	Alexander I
c. 452–c. 413 B.C.	Perdiccas II
c. 413–c. 399 B.C.	Archelaus
c. 399–c. 398 B.C.	Orestes
c. 398–c. 395 B.C.	Aeropus II
c. 395–c. 394 B.C.	Amyntas II
c. 394–c. 393 B.C.	Pausanias
c. 393–c. 393 B.C.	Amyntas III
c. 393–c. 392 B.C.	Argaeus II
c. 392–369 B.C.	Amyntas III, restored
369–368 B.C.	Alexander II
368–365 B.C.	Ptolemy I
365–359 B.C.	Perdiccas III
359–336 B.C.	Philip II
336–323 B.C.	Alexander III "the Great"

323–310 B.C.	Alexander IV, joint king to 310 B.C.
323–317 B.C.	Philip III Arrhidaeus, joint king
310–305 B.C.	No king

Antipatrid Dynasty

305–297 B.C.	Cassander
297–297 B.C.	Philip IV
297–294 B.C.	East: Antipater;
297–294 B.C.	West: Alexander V
279–277 B.C.	Sosthenes

Antigonid Dynasty

294–288 B.C.	Demetrius I Poliorcetes
288–281 B.C.	Lysimachus
288–285 B.C.	Pyrrhus, King of Epirus
281–279 B.C.	Ptolemy II Ceraunus
279–277 B.C.	Galatian invasion
277–274 B.C.	Antigonus II Gonatas
274–272 B.C.	Pyrrhus, King of Epirus, restored
272–239 B.C.	Antigonus II Gonatas, restored
239–229 B.C.	Demetrius II
229–221 B.C.	Antigonus III Doson
221–179 B.C.	Philip V
179–168 B.C.	Perseus

GREECE (MODERN)

PRESIDENT, FIRST REPUBLIC

| 1829–1831 | Ioannis Kapodistrias |

MONARCHS, KINGDOM OF GREECE

| 1832–1862 | Otho (Otto of Wittelsbach) |
| 1863–1913 | Georgios (George) I |

Greece's blue and white flag was officially adopted in 1978.

1913–1917	Konstantinos (Constantine) I
1917–1920	Alexandros (Alexander)
1920–1922	Konstantinos (Constantine) I, restored
1922–1923	Georgios (George) II
1923–1924	Pavlos Koundouriotis

PRESIDENTS, SECOND REPUBLIC

1924–1926	Pavlos Koundouriotis
1926–1926	Theodoros Pangalos
1926–1929	Pavlos Koundouriotis
1929–1935	Alexandros T. Zaimis

MONARCHS, KINGDOM OF GREECE

1935–1935	Georgios Kondylis
1935–1947	Georgios (George) II
1947–1964	Pavlos (Paul) I
1964–1967	Konstantinos (Constantine) II
1967–1973	Military junta
1973–1973	Georgios Papadopoulos

PRESIDENTS, THIRD REPUBLIC

1973–1973	Georgios Papadopoulos
1973–1974	Phaedon Gizikis
1974–1975	Michael Stasinopoulos
1975–1980	Konstantinos Tsatsos
1980–1985	Konstantinos Karamanlis

1985–1990	Christos Sartzetaki
1990–1995	Konstantinos Karamanlis
1995–2005	Kostis Stephanopoulos
2005–	Karolos Papoulias

PRIME MINISTERS

1833–1833	Spyridon Trikoupis
1833–1834	Alexandros Mavrokordatos
1834–1835	Ioannis Kolettis
1835–1837	Count Josef von Armansperg
1837–1837	Ivon Rudhart
1837–1841	Konstantinos Zographos
1841–1841	Alexandros Mavrokordatos
1841–1843	Antonios Kriezis
1843–1844	Andreas Metaxas
1844–1844	Konstantinos Kanaris
1844–1844	Alexandros Mavrokordatos
1844–1847	Ioannis Kolettis
1847–1848	Kitsos Tzavellas
1848–1848	Georgios Koundouriotis
1848–1849	Konstantinos Kanaris
1849–1854	Antonios Kriezis
1854–1855	Alexandros Mavrokordatos
1855–1857	Dimitrios Voulgaris
1857–1862	Athanasios Misoulis
1862–1862	Gennaios Kolokotronis
1862–1863	Dimitrios Voulgaris
1863–1863	Zinovios Valvis
1863–1863	Diomidis Kiriakos
1863–1863	Benizelos Roufos
1863–1864	Dimitrios Voulgaris
1864–1864	Konstantinos Kanaris
1864–1864	Zinovios Valvis
1864–1865	Konstantinos Kanaris

1865–1865	Alexandros Koumoundhouros
1865–1865	Epameinontas Deligiorgis
1865–1865	Dimitrios Voulgaris
1865–1865	Alexandros Koumoundhouros
1865–1865	Epanmeinontas Deligiorgis
1865–1866	Benizelos Roufos
1866–1866	Dimitrios Voulgaris
1866–1868	Alexandros Koumoundhouros
1868–1868	Aristidis Moraitinis
1868–1869	Dimitrios Voulgaris
1869–1870	Thrasivoulos A Zaimis
1870–1870	Epameinontas Deligiorgis
1870–1871	Alexandros Koumoundhouros
1871–1872	Thrasivoulos A Zaimis
1872–1872	Dimitrios Voulgaris
1872–1874	Epameinontas Deligiorgis
1874–1875	Dimitrios Voulgaris
1875–1875	Kharilaos Trikoupis
1875–1876	Alexandros Koumoundhouros
1876–1876	Epameinontas Deligiorgis
1876–1877	Alexandros Koumoundhouros
1877–1877	Epameinontas Deligiorgis
1877–1877	Alexandros Koumoundhouros
1877–1878	Konstantinos Kanaris
1878–1878	Alexandros Koumoundouros
1878–1878	Kharilaos Trikoupis
1878–1880	Alexandros Koumoundouros
1880–1880	Kharilaos Trikoupis
1880–1882	Alexandros Koumoundhouros
1882–1885	Kharilaos Trikoupis
1885–1886	Theodoros Deligiannis
1886–1886	Dimitrios Valvis
1886–1890	Kharilaos Trikoupis
1890–1892	Theodoros Deligiannis

1892–1892	Konstantinos Konstantopoulos
1892–1893	Kharilaos Trikoupis
1893–1893	Sotirios Sotiropoulos
1893–1895	Kharilaos Trikoupis
1895–1895	Nikolaos Petros Deligiannis
1895–1897	Theodoros Deligiannis
1897–1897	Dimetrios Georgios Rallis
1897–1899	Alexandros Thrasyboulos Zaimis
1899–1901	Georgios Theotokis
1901–1902	Alexandros Thrasyboulos Zaimis
1902–1903	Theodoros Deligiannis
1903–1903	Georgios Theotokis
1903–1903	Dimitrios Georgios Rallis
1903–1904	Georgios Theotokis
1904–1905	Theodoros Deligiannis
1905–1905	Dimitrios Georgios Rallis
1905–1909	Georgios Theotokis
1909–1909	Dimitrios Georgios Rallis
1909–1910	Kyriakoulis P. Mavromichalis
1910–1910	Stephanos Nikolaos Dragoumis
1910–1915	Eleftherios K. Venizelos
1915–1915	Dimitrios P. Gounaris
1915–1915	Eleftherios K. Venizelos
1915–1915	Alexandros Thrasyboulos Zaimis
1915–1916	Stephanos Skouloudis
1916–1916	Alexandros Thrasyboulos Zaimis
1916–1916	Nikolaos P. Kalogeropoulos
1916–1917	Spyridon Lambros
1917–1917	Alexandros Thrasyboulos Zaimis
1917–1920	Eleftherios K. Venizelos
1920–1921	Dimitrios Georgios Rallis
1921–1921	Nikolaos P. Kalogeropoulos
1921–1922	Dimitrios P. Gounaris
1922–1922	Nikolaos Stratos

1922–1922	Petros E. Protopapadakis
1922–1922	Nikolaos Triandaphyllakos
1922–1922	Sotirios Krokidas
1922–1922	Alexandros Thrasyboulos Zaimis
1922–1923	Stylianos Gonatas
1924–1924	Eleftherios K. Venizelos
1924–1924	Georgios Kaphandaris
1924–1924	Alexandros Papanastasiou
1924–1924	Themistocles Sophoulis
1924–1925	Andreas Michalakopoulos
1925–1926	Alexandros N. Chatzikyriakos
1926–1926	Theodoros Pangalos
1926–1926	Athanasius Eftaxias
1926–1926	Georgios Kondylis
1926–1928	Alexandros Thrasyboulos Zaimis
1928–1932	Eleftherios K. Venizelos
1932–1932	Alexandros Papanastasiou
1932–1932	Eleftherios K. Venizelos
1932–1933	Panagiotis Tsaldaris
1933–1933	Eleftherios K. Venizelos
1933–1933	Nikolaos Plastiras
1933–1933	Alexandros Othonaos
1933–1935	Panagiotis Tsaldaris
1935–1935	Georgios Kondylis
1935–1936	Konstantinos Demertzis
1936–1941	Yanni Metaxas
1941–1941	Alexandros Koryzis
1941–1941	Georgios (George) II, chairman of ministers
1941–1941	Emmanuel Tsouderos (under German occupation)
1941–1942	Georgios Tsolakoglou
1942–1943	Konstantinos Logothetopoulos
1943–1944	Ioannis Rallis

MINISTERS, GREEK GOVERNMENT IN EXILE

1941–1944	Emmanuel Tsouderos
1944–1944	Sophocles Venizelos
1944–1945	Georgios Papandreou

POSTWAR PRIME MINISTERS

1945–1945	Nikolaos Plastiras
1945–1945	Petros Voulgaris
1945–1945	Damaskinos, Archbishop of Athens
1945–1945	Panagiotis Kanellopoulos
1945–1946	Themistocles Sophoulis
1946–1946	Panagiotis Politzas
1946–1947	Konstantinos Tsaldaris
1947–1947	Dimitrios Maximos
1947–1947	Konstantinos Tsaldaris
1947–1949	Themistocles Sophoulis
1949–1950	Alexandros Diomedes
1950–1950	Ioannis Theotokis
1950–1950	Sophocles Venizelos
1950–1950	Nikolaos Plastiras
1950–1951	Sophocles Venizelos
1951–1951	Nikolaos Plastiras
1952–1952	Dimitrios Kiusopoulos
1952–1955	Alexandros Papagos
1955–1955	Stephanos C Stefanopoulos
1955–1958	Konstantinos Karamanlis
1958–1958	Konstantinos Georgakopoulos
1958–1961	Konstantinos Karamanlis
1961–1961	Konstantinos Dovas
1961–1963	Konstantinos Karamanlis
1963–1963	Panagiotis Pipinellis
1963–1963	Stylianos Mavromichalis
1963–1963	Georgios Papandreou
1963–1964	Ioannis Paraskevopoulos

1964–1965	Georgios Papandreou
1965–1965	Georgios Athanasiadis-Novas
1965–1965	Elias Tsirimokos
1965–1966	Stephanos C Stefanopoulos
1966–1967	Ioannis Paraskevopoulos
1967–1967	Panagiotis Kanellopoulos
1967–1967	Konstantinos Kollias
1967–1973	Georgios Papadopoulos
1973–1973	Spyridon Markezinis
1973–1974	Adamantios Androutsopoulos
1974–1980	Konstantinos Karamanlis
1980–1981	Georgios Rallis
1981–1989	Andreas Georgios Papandreou
1989–1989	Tzannis Tzannetakis
1989–1990	Xenofon Zolotas
1990–1993	Konstantinos Mitsotakis
1993–1996	Andreas Georgios Papandreou
1996–2004	Kostas Simitis
2004–	Kostas Karamanlis

ISRAEL

KINGS, ISRAEL

c. 1020–c. 1000 B.C.	Saul
c. 1000–c. 961 B.C.	David
c. 961–c. 922 B.C.	Solomon

(In 922 B.C., Palestine divided into two kingdoms: Israel in the north and Judah in the south.)

c. 922–c. 901 B.C.	Jeroboam I
c. 901–c. 900 B.C.	Nadab
c. 900–c. 877 B.C.	Baasha
c. 877–c. 876 B.C.	Elah
c. 876–c. 876 B.C.	Zimri

c. 876–c. 869 B.C.	Omri
c. 869–c. 850 B.C.	Ahab
c. 850–c. 849 B.C.	Ahaziah
c. 849–c. 842 B.C.	Jehoram
c. 842–c. 815 B.C.	Jehu
c. 815–c. 801 B.C.	Jehoahaz
c. 801–c. 786 B.C.	Joash
c. 786–c. 746 B.C.	Jeroboam II
c. 746–c. 745 B.C.	Zachariah
c. 745–c. 745 B.C.	Shallum
c. 745–c. 736 B.C.	Menahem
c. 736–c. 735 B.C.	Pekahiah
c. 735–c. 732 B.C.	Pekah
c. 732–c. 724 B.C.	Hoshea

KINGS, JUDAH

c. 922–c. 915 B.C.	Rehoboam
c. 915–c. 913 B.C.	Abijah
c. 913–c. 873 B.C.	Asa
c. 873–c. 849 B.C.	Jehoshaphat
c. 849–c. 842 B.C.	Jehoram
c. 842–c. 842 B.C.	Ahaziah
c. 842–c. 837 B.C.	Athaliah
c. 837–c. 800 B.C.	Joash
c. 800–c. 783 B.C.	Amaziah
c. 783–c. 742 B.C.	Uzziah
c. 742–c. 735 B.C.	Jotham
c. 735–c. 715 B.C.	Ahaz
c. 715–c. 687 B.C.	Hezekiah
c. 687–c. 642 B.C.	Manasseh
c. 642–c. 640 B.C.	Amon
c. 640–c. 609 B.C.	Josiah
609–609 B.C.	Jehoahaz
609–597 B.C.	Jehoiakim

| 597–597 B.C. | Jehoiachin |
| 597–587 B.C. | Zedekiah |

KINGS, SYRIA
House of Seleucus

305–281 B.C.	Seleucus I Nicator
281–261 B.C.	Antiochus I Soter
261–246 B.C.	Antiochus II Theos
246–225 B.C.	Seleucus II Callinicus
225–223 B.C.	Seleucus III Soter
223–187 B.C.	Antiochus III "the Great"
187–175 B.C.	Seleucus IV Philopator
175–163 B.C.	Antiochus IV Epiphanes
163–162 B.C.	Antiochus V Eupator
162–150 B.C.	Demetrius I Soter
150–145 B.C.	Alexander I Balas
145–139 B.C.	Demetrius II Nicator, joint king and regent until 142 B.C.
145–142 B.C.	Antiochus VI Epiphanes, joint king
139–129 B.C.	Antiochus VII Sidetes
129–125 B.C.	Demetrius II Nicator, restored
128–123 B.C.	Alexander II Zabinas, rival king
125–125 B.C.	Seleucus V
125–96 B.C.	Antiochus VIII Gryphus, rival king from 115 B.C.
115–95 B.C.	Antiochus IX Cyzicenus, rival king
96–95 B.C.	Seleucus VI Epiphanes Nicator, rival king
95–83 B.C.	Antiochus X Eusebes Philopator, rival king
95–88 B.C.	Demetrius III Eukairos Sotor, rival king
92–92 B.C.	Antiochus XI Philadelphus, rival king
92–83 B.C.	Philip I Philadelphus, rival king
87–84 B.C.	Antiochus XII Dionysus, rival king
83–69 B.C.	Tigranes, king of Armenia

| 69–64 B.C. | Antiochus XIII Asiaticus |
| 65–64 B.C. | Philip II, rival king |

KINGS, JUDEA
House of Maccabeus

166–161 B.C.	Jehudah Makkabi (Judas Maccabeus)
161–142 B.C.	Jonathan
142–134 B.C.	Simon
134–104 B.C.	John Hyrcanus I
104–103 B.C.	Aristobulus I
103–76 B.C.	Alexander Jannaeus
76–67 B.C.	Alexandra Salome
67–40 B.C.	Hyrcanus II
67–63 B.C.	Aristobulus II, rival king
40–37 B.C.	Antigonus

House of Herod

37–4 B.C.	Herod I "the Great"
4 B.C.–A.D.	Archelaus
4 B.C.–A.D. 39	Herod Antipas, tetrarch of Galilee
4 B.C.–A.D. 34	Philip, tetrarch of Batanea
37–44	Herod Agrippa I, tetrarch of Batanea, Galilee from 40 B.C., and Judaea from 41 B.C.
41–48	Herod II, tetrarch of Chalcis
50–100	Herod Agrippa II, tetrarch of Chalcis, Batanea from 53 B.C.

KINGS, JERUSALEM

1099–1100	Godfrey of Bouillon
1100–1118	Baldwin I
1118–1131	Baldwin II "of Bourcq"
1131–1143	Fulk of Anjou
1143–1162	Baldwin III
1162–1174	Amalric I

1174–1185	Baldwin IV
1185–1186	Baldwin V
1186–1190	Guy of Lusignan, King of Cyprus from 1192
1190–1192	Conrad of Montferrat
1192–1197	Henry I (of Champagne)
1197–1205	Amalric II, King of Cyprus
1205–1210	Maria
1210–1225	John of Brienne
1225–1243	Frederick (Holy Roman Emperor as Frederick II)
1243–1254	Conrad II (Holy Roman Emperor as Conrad IV)
1254–1284	Conradin of Hohenstauffen
1284–1291	Under rule of Cyprus

PRESIDENTS, STATE OF ISRAEL

1948–1952	Chaim Weizmann
1952–1963	Itzhak Ben-Zvi
1963–1973	Zalman Shazar
1973–1978	Ephraim Katzair
1978–1983	Yitzhak Navon
1983–1993	Chaim Herzog
1993–2000	Ezer Weizman
2000–2007	Moshe Katsav
2007–	Shimon Peres

The flag of Israel
originated as a symbol
of the Zionist movement.

PRIME MINISTERS

1948–1953	David Ben-Gurion
1954–1955	Moshe Sharett
1955–1963	David Ben-Gurion
1963–1969	Levi Eshkol
1969–1974	Golda Meir
1974–1977	Yitzhak Rabin
1977–1983	Menachem Begin
1983–1984	Yitzhak Shamir
1984–1986	Shimon Peres
1986–1992	Yitzhak Shamir
1992–1995	Yitzhak Rabin
1995–1996	Shimon Peres
1996–1999	Benjamin Netanyahu
1999–2001	Ehud Barak
2001–2006	Ariel Sharon
2006–2008	Ehud Olmert

ITALY

COUNTS, SAVOY

1034–1049	Umberto I
1049–1056	Amedeo I
1056–1057	Otto
1057–1078	Pietro I
1078–1080	Amedeo II
1080–1103	Umberto II
1103–1149	Amedeo III
1149–1189	Umberto III
1189–1233	Tommaso
1233–1253	Amedeo IV
1253–1263	Bonifacio, joint ruler
1253–1259	Tommaso II, joint ruler

1263–1268	Pietro II
1268–1285	Filippo I
1285–1323	Amedeo V "the Great"
1323–1329	Edoardo
1329–1343	Aimone "the Peaceful"
1343–1383	Amedeo VI "the Green Count"
1383–1391	Amedeo VII
1391–1416	Amedeo VIII "the Red Count"

DUKES, SAVOY

1416–1440	Amedeo VIII "the Peaceful"
1440–1465	Ludovico
1465–1472	Amedeo IX
1472–1482	Filiberto I
1482–1490	Carlo I
1490–1496	Carlo II
1496–1497	Filippo II
1497–1504	Filiberto I
1504–1553	Carlo III
1553–1580	Emanuel-Filiberto
1580–1630	Carlo-Emanuele I
1630–1637	Vittorio-Amedeo I
1637–1638	Francesco-Giacinto
1638–1675	Carlo-Emanuele II
1675–1720	Vittorio-Amedeo II, King of Sicily (1713–1718)

DUKES, SAVOY AND KINGS, SARDINIA

1720–1730	Vittorio-Amedeo II
1730–1773	Carlo-Emanuele III
1773–1796	Vittorio-Amedeo III
1796–1802	Carlo-Emanuele IV
1802–1821	Vittorio-Emanuele I
1821–1831	Carlo-Felice

| 1831–1849 | Carlo-Alberto (Charles Albert) |
| 1849–1861 | Vittorio-Emanuele (Victor-Emmanuel) II |

MONARCHS, KINGDOM OF ITALY

1861–1878	Vittorio-Emanuele (Victor-Emmanuel) II
1878–1900	Umberto I
1900–1946	Vittorio-Emanuele (Victor-Emmanuel) III
1946–1946	Umberto II

PRESIDENTS, ITALIAN REPUBLIC

1946–1948	Enrico de Nicola
1948–1955	Luigi Einaudi
1955–1962	Giovanni Gronchi
1962–1964	Antonio Segni
1964–1971	Giuseppe Saragat
1971–1978	Giovanni Leone
1978–1985	Alessandro Pertini
1985–1992	Francesco Cossiga
1992–1999	Oscar Luigi Scalfaro
1999–2006	Carlo Azeglio Ciampi
2006–	Giorgio Napolitano

PRIME MINISTERS

1861–1861	Count Camillo Benso di Cavour
1861–1862	Bettino, Baron Ricasoli
1862–1862	Urbano Rattazzi
1862–1863	Luigi Carlo Farini
1863–1864	Marco Minghetti
1864–1866	Alfonso Ferrero, Marquis de la Marmora
1866–1867	Bettino, Baron Ricasoli
1867–1867	Urbano Rattazzi
1867–1869	Luigi Federcio Menabrea
1869–1873	Giovanni Lanza
1873–1876	Marco Minghetti

1876–1878	Agostino Depretis
1878–1878	Benedetto Cairoli
1878–1879	Agostino Depretis
1879–1881	Benedetto Cairoli
1881–1887	Agostino Depretis
1887–1891	Francesco Crispi
1891–1892	Antonio Starabba, Marchese di Rudini
1892–1893	Giovanni Giolitti
1893–1896	Francesco Crispi
1896–1898	Antonio Starabba, Marchese di Rudini
1898–1900	Luigi Pelloux
1900–1901	Giuseppe Saracco
1901–1903	Giuseppe Zanardelli
1903–1905	Giovanni Giolitti
1905–1906	Alessandro Fortis
1906–1906	Baron Sydney Sonnino
1906–1909	Giovanni Giolitti
1909–1910	Baron Sydney Sonnino
1910–1911	Luigi Luzzatti
1911–1914	Giovanni Giolitti
1914–1916	Antonio Salandra
1916–1917	Paolo Boselli
1917–1919	Vittorio Emmanuele Orlando
1919–1920	Francesco Saverio Nitti
1920–1921	Giovanni Giolitti
1921–1922	Ivanoe Bonomi
1922–1922	Luigi Facta
1922–1943	Benito Mussolini
1943–1944	Pietro Badoglio
1944–1945	Ivanoe Bonomi
1945–1945	Ferrucio Parri
1945–1953	Alcide de Gasperi
1953–1954	Giuseppe Pella
1954–1954	Amintore Fanfani

Italy's coat of arms was
adopted in 1948.

1954–1955	Mario Scelba
1955–1957	Antonio Segni
1957–1958	Adone Zoli
1958–1959	Amintore Fanfani
1959–1960	Antonio Segni
1960–1960	Fernando Tambroni
1960–1963	Amintore Fanfani
1963–1963	Giovanni Leone
1963–1968	Aldo Moro
1968–1968	Giovanni Leone
1968–1970	Mariano Rumor
1970–1972	Emilio Colombo
1972–1974	Giulio Andreotti
1974–1976	Aldo Moro
1976–1978	Giulio Andreotti
1979–1980	Francisco Cossiga
1980–1981	Arnaldo Forlani
1981–1982	Giovanni Spadolini
1982–1983	Amintore Fanfani
1983–1987	Bettino Craxi
1987–1987	Amintore Fanfani
1987–1988	Giovanni Goria
1988–1989	Ciriaco de Mita
1989–1992	Giulio Andreotti
1992–1993	Giuliano Amato
1993–1994	Carlo Azeglio Ciampi
1994–1995	Silvio Berlusconi
1995–1996	Lamberto Dini
1996–1998	Romano Prodi
1998–2000	Massimo D'Alema
2000–2001	Giuliano Amato
2001–2006	Silvio Berlusconi
2006–	Romano Prodi

ITALY
(ANCIENT COMMUNES)

CAPTAIN GENERALS, MANTUA

House of Gonzaga

1328–1360	Luigi I
1360–1369	Guido
1369–1382	Luigi II
1382–1407	Francesco I
1407–1433	Gian-Francesco

MARQUIS, MANTUA

House of Gonzaga

1433–1444	Gian-Francesco
1444–1478	Luigi III
1478–1484	Federigo I
1484–1519	Francesco II
1519–1530	Federigo II

DUKES, MANTUA

House of Gonzaga

1530–1540	Federigo II
1540–1550	Francesco III
1550–1587	Guglielmo
1587–1612	Vincenzo I
1612–1612	Francesco IV
1612–1626	Ferdinando
1626–1627	Vincenzo II
1627–1637	Carlo I
1637–1665	Carlo III
1665–1707	Ferdinando-Carlo IV
1708–1861	Under rule of Milan

COUNTS, MILAN

House of Visconti

1310–1322	Matteo I
1322–1328	Galeazzo I
1328–1339	Azzo
1339–1349	Lucchino
1349–1354	Giovanni
1354–1355	Matteo II
1354–1385	Bernabo, joint ruler
1354–1378	Galeazzo II, joint ruler
1378–1396	Gian Galeazzo (Visconti), joint ruler until 1385

DUKES, MILAN

House of Visconti

1378–1395	Gian Galeazzo (Visconti)
1402–1412	Giovanni Maria
1412–1447	Filippo Maria

House of Sforza

1450–1466	Francesco (Sforza)
1466–1476	Galeazzo Maria (Sforza)
1476–1481	Gian Galeazzo (Sforza)
1481–1499	Ludovico (Sforza) "the Moor"
1499–1512	French rule
1512–1515	Massimiliano (Sforza)
1515–1521	French rule
1521–1535	Francesco Maria
1535–1796	Austrian rule
1797–1799	Part of Cisalpine Republic
1799–1859	Austrian rule
1859–1861	Part of Kingdom of Sardinia

LORDS, FERRARA (MODENA)

House of Este

1209–1212	Azzo I
1212–1215	Aldobrandino I
1215–1264	Azzo II
1264–1288	Obizzo I

LORDS, FERRARA AND MODENA

House of Este

1288–1293	Obizzo I
1293–1308	Azzo VIII
1308–1310	Disputed succession
1310–1317	Papal rule
1317–1352	Obizzo II, joint ruler to 1344
1317–1344	Nicolò I, joint ruler
1317–1335	Rinaldo I, joint ruler
1352–1361	Aldobrandino III
1361–1388	Nicolò II
1388–1393	Alberto
1393–1441	Nicolò III
1441–1450	Lionello
1450–1452	Borso

DUKE, MODENA

House of Este

1452–1471	Borso

DUKES, FERRARA AND MODENA

House of Este

1471–1471	Borso
1471–1505	Ercole I
1505–1534	Alfonso I

| 1534–1559 | Ercole II |
| 1559–1597 | Alfonso II |

DUKES, MODENA

House of Este
1597–1628	Cesare
1628–1629	Alfonso III
1629–1658	Francesco I
1658–1662	Alfonso IV
1662–1694	Francesco II
1694–1737	Rinaldo II
1737–1780	Francesco III
1780–1797	Ercole III
1797–1814	French rule

House of Habsburg
| 1814–1846 | Francesco IV |
| 1846–1859 | Francesco V |

DUKES, PARMA

House of Farnese
1545–1547	Pier Luigi
1547–1586	Ottavio
1586–1592	Alessandro (Farnese)
1592–1622	Ranuccio I
1622–1646	Oduardo
1646–1694	Ranuccio II
1694–1727	Francesco
1727–1731	Antonio

House of Bourbon-Parma
| 1731–1735 | Under rule of Spain |
| 1748–1765 | Philip |

1765–1799	Ferdinand
1799–1814	Under rule of France
1814–1847	Marie-Louise of Habsburg
1847–1849	Charles II Louis
1849–1854	Charles III Ferdinand
1854–1860	Robert I

COUNTS, SICILY

Norman rulers

1072–1101	Roger I of Hauteville
1101–1105	Simon
1105–1130	Roger II

KINGS, NAPLES AND SICILY

Norman kings

1130–1154	Roger II
1154–1166	William I
1166–1189	William II
1189–1194	Tancred
1194–1194	William III

House of Hohenstauffen

1194–1197	Henry (Holy Roman Emperor as Henry VI)
1197–1250	Frederick (Holy Roman Emperor as Frederick II)
1250–1254	Conrad (Holy Roman Emperor as Conrad IV)
1254–1258	Conradin (Holy Roman Emperor)
1258–1266	Manfred

House of Anjou

| 1266–1282 | Charles I of Anjou |

KINGS, NAPLES

House of Anjou
1282–1285	Charles I of Anjou
1285–1309	Charles II
1309–1343	Robert "the Wise"
1343–1382	Joanna I
1382–1386	Charles III
1386–1414	Ladislaus
1414–1435	Joanna II

House of Aragon
1435–1458	Alfonso V
1458–1494	Ferdinand I
1494–1495	Alfonso II
1495–1496	Ferdinand II
1496–1501	Frederick IV
1501–1516	Fernando II

KINGS, SICILY

House of Aragon
1282–1285	Peter I King Pedro II of Aragon
1285–1295	James King Jaime II of Aragon
1295–1337	Frederick II
1337–1342	Peter II
1342–1355	Louis
1355–1377	Frederick II
1377–1402	Maria, joint ruler from 1391
1391–1409	Martin I
1409–1410	Martin II
1409–1516	Under rule of Spain

KINGS, THE TWO SICILIES
1516–1700	Under rule of Spain

1700–1713	Disputed succession
1713–1718	Under rule of Savoy
1718–1734	Disputed succession

House of Bourbon

1734–1759	Charles III
1759–1825	Ferdinand I
1825–1830	Francis I
1830–1859	Ferdinand II
1859–1860	Francis II

LORDS, FLORENCE

This emblem served as both the coat of arms and the flag of the Kingdom of the Two Sicilies.

House of Medici

1434–1464	Cosimo (Medici) "Pater Patriae"
1464–1469	Piero I (Medici) "the Gouty"
1469–1492	Lorenzo I (Medici) "the Magnificent"
1492–1494	Piero II (Medici) "the Unfortunate"
1494–1512	Republic
1512–1519	Lorenzo II
1519–1523	Clement VII (Giulio de'Medici)
1523–1527	Alessandro Medici (Silvio Passerini regent)
1527–1530	Republic
1530–1531	Alessandro Medici, restored

DUKES, FLORENCE

House of Medici

| 1531–1537 | Alessandro (Medici) |
| 1537–1569 | Cosimo I (Medici) "the Great" |

GRAND DUKES, TUSCANY

House of Medici

1569–1574	Cosimo I (Medici) "the Great"
1574–1587	Francesco
1587–1609	Ferdinand I
1609–1621	Cosimo II
1621–1670	Ferdinand II
1670–1723	Cosimo III
1723–1737	Gian Gastone

House of Habsburg-Lorraine

1737–1765	Francis (Holy Roman Emperor as Francis I)
1765–1790	Leopold (Holy Roman Emperor as Leopold II)
1790–1801	Ferdinand III
1801–1814	French rule
1814–1824	Ferdinand III
1824–1859	Leopold II

JAPAN

(The traditional dates [T.D.] for early reigns are not generally considered to be reliable.)

EMPERORS

c. 40–c. 10 B.C. (T.D. 660–658 B.C.)	Jimmu
c. 10 B.C.–c. A.D. 20 (T.D. 581–549 B.C.)	Suizei
c. 20–c. 50 (T.D. 549–510 B.C.)	Annei
c. 50–c. 80 (T.D. 510–475 B.C.)	Itoku
c. 80–c. 110 (T.D. 475–392 B.C.)	Kosho
c. 110–c. 140 (T.D. 392–290 B.C.)	Koan
c. 140–c. 170 (T.D. 290–214 B.C.)	Korei
c. 170–c. 200 (T.D. 214–157 B.C.)	Kogen
c. 200–c. 230 (T.D. 157–97 B.C.)	Kaika

c. 230–c. 259 (T.D. 97–29 B.C.)	Sujin
c. 259–c. 291 (T.D. 29 B.C.–A.D. 71)	Suinin
c. 291–c. 323 (T.D. 71–131)	Keikō
c. 323–c. 356 (T.D. 131–192)	Seimu
c. 356–c. 363 (T.D. 192–201)	Chuai
c. 363–c. 380 (T.D. 201–270)	Jingo
c. 380–c. 395 (T.D. 270–313)	Ojin
c. 395–c. 428 (T.D. 313–400)	Nintoku
c. 428–c. 433 (T.D. 400–406)	Richu
c. 433–c. 438 (T.D. 406–412)	Hanzei
c. 438–c. 455 (T.D. 412–454)	Inkyō
c. 455–c. 457 (T.D. 454–457)	Ankō
c. 457–c. 490 (T.D. 457–480)	Yuryaku
c. 490–c. 495 (T.D. 480–485)	Seinei
c. 495–c. 498 (T.D. 485–488)	Kensō
c. 498–c. 504 (T.D. 488–499)	Ninken
c. 504–c. 510 (T.D. 499–507)	Muretsu
c. 510–c. 534 (T.D. 507–534)	Keitai
534–536	Ankan
536–540	Senka
540–572	Kimmei
572–586	Bidatsu
586–588	Yōmei
588–593	Sujun
593–629	Suiko
629–642	Jomei
642–645	Kōgyoku
645–655	Kōtoku
655–662	Saimei*
662–672	Tenchi
672–673	Kōbun
673–686	Temmu
686–697	Jitō

*Empress Kōgyoku, under a new name

697–708	Mommu
708–715	Gemmyo
715–724	Genshō
724–749	Shōmu
749–759	Kōken
759–765	Junnin
765–770	Shōtoku*
770–782	Kōnin
782–806	Kwammu
806–810	Heijo
810–824	Saga
824–834	Junna
834–851	Nimmyō
851–859	Montoku
859–877	Seiwa
877–885	Yōzei
885–889	Kōkō
889–898	Uda
898–931	Daigo
931–947	Shujaku
947–968	Murakami
968–970	Reizei
970–985	Enyu
985–987	Kazan
987–1012	Ichijō
1012–1017	Sanjō
1017–1037	Go-Ichijo
1037–1047	Go-Shujaku
1047–1069	Go-Reizei
1069–1073	Go-Sanjo
1073–1087	Shirakawa
1087–1108	Horikawa
1108–1124	Toba

*Empress Kōken, under a new name

1124–1142	Sutoku
1142–1156	Konoe
1156–1159	Go-Shirakawa
1159–1166	Nijō
1166–1169	Rokujō
1169–1181	Takakura
1181–1184	Antoku
1184–1199	Go-Toba
1199–1211	Tsuchi-Mikado
1211–1221	Juntoku
1221–1222	Chūkyō
1222–1233	Go-Horikawa
1233–1243	Shijo
1243–1247	Go-Saga
1247–1260	Go-Fukakusa
1260–1275	Kameyama
1275–1288	Go-Uda
1288–1299	Fushima
1299–1302	Go-Fushima
1302–1308	Go-Nijō
1308–1319	Hanazono
1319–1331	Go-Daigō
1331–1333	Kōgen
1333–1339	Go-Daigo (restored; south only from 1336)
1336–1349	Komyō (north)
1339–1368	Go-Murakami (south)
1349–1352	Sukō (north)
1352–1372	Go-Kogen (north)
1368–1373	Chokei (south)
1372–1384	Go-Enyu (north)
1373–1392	Go-Kameyama (south)
1384–1413	Go-Komatu (north; only until 1392)
1413–1429	Shōkō
1429–1465	Go-Hanazono

1465–1501	Go-Tsuchi-Mikado
1501–1527	Go-Kashiwabara
1527–1558	Go Nara
1558–1587	Ōgimachi
1587–1612	Go-Yōzei
1612–1630	Go-Mizu-no-o
1630–1644	Myoshō
1644–1655	Go-Kōmyō
1655–1663	Go-Saiin
1663–1687	Reigen
1687–1710	Higashiyama
1710–1736	Naka-no-Mikado
1736–1748	Sakuramachi
1748–1763	Momozono
1763–1771	Go-Sakuramachi
1771–1780	Go-Momozono
1780–1817	Kōkaku
1817–1847	Ninkō
1847–1867	Kōmei
1867–1912	Meiji (Mutsuhito)
1912–1926	Taishō (Yoshihito)
1926–1989	Shōwa (Hirohito)
1989–	Heisei (Akihito)

SHOGUNS

Minamoto Shoguns

1192–1199	Yoritomo Minamoto
1199–1203	Yori-ie Minamoto
1203–1219	Sanemoto Minamoto

Fujiwara Shoguns

| 1220–1244 | Yoritsune Fujiwara |
| 1244–1251 | Yoritsugu Fujiwara |

Imperial Shoguns

1251–1266	Munetaka
1266–1289	Koreyasu
1289–1308	Hisakira
1308–1333	Morikune

Ashikaga Shoguns

1338–1358	Takuji Ashikaga
1358–1367	Yoshiaki Ashikaga
1367–1395	Yoshimitsu Ashikaga
1395–1423	Yoshimochi Ashikaga
1423–1428	Yoshikazu Ashikaga
1428–1441	Yoshinori Ashikaga
1441–1443	Yoshikatsu Ashikaga
1443–1474	Yoshimasa Ashikaga
1474–1490	Yoshihisa Ashikaga
1490–1493	Yoshitane Ashikaga
1493–1508	Yoshizume Ashikaga
1508–1521	Yoshitane Ashikaga, restored
1521–1545	Yoshiharu Ashikaga
1545–1565	Yoshiteru Ashikaga
1565–1568	Yoshihide Ashikaga
1568–1573	Yoshiaki Ashikaga

Tokugawa Shoguns

1603–1605	Ieyasu Tokugawa
1605–1623	Hidetada Tokugawa
1623–1651	Iemitsu Tokugawa
1651–1680	Ietsuna Tokugawa
1680–1709	Tsunayoshi Tokugawa
1709–1713	Ienobu Tokugawa
1713–1716	Ietsugu Tokugawa
1716 1745	Yoshimune Tokugawa
1745–1761	Ieshige Tokugawa

1761–1787	Ieharu Tokugawa
1787–1838	Ienari Tokugawa
1838–1853	Ieyoshi Tokugawa
1853–1858	Iesada Tokugawa
1858–1866	Iemochi Tokugawa
1866–1867	Yoshinobu Tokugawa

PRIME MINISTERS

1885–1888	Hirobumi Ito
1888–1889	Kiyotaka Kuroda
1889–1891	Aritomo Yamagata
1891–1892	Masayoshi Matsukata
1892–1896	Hirobumi Ito
1896–1898	Masayoshi Matsukata
1898–1898	Hirobumi Ito
1898–1898	Shigenobu Okuma
1898–1900	Aritomo Yamagata
1900–1901	Hirobumi Ito
1901–1906	Taro Katsura
1906–1908	Kimmochi Saionji
1908–1911	Taro Katsura
1911–1912	Kimmochi Saionji
1912–1913	Taro Katsura
1913–1914	Gonbe Yamamoto
1914–1916	Shigenobu Okuma
1916–1918	Masatake Terauchi
1918–1921	Takashi Hara
1921–1922	Korekiyo Takahashi
1922–1923	Tomosaburo Kato
1923–1924	Gonbe Yamamoto
1924–1924	Keigo Kiyoura
1924–1926	Takaaki Kato
1926–1927	Reijiro Wakatsuki
1927–1929	Giichi Tanaka

1929–1931	Osachi Hamaguchi
1931–1931	Reijiro Wakatsuki
1931–1932	Tsuyoshi Inukai
1932–1934	Makoto Saito
1934–1936	Keisuke Okada
1936–1937	Koki Hirota
1937–1937	Senjuro Hayashi
1937–1939	Fumimaro Konoe
1939–1939	Kiichiro Hiranuma
1939–1940	Nobuyuki Abe
1940–1940	Mitsumasa Yonai
1940–1941	Fumimaro Konoe
1941–1944	Hideki Tojo
1944–1945	Kuniaki Koiso
1945–1945	Kantaro Suzuki
1945–1945	Naruhiko Higashikuni
1945–1946	Kijuro Shidehara
1946–1947	Shigeru Yoshida
1947–1948	Tetsu Katayama
1948–1948	Hitoshi Ashida
1948–1954	Shigeru Yoshida
1954–1956	Ichiro Hatoyama
1956–1957	Tanzan Ishibashi
1957–1960	Nobusuke Kishi
1960–1964	Hayato Ikeda
1964–1972	Eisaku Sato
1972–1974	Kakuei Tanaka
1974–1976	Takeo Miki
1976–1978	Takeo Fukuda
1978–1980	Masayoshi Ohira
1980–1982	Zenko Suzuki
1982–1987	Yasuhiro Nakasone
1987–1989	Noboru Takeshita
1989–1989	Sasuke Uno

1989–1991	Toshiki Kaifu
1991–1993	Kiichi Miyazama
1993–1994	Morihiro Hosokawa
1994–1994	Tsutomu Hata
1994–1996	Tomiichi Murayama
1996–1998	Ryutaro Hashimoto
1998–2000	Keizo Obuchi
2000–2001	Yoshiro Mori
2001–2006	Junichiro Koizumi
2006–2007	Shinzo Abe
2007–	Yasuo Fukuda

Dating back to 1870,
Japan's flag was officially
adopted in 1999.

MEXICO

KINGS, TENOCHTITLAN (AZTEC) *(dates are approximate)*

1372–1391	Acamapichtli
1391–1415	Huitzilihuitl
1415–1426	Chimalpopoca
1426–1440	Itzcoatl
1440–1468	Moctezuma I Ilhuicamina
1468–1481	Axayacatl
1481–1486	Tizoc
1486–1502	Ahuitzotl
1502–1520	Moctezuma II Xocoyotzin
1520–1520	Cuitlahuac

| 1520–1521 | Cuauhtemoc |
| 1521–1821 | Spanish rule |

RULERS, TEXOCO (AZTEC)

c. 1300–c. 1357	Quinatzin
c. 1357–c. 1409	Techotlala
c. 1409–1418	Ixlilxochitl
1418–1426	Tezozomoc
1426–1428	Maxtla
1431–1472	Nezahualcoyotl
1472–1515	Nezahualpilli
1515–1520	Cacma
1520–1521	Coanacochtzin
1521–1821	Spanish rule

EMPERORS, THE MEXICAN EMPIRE

| 1822–1823 | Agustin de Iturbide |

PRESIDENTS, MEXICO

1824–1829	Guadelupe Victoria
1829–1829	Vicente Guerrero
1829–1829	Jose Maria de Bocanegra (five days only)
1829–1830	Triumvirate of Lucas Alaman, Luis Quintanar, and Pedro Velez
1830–1832	Anastasio Bustamente
1832–1832	Melchor Múzquiz
1832–1833	Manuel Gómez Pedraza
1833–1833	Valentin Gómez Farias
1833–1835	Antonio López de Santa Anna
1835–1836	Miguel Barragan
1836–1837	José Justo Corro
1837–1839	Anastasio Bustamente
1839–1839	Antonio López de Santa Anna
1839–1839	Nicolás Bravo

1839–1841	Anastasio Bustamente
1841–1841	Javier Echeverria
1841–1842	Antonio López de Santa Anna
1842–1843	Nicolás Bravo
1843–1843	Antonio López de Santa Anna
1843–1844	Valentin Canalizo
1844–1844	Antonio López de Santa Anna
1844–1845	José Joaquin de Herrera
1845–1846	Gabriel Valencia
1846–1846	Mariano Paredes y Arrillaga
1846–1846	Nicolas Bravo
1846–1846	Mariano Salas
1846–1847	Valentin Gómez Farías
1847–1847	Antonio López de Santa Anna
1847–1847	Pedro María Anaya
1847–1847	Antonio López de Santa Anna
1847–1847	Manuel de la Peña y Peña
1847–1848	Pedro María de Anaya
1848–1851	José Joaquín de Herrera
1851–1853	Mariano Arista
1853–1853	Juan Bautista Ceballos
1853–1853	Manuel María Lombardini
1853–1855	Antonio López de Santa Anna
1855–1855	Martin Carrera
1855–1855	Rómulo Díaz de la Vega
1855–1855	Juán Alvárez
1855–1858	Ignacio Comonfort
1858–1867	Benito Pablo Juarez
1858–1858	Félix Zuloaga, rival president
1858–1859	Manuel Robles Pezuala, rival president
1859–1860	Mariano Salas, rival acting president
1860–1860	Miguel Miramón, rival president
1860–1860	José Ignacio Pavón, rival president

| 1860–1860 | Miguel Miramón, rival acting president |
| 1860–1862 | Félix Zuloaga |

EMPEROR, MEXICO
| 1864–1867 | Maximilian of Habsburg |

PRESIDENTS, REPUBLIC OF MEXICO
1867–1872	Benito Pablo Juárez
1872–1876	Sebastián Lerdo de Tejada (José de la Cruz)
	Porfirio Díaz
1876–1877	Juan N Méndez
1876–1877	Jose Maria Iglesias, rival president
1877–1880	Porfirio Diaz (José de la Cruz)
1880–1884	Manuel Gonzalez
1884–1911	Porfirio Diaz (José de la Cruz)
1911–1911	Francisco León de la Barra
1911–1913	Francisco I Madero
1913–1914	Victoriano Huerta
1914–1914	Francisco Carvajal
1914–1914	Venustiano Carranza
1914–1915	Eulalio Gutierrez
1915–1915	Roque González Garza
1915–1915	Francisco Lagos Cházaro
1917–1920	Venustiano Carranza
1920–1920	Adolfo de la Huerta
1920–1924	Álvaro Obregón
1924–1928	Plutarco Elias Calles
1928–1930	Emilio Portes Gil
1930–1932	Pascual Ortiz Rubio
1932–1934	Abelardo L Rodríguez
1934–1940	Lázaro Cárdenas
1940–1946	Manuel Avila Camacho
1946–1952	Miguel Aleman
1952–1958	Adolfo Ruiz Cortines

1958–1964	Adolfo López Mateos
1964–1970	Gustavo Diaz Ordaz
1970–1976	Luis Echeverría
1976–1982	José López Portillo
1982–1988	Miguel de la Madrid Hurtado
1988–1994	Carlos Salinas de Gortari
1994–2000	Ernesto Zedillo
2000–2006	Vincente Fox
2006–	Felipe Calderón

ROME

KINGS, ROME

753–716 B.C.	Romulus
716–672 B.C.	Numa Pompilius
672–640 B.C.	Tullus Hostilius
640–616 B.C.	Ancus Marcius
616–578 B.C.	Lucius Tarquinius Priscus
578–534 B.C.	Servius Tullius
534–509 B.C.	Lucius Tarquinius Superbus
509–30 B.C.	Republic

EMPERORS, ROME

30 B.C.–A.D. 14	Augustus (actual name: Gaius Julius Caesar Octavianus)
14–37	Tiberius (Tiberius Julius Caesar Augustus)
37–41	Caligula (Gaius Julius Caesar Germanicus)
41–54	Claudius I (Tiberius Claudius Nero Germanicus)
54–68	Nero (Lucius Domitius Ahenobarbus)
68–69	(Servius Sulcipius) Galba
69–69	(Marcus Salvius) Otho
69–69	(Aulus) Vitellius

69–79	Vespasian (Titus Flavius Vespasianus)
79–81	Titus (Flavius Sabinus Vespasianus)
81–96	Domitian (Titus Flavius Domitianus)
96–98	(Marcus Cocceius) Nerva
98–117	Trajan (Marcus Ulpius Trajanus)
117–138	Hadrian (Publius Aelius Hadrianus)
138–161	(Titus Aurelius Fulvus) Antoninus Pius
161–180	Aurelius (Marcus Aurelius Verus)
161–169	(Lucius Aurelius) Verus, joint emperor
180–192	(Marcus Aurelius Antoninus) Commodus
193–193	(Publius Helvius) Pertinax
193–193	(Marcus) Didius Julianus
193–211	(Lucius Septimius) Severus
193–194	Gaius Pescennius Niger, rival emperor
193–197	Decimus Clodius Albinus, rival emperor
211–217	(Marcus Aurelius Antoninus) Caracalla
211–212	Publius Septimius Antoninus Geta, joint emperor
217–218	(Marcus Opellius) Macrinus
218–222	Elagabalus (Varius Avitus Bassianus)
222–235	(Marcus Aurelius) Alexander Severus
235–238	(Gaius Julius) Maximinus Thrax
238–238	Gordian I (Marcus Antonius Gordianus)
238–238	Gordian II (Marcus Antonius Gordianus), joint emperor
238–238	(Marcus Clodius) Pupienus Maximus
238–238	(Decimus Caelius) Balbinus
238–244	Gordian III (Marcus Antonius Gordianus Pius)
244–249	Philip the Arab (Marcus Julius Philippus Arabs)
249–251	(Gaius Messius Quintus Trajanus) Decius
251–253	(Gaius Vibius Trebonianus) Gallus, joint emperor
251–253	(Gaius Vibius) Volusianus, joint emperor

253–253	(Marcus Aemilius) Aemilianus
253–260	Valerian (Publius Licinius Valerianus), joint emperor
253–268	(Publius Licinius) Gallienus, joint emperor
260–269	(Marcus Latinius) Postumus (recognized as emperor in Gaul)
260–261	(Titus Fulvius) Macrianus, rival emperor
260–261	Titus Fulvius Quietus, rival emperor
268–270	(Marcus Aurelius) Claudius II Gothicus
269–269	Lucius Aelianus, Emperor recognized in Gaul
269–269	Marcus Aurelius Marius, recognized as emperor in Gaul
269–270	(Marcus Piavonius) Victorinus, recognized as emperor in Gaul
270–270	(Marcus Aurelius) Quintillus
270–275	Aurelian (Lucius Domitius Aurelianus)
270–274	(Gaius Pius) Tetricus I (recognized as emperor in Gaul)
274–274	(Gaius Pius) Tetricus II, recognized as emperor in Gaul
275–276	(Marcus Claudius) Tacitus
276–276	(Marcus Annius) Florianus
276–282	(Marcus Aurelius) Probus
282–283	(Marcus Aurelius) Carus
283–285	(Marcus Aurelius) Carinus, joint emperor until 284
283–284	(Marcus Aurelius) Numerianus, joint emperor
284–305	Diocletian (Gaius Aurelius Diocletianus), joint emperor for the Eastern Empire
286–305	Maximian (Marcus Aurelius Maximianus), joint emperor for the Western Empire
286–293	(Marcus Aurelius) Carausius, recognized as emperor in Britain
293–296	Allectus, recognized as emperor in Britain

305–306	(Marcus Flavius) Constantius I Chlorus, joint emperor for the Western Empire
305–311	(Gaius) Galerius (Valerius Maximianus), joint emperor for the Eastern Empire
306–307	Severus II (Flavius Valerius Severus)
306–312	(Marcus Aurelius) Maxentius, rival emperor of the Western Empire
307–308	Maximian (Marcus Aurelius Maximianus), restored as rival emperor of the Western Empire
306–337	Constantine I "the Great" (Flavius Valerius Aurelius Constantinus), joint emperor in the West until 324
307–324	(Gaius Flavius Valerius) Licinius, joint emperor in the East
308–313	(Galerius Valerius) Maximianus Daia, joint emperor in the East
337–340	Constantine II (Flavius Valerius Claudius Constantinus), joint emperor
337–350	(Flavius Valerius Julius) Constans I, joint emperor in the West
337–361	(Flavius Valerius Julius) Constantius II, joint emperor in the east until 350 and from 360
350–353	(Flavius Magnus) Magnentius, rival emperor
360–363	Julian "the Apostate" (Flavius Claudius Julianus), joint emperor until 361
363–364	Jovian (Flavius Claudius Jovianus)
364–375	Valentinian I (Flavius Valentinianus), joint emperor in the West
364–378	(Flavius) Valens, joint emperor in the East
367–383	Gratian (Augustus Gratianus), joint emperor in the West
375–392	Valentinian II (Flavius Valentinianus),

	joint emperor in the West
379–395	(Flavius) Theodosius I "the Great," joint emperor in the East
383–388	Magnus (Clemens) Maximus, joint emperor in the West
392–394	Eugenius, joint emperor in the West

Western Empire

395–423	(Flavius) Honorius
407–411	Constantine III (Flavius Claudius Constantinus), joint emperor
421–421	(Flavius) Constantius III, joint emperor
423–425	Johannes
425–455	Valentinian III (Flavius Placidius Valentinianus)
455–455	(Flavius Ancius) Petronius Maximus
455–456	(Flavius Maecilius Eparchius) Avitus
457–461	(Julius Valerius) Majorianus
461–465	(Libius Severianus) Libius Severus
467–472	(Procopius) Anthemius
472–472	(Anicius) Olybrius
473–474	(Flavius) Glycerius
474–475	Julius Nepos
475–476	(Flavius Momyllus) Romulus Augustus

Emperors, Holy Roman Empire
(revival following the fall of Rome in 476 and the Dark Ages)

911–919	Conrad I of Franconia
919–936	Henry I "the Fowler" of Saxony
936–973	Otto I "the Great"
973–983	Otto II
983–1002	Otto III
1002–1024	Henry II of Bavaria
1024–1039	Conrad II of Franconia
1039–1056	Henry III

1056–1106	Henry IV
1077–1080	Rudolf of Swabia, rival emperor
1081–1093	Hermann of Salm, rival emperor
1093–1101	Conrad of Franconia, rival emperor
1106–1125	Henry V
1125–1137	Lothair III of Supplinberg
1138–1152	Conrad III of Hohenstauffen (Duke of Franconia)
1152–1190	Frederick I Barbarossa (Duke of Swabia)
1190–1197	Henry VI
1198–1218	Otto IV of Saxony
1198–1208	Philip of Swabia, rival emperor
1212–1250	Frederick II of Sicily, "the Wonder of the World"
1246–1247	Henry Raspe of Thuringia, rival emperor
1247–1256	William II of Holland, rival emperor
1250–1254	Conrad IV
1254–1257	Conradin of Swabia
1257–1272	Richard of Cornwall
1257–1273	Alfonso X "the Astronomer" of Castile
1273–1291	Rudolf I of Habsburg
1292–1298	Adolf of Nassau
1298–1308	Albert I of Austria
1308–1313	Henry VII (Henry IV of Luxembourg)
1314–1347	Ludwig "the Bavarian" (Ludwig IV of Upper Bavaria)
1314–1330	Frederick II of Austria, rival emperor
1346–1378	Charles IV of Luxembourg and Bohemia
1349–1349	Günther of Schwarzburg, rival emperor
1378–1400	Wenceslas IV of Bohemia
1400–1400	Frederick of Brunswick-Lüneburg, rival emperor
1400–1410	Ruprecht III of the Palatinate
1410–1437	Sigismund of Bohemia-Hungary
1410–1411	Jobst of Moravia, rival emperor

1437–1439	Albrecht II (Albrecht V of Austria)
1440–1493	Frederick III of Styria
1493–1519	Maximilian I
1519–1558	Charles V (Charles I of Spain)
1558–1564	Ferdinand I
1564–1576	Maximilian II
1576–1612	Rudolf II
1612–1619	Matthias
1619–1637	Ferdinand II of Styria
1637–1658	Ferdinand III
1658–1705	Leopold I
1705–1711	Joseph I
1711–1740	Charles VI
1742–1745	Charles VII (of Bavaria)
1745–1765	Francis I (Francis III of Lorraine)
1765–1790	Joseph II
1790–1792	Leopold II
1792–1806	Francis II (emperor of Austria to 1835)

RUSSIA

GRAND PRINCES, VLADIMIR

House of Riurik

1283–1303	Daniel
1303–1325	Yuri
1325–1341	Ivan I Kalita
1341–1353	Semeon
1353–1359	Ivan II

PRINCES, VLADIMIR-MOSCOW

House of Riurik

| 1359–1389 | Dmitri I Donskoy |
| 1389–1425 | Vasily I |

1425–1462	Vasily II
1462–1505	Ivan III "the Great"
1505–1533	Vasily III
1533–1547	Ivan IV "the Terrible"

TSARS, RUSSIA

House of Riurik

1547–1584	Ivan IV "the Terrible"
1584–1598	Fedor I
1598–1605	Boris Godunov
1605–1605	Fedor II
1605–1606	Dmitri II (the "false Dmitri")
1606–1610	Vasily IV Shuisky
1610–1613	Civil war

House of Romanov

1613–1645	Mikhail (Michael Romanov)
1645–1676	Alexei I Mihailovitch
1676–1682	Fedor III
1682–1725	Peter I "the Great," joint ruler to 1696
1682–1696	Ivan V, joint ruler
1725–1727	Catherine I
1727–1730	Peter II
1730–1740	Anna Ivovna
1740–1741	Ivan VI
1741–1762	Elizabeth Petrovna
1762–1762	Peter III
1762–1796	Catherine II "the Great"
1796–1801	Paul
1801–1825	Alexander I "the Blessed"
1825–1855	Nicholas I
1855–1881	Alexander II "the Liberator"
1881–1894	Alexander III "the Peace-maker"
1894–1917	Nicholas II "the Martyr"

Adopted in 1923, this plain red flag with yellow star, hammer, and sickle served as the national symbol of the USSR until its collapse in 1991.

PRESIDENTS, USSR

1917–1922	Vladimir Ilich Lenin
1919–1946	Mikhail Ivanovich Kalinin
1946–1953	Nikolai Mikhailovich Shvernik
1953–1960	Klimenti Efremovich Voroshilov
1960–1964	Leonid Ilyich Brezhnev
1964–1965	Anastas Ivanovich Mikoyan
1965–1977	Nikolai Viktorovich Podgorny
1977–1982	Leonid Ilyich Brezhnev
1982–1983	Vasily Vasiliyevich Kuznetsov (acting)
1983–1984	Yuri Vladimirovich Andropov
1984–1984	Vasily Vasiliyevich Kuznetsov (acting)
1984–1985	Konstantin Ustinovich Chernenko
1985–1985	Vasily Vasiliyevich Kuznetsov (acting)
1985–1988	Andrei Andreevich Gromyko
1988–1990	Mikhail Sergeevich Gorbachev

EXECUTIVE PRESIDENT

1990–1991	Mikhail Sergeevich Gorbachev

CHAIRMEN (PRIME MINISTERS)

Chairmen of Council of Ministers

1905–1906	Sergey Julyevich Witte
1906–1906	Ivan Logginovich Goremykin
1906–1911	Pyotr Arkadyevich Stolypin

1911–1914	Vladimir Nikolaevich Kokovtsov
1914–1916	Ivan Logginovich Goremykin
1916–1916	Boris Vladimirovich Sturmer
1916–1916	Alexsandr Fedorovich Trepov
1916–1917	Nikolai Dmitrievich Golitsyn
1917–1917	Georgi Evgenievich Lvov
1917–1917	Alexander Feodorovich Kerensky

Chairmen of Council of People's Commissars

1917–1924	Vladimir Ilyich Lenin
1924–1930	Aleksei Ivanovich Rykov
1930–1941	Vyacheslav Mikhailovich Molotov
1941–1953	Josef Stalin

Chairmen of Council of Ministers

1953–1955	Georgi Maksemilianovich Malenkov
1955–1958	Nikolai Bulganin
1958–1964	Nikita Sergeyevich Khrushchev
1964–1980	Alexei Nikolayevich Kosygin
1980–1985	Nikolai Aleksandrovich Tikhonov
1985–1990	Nikolai Ivanovich Ryzhkov
1990–1991	Yury Dmitrievich Maslyukov
1991–1991	Valentin Pavlov

GENERAL SECRETARIES,
THE COMMUNIST PARTY OF THE SOVIET UNION

1922–1953	Josef Stalin
1953–1953	Georgi Maksemilianovich Malenkov
1953–1964	Nikita Sergeyevich Khrushchev
1964–1982	Leonid Ilyich Brezhnev
1982–1984	Yuri Vladimirovich Andropov
1984–1985	Konstantin Ustinovich Chernenko
1985–1991	Mikhail Sergeevich Gorbachev

PRESIDENTS, RUSSIAN FEDERATION

1991–1999	Boris Yeltsin
1999–2008	Vladimir Putin
2008–	Dmitry Medvedev

PRIME MINISTERS

1991–1992	Yegor Gaidar
1992–1998	Victor Chernomyrdin
1998–1998	Boris Yeltsin
1998–1998	Sergei Kiriyenko
1998–1998	Viktor Chernomyrdin
1999–1999	Yevgeny Primakov
1999–1999	Sergei Stepashin
1999–2000	Vladimir Putin
2000–2004	Mikhail Kasyanov
2004–2004	Viktor Khristenko
2004–2007	Mikhail Fradlov
2007–2008	Viktor Zubkov
2008–	Vladimir Putin

SPAIN

KINGS, NAVARRE

c. 810–c. 851	Íñigo Arista
c. 851–c. 880	García Íñiguez
c. 880–905	Fortún Garcés
905–926	Sancho I
926–931	García II
931–970	García Sanchez I
970–994	Sancho II
994–1000	García Sanchez II
1000–1035	Sancho III "the Great"

KINGS, CASTILE-LEON

1035–1065	Fernando (Ferdinand) I, King of Castile, King of Leon from 1037
1065–1072	Sancho II, King of Castile
1065–1109	Alfonso VI, King of Leon, King of Castile from 1072
1109–1126	Urraca
1126–1157	Alfonso VII
1157–1188	Fernando (Ferdinand) II, King of Leon
1188–1230	Alfonso IX, King of Leon
1157–1158	Sancho III, King of Castile
1158–1214	Alfonso VIII, King of Castile
1214–1217	Enrique I, King of Castile
1217–1252	Fernando (Ferdinand) III, King of Castile, King of Leon from 1230
1252–1284	Alfonso X "the Astronomer," Holy Roman Emperor from 1257
1284–1295	Sancho IV
1295–1312	Fernando (Ferdinand) IV
1312–1350	Alfonso XI
1350–1366	Pedro "the Cruel"
1366–1367	Enrique II (of Trestamara)
1367–1369	Pedro the Cruel," restored
1369–1379	Enrique II (of Trestamara), restored
1379–1390	Juan I
1390–1406	Enrique III
1406–1454	Juan II
1454–1474	Enrique IV
1474–1504	Isabel (Isabella) I of Castile
1504–1516	Juana "the Mad" (King Fernando II of Aragon), regent
1504–1506	Felipe (Philip) I "the Handsome," joint ruler

MONARCHS, KING OF ARAGON

1035–1063	Ramiro I
1063–1094	Sancho
1094–1104	Pedro I
1104–1134	Alfonso I "the Battler"
1134–1137	Ramiro II
1137–1162	Petronila
1162–1196	Alfonso II
1196–1213	Pedro II
1213–1276	Jaime I "the Conqueror"
1276–1285	Pedro III, King of Sicily from 1282
1285–1291	Alfonso III
1291–1327	Jaime II, King of Sicily from 1285
1327–1336	Alfonso IV
1336–1387	Pedro IV
1387–1395	Juan I
1385–1410	Martin I, King of Sicily from 1409
1410–1412	Disputed succession
1412–1416	Fernando (Ferdinand) I
1416–1458	Alfonso V "the Magnanimous"
1458–1479	Juan II
1479–1516	Fernando (Ferdinand) II "the Catholic," called Fernando V of Castile from 1506
1516–1555	Joanna

KINGS, SPAIN

House of Habsburg

1516–1556	Carlos I (Charles V, Holy Roman Emperor)
1556–1598	Felipe (Philip) II
1598–1621	Felipe (Philip) III
1621–1665	Felipe (Philip) IV
1665–1700	Carlos (Charles) II

House of Bourbon

1700–1724	Felipe (Philip) V
1724–1724	Luis
1724–1746	Felipe (Philip) V, restored
1746–1759	Fernando (Ferdinand) VI
1759–1788	Carlos (Charles) III
1788–1808	Carlos (Charles) IV
1808–1808	Fernando (Ferdinand) VII

House of Bonaparte

1808–1814	Jose (Joseph Bonaparte)

House of Bourbon (restored)

1814–1833	Fernando (Ferdinand) VII
1833–1868	Isabel (Isabella) II

REGENT, FIRST REPUBLIC

1868–1870	Antonio Canovas del Castillo

MONARCH, KINGDOM OF SPAIN

House of Savoy

1870–1873	Amadeo I

House of Bourbon (restored)

1874–1885	Alfonso XII
1886–1931	Alfonso XIII

Spain's coat of arms was adopted by Juan Carlos I in 1981.

PRESIDENTS, SECOND REPUBLIC

1931–1936	Niceto Alcala Zamora y Torres
1936–1936	Diego Martinez Barrio

PRESIDENTS, DURING CIVIL WAR

1936–1939	Manuel Azana y Diez
1936–1939	Miguel Cabanellas Ferrer

CHIEF OF STATE, NATIONALIST GOVERNMENT

1936–1975 Francisco Franco Bahamonde

MONARCH, KINGDOM OF SPAIN

House of Bourbon (restored)
1975– Juan Carlos I

TURKEY

The ancient design of Turkey's flag dates back to the Ottoman Empire.

KINGS, HATTI (HITTITES)

c. 1800 B.C.	Pitkhana
?	Anitta
?	Tudkhaliash I
c. 1700 B.C.	Pu-Sharruma
?	Labarnash
c. 1650 B.C.	Khattushilish I
?	Murshilish I
?	Khantilish I
?	Zidantash I
c. 1550 B.C.	Ammunash
?	Khuzziyash I
?	Telepinush
c. 1500 B.C.	Alluwamnash
?	Khantilish II

?	Zidantash II
c. 1450 B.C.	Khuzziyash II
?	Tudkhaliash II
?	Arnuwandash I
c. 1400–c. 1390 B.C.	Khattushilish II
c. 1390–c. 1380 B.C.	Tudkhaliash III
c. 1380–c. 1346 B.C.	Shuppiluliumash I
c. 1346–c. 1345 B.C.	Arnuwandash II
c. 1345–c. 1320 B.C.	Murshilish II
c. 1320–c. 1294 B.C.	Muwatallish
c. 1294–c. 1286 B.C.	Murshilish III (Urkhi-Teshub)
c. 1286–c. 1265 B.C.	Khattushilish III
c. 1265–c. 1220 B.C.	Tudkhaliash IV
c. 1220–c. 1200 B.C.	Arnuwandash III
c. 1200–c. 1200 B.C.	Shuppiluliumash II

SULTANS, THE OTTOMAN EMPIRE

1299–1326	Osman I
1326–1359	Orkhan
1359–1389	Murad I
1389–1403	Bayezit I
1403–1421	Mehmet I, rival sultan, to 1413
1403–1410	Suleyman I, rival sultan
1410–1413	Musa, rival sultan
1421–1444	Murad II
1444–1446	Mehmet II "the Conqueror"
1446–1451	Murad II, restored
1451–1481	Mehmet II "the Conqueror," restored
1481–1512	Bayezit II
1512–1520	Selim I "the Grim"
1520–1566	Suleyman II "the Magnificent"
1566–1574	Selim II "the Blond"
1574–1595	Murad III
1595–1603	Mehmet III

1603–1617	Ahmet I
1617–1618	Mustafa I
1618–1622	Osman II "the Young"
1622–1623	Mustafa I, restored
1623–1640	Murad IV
1640–1648	Ibrahim"the Mad"
1648–1687	Mehmet IV "the Hunter"
1687–1691	Suleyman III
1691–1695	Ahmet II
1695–1703	Mustafa II
1703–1730	Ahmet III
1730–1754	Mahmut I
1754–1757	Osman III
1757–1774	Mustafa III
1774–1789	Abd-ul-Hamid I
1789–1807	Selim III
1807–1808	Mustafa IV
1808–1839	Mahmut II
1839–1861	Abd-ul-Medjid
1861–1876	Abdul-Aziz
1876–1876	Murad V
1876–1909	Abd-ul-Hamid II
1909–1918	Mehmet V Reşat
1918–1922	Mehmet VI Vahideddin

PRESIDENTS, TURKISH REPUBLIC

1923–1938	Mustafa Kemal Atatürk
1938–1950	Ismet Paza İnonu
1950–1960	Celal Bayar
1961–1966	Cemal Gürsel
1966–1973	Cevdet Sunay
1973–1980	Fahri S Korutürk
1982–1989	Kenan Evren
1989–1993	Turgut Özal

1993–2000	Süleyman Demirel
2000–2007	Ahmet Necdet Sezer
2007–	Abdullah Gül

UNITED KINGDOM

Nicknamed Union Jack, the flag combines the Crosses of St. George, St. Andrew, and St. Patrick.

MONARCHS, ENGLAND

West Saxons

802–839	Egbert
839–858	Aethelwulf
858–860	Aethelbald
860–865	Aethelbert
866–871	Aethelred
871–899	Alfred "the Great"
899–924	Edward "the Elder"
924–939	Athelstan
939–946	Edmund I
946–955	Edred
955–959	Edwy
959–975	Edgar
975–978	Edward "the Martyr" (St. Edward)
978–1016	Aethelred II "the Unready"
1016–1016	Edmund II "Ironside"

Danes

1013–1014	Sweyn Forkbeard
1016–1035	Knut Sveinsson (Cnut; Canute the Great)
1035–1037	Hardaknut Knutsson (Harthacnut; Harold "Harefoot"), regent
1037–1040	Harold I Knutsson "Harefoot"
1040–1042	Hardaknut Knutsson (Harthacnut), restored

West Saxon Restoration

1042–1066	Edward "the Confessor"
1066–1066	Harold II

House of Normandy

1066–1087	William I "the Conqueror"
1087–1100	William II "Rufus"
1100–1135	Henry I

House of Blois

1135–1154	Stephen

House of Plantagenet

1154–1189	Henry II
1189–1199	Richard I "Coeur de Lion"
1199–1216	John
1216–1272	Henry III
1272–1307	Edward I
1307–1327	Edward II
1327–1377	Edward III
1377–1399	Richard II

House of Lancaster

1399–1413	Henry IV
1413–1422	Henry V
1422–1461	Henry VI

House of York

1461–1470	Edward IV

House of Lancaster (restored)

1470–1471	Henry VI

House of York (restored)

1471–1483	Edward IV
1483–1483	Edward V
1483–1485	Richard III

House of Tudor

1485–1509	Henry VII
1509–1547	Henry VIII
1547–1553	Edward VI
1553–1558	Mary I
1558–1603	Elizabeth I

MONARCHS, SCOTLAND

House of Alpin

843–860	Kenneth I Macalpin
860–863	Donald I
863–877	Constantine I
877–878	Aodh
878–889	Eocha
889–900	Donald II
900–943	Constantine II
943–954	Malcolm I
954–962	Indulf
962–967	Duff
967–971	Colin
971–995	Kenneth II
995–997	Constantine III
997–1005	Kenneth III

1005–1034	Malcolm II
1034–1040	Duncan I
1040–1057	Macbeth
1057–1058	Lulach
1058–1093	Malcolm III "Canmore"
1093–1094	Donald III Ban (Donaldbane)

House of Canmore

| 1094 | Duncan II |

House of Alpin (restored)

| 1094–1097 | Donald III Ban (Donaldbane) |

House of Canmore (restored)

1097–1107	Edgar
1107–1124	Alexander I "the Fierce"
1124–1153	David I "the Saint"
1153–1165	Malcolm IV "the Maiden"
1165–1214	William I "the Lion"
1214–1249	Alexander II
1249–1286	Alexander III
1286–1290	Margaret "Maid of Norway"
1290–1292	No monarch
1292–1296	John de Balliol
1296–1306	English rule

House of Bruce

| 1306–1329 | Robert I "Robert the Bruce" |
| 1329–1371 | David II |

House of Stuart

1371–1390	Robert II "the Steward"
1390–1406	Robert III "the Lame"
1406–1437	James I

1437–1460	James II
1460–1488	James III
1488–1513	James IV
1513–1542	James V
1542–1567	Mary "Queen of Scots"
1567–1603	James VI (James I of England)

MONARCHS, ENGLAND AND SCOTLAND

House of Stuart

| 1603–1625 | James I (James VI of Scotland) |
| 1625–1649 | Charles I |

LORD PROTECTOR, COMMONWEALTH/PROTECTORATE

1649–1653	Council of State
1653–1658	Oliver Cromwell
1658–1659	Richard Cromwell

MONARCHS, GREAT BRITAIN

House of Stuart (restored)

1660–1685	Charles II
1685–1688	James II
	(James VII of Scotland)
1689–1694	William III and Mary II
1694–1702	William III
1702–1707	Anne

House of Stuart

| 1707–1714 | Anne |

House of Hanover

1714–1727	George I
1727–1760	George II
1760–1801	George III

MONARCHS, UNITED KINGDOM OF GREAT BRITAIN AND IRELAND

House of Hanover

1801–1820	George III
1820–1830	George IV
1830–1837	William IV
1837–1901	Victoria

House of Saxe-Coburg

1901–1910	Edward VII

House of Windsor

1910–1922	George V

MONARCHS, UNITED KINGDOM OF GREAT BRITAIN AND NORTHERN IRELAND

House of Windsor

1922–1936	George V
1936–1936	Edward VIII
1936–1952	George VI
1952–	Elizabeth II

PRIME MINISTERS

1721–1742	Robert Walpole, Earl of Orford (Whig)
1742–1743	Spencer Compton, Earl of Wilmington (Whig)
1743–1754	Henry Pelham (Whig)
1754–1756	Thomas Pelham (Holles), Duke of Newcastle (Whig)
1756–1757	William Cavendish, 1st Duke of Devonshire (Whig)
1757–1762	Thomas Pelham (Holles), Duke of Newcastle (Whig)
1762–1763	John Stuart, 3rd Earl of Bute (Tory)
1763–1765	George Grenville (Whig)

1765–1766	Charles Watson Wentworth, 2nd Marquis of Rockingham (Whig)
1766–1767	William Pitt, 1st Earl of Chatham (Whig)
1767–1770	Augustus Henry Fitzroy, 3rd Duke of Grafton (Whig)
1770–1782	Frederick North, 8th Lord North (Tory)
1782–1782	Charles Watson Wentworth, 2nd Marquis of Rockingham (Whig)
1782–1783	William Petty, 2nd Earl of Shelburne (Whig)
1783–1783	William Henry Cavendish, Duke of Portland (Coalition)
1783–1801	William Pitt the Younger (Tory)
1801–1804	Henry Addington, 1st Viscount Sidmouth (Tory)
1804–1806	William Pitt the Younger (Tory)
1806–1807	William Wyndham Grenville, 1st Baron Grenville (Whig)
1807–1809	William Henry Cavendish, Duke of Portland (Coalition)
1809–1812	Spencer Perceval (Tory)
1812–1827	Robert Banks Jenkinson, 2nd Earl of Liverpool (Tory)
1827–1827	George Canning (Tory)
1827–1828	Frederick John Robinson, 1st Earl of Ripon (Tory)
1828–1830	Arthur Wellesley, 1st Duke of Wellington (Tory)
1830–1834	Charles Grey, 2nd Earl Grey (Whig)
1834–1834	William Lamb, 2nd Viscount Melbourne (Whig)
1834–1835	Robert Peel (Conservative)
1835–1841	William Lamb, 2nd Viscount Melbourne (Whig)
1841–1846	Robert Peel (Conservative)
1846–1852	Lord John Russell, 1st Earl Russell (Liberal)
1852–1852	Edward Geoffrey Smith Stanley, 14th Earl of Derby (Conservative)
1852–1855	George Hamilton-Gordon, 4th Earl of Aberdeen (Peelite)

1855–1858	Henry John Temple, 3rd Viscount Palmerston (Liberal)
1858–1859	Edward Geoffrey Smith Stanley, 14th Earl of Derby (Conservative)
1859–1865	Henry John Temple, 3rd Viscount Palmerston (Liberal)
1865–1866	Lord John Russell, 1st Earl Russell (Liberal)
1866–1868	Edward Geoffrey Smith Stanley, 14th Earl of Derby (Conservative)
1868–1868	Benjamin Disraeli, 1st Earl of Beaconsfield (Conservative)
1868–1874	William Ewart Gladstone (Liberal)
1874–1880	Benjamin Disraeli, 1st Earl of Beaconsfield (Conservative)
1880–1885	William Ewart Gladstone (Liberal)
1885–1886	Robert Arthur James Gascoyne-Cecil, 5th Marquis of Salisbury (Conservative)
1886–1886	William Ewart Gladstone (Liberal)
1886–1892	Robert Arthur James Gascoyne-Cecil, 5th Marquis of Salisbury (Conservative)
1892–1894	William Ewart Gladstone (Liberal)
1894–1895	Archibald Philip Primrose, 5th Earl of Rosebery (Liberal)
1895–1902	Robert Arthur James Gascoyne-Cecil, 5th Marquis of Salisbury (Conservative)
1902–1905	Arthur James Balfour, 1st Earl of Balfour (Conservative)
1905–1908	Henry Campbell-Bannerman (Liberal)
1908–1915	Herbert Henry Asquith, 1st Earl of Oxford and Asquith (Liberal)
1915–1916	Herbert Henry Asquith, 1st Earl of Oxford and Asquith (Coalition)
1916–1922	David Lloyd-George, 1st Earl Lloyd-George of Dwyfor (Coalition)

1922–1923	Andrew Bonar Law (Conservative)
1923–1924	Stanley Baldwin, 1st Earl Baldwin of Bewdley (Conservative)
1924–1924	James Ramsay MacDonald (Labour)
1924–1929	Stanley Baldwin, 1st Earl Baldwin of Bewdley (Conservative)
1929–1931	James Ramsay MacDonald (Labour)
1931–1935	James Ramsay MacDonald (Nationalist)
1935–1937	Stanley Baldwin, 1st Earl Baldwin of Bewdley (Nationalist)
1937–1940	(Arthur) Neville Chamberlain (Nationalist)
1940–1945	Winston Leonard Spencer Churchill (Coalition)
1945–1951	Clement Richard Atlee, 1st Earl Attlee (Labour)
1951–1955	Winston Leonard Spencer Churchill (Conservative)
1955–1957	(Robert) Anthony Eden, 1st Earl of Avon (Conservative)
1957–1963	(Maurice) Harold Macmillan, 1st Earl of Stockton (Conservative)
1963–1964	Alexander Frederick "Alec" Douglas-Home, Baron Home of the Hirsel (Conservative)
1964–1970	(James) Harold Wilson, Baron Wilson (Labour)
1970–1974	Edward Richard George Heath (Conservative)
1974–1976	(James) Harold Wilson, Baron Wilson (Labour)
1976–1979	(Leonard) James Callaghan, Baron Callaghan (Labour)
1979–1990	Margaret Hilda Thatcher, Baroness Thatcher (Conservative)
1990–1997	John Major (Conservative)
1997–2007	Tony Blair (Labour)
2007–	Gordon Brown (Labour)

THE WIVES OF HENRY VIII

1509–1533: Catherine of Aragon, daughter of Ferdinand and
Isabella, mother of Mary I (annulled)

1533–1536: Anne Boleyn, mother of Elizabeth I (beheaded)

1536–1537: Jane Seymour, mother of Edward VI (died)

1540: Anne of Cleves (annulled)

1540–1542: Catherine Howard (beheaded)

1543: Catherine Parr (survived Henry)

UNITED STATES OF AMERICA

The 50-star version of the
U.S. flag debuted in 1960.

PRESIDENTS

(Dem=Democrat; Fed=Federalist; Nat=National Union;
Rep=Republican; Dem-Rep = Democratic Republican)

1789–1797	George Washington
1797–1801	John Adams (Fed)
1801–1809	Thomas Jefferson (Dem-Rep)
1809–1817	James Madison (Dem-Rep)
1817–1825	James Monroe (Dem-Rep)
1825–1829	John Quincy Adams (Dem-Rep)
1829–1837	Andrew Jackson (Dem)
1837–1841	Martin Van Buren (Dem)
1841–1841	William Henry Harrison (Whig)
1841–1845	John Tyler (Whig)

1845–1849	James Knox Polk (Dem)
1849–1850	Zachary Taylor (Whig)
1850–1853	Millard Fillmore (Whig)
1853–1857	Franklin Pierce (Dem)
1857–1861	James Buchanan (Dem)
1861–1865	Abraham Lincoln (Rep)
1865–1869	Andrew Johnson (Dem-Nat)
1869–1877	Ulysses Simpson Grant (Rep)
1877–1881	Rutherford Birchard Hayes (Rep)
1881–1881	James Abram Garfield (Rep)
1881–1885	Chester Alan Arthur (Rep)
1885–1889	Stephen Grover Cleveland (Dem)
1889–1893	Benjamin Harrison (Rep)
1893–1897	Stephen Grover Cleveland (Dem)
1897–1901	William McKinley (Rep)
1901–1909	Theodore Roosevelt (Rep)
1909–1913	William Howard Taft (Rep)
1913–1921	Thomas Woodrow Wilson (Dem)
1921–1923	Warren Gamaliel Harding (Rep)
1923–1929	Calvin Coolidge (Rep)
1929–1933	Herbert Clark Hoover (Rep)
1933–1945	Franklin Delano Roosevelt (Dem)
1945–1953	Harry S. Truman (Dem)
1953–1961	Dwight David Eisenhower (Rep)
1961–1963	John Fitzgerald Kennedy (Dem)
1963–1969	Lyndon Baines Johnson (Dem)
1969–1974	Richard Milhous Nixon (Rep)
1974–1977	Gerald Rudolph Ford (Rep)
1977–1981	James Earl (Jimmy) Carter, Jr. (Dem)
1981–1989	Ronald Wilson Reagan (Rep)
1989–1993	George Herbert Walker Bush (Rep)
1993–2001	William Jefferson (Bill) Clinton (Dem)
2001–2009	George Walker Bush (Rep)
2009–	Barack Hussein Obama (Dem)

GOVERNMENT & MILITARY

One tries to find in events an old-fashioned divine governance—an order of things that rewards, punishes, educates, and betters . . .

—Friedrich Nietzsche, *The Will to Power*

ARMED FORCES OF THE UNITED STATES

AIR FORCE GROUPS

Airman: single member
Section: 2 or more airmen
Flight: 2 aircraft
Squadron: 2 flights
Group: 2 squadrons
Wing: 2 groups
Air division: 2 wings
Air force: 2 air divisions
Air command: all divisions and support units

AIR FORCE ORGANIZATION

(major commands of U.S. air force, largest to smallest)
Air Combat Command
 8th Air Force
 1st Air Force
 9th Air Force
 12th Air Force
Air Education and Training Command
Air Force Cyber Command (provisional)
Air Force Reserve Command
 4th Air Force
 10th Air Force
 22nd Air Force
Air Force Materiel Command
Air Mobility Command
 21st Air Force
 15th Air Force
 22nd Air Force
Air Force Space Command
Air Force Special Operations Command
 23rd Air force
Pacific Air Forces

5th Air Force
7th Air Force
11th Air Force
13th Air Force
U.S. Air Forces, Europe
3rd Air Force
16th Air Force
17th Air Force

AIR FORCE RANKS AND GRADES

General of the Air Force (5-star, special)
General (4-star, O-10)
Lieutenant general (3-star, O-9)
Major general (2-star O-8)
Brigadier general (1-star, O-7)
Colonel (O-6)
Lieutenant colonel (O-5)
Major (O-4)
Captain (O-3)
First lieutenant (O-2)
Second lieutenant (O-1)
Chief warrant officer (W-4)
Chief warrant officer (W-3)
Chief warrant officer (W-2)
Warrant officer (W-1)
Chief master sergeant (E-9)
Senior master sergeant (E-8)
Master sergeant (E-7)
Technical sergeant (E-6)
Staff sergeant (E-5)
Senior airman (E-4)
Airman first class (E-3)
Airman (E-2)
Airman basic (E-1)

AIR FORCE THUNDERBIRDS
(a team of highly trained pilots who perform precision maneuvers; the aircraft are placed in five specific positions, each with its own flight path)

Leader

Left wing

Right wing

Solo

Slot

ARMY GROUPS
Squad: 4–10 soldiers

Platoon: 3–4 squads, 16–40 soldiers

Company: 3–5 platoons, 100–200 soldiers

Battalion: 3–5 companies, 500–900 soldiers

Brigade: 3 or more battalions, 3,000–5,000 soldiers

Division: 3 brigades, 10,000–18,000 soldiers

Corps: 2–5 divisions

Field army: 2–5 corps

ARMY ORGANIZATION

Forces Command
 First U.S. Army
 Second U.S. Army
 Third U.S. Army
 Fifth U.S. Army
 Sixth U.S. Army
 I Corps
 III Corps (Phantom Corps)
 1st infantry (The Big Red One)
 4th infantry (The Ivy Division)
 1st cavalry
 2nd armored
 13th corps support command

XVIII Airborne Corps
- 1st cavalry
- 7th infantry
- 10th mountain (Climb to Glory)
- 24th infantry (Victory)
- 82nd airborne (All American)
- 101st airborne (Screaming Eagles)

XVIII Airborne Corps Artillery
- 1st corps support command

National Training Center
Joint Readiness Training Center
U.S. Army Reserve
Division Ready Brigade

U.S. Army Europe (7th Army)
- V Corps
 - 3rd infantry (Marne)
 - 1st armored (Old Ironsides)
 - 32nd air defense command
 - 3rd corps support command
 - 21st theater army area command
 - Seventh Army training command
 - Seventh Army medical command

U.S. Army Pacific
- U.S. Army, Japan, IX Corps
 - 6th infantry
 - 25th infantry (Tropic Lightning)

Eighth Army
- 2nd infantry (Indianhead)

U.S. Army South

National Guard
- 28th infantry (Keystone)
- 29th infantry (Blue and Gray)
- 34th infantry
- 35th infantry (Santa Fe)

38th infantry (Cyclone)
40th infantry (Sunshine)
42nd infantry (Rainbow)
49th armored (Lone Star)

ARMY RANKS AND GRADES

Commissioned Officers
General of the Army (5-star, special)
General (4-star, 0-10)
Lieutenant general (3-star, O-9)
Major general (2-star, O-8)
Brigadier general (1-star, O-7)
Colonel (O-6)
Lieutenant colonel (O-5)
Major (O-4)
Captain (O-3)
First lieutenant (O–2)
Second lieutenant (O-1)
Chief warrant officer 5 (W-5)
Chief warrant officer 4 (W-4)
Chief warrant officer 3 (W-3)
Chief warrant officer 2 (W-2)
Warrant officer 1 (W-1)

Noncommissioned (Enlisted) Officers
Sergeant major specialist (E-9)
First (Master) sergeant specialist (E-8)
Sergeant first class specialist (E-7)
Staff sergeant specialist (E-6)
Sergeant (E-5)

Enlisted Ranks
Corporal specialist (E-4) Private (E-2)
Private first class (E-3) Private (E-1)

CONTINENTAL (REGULAR) ARMY OF REVOLUTIONARY WAR

(Before the Continental Congress in 1778, each state prescribed its own military organization; though there were similarities, each was different.)

Artillery

Commander in chief
General
Major general
Brigadier general
Quartermaster general
Adjutant general
Deputy adjutant general
Colonel
Lieutenant colonel
Major
Captain
Captain lieutenant
First lieutenant
Second lieutenant
Ensign
Sergeant major
Sergeant
Corporal
Drum major
Fife major
Drummer (Fifer)

Cavalry

Regiment
 Colonel
 Lieutenant colonel
 Major
 Adjutant
 Chaplain
 Quartermaster
 Surgeon
 Surgeon's mate
 Ridingmaster
 Paymaster
 Riding master
 Trumpet major
 Saddler
 Sergeant major
 Supernumeraries

Troop members
 Captain
 Lieutenant
 Cornet (carried colors for cavalry)
 Quartermaster sergeant
 Orderly or drill sergeant
 Trumpeter
 Farrier (blacksmith)
 Corporal
 Dragoon (mounted infantryman with short musket)
 Private
 Armorer (upkeep of small arms, ammunition)

Other Ranks, Officers, and Staff

Chaplain
Adjutant
Regimental quartermaster
Surgeon
Surgeon's mate
Quartermaster's sergeant
Paymaster
Commissary
Clerk
Conductor

Bombardier
Gunner
Matross
Cadet
Bandsman
Artillery artificers (carpenters, blacksmiths, wheelwrights, tinners, turners, harness makers, coopers, nailers, farriers)

DRAFT CLASSIFICATION

1-A: available to serve

1-A-M: medical or other specialist

1-A-O: conscientious objector; noncombatant service

1-C: present member of armed forces

1-D-D: deferment for certain members or students taking military training

1-D-E: exemption for certain members or students taking military training

1-H: exempt from induction for other reasons than below

1-O: conscientious objector; nonmilitary service

1-W: conscientious objector; to perform alternative service

2-A-M: medical or other specialist; deferred for community obligations

2-D: theological student; deferred

2-M: medical student; deferred

3-A: sole supporter of others; deferred

4-A: already served in military

4-B: public servant; deferred

4-C: alien or dual national

4-D: clergy

4-F: unqualified, often due to medical problem

4-G: exemption due to death of parent or sibling only used in wartime

4-W: conscientious objector who served in nonmilitary capacity

5-A: over the age of liability (25) or previously deferred (35)

GUN SALUTE BY DEGREES

50: July 4 at noon

21: arrival and departure of president, former president, president-elect, or a foreign leader or royalty

19: arrival and departure of vice president, Speaker of the House, cabinet members, Senate president pro tempore, Chief Justice, state governor, U.S. or foreign ambassador, prime minister, premier, secretary of a military branch, or chairman of the Joint Chiefs of Staff

17: arrival and departure of general, admirals, assistant secretaries of military branches, or arrival of a chairman of a congressional committee

15: arrival of American or visiting foreign envoys or ministers, or for lieutenant general or vice admiral

13: arrival of rear admiral (upper half) or resident ministers

11: arrival of brigadier general or rear admiral (lower half), or for American chargés d'affaires, foreign counterparts, and consuls general

MARINE CORPS ORGANIZATION

(largest to smallest)

Fleet Marine Force, Atlantic
Fleet Marine Force, Pacific
Marine Corps Combat Development
 Command
I Marine Expeditionary Force
II Marine Expeditionary Force
III Marine Expeditionary Force
Marine Corps Combat Development Command

MARINE CORPS RANKS AND GRADES

General (4-star, O-10)

Lieutenant general (3-star, O-9)

Major general (2-star, O-8)

Brigadier general (1-star, O-7)

Colonel (O-6)

Lieutenant colonel (O-5)

Major (O-4)

Captain (O-3)

First lieutenant (O-2)

Second lieutenant (O-1)

Chief warrant officer (W-5)

Chief warrant officer (W-4)

Chief warrant officer (W-3)

Chief warrant officer (W-2)

Warrant officer (W-1)

Sergeant major or master gunnery sergeant (E-9)

First or master sergeant (E-8)

Gunnery sergeant (E-7)

Staff sergeant (E-6)

Sergeant (E-5)

Corporal (E-4)

Lance corporal (E-3)

Private first class (E-2)

Private (E-1)

NAVY AND COAST GUARD RANKS AND GRADES

Officers

Fleet admiral (5-star, O-11)

Admiral (4-star, O-10)

Vice admiral (3-star, O-9)

Rear admiral (upper half, 2-star, O-8)

Rear admiral (lower half, 1-star, O-7; formerly Commodore)

Captain (O-6)

Commander (O-5)

Lieutenant commander (O-4)

Lieutenant (O-3)

Lieutenant junior grade (O-2)

Ensign (O-1)

Chief warrant officer (W-4)

Chief warrant officer (W-3)

Chief warrant officer (W-2)

Warrant officer (W-1)

Enlisted Personnel

Master chief petty officer (E-9)

Senior chief petty officer (E-8)

Chief petty officer (E-7)

Petty officer first class (E-6)

Petty officer second class (E-5)

Petty officer third class (E-4)

Seaman (E-3)

Seaman apprentice (E-2)

Seaman recruit (E-1)

NAVY GROUPS
Division: 4 ships
Squadron: 2 divisions
Fleet: 2 squadrons

NAVY OPERATING FORCES ORGANIZATION
(largest to smallest)
Pacific Fleet
 Third Fleet
 Seventh Fleet
Atlantic Fleet
 Second Fleet
U.S. Naval Forces Europe
 Sixth Fleet

Military Sealift Command
Naval Reserve Force
Mine Warfare Command
Operational and Test Evaluation Force
Naval Forces Southern Command (Fourth Fleet)
Naval Forces Central Command (Fifth Fleet)
 Middle East Force
Naval Special Warfare Command

NAVY ORGANIZATION
Office of the Undersecretary
Office of the Assistant Secretary (material)
Office of the Assistant Secretary (research and development)
Office of the Assistant Secretary (personnel and reserves)
Executive Offices of the Secretary
Office of the Chief of Naval Operations
Headquarters, United States Marine Corps
United States Coast Guard (in wartime)
Bureau of Medicine and Surgery
Bureau of Naval Personnel

Bureau of Naval Weapons
Bureau of Ships
Bureau of Supplies and Accounts
Bureau of Yards and Docks

NAVY RANKS, CIVIL WAR

Union

Ensign	Commander
Master	Commodore
Lieutenant	Captain
Lieutenant commander (no equivalent in Confederacy)	Rear admiral (no equivalent in Confederacy)

Confederacy

Passed midshipman	Commander
Master	Captain
Lieutenant	Flag officer

RANKS OF MILITARY RESERVES

(Air Force, Army, Navy)
Drilling reserves, paid
 Category A
 Category B
Drilling reserves, unpaid
 Category D
Inactive reserves, unpaid and no training
 Category H

ARMED FORCES OF THE WORLD

ANCIENT ATHENIAN ARMY

Strategoi (commanders): ten total, one from each of the
 Athenian tribes and elected by the Assembly

Phyle (regiment): group of soldiers provided by each of the ten tribes

Cavalry: group of soldiers provided by each of the ten tribes

Hipparchs (commanders): two men who each controlled five squadrons

Phalanx: long block of soldiers, usually eight ranks deep

Hoplites: armed foot soldiers

Ephebes: young men 18–20 years old doing two years' military training

Psiloi: auxiliary soldiers, including archers and stone slingers

Peltastes: auxillary soldiers, inluding javelin throwers

Ekdromoi: "runners out" who would run out of the phalanx to chase the enemy

CANADIAN ARMY AND AIR FORCE RANKS

General
Lieutenant-general
Major-general
Brigadier-general
Senior officers
 Colonel
 Lieutenant-colonel
 Major
Junior officers
 Captain
 Lieutenant
 Second lieutenant

Subordinate officer
 Officer cadet
Noncommissioned members
 Chief warrant officer
 Master warrant officer
 Warrant officer
 Sergeant
 Master-corporal (senior corporal of section)
 Corporal
 Private
 Private recruit

CANADIAN NAVY RANKS

Admiral
Vice-admiral

Rear-admiral
Commodore

Senior officers
 Captain
 Commander
 Lieutenant-commander
Junior officers
 Lieutenant
 Sub-lieutenant
 Acting sub-lieutenant
Subordinate officers
 Naval cadet (midshipman)

Non commissioned members
 Chief petty officer 1st class
 Chief petty officer 2nd class
 Petty officer 1st class
 Petty officer 2nd class
 Master seaman (senior
 corporal of section)
 Leading seaman
 Able seaman
 Ordinary seaman

CHINESE ARMY RANKS

Generalissimo
General of the army
General
Lieutenant general
Major general
Senior colonel
Colonel
Lieutenant colonel
Major
Captain
First lieutenant

Second lieutenant
Warrant officer
Chief sergeant major
Senior sergeant major
Sergeant major
Master sergeant
Sergeant first class
Staff sergeant
Sergeant
Corporal
Private first class

FRENCH ARMY RANKS

Officers

Maréchal de France
Général d'armée
Général de
 corps d'armée
Général de division
Général de brigade
 (brigadier general)

Colonel
Lieutenant colonel
Commandant
Capitaine
Lieutenant
Sous-lieutenant
Aspirant

Enlisted personnel

Adjutant-chef

Adjutant

Sergent-major

Sergent

Eleve sous-officier

Caporol-chef de ère classe

Caporal-chef

Caporal

Soldat, 1ère classe

Soldat, 2ème classe

FRENCH LEGION OF HONOR RANKS

(The Legion of Honor was founded in 1802 by Napoléon Bonaparte; rankings from highest to lowest.)

Grand Croix

Grand Officier

Commandeur

Officier

Chevalier

ITALIAN ARMY RANKS

Generale

Generale di corpo d'armata

Generale di divisione

Generale di brigata

Colonello

Tenente Colonello

Maggiore

Primo capitano

Capitano

Tenente

Sottotenente

Sergente Maggiore

Sergente

Primo caporale

Caporale

ROMAN ARMY BATTLE LINE *(rear to front)*

Velites (youthful novices)

Triarii (older men with light infantry)

Principes (seasoned veterans)

Hastati (men with some battle experience)

ROMAN ARMY RANKS

Imperator, or general (leader of army)

Legate (aide to general)

Tribune (commander of legion)

Company officer (two to a maniple)
Centurion (leader or officer of century or maniple)
 Senior
 Junior
Contubernalis (cadet)
Aquilifier (finest soldier in legion)
Imaginifer (bearer of staff)
Signifer (standard-bearer)
Legionary or Trooper (common infantryman or cavalry)
Sagittari (archer)
Cornicen (trumpeter)
Auxiliary (reservist)
Calo (noncombatant servant)

ROMAN MILITARY GROUPS

Army: two or more legions approx. 10,000 men
Legion: ten cohorts approx. 5,100 men
Cohort: six centuries turma (30), 3 maniples of infantry,
 1 maniple of 120 velites, evolved into 1 each hastati,
 princepes, triarii
Maniple: two centuries, 200 men or 120; replaced by cohort
Century: 100 men; replaced by maniple

SOVIET UNION ARMY RANKS

Officers

Generalissimo of the
 Soviet Union
Marshal of the Soviet Union
Chief marshal
Marshal
General of the army
Colonel general
Lieutenant general
Major general

Colonel (Podpolkovnik)
Lieutenant colonel
 (Podpolkovnik)
Major
Captain
Senior lieutenant
Lieutenant
Junior lieutenant

Enlisted Personnel

Warrant officer (Praporshchik)	Senior sergeant
Chief sergeant major	Sergeant
(Glav Starshina)	Corporal
Sergeant major (Starshina)	Private (reiter)

U.K. ARMY RANKS

Field marshal	Brigadier	Captain
General	Colonel	Lieutenant
Lieutenant-general	Lieutenant-colonel	Second lieutenant
Major-general	Major	

U.K. ROYAL NAVY RANKS

Admiral of the Fleet	Sub-lieutenant
Admiral	Acting sub-lieutenant
Vice-admiral	Midshipman
Rear-admiral	Fleet chief petty officer
Commodore	Petty officer
Captain	Leading seaman
Commander	Able seaman
Lieutenant-commander	Ordinary seaman
Lieutenant	Junior seaman

U.K. ROYAL AIR FORCE (RAF)

Marshal of the RAF	Pilot officer
Air chief marshal	Warrant officer
Air marshal	Flight sergeant
Air vice-marshal	Chief technician
Air commodore	Sergeant
Group captain	Corporal
Wing commander	Junior technician
Squadron leader	Senior aircraftsman
Flight lieutenant	Leading aircraftsman
Flying officer	Aircraftsman

FEUDAL SYSTEMS

CHINESE FEUDAL SYSTEM
(during Chou dynasty, 1111–500 B.C.)

Ruler of a state: 5 grades determined by strength of state

Feudal lords: served in the ruler's court as ministers; 2–3 grades
determined by lord-vassal relationship

Shih (gentlemen or knights): served at the households of
the feudal lords; as feudal system died out, shih class and
descendants of the old nobility composed the new elite class
(example: Confucius)

Commoners (peasants): paid lords for use of their land

Slaves: performed menial labor

ENGLISH FEUDAL SYSTEM

King: ruler; leased land, known as fief, to lords

Lords or overlords: tenants in chief

Vassals or tenants: took oath of loyalty and pledge of military
service on request

Mesne: a lord who is also a tenant

Knights: owing service to overlord

 Squire: age 14 to approximately 21, in training,
first becoming an attendant ecuyer (shieldbearer),
armiger (bannerbearer), or damoiseau (lordling),
or varlet (valet)

 Page: age 7–13, in training

Stewards: managed secondary manors

Priests: offered guidance

Scholars: undertook writing and studied law

Townsmen: merchants and craftsmen

Servants: served nobility and wealthy merchants

Villeins and serfs: peasants who worked the land
for the lords

MEDIEVAL EUROPEAN FEUDAL SYSTEM

(manorial system in which the peasants were dependent on their land and on their overlord)

The Pope: as God's representative, he held power over the king

King: ultimately held all land

Vassals and nobles: held land from the king and in turn leased it to lesser nobles

Lesser nobles: held limited rights and property

Archbishop: esteemed leader of the church

Dukes: men holding the highest hereditary title

Counts: foreign noblemen

Knights: mounted warriors who were granted a fief to support themselves and their entourage

Squires: young men of good birth, attendant to a knight

Seigneur or suzerain: lord of the manor

Free peasants or freemen: lived on fief and paid rent and dues to the lord

Villeins and serfs: held land from the lord of the manor, surrendered their freedom and were bound to the fief, worked for the lord, paid rent and dues to him

GOVERNMENT CLASSIFICATIONS

GOVERNMENT LEVELS AND STRUCTURES

Supranational political systems: empires, confederations, commonwealths

National political systems: nation-state systems, federal state systems

Urban governments: large-town governing system

Subnational political systems: tribal, rural, regional community governments

REPRESENTATIVE DEMOCRACY
Legislature: deliberates on and passes laws
Judiciary: interprets laws, monitors actions of executive and
　　legislative
Executive: carries out the law and administers the country
　　through departments

SYSTEMS OF GOVERNMENT
Autocracy or monarchy: rule by one
Oligarchy or aristocracy: rule by a few leaders
Plutocracy: rule by the wealthy
Ochlocracy: rule by a mob
Democracy or polity: rule by the people
Anarchy: rule by no one

WORLD CLASSIFICATION OF NATIONS
First World nation: country or group of countries that is major
　　force in international politics or finance, esp. the major
　　industrialized non-Communist nations of Western Europe,
　　the United States, Canada, and Japan
Second World nation: advanced and powerful but less
　　prosperous, like countries of the former Eastern Bloc
Third World nation: neither a major force in international
　　politics or finance; many live at or below level of extreme
　　poverty, esp. in Asia and Africa
Fourth World nation: the world's most poverty-stricken
　　nations, esp. in Africa and Asia, marked by very low
　　GNP per capita and great dependence upon foreign
　　economic aid

UNITED NATIONS

BASIC RIGHTS OF ALL CHILDREN *(An adaptation of the Declaration of the Rights of the Child, adopted by UN General Assembly Resolution of December 10, 1959)*

To enjoy the rights listed regardless of race, color, religion, or nationality.

To be able to grow in a healthy, normal way, free and dignified. Children should be specially protected and should be given special opportunities to grow.

To name and nationality.

To social security. This includes a decent place to live, good food, health care, and opportunities to play.

To special treatment, schooling, and care if handicapped.

To love and understanding. Children should be raised so that they feel secure and loved and live with their parents, if possible.

To free schooling and an equal opportunity to become everything they can be.

To prompt protection and relief in times of disaster.

To protection against all kinds of neglect, cruelty, and abuse from others.

To protection from any kind of unfair treatment because of race or religion.

UN SECRETARY GENERALS

(with country of origin)

1946–1953	Trygve Halvdan Lie (Norway)
1953–1961	Dag Hjalmar Agne Carl Hammarskjöld (Sweden)
1961–1971	U Thant (Burma)
1971–1981	Kurt Waldheim (Austria)
1982–1991	Javier Perez de Cuellar (Peru)
1992–1996	Boutros Boutros Ghali (Egypt)
1997–2006	Kofi Annan (Ghana)
2007–	Ban Ki-moon (South Korea)

UNITED NATIONS ORGANIZATION

General Assembly: discussion body (each member nation may send up to 5 representatives)

Security Council: keeps world peace (5 permanent members—U.S., Russia, U.K., France, China—and 10 nonpermanent members)

Economic and Social Council: works on economic, social, cultural, and humanitarian problems; one of its agencies is UNICEF (54 members elected for three years by General Assembly)

Trusteeship Council: prepares members for self-government and independence; handles trust territories—colonies that have been placed under the care of a country by the UN.

International Court of Justice (World Court): settles international legal problems (15 judges elected for 9-year terms by General Assembly and Security Council)

Secretariat (Secretary-General): political responsibility to carry out UN Charter's aims

Suboffices

Executive Office of the Secretary-General
Under-Secretary for General Assembly Affairs
Offices of the Under-Secretaries for Special Political Affairs
Office of Legal Affairs
Office of the Controller
Office of Personnel
Political and Security Council Affairs
Department of Economic and Social Affairs
Department of Trusteeship and Information from Non-Self-Governing Territories
Office of Public Information
Office of Conference Services
Office of General Services
U.N. Office at Geneva

DIPLOMATIC PERSONNEL ORGANIZATION
(three classes of heads of mission)

Ambassadors or nuncios: answering to heads of state and heads of missions equal in rank

Envoys, ministers, and internuncios: answering to heads of state

Chargés d'affaires: answering to ministers of foreign affairs

U.S. GOVERNMENT

ADMISSION OF STATES TO UNION
(date of admission to union)

Delaware (1787)
Pennsylvania (1787)
New Jersey (1787)
Georgia (1788)
Connecticut (1788)
Massachusetts (1788)
Maryland (1788)
South Carolina (1788)
New Hampshire (1788)
Virginia (1788)
New York (1788)
North Carolina (1789)
Rhode Island (1790)
Vermont (1791)
Kentucky (1792)
Tennessee (1796)
Ohio (1803)
Louisiana (1812)
Indiana (1816)
Mississippi (1817)
Illinois (1818)
Alabama (1819)

Maine (1820)
Missouri (1821)
Arkansas (1836)
Michigan (1837)
Florida (1845)
Texas (1845)
Iowa (1846)
Wisconsin (1848)
California (1850)
Minnesota (1858)
Oregon (1859)
Kansas (1861)
West Virginia (1863)
Nevada (1864)
Nebraska (1867)
Colorado (1876)
North Dakota (1889)
South Dakota (1889)
Montana (1889)
Washington (1889)
Idaho (1890)
Wyoming (1890)

Utah (1896)	Arizona (1912)
Oklahoma (1907)	Alaska (1959)
New Mexico (1912)	Hawaii (1959)

AMENDMENTS TO THE U.S. CONSTITUTION

First Amendment: ensures freedom of religion, prohibits congressional establishment of a religion over another religion through law and protecting the right to free exercise of religion; freedom of speech, freedom of the press, freedom of assembly, and freedom of petition.

Second Amendment: declares "a well regulated militia" as "necessary to the security of a free State," and as explanation for prohibiting infringement of "the right of the people to keep and bear arms."

Third Amendment: prohibits the government from using private homes as quarters for soldiers without the consent of the owners.

Fourth Amendment: prohibits searches, arrests, and seizures of property without a specific warrant or "probable cause" to believe a crime has been committed. Some rights to privacy have been inferred from this amendment by the Supreme Court.

Fifth Amendment: forbids trial for a major crime except after indictment by a grand jury; prohibits double jeopardy (repeated trials), except in certain very limited circumstances; forbids punishment without due process of law; and provides that an accused person may not be compelled to testify against himself (this is also known as "taking the Fifth" or "pleading the Fifth"). This is regarded as the "rights of the accused" amendment. It also prohibits government from taking private property without "just compensation," the basis of eminent domain proceedings in the United States.

Sixth Amendment: guarantees a speedy public trial for criminal offenses. It requires trial by a jury, guarantees the right

to legal counsel for the accused, and guarantees that the
accused may require witnesses to attend the trial and testify
in the presence of the accused. It also guarantees the accused
a right to know the charges against him. In 1966, the Supreme
Court ruled that the Fifth Amendment prohibition on forced
self-incrimination and the Sixth Amendment clause on right
to counsel were to be made known to all persons placed
under arrest, and these clauses have become known as the
Miranda rights.

Seventh Amendment: assures trial by jury in civil cases.

Eighth Amendment: forbids excessive bail or fines, and cruel
or unusual punishment.

Ninth Amendment: declares that the listing of individual
rights in the Constitution and Bill of Rights is not meant
to be comprehensive; and that other rights not specifically
mentioned are retained elsewhere by the people.

Tenth Amendment: powers that the Constitution does not
delegate to the United States and does not prohibit the states
from exercising, are "reserved to the States respectively, or to
the people."

Eleventh Amendment (1795): Clarifies judicial power over
foreign nationals, and limits ability of citizens to sue states in
federal courts and under federal law.

Twelfth Amendment (1804): Changes the method of
presidential elections so that members of the electoral
college cast separate ballots for president and vice president.

Thirteenth Amendment (1865): Abolishes slavery and grants
Congress power to enforce Abolition.

Fourteenth Amendment (1868): Defines United States
citizenship; prohibits states from abridging citizens' privileges
or immunities and rights to due process and the equal
protection of the law; repeals the three-fifths compromise;
prohibits repudiation of the federal debt caused by the
Civil War.

Fifteenth Amendment (1870): Forbids the federal government and the states from using a citizen's race, color, or previous status as a slave as a disqualification for voting.

Sixteenth Amendment (1913): Authorizes unapportioned federal taxes on income.

Seventeenth Amendment (1913): establishes direct election of senators.

Eighteenth Amendment (1919): prohibits the manufacture, importing, and exporting of alcoholic beverages. Repealed by the Twenty-First Amendment.

Nineteenth Amendment (1920): Prohibits the federal government and the states from forbidding any citizen to vote because of her sex.

Twentieth Amendment (1933): Changes details of congressional and presidential terms and of presidential succession.

Twenty-first Amendment (1933): Repeals Eighteenth Amendment. Permits states to prohibit the importation of alcoholic beverages.

Twenty-second Amendment (1951): Limits president to two terms.

Twenty-third Amendment (1961): Grants presidential electors to the District of Columbia.

Twenty-fourth Amendment (1964): Prohibits the federal government and the states from requiring the payment of a tax as a qualification for voting for candidates for federal office.

Twenty-fifth Amendment (1967): Changes details of presidential succession, provides for temporary removal of president, and provides for replacement of the vice president.

Twenty-sixth Amendment (1971): The federal government and the states may not forbid any citizen age 18 or older to vote on the basis of age.

Twenty-seventh Amendment (1992): Limits congressional pay raises.

CENSUS DIVISIONS AND REGIONS

West
Pacific: Alaska, Washington, Oregon, California
Mountain: Montana, Idaho, Wyoming, Nevada, Utah, Colorado,
 Arizona, New Mexico

Midwest
West North Central: North Dakota, South Dakota, Nebraska,
 Kansas, Minnesota, Iowa, Missouri
East North Central: Wisconsin, Illinois, Indiana, Michigan, Ohio

South
West South Central: Texas, Oklahoma, Arkansas, Louisiana
East South Central: Mississippi, Alabama, Tennessee,
 Kentucky

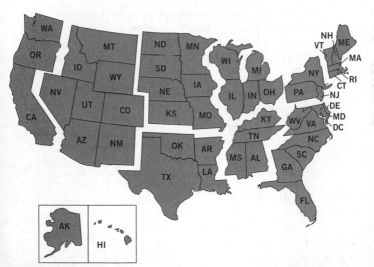

South Atlantic
Florida, Georgia, South Carolina, North Carolina, West Virginia, Virginia, Washington, DC, Maryland, Delaware

Northeast
Middle Atlantic: New York, Pennsylvania, New Jersey
New England: Maine, New Hampshire, Vermont, Massachusetts, Rhode Island, Connecticut

CLASSIFICATION OF NON-U.S. CITIZENS
Illegal aliens: entered country secretly or by using false documents or who have ignored conditions of their visas
Temporary visitors: admitted by visa for business or school; stay is limited and visas must be renewed
Refugees: admitted after being forced to flee other countries' war or oppression.
 Parole: those with temporary status and no set time limit
 Conditional entrant: eligible for permanent resident status in two years
Permanent resident aliens: may stay as long as they like; must give the government their latest address each January; cannot vote or hold public office.

CENTRAL INTELLIGENCE AGENCY
Directorate of Intelligence
National Clandestine Service
Directorate of Science and Technology
Directorate of Support

CHECKS AND BALANCES SYSTEM
Congress can pass federal legislation
President can veto federal bills
Supreme Court can declare new laws unconstitutional
President can appoint federal judges

Senate can refuse to confirm presidential appointments
Congress can impeach federal judges
President can make foreign treaties
Congress can override a presidential veto
Supreme Court interprets the law
Congress can propose constitutional amendments to overturn
 judicial decisions
Congress can declare executive acts unconstitutional

CIVIL WAR—DATES OF SECESSION OF STATES
South Carolina: December 20, 1860
Mississippi: January 9, 1861
Florida: January 10, 1861
Alabama: January 11, 1861
Georgia: January 19, 1861
Louisiana: January 26, 1861
Texas: February 1, 1861
Virginia: April 17, 1861
Arkansas: May 6, 1861
North Carolina: May 20, 1861
Tennessee: June 8, 1861

CIVIL WAR—READMISSION OF STATES AFTER CIVIL WAR
Tennessee: July 24, 1866
Arkansas: June 22, 1868
Alabama: June 25, 1868
Florida: June 25, 1868
Georgia: July 15, 1870
Louisiana: June 25, 1868
North Carolina: June 25, 1868
South Carolina: June 25, 1868
Virginia: January 26, 1870
Mississippi: February 23, 1870
Texas: March 30, 1870

FDR'S FOUR FREEDOMS

(President Franklin D. Roosevelt's State of the Union address, 1941)

Freedom of speech and expression

Freedom of the individual to worship God in his own way

Freedom from want

Freedom from fear

FEDERAL BUREAU OF INVESTIGATION'S BRANCHES

National Security Branch

Criminal Investigation Branch

Law Enforcement Branch

Administration Branch

Office of the Chief Information Officer

FEDERAL BUREAU OF INVESTIGATION'S HIERARCHY

Headquarters

Director

Deputy director

Associate deputy directors

 Administration

 Investigation

Assistant directors

 Records management

 Identification division

 Administration services

 Technical services

 Training

 Intelligence

 Criminal investigative division

 Laboratory division

Section chiefs

Unit chiefs

Supervisory special agents

FBI Field Offices
(In some cities, there is also an assistant director and deputy assistant.)
Special agent in charge
Assistant special agent in charge
Supervisory special agents
Special agents

GOVERNMENT BRANCHES

Executive Branch
President
Vice President
Cabinet
 Department of State
 Department of the Treasury
 Department of Defense
 Department of Justice
 Department of the Interior
 Department of Agriculture
 Department of Commerce
 Department of Labor
 Department of Health and Human Services
 Department of Homeland Security
 Department of Housing and Urban Development
 Department of Transportation
 Department of Energy
 Department of Education
 Department of Veterans Affairs
Executive Office of the President
White House Office
Office of Management and Budget
Council of Economic Advisers
National Security Council
Office of the U.S. Trade Representative

Council on Environmental Quality
Office of Science and Technology Policy
Office of National Drug Control Policy
Office of Administration

Legislative Branch

Congress—House and Senate
Architect of the Capitol
U.S. Botanic Garden
Government Accountability
 Office
Government Printing Office
Library of Congress
Congressional Budget Office

Congressional Research
 Service
Copyright Office
Medicare Payment Advisory
 Commission
Open World Leadership
 Center
Stennis Center Public Service

Judicial Branch

Supreme Court
Courts of Appeals
District Courts
Court of International Trade
Court of Federal Claims
Court of Military Appeals
Tax Court
Court of Veterans Appeals
Administrative Office of
 the Courts

Federal Judicial Center
Sentencing Commission
Judicial Panel on Multidistrict
 Litigation
Bankruptcy Court
Federal Courts
Court of Appeals for Armed
 Forces
Court of Appeals for Veterans
 Claims

PRESIDENTIAL CABINET HIERARCHY

Vice President
Secretary of State
 Deputy secretary
 Under secretary
 Assistant secretary

Secretary of the Treasury
 Deputy secretary
 Under secretary
 Assistant secretary

Secretary of Defense
 Deputy secretary
 Under secretary
 Assistant secretary
Attorney General
 Deputy attorney general
 Associate attorney general
 Solicitor general
 Legal counsel
 Pardon attorney
Secretary of the Interior
 Deputy secretary
 Under secretary
 Assistant secretary
Secretary of Agriculture
 Deputy secretary
 Under secretary
 Assistant secretary
Secretary of Commerce
 Deputy secretary
 Under secretary
 Assistant secretary
Secretary of Labor
 Deputy secretary
 Under secretary
 Assistant secretary
Secretary of Health and
 Human Services
 Deputy secretary
 Under secretary
 Assistant secretary

Secretary of Housing and
 Urban Development
 Deputy secretary
 Under secretary
 Assistant secretary
Secretary of Transportation
 Deputy secretary
 Under secretary
 Assistant secretary
Secretary of Energy
 Deputy secretary
 Under secretary
 Assistant secretary
Secretary of Education
 Deputy secretary
 Under secretary
 Assistant secretary
Secretary of Veterans' Affairs
 Deputy secretary
 Under secretary
 Assistant secretary
Secretary of Homeland
 Security
 Deputy secretary
 Under secretary
 Assistant secretary

SIX FLAGS OVER TEXAS

(the flags of six nations have flown in Texas)

Spain (colony, 1519–1685, 1690–1821)

France (colony, 1685–1690)

Mexico (territory, 1821–1836)

Texas (independent republic, 1836–1845)

Confederate States of America (state, 1861–1865)

United States (state, 1845–1861, 1865–present)

SOCIAL SECURITY NUMBER SYSTEM

001–003	New Hampshire	268–302	Ohio
004–007	Maine	303–317	Indiana
008–009	Vermont	318–361	Illinois
010–034	Massachusetts	362–386	Michigan
035–039	Rhode Island	387–399	Wisconsin
040–049	Connecticut	400–407	Kentucky
050–134	New York	408–415,	Tennessee
135–158	New Jersey	756–763	
159–211	Pennsylvania	416–424	Alabama
212–220	Maryland	425–428,	Mississippi
221–222	Delaware	587–588,	
223–231,	Virginia	752–755	
691–699		429–432,	Arkansas
232–236	West Virginia	676–679	
232,	North Carolina	433–439,	Louisiana
237–246,		659–665	
681–690		440–448	Oklahoma
247–251,	South Carolina	449–467,	Texas
654–658		627–645	
252–260,	Georgia	468–477	Minnesota
667–675		478–485	Iowa
261–267,	Florida	486–500	Missouri
589–595,		501–502	North Dakota
766–772		503–504	South Dakota

505–508	Nebraska	545–573,	California
509–515	Kansas	602–626	
516–517	Montana	574	Alaska
518–519	Idaho	575–576,	Hawaii
520	Wyoming	750–751	
521–524,	Colorado	577–579	District of
650–653			Columbia
525–585,	New Mexico	580	Virgin Islands
648–649		580–584,	Puerto Rico
526–527,	Arizona	596–599	
600–601		586	Guam, American
528–529,	Utah		Samoa, Philippine
646–647			Islands
530, 680	Nevada	729–733	Enumeration at
531–539	Washington		entry
540–544	Oregon		

U.S. COURT SYSTEM *(There are two separate systems; one for each state and one for the nation as a whole.)*

U.S. Supreme Court
Federal appellate court
Federal district court (income tax evasion, federal narcotics, civil rights suits)

U.S. Courts of Appeals

U.S. special courts	Claims court
Federal circuit courts of appeals	Court of military appeals

U.S. District Courts
(A trial court that has jurisdiction to hear nearly all categories of federal cases, including both civil and criminal matters.)
State supreme courts
State appellate courts

State district courts (divorce, murder)
County courts (state and county traffic, contract collections)
Municipal courts (dog bite, local traffic cases)
Justices of the peace

U.S. STATE GOVERNMENT ORGANIZATION

Governor
Lieutenant governor
Secretary of state
Attorney general
Treasurer (some states have a comptroller)
Auditor
General assembly: senate and house

U.S. TERRITORIAL EXPANSION

Louisiana Purchase (1803)
Florida (1819)
Texas (1845)
Oregon (1846)
Mexican cession (1848)
Gadsden purchase (1853)
Alaska (1867)
Hawaii (1898)

Puerto Rico (1898)
Guam (1898)
Philippine Islands (1898)
American Samoa (1899)
Panama Canal Zone (1904)
Virgin Islands (1916)
Jarvis Island (1935)

U.S. LAW

CRIME CLASSIFICATIONS

(from most to least serious)

Treason: acts of disloyalty

Felony: serious offense or grave crime so declared in a statute
or so considered in common law

Misdemeanor: less serious offense, an offense for which a
punishment other than death or imprisonment in the state
prison is prescribed by law

Anglo-American Law Classifications

(The system of law from which the type of legal system now found also in the United States and in most of the member states of the Commonwealth of Nations evolved.)

Crimes mala in se: acts that are thought to be immoral or wrong in themselves, or naturally evil, such as murder, rape, arson, burglary, larceny

Crimes mala prohibita: acts that are prohibited by statute because they infringe on the rights of others (e.g., acts in restraint of trade that have been made criminal under antitrust legislation)

Criminal Law Classifications

Crimes against person: rape, armed robbery, predatory crime

Crimes against property: burglary, arson, larceny; involve no threat to a victim

Criminal Typology

(from Marshall B. Clinard and Richard Quinney, Criminal Behavior Systems: A Typology*)*

Violent crime against the person: murder, assault, forcible rape, child molestation

Occasional property crime: shoplifting, check forgery, vandalism, auto theft

Occupational crime: white-collar crime

Political crime: treason, sedition, espionage, sabotage, military draft violation, war collaboration, criminal protest

Public order crime: drunkenness, vagrancy, nonforced sex offenses, gambling, drug addiction ("crimes without victims")

Conventional crime: robbery, larceny, burglary, youth gang crime

Organized crime: racketeering, commercialized vice, drug traffic, illegal gambling

Professional crime: confidence games, forgery, counterfeiting, pickpocketing

COMPUTER CRIMES

(The European Union Convention on Cybercrime defines four types of "pure" computer crimes: offences against the confidentiality, integrity, and availability of computer data and systems.)

Illegal access: unauthorized access to the whole or any part of a computer system

Illegal interception: unauthorized intentional interception made by technical means, of nonpublic transmissions of computer data to, from, or within a computer system

Data interference: unauthorized damaging, deletion, deterioration, alteration or suppression of computer data

System interference: unauthorized serious hindering of the functioning of a computer system by inputting, transmitting, damaging, deleting, deteriorating, altering, or suppressing computer data

HIERARCHY OF U.S. LAWS

(in order of precedence)
Constitution
U.S. laws and treaties
State constitutions
State laws
Local laws (county, township, city, town, village)

MIRANDA WARNING

(procedural safeguards that must be read to those arrested, before they are questioned by police)
You have the right to remain silent and refuse to answer any questions.
Anything you say may be used against you in a court of law.
As we discuss this matter, you have a right to stop answering my questions at any time you desire.

You have a right to a lawyer before speaking to me, to remain
 silent until you can talk to him/her, and to have him/her
 present when you are being questioned.
If you want a lawyer but cannot afford one, one will be provided
 to you without cost.
Do you understand each of these rights I have explained to
 you?
Now that I have advised you of your rights, are you willing to
 answer my questions without an attorney present?

Abbreviated Version
You have the right to remain silent, anything you say may be used
 against you as evidence, and you have the right to the counsel
 of an attorney.

NINE POINTS OF THE LAW
*(the ideal requirements of a successful legal case or trial;
from* Dictionary of Phrase and Fable, *E. Cobham Brewer, 1894)*
A good deal of money
A good deal of patience
A good cause
A good lawyer
A good counsel
Good witnesses
A good jury
A good judge
Good luck

AUTOMOBILE INFORMATION ON POLICE RADIO
MNEMONIC: CYMBOL
C—Color
Y—Year
M—Make

B—Body style
O—Occupants
L—License plate number

SEARCH WARRANT CONDITIONS MNEMONIC:
COP IS ME

C—Consent
O—Open view
P—Public place
I—Incidental to a lawful arrest

S—Stop and frisk a suspicious
 person
M—Mobile premises
E—Emergency

WORLD CLASSIFICATION OF NOBILITY

(most to least important)

FRENCH NOBILITY
Duc, duchesse
Prince, princesse
Marquis, marquise
Comte, comtesse
Vicomte, vicomtesse
Baron, baronne
Seigneur, Madame
Chevalier, Dame

GERMAN NOBILITY *(the elite hereditary ruling class or aristocratic class in the Holy Roman Empire and titles in present-day Germany)*
Herzog, Herzogin
Furst, Fürstin
Prinz, Prinzessin
Markgraf, Markgräfin
Pfalzgraf, Pfalzgräfin
Landgraf, Landgräfin
Graf, Gräfin
Baron, Baronin
Freiherr, Freiherrin
Freier, Freierin

SPANISH NOBILITY
Duque, duquesa
Principe, principesa
Marqués, marquesa
Conde, condesa
Visconde, viscondesa
Barón, baronesa
Señor, señora

U.K. NOBILITY AND FORMS OF ADDRESS

Hereditary Titles
Duke or duchess (your grace)
Marquess or marchioness (my lord, my lady, or madam)
Earl or countess (my lord, my lady, or madam)
Viscount or viscountess (my lord, my lady, or madam)
Baron or baroness (my lord, my lady, or madam)
Life baron or life baroness (my lord, my lady)

U.K. Life Peerages and Forms of Address
(honorary; nonhereditary)
Lord or lady (my lord, my lady)
Knight or dame (sir, lady)

Nonpeerage Hereditary Title
Baronetcy
Baronet or Baronetess (my lord, my lady)

U.K. HERALDIC HELMET DESIGN

Ranks
Sovereign: gold, full-faced
Peer: silver with gold grill, turned
Baronet and knight: silver, full-faced
Esquire and gentleman: silver, turned

U.K. HERALDIC COAT OF ARMS

Elements

(marks of cadency, or order of birth, for sons; daughters get only a diamond-shaped "lozenge")

First cadet (eldest): label (the arms of the Prince of Wales, heir to the throne)

Second cadet: crescent with upward-pointing cusps

Third cadet: mullet (five-pointed star)

Fourth cadet: martlet or swallow

Fifth cadet: amulet or ring

Sixth cadet: fleur-de-lis

Seventh cadet: five hearts in a rose atop a mullet

Eighth cadet: cross

WORLD GOVERNMENTS

AZTEC POLITICAL SYSTEM

Emperor of empire

Tlatoani (head of state—an area of 50–60 sq mi)

Staff of professional administrators (including calpixque, or tax collectors)

Chief (head of Calpulli—a physical, territorial, and socially organized ward/unit within the state)

Council of Household Heads (served the Tlatoani)

Barrios Pequenos (little wards, or a territorial subdivision)

Aztec Province Organization

State

 Provinces

 Capital

 Tax collector-governor

 Garrison

BRITISH COMMONWEALTH CADRE SYSTEM—
FIVE FORMAL ASSESSMENT CATEGORIES
(persons appointed to paid position in government or
party system)
1. Virtue (character and political correctness)
2. Ability
3. Attention to duties
4. Achievements
5. Level of formal study

EGYPTIAN GOVERNMENTAL HIERARCHY
Pharaoh
Vizier of Upper Egypt (Thebes)
Vizier of Lower Egypt (Memphis): all official positions duplicated
 for Upper and Lower Egypt; state had departments of
 Treasury, the Granaries, Royal Works, Cattle, and Foreign
 Affairs
Governors (rural districts): staffs of officials, messengers, and scribes
Mayors (towns): staffs of officials, messengers, and scribes

FRENCH EMPIRES
First Empire, 1804–1814: under Napoléon Bonaparte
Second Empire, 1852–1870: under Napoléon III

FRENCH REPUBLICS
First Republic, 1792–1804: the result of the French Revolution
Second Republic, 1848–1852: ended when Louis-Napoléon
 Bonaparte proclaimed the Second Empire
Third Republic, 1870–1940: fall of Napoléon III till German
 occupation of World War II
Fourth Republic, 1945–1958: the new constitution reorganized
 the empire as the French Union
Fifth Republic: 1958–present: since Charles de Gaulle became
 president

GERMAN REICH

(the three distinct periods in German history from 1871 to 1945)

German Empire: a monarchy under Hohenzollern rule, 1871–1918

Weimar Republic: a democratic republic, 1919–1933

Nazi Germany: a totalitarian dictatorship, also known as the Third Reich, 1933–1945

GREEK CITY-STATE DEMOCRACY

Phyle: ten tribes made up of three trittyes—city, country, coastal

Trittys: thirty larger groups—ten representing Athens, ten for the countryside, ten for coastal areas

Demes: small communities

Assembly: every male citizen entitled to attend, with the right to debate, offer amendments, and vote on proposals

Council: fifty councillors from each of the ten tribes

INTERNATIONAL TREATIES AND AGREEMENTS

(in order of precedence)

Treaties between nations

International custom, such as law of the sea

Existing national laws

Previous international decisions

Previous national decisions

Testimony of experts from a variety of nations

ROMAN REPUBLIC STRUCTURE

Legislative branch

 Senate: 300 people chosen from ex-magistrates by the censors who watched over public morals

 Concilium plebis: people's assembly (Cornitia Centuriata)

 Assembly of the tribes: 35 tribes (Cornitia Tributa) representing geographical subdivisions

Executive branch
 Magistrates
 Censors (highest-ranking)
 Consuls (lowest-ranking)
Chief executives
 Two consuls (elected from candidates proposed by the Senate
 by the comitia centuriata; presided over Senate and
 were supreme commanders in war)
 Two–eight praetors (judges and administrators of law)
 Praetor urbanus (worked in Rome)
 Praetor peregrinus (worked abroad)
Four quaestors (in charge of finances)
 Two censors (supervised contracts, public morals)
 Aediles (responsible for streets, temples, public works, grain
 supply, public games)
Prefects (leader of a decury, a group of ten lictors)
Twelve lictors (civil servants who preceded the consuls and
 praetors, clearing the way and carrying fasces)
Ten tribunes (defended the plebeians, with veto power over
 magistrates and laws)

ROMAN TRIUMVIRATES

First Triumvirate, 60 B.C. *(The first Roman triumvirate members had an informal understanding.)*
Julius Caesar
Marcus Licinius Crassus
Pompey

Second Triumvirate, 43 B.C. *(The second triumvirate exercised absolute, dictatorial authority.)*
Marcus Aemilius Lepidus
Mark Antony
Octavian (Octavius, later Augustus)

POLITICAL ORGANIZATION OF FORMER SOVIET UNION

Supreme Soviet
Peasants' soviets
 Central executive committee
Soldiers' soviets
 Central executive committee
Workers' soviets
 Central executive committee

RUSSIAN FEDERATION COURT SYSTEM

Supreme Court
Supreme Courts of union republic and regional courts
Tribunals and people's courts
Office of state prosecution
 Procurator-general
 Hierarchy of procurators
 Union republics
 Autonomous republics
 Autonomous oblasts (regions)
 Autonomous okrugs and krays (provinces)
 Rural and urban rayons (rural districts)

RUSSIAN FEDERATION GOVERNMENT STRUCTURE

President
Prime Minister
First deputy premier (2)
Deputy premier (3)
Department ministers
Supreme Soviet (elected by Congress of People's Deputies)
 Council of the Union
 Council of Nationalities
Congress of People's Deputies (in each republic)

STRUCTURE OF THE COMMUNIST PARTY OF THE (FORMER) SOVIET UNION (CPSU)

General secretary (highest office elected by the Politburo)
Secretariat
Political Bureau (Politburo: chosen by Central Committee)
Central Committee (elected by Congress)
All-Union Congress (supreme policymaking body)
Committees
 Republic
 Regional
 District
 City
 Rural
Party cells (primary party organizations)

U.K. CONSTITUTIONAL MONARCHY

Monarch (King or Queen)
Parliament (two houses, each with a speaker and leader,
 and a leader of the opposition)
 House of Lords
 House of Commons
Prime minister
Cabinet
 First Lord of the Treasury
 Minister for the Civil Service
 Leader of the Labour Pary
 Second Lord of the Treasury
 Leader of the House of Commons
 Lord High Chancellor of Great Britain
 Chancellor of the Exchequer
 Secretary of State for Foreign and Commonwealth Affairs
 Secretary of State for the Home Department
 Lord President of the Council
 Lord Privy Seal

Secretary of State for Business, Enterprise and Regulatory
 Reform and President of The Board of Trade
Secretary of State for Children, Schools and Families
Secretary of State for Communities and Local Government
Secretary of State for Culture, Media and Sport
Secretary of State for Defence
Secretary of State for Environment, Food and Rural Affairs
Secretary of State for Health
Secretary of State for Innovation, Universities and Skills
Secretary of State for International Development
Secretary of State for Justice
Secretary of State for Northern Ireland
Secretary of State for Scotland
Secretary of State for Transport
Secretary of State for Work and Pensions
Secretary of State for Wales
Chancellor of the Duchy of Lancaster, Minister for the Cabinet
 Office
Chief Secretary to the Treasury
Parliamentary Secretary to the Treasury, Chief Whip

SOCIETY & SOCIAL INSTITUTIONS

There is no structural organization of society which can bring about the coming of the Kingdom of God on earth, since all systems can be perverted by the selfishness of man.

—William Temple, *The Malvern Manifesto*

EARLIEST CIVILIZATIONS AND ERAS

ARCHAEOLOGY'S THREE-AGE SYSTEM
(named for their predominant tool-making technologies)
Stone Age
Bronze Age
Iron Age

EARLIEST HUMAN CIVILIZATIONS
Natufian: before 11,500 B.C.
Mesopotamian: before 5000 B.C.
Sumeric or Sumerian: before 4000 B.C.
Egyptiac: before 3000 B.C.
Indic: before 2500 B.C.
Minoan: before 3000 B.C.
Far Eastern: c. 2000 B.C.
Hittite: 2000 B.C.
Mayan: after 2000 B.C.
Polynesian: c. 1800 B.C.
Babylonian: 1700 B.C.
Babylonic: c. 1500 B.C.
Mycenaean: c. 1400 B.C.
Hellenic: c. 1300 B.C.
Spartan: c. 900 B.C.
Hindu: c. 200 B.C.
Khmer: c. 100
Teotihuacán: c. 100
Far Eastern (Japan and Korea): 600
Orthodox Christian (main): c. 680
Orthodox Christian (Russia): 950
Arabic: c. 975
Inuit: c. 1000
Mexic: c. 1075

Ottoman: c. 1310
Iranic (now Islamic): c. 1320
Inca: 1400

BIBLICAL HISTORICAL AGES
(This chronology, with approximated dates, is used to calculate the age of the earth in the theory of Creationism.)
First age: Creation to the Deluge, 4004–2349 B.C.
Second age: to the coming of Abraham into Canaan, 2348–1922 B.C.
Third age: to the Exodus from Egypt, 1921–1491 B.C.
Fourth age: to the founding of Solomon's Temple, 1490–1014 B.C.
Fifth age: to the capture of Jerusalem, 1014–588 B.C.
Sixth age: to the birth of Christ, 588–4 B.C.
Seventh age: to the present time, 4 B.C.–present

HESIOD'S AGES OF HUMAN HISTORY
(Hesiod lived c. 800–850 B.C. and wrote Works and Days.*)*
Age of Gold and the Immortals: an age of ease and peace, innocence and joy, when Cronus ruled; before Zeus
Age of Silver: humans become less noble, Zeus ruled; age of unpleasantness
Age of Bronze, or the brazen age: c. 2000–1500 B.C.; age of bronze weapons
Age of Epic Heroes, Heroic Age: c. 1500–1000 B.C.; before and after the Trojan War; age of nobility and heroism
Age of Iron and Dread Sorrow: age of corruption, warfare, of unhappiness and sorrow by day and fear of perishing by night; no rest from labor

HISTORICAL AGES AND ERAS
(approximate)
Stone Age: 570 million years ago–3000 B.C.
 Palaeolithic stage: Early Stone Age

Mesolithic stage: Middle Stone Age
Neolithic stage: New Stone Age
Bronze Age: 3000–1200 B.C.
Copper Age: c. 3500–1100 B.C.
Dark Ages in Greece: 1100–700 B.C.
Iron Age: 1100 B.C.–A.D. 1000
Roman Empire: 27 B.C.–A.D. 410
Dark Ages: 410–1000 (or until 1450)
Early Middle Ages: 500–1000
Middle Ages: 850–1400 or 1450
Renaissance: 1450–1750
Age of Exploration: 1490–1911
Age of the Reformation: 1500–1600
Colonization and invention: 1600–1700
Revolution and independence: 1700–1815
Industrial Revolution: 1750–1900
Warring World: 1900–1946
Cold War: 1947–1991
Modern World: 1947–present

HISTORICAL CYCLE
(the three ages in the historical cycle of Giambattista Vico, 1668–1744)
Theocratic: the Age of Gods
Aristocratic: the Age of Heroes
Democratic: the Age of Men

TOOL CULTURES
(These ancient developments in technology shaped the way mankind lived and laid the groundwork for modern society.)
Old Stone Age (also called Paleolithic Period, by 10,000 B.C.): rudimentary chipped stone tools
Lower Paleolithic Period (3 million–70,000 B.C.): hand ax appears

Abbevillian culture: primitive stone hand axes, pebble tools

Acheulian culture: hand axes of stone, bone, wood

Middle Paleolithic Period (200,000–35,000 B.C.): Neanderthal flake tools

Mousterian culture: flaked stone tools; stone-tipped spears

Upper Paleolithic Period (35,000–10,000 B.C.): emergence of regional stone-tool industries

Lower Perigordian culture: wood hammer and punch, flint blades

Aurignacian culture: beveled flint tool, carved bone tools and weapons

Upper Perigordian culture: straight-backed flint knives, carved spearheads

Solutrean culture: pressure-flaked flint tools, fine-pointed weapons

Magdalenian culture: eyed needles, barbed spearheads, saw, awl

Middle Stone Age (Mesolithic Period), 10,000–2700 B.C.: bow and arrow, fishhooks and traps, coracle, raft, canoe, adz, microliths

New Stone Age (Neolithic Period), 9000–6000 B.C.: plow, farming implements, pottery, copper smelting; battleaxes

Copper Age (6500–3500 B.C.): first use of copper

Bronze Age (4500–1200 B.C.): first use of bronze

Sumerian civilization: wheel, oars, fired bricks, copper smelting, copper and tin mixed to make bronze

Egyptian civilization: copper and tin mixed to make bronze, for buckets, locks, etc.

Iron Age (1200–400 B.C.): first use of iron

Hittite civilization: iron smelting and carbonizing for tools and weapons

FAMILY

CONSANGUINITY CHART

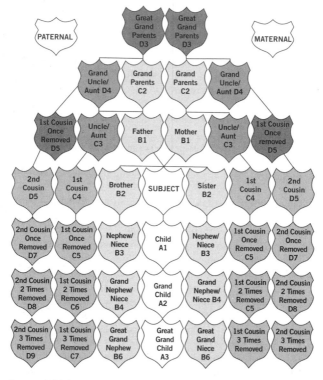

Consanguinity charts are more than simple family trees. The letters B, C, and D identify the nearest ancestors in common with A. Numbers 1 through 9 indicate the degree of kinship to A under civil law.

GENERATIONS

Baby boomers, born 1946–1965
Gen(eration) X, born 1965–1978
Gen(eration) Y, born 1979–1998
Millennial Generation, born 1980–

MONTHS FOR WEDDINGS

*(most to least popular, from Mindy Weiss,
author of* The Wedding Book)

June	September	November
May	October	March
July	April	February
August	December	January

LINGUISTICS

SYMBOLISM OF LETTERS OF LATIN ALPHABET

A: mountain, pyramid, creation, birth

B: mother's breasts

C: sea, crescent moon

D: day, brilliance

E: sun

F: fire

G: creator

H: twins, dualism, threshold

I: axis of the universe, the self, number one

J: tree and root

K: connections

L: power

M: mountains

N: sea waves, serpentine path

O: perfection, completion

P: the staff, shepherd's crook

Q: rising sun, setting sun

R: support

S: serpent

T: hammer, ax, cross, conflict, sacrifice

U: chain

V: convergence, receptacle

W: waves

X: union, cross of light

Y: crossroads, choices, decisions

Z: lightning, the destroyer

BRAILLE SYSTEM

Capital sign	Comma	Semi colon	
Period	Single quote mark	Dash	
!	?		
A 1	B 2	C 3	D 4
E 5	F 6	G 7	H 8
I 9	J 0	K	L
M	N	O	P
Q	R	S	T
U	V	W	X
Y	Z	#sign	

ENGLISH LANGUAGE DEVELOPMENT

Old English or Anglo-Saxon (449–1100)

Middle English (1100–1500)

Modern English (1500–present)

LANGUAGE FAMILY CLASSIFICATION

(Linguistics experts disagree on the classification of language families. Languages listed are representative.)

African languages
 Afro-Asiatic
 Khoisian
 Niger-Congo
 Nilo-Saharan
Altaic languages
 Manchu-Tungus
 Mongol languages (Manchu, Mongol, Samoyed, etc.)
 Turko-Tataric languages (Turkish, Uzbek, etc.)
American Indian languages
 North America (Apache, Iroquois, Sioux, etc.)
 Central America (Maya, Aztec, Zapotec, etc.)
 South America (Peruvian, Quichua, etc.)
Austro-Asiatic languages
 Mon-Khmer (Mon, Vietnamese, Khmer)
 Munda
 Nicobarese
Austronesian languages
 Languages of islands of Southeast Asia and the Pacific
 Malay and Chaimic
 Formosan
 Malayo-Polynesian
Bantu languages (within the Niger-Congo family)
 Languages of the interior of Africa
 Rundi
 Rwanda
 Shona
 Xhosa
 Zulu
 Swahili
Caucasian languages

Languages of the Caucases
 Kartvelian
 Nakh
 Abkhazo-Adyghian
 Nakho-Dagestanian
 Dagestanian
 Andí
 Dido
Sino-Tibetan
 Mandarin
 Wu
 Gan
 Hakka
 Xiang
 Cantonese
 Burmic
 Miao-Yao
 Sinitic
Dravidian languages
 Telugu
 Tamil
 Kannada
 Malayalam, etc.
Hamitic-Semitic languages
 Hamitic
 Semitic
Indo-European languages
 Albanian
 Anatolian
 Armenian
 Balto-Slavic and Slavonic
 Russian
 Polish
 Czech, Moravian, Slovak

 Serbo-Croation
 Slovene
 Bulgarian
 Lithuanian
Indo-Iranian
 Indo: Bengali, Kafir, Hindi, etc.
 Iranian: Kurdish, Afghan, etc.
Italic (Latin)
Celtic
 Irish
 Gaelic
 Welsh
 Cornish
Romance
 French
 Provençal
 Walloon
 Spanish
 Portuguese
 Italian
 Romanian
 New Greek
Germanic
 English
 German
 Swedish
 Danish
 Norwegian
 Dutch
 Frisian
 Flemish
Swedish Afrikaans
Indo-Pacific languages
 Languages of New Guinea, Tasmania, and Adamun Islands

Japanese-Korean languages
Malay-Polynesian languages
 Malay
 Melanesian, Polynesian,
 Maori
Tai languages
 Languages of Thailand, Laos, Myanmar, Assam
 Shan
 Dai
 Zhuang
 Buyei
 Tay
 Khün
 Lü
Uralic languages
 Finnish, Estonian, Livonian, Lapp
 Magyar, Hungarian
 Samoyedic
 Ugric
Unclassified and isolated languages
 Iberian
 Basque
 Northern Asia and America (Inuit, Aleutian)
 Sumerian
 Etruscan

NATIVE AMERICAN LANGUAGE CLASSIFICATION
(according to the linguist Edward Sapir)
Eskimo-Aleut
Algonquian- (Algonkian-) Wakashan
Na-Dené
Penutian
Hokan-Siouan
Aztec-Tanoan

MANUAL ALPHABET

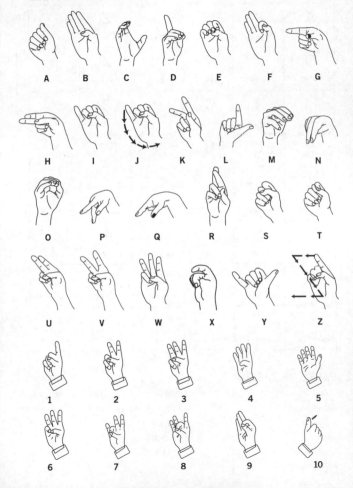

MORSE CODE

A ·—	B —···	C —·—·	D —··	E ·	F ··—·
G ——·	H ····	I ··	J ·———	K —·—	L ·—··
M ——	N —·	O ———	P ·——·	Q ——·—	R ·—·
S ···	T —	U ··—	V ···—	W ·——	X —··—
Y —·——	Z ——··	Ä ·—·—	Ö ———·	Ü ··——	Ch ————
0 —————	1 ·————	2 ··———	3 ···——	4 ····—	5 ·····
6 —····	7 ——···	8 ———··	9 ————·	. ·—·—·—	, ——··——
? ··——··	! ··——·—	: ———···	" ·—··—·	' ·————·	= —···—

PARTS OF SPEECH

(traditional grouping of types of words in the English language)

Adjective	Preposition
Adverb	Pronoun
Article	Noun
Conjunction	Verb
Interjection	

PRINCIPAL NATIVE LANGUAGES OF THE WORLD

(number of speakers, in millions; from Ethnologue: Languages of the World, *15th edition)*

Mandarin	873
Hindi	370
Spanish	350
English	340
Arabic	206
Portuguese	203
Bengali	196
Russian	145
Japanese	126
German	101

RADIO PHONETIC ALPHABET

(This is the standard list of words used to identify letters of the alphabet unambiguously in police and maritime communications, air traffic control, and military contexts.)

Alpha	Juliet	Sierra
Bravo	Kilo	Tango
Charlie	Lima	Uniform
Delta	Mike	Victor
Echo	November	Whiskey
Foxtrot	Oscar	X-ray
Golf	Papa	Yankee
Hotel	Quebec	Zulu
India	Romeo	

WRITING DEVELOPMENT

(least to most complex)

Picture word: communication by means of drawings the objects involved

Symbol: a simplification of the picture word system

Ideograph: method of condensing symbols

Hieroglyph: use pictures to represent things and spelled-out names and words by using the first letter of the object previously drawn

Hieratic script: replaced hieroglyphic pictures with abbreviated versions

Alphabet: hieratic forms were adapted by the Greeks and gradually changed by the Romans, who gave us the capitals of our alphabet; Alcuin, a scholar in Charlemagne's empire, developed the small letters, called Caroline minuscules

WRITING SYSTEMS *(number of characters used)*

Ideographic Characters

Chinese	40–50,000
Japanese	18,000

Alphabetic Characters

Khmer (Cambodian)	74
Sanskrit	48
Cyrillic	33
Russian	33
Persian	32
Turkish	29
Spanish	29
Arabic	28
German	26
English	26
French	26
Latin	26
Greek	24
Hebrew	22
Early Latin	21
Italian	21
Hawaiian	12
Rotokas (Solomon Islands)	11

ORGANIZATIONS

ALCOHOLICS ANONYMOUS TWELVE STEPS

1. We admitted we were powerless over alcohol—that our lives had become unmanageable.
2. Came to believe that a Power greater than ourselves could restore us to sanity.
3. Made a decision to turn our will and our lives over to the care of God as we understood Him.
4. Made a searching and fearless moral inventory of ourselves.
5. Admitted to God, to ourselves, and to another human being the exact nature of our wrongs.
6. We were entirely ready to have God remove all these defects of character.
7. Humbly asked Him to remove our shortcomings.
8. Made a list of all persons we had harmed, and become willing to make amends to them all.
9. Made direct amends to such people whenever possible, except when to do so would injure them or harm others.
10. Continued to take personal inventory and when we were wrong promptly admitted it.
11. Sought through prayer and meditation to improve our conscious contact with God as we understood Him, praying only for knowledge of His will for us and the power to carry that out.
12. Having had a spiritual awakening as the result of these Steps, we tried to carry this message to alcoholics, and to practice these principles in all our affairs.

BOY SCOUTS AND GIRL SCOUTS

Boy Scouts of America Ranks
Bobcat (all ages; must fulfill requirements to ascend rank)
Tiger Cub: grade 1

Cub Scout: Grades 2–5; group = pack or den
- Bobcat
- Wolf
- Bear
- Webelos
- Arrow of Light

Boy Scout: Grades 6–12; group = troop
- Tenderfoot
- Second Class
- First Class
- Star
- Life
- Eagle

The Boy Scouts
of America logo

Girl Scouts of the U.S.A. Rankings
Daisy: ages 4–5
Brownie: ages 6–8
Junior: ages 9–11
Cadette: ages 12–14
Senior: ages 14–15
Ambassador: ages 16–17

The Girl Scouts
of America logo

Camp Fire Boys and Girls Levels
Little Stars: ages 3–5
Starflight: age 6
Adventure Club: ages 7–9
Discovery Club: ages 10–12
Horizon Club: age 13+

FREEMASONRY HIERARCHY
(secret brotherhood, from lowest to highest)

York Rite
Lodge or Craft
- Entered Apprentice

Fellow Craft
Master Mason
Chapter
 Mark Master
 Past Master
 Most Excellent Master
 Royal Arch Mason
Council
 Royal Master
 Select Master
 Super Excellent Master
Commandery
 Red Cross Knight
 Knight Templar
 Knight of Malta

The Freemasons logo

Scottish Rite

(degrees vary by jurisdiction)
Lodge
 Entered Apprentice
 Fellow Craftsman
 Master Mason
Lodge of Perfection
 Secret Master
 Perfect Master
 Intimate Secretary
 Provost and Judge
 Intendant of the Building
 Master Elect of Nine
 Master Elect of Fifteen
 Sublime Master Elected
 Master Architect
 Master of the Ninth Arch
 Grand Elect Mason

Councils of Princes of Jerusalem
 Knight of the East or Sword
 Prince of Jerusalem
Chapters of Rose Croix
 Knight of the East and West
 Knight of the Rose Croix de H.R.D.M.
Consistories of Sublime Princes of the Royal Secret
 Grand Pontiff
 Master Ad Vitam
 Patriarch Noachite
 Prince of Libanus
 Chief of the Tabernacle
 Prince of the Tabernacle
 Knight of the Brazen Serpent
 Prince of Mercy
 Commander of the Temple
 Knight of the Sun
 Knight of St. Andrew
 Grand Elect Knight, K.H., or Knight of the White and Black Eagle
 Grand Inspector Inquisitor Commander
 Sublime Prince of the Royal Secret
 Sovereign Grand Inspector-General of the 33d and Last Degree

SALVATION ARMY HIERARCHY

International Headquarters
The General
The Chief of Staff

International Zones
International Secretary for Africa
International Secretary for the Americas and Caribbean
International Secretary for Europe
International Secretary for South Asia
International Secretary for South Pacific and East Asia

Territories (115 Countries)
Territorial Commanders
Commands
Regional Commands

Divisions
Divisional Commanders
Adult Rehabilitation Center Commander

Area Commands
Area Commander

Corps Community Centers
Corps Commanding Officer
Administrators

The Salvation Army logo

PSYCHOLOGY

SIGMUND FREUD

Divisions of the Psyche
Consciousness: awareness of oneself and one's environment
Preconscious: all contents of the mind that are not immediately at
 a conscious level but can readily be brought into consciousness
Unconscious: the part of the mind not readily accessible to
 conscious awareness, but that may manifest its existence in
 symptom formation, in dreams, and under the influence of drugs

Structural Categories
Ego: desires countered by defense mechanisms; essential core
 that balances the other two
Id: primitive illogical urges; animalistic part of psyche
Superego: guilt-causing aggressive elements; conscience
 governing our standards of conduct

Three Stages of Development of Child's Sexuality
Oral: the infant understands the world through the lips and mouth
Anal-sadistic: the child is fascinated by feces and the anus
Phallic-genital: the child discovers the penis or clitoris as the
 center of sexual sensation

CARL JUNG

Levels of Consciousness *(ascending order)*
Ordinary wakefulness: body relaxed and mind stilled
Deep rest or personal awareness
Cosmic consciousness: a sense of illumination beyond self and time
God consciousness: a sense of inseparability of creator and creation
**Consciousness transcended in a unity with the whole,
 or oneness**

Levels of Learning *(four stages of competence)*
Unconscious incompetence: you do not know what you do not
 know, do not recognize deficit, and do not redress it
Conscious incompetence: you know what you do not know,
 recognize deficit, but do not yet address it
Conscious competence: you know what you know, but
 demonstrating your knowledge requires great concentration
Unconscious competence: knowledge is second nature and
 you can teach others

MASLOW'S HIERARCHY OF FIVE BASIC NEEDS
(from most basic to less necessary)
Physiological: hunger, thirst, sex, etc.
Safety: protection against danger, threat, deprivation, etc.
Social: belonging, association, acceptance by others, giving and
 receiving friendship and love
Ego: self-esteem (self-confidence, independence, achievement,
 competence, knowledge) and personal reputation (status,
 recognition, appreciation, respect)

Self-fulfillment: realizing one's own potential, continued self-development, creativity

PHASES OF MEMORY CREATION
Learning: experiencing or perceiving an event, registering or recording a description in memory
Retention: when the person is not thinking about the event
Retrieval: a memory is remembered and utilized in guiding performance

Also:
Short-term memory system: contents of awareness to which one has immediate access
Long-term memory system: everything else in memory that typically can be retrieved, but more slowly

STATES OF FEELING
(agitated to unaware; based on types of brain waves)
Beta-theta state: disturbed and negative; feeling of unhappiness
Beta state: subject to anger, excitement, tension
Alpha-beta state: wakeful, calm, creative, perceptive; sensitive, investigative, intellectual thoughts
Alpha state: feeling of transcendence; alert, calm, elated; sense of insight
Alpha-theta state: inner stillness; decreased self-awareness; pleasant feeling of freedom
Theta state: dreamlike trance; no self-awareness
Delta state: deep, dreamless sleep

SCHOOLS AND EDUCATION

COLLEGE DEGREES
Associate's degree: 2 years
Bachelor's degree: 4 years

Master's degree: 2–6 years
Doctorate: 4–8 years

COLLEGE GRADUATING HONORARY TITLES
Summa cum laude: "with highest praise"
Magna cum laude: "with great praise"
Cum laude: "with praise"

I.Q. CLASSIFICATION *(from 1916; no longer in use)*

Lewis Terman's The Measurement of Intelligence
Genius	Above 140
Very superior	120–140
Superior	110–120
Normal	90–110
Dull	80–90
Borderline	70–80
Moron	50–70
Imbecile	25–50
Idiot	0–25

Wechsler Adult Intelligence Scale *(from David Wechsler, 1997)*
Very superior	130 and above
Superior	120–129
High average	110–119
Average	90–109
Low average	80–89
Borderline	70–79
Extremely low	69 and below

IVY LEAGUE COLLEGES
(by founding date)
1636	Harvard University
1701	Yale University

1740	University of Pennsylvania
1746	Princeton University
1754	Columbia University
1764	Brown University
1769	Dartmouth College
1865	Cornell University

THE IVY LEAGUE

SOCIAL CASTES AND CLASSES

ANCIENT JAPANESE SOCIAL CLASSES
(most to least important)
Samurai
Farmers
Artisans
Traders

ATHENIAN SOCIAL CLASSES
(Women's social status was determined by that of male relations and were not permitted to take part in public life.)
Free people
 Citizens: free men born to Athenian parents who could take part in the polis
 Metics: free men born outside Athens; could never become citizens
Slaves

AZTEC CASTE SYSTEM
(Within three principal divisions there were a number of social classes, according to wealth, occupation, and political office; there was an ascribed and achieved status.)
Pipiltin
 Nobles: by birth and members of the royal lineage
 Priestly and bureaucratic class: administration of the empire
 Warriors

Maceualtin
 Tlalmaitl: commoners who had captured four enemy
 warriors were promoted
 Pochteca: merchants
 Lapidarians
 Goldsmiths
 Featherworkers
Mayeques
 Serfs: attached to rural estates
 Pawns: indentured servants who could buy their freedom
 Slaves: bottom class of society

CAPITALIST CASTE SYSTEM *(according to Eugene Debs, 1912 Socialist Party candidate for the U.S. presidency)*

We work for all, we feed all: workers supporting everyone
We eat for you: rich eating what workers produced
We shoot at you: soldiers who defended the rich
We foot you: clergy guaranteeing workers their reward in the
 next world
We rule you: "kings" of labor and politics

CELTIC TRIBE HIERARCHY

King
Chieftain: head of a village; often elected from ranks of nobles
 or warriors
Archdruid: one in charge of each Druid class
Druids: priests, religious teachers, judges, civil administrators;
 three classes, assisted by female prophets or sorcerers
 Prophets
 Bards
 Priests
Nobles: major landowners and merchants
Warriors: highly regarded cavalrymen and charioteers
Commoners

Metal-working smiths: very important to farming and war
Bards: interpreted and applied local historical records
Free peasants: small landowners
Semifree peasants: laborers bound to a noble but had
 possessions
Retainers: servants who lived with nobles
Slaves: prisoners of war who were sold or sacrificed

CHINESE COMMUNES
Commune: average of 15,000 inhabitants; in the countryside
Production brigades: about 1,000 people
Production teams: 20–60 households that farm the land and
 operate as a cooperative
(After 1983, production teams no longer farm land as a unit.
The fields are contracted out to single families.)

EGYPTIAN POLITICAL HIERARCHY
(the most important of about 2,000 titles)
Pharaoh: king of Egypt and incarnation of Ra, the sun god
Crown prince: heir to the throne
Princes: younger or adopted children
Superintendent of all the Works of the King: recorded,
 organized, and carried out pharaoh's edicts
Viziers: philosophers, sages, or scholars who advised pharaoh
Keepers or directors: aides to viziers
Priests: oversaw education, archives, science, workplaces, and rites
Nomarchs: provincial rulers
General of the braves of the king: led the best soldiers
Generals and captains: led axemen, spearsmen, archers, reserves
Grandees: noblemen who were friends of the royal household;
 highest were those allowed to kiss the feet of the pharaoh
Steward of the harem: responsible for pharaoh's wives
Overseers: responsible for specific duties within the pharaoh's
 household or the kingdom's civic projects

Scribes and artists: recordkeepers of the lives of pharaohs, priests, and noblemen

EGYPTIAN SOCIAL CASTES

Those Ranked Far Above Others in Dignity and Privilege
Priests (included landowners not in religious office; the sole learned caste)
Soldiers and warriors

Lower Castes
Husbandmen: tilled soil
Artificers, tradesmen, artisans
Miscellaneous class of fishermen, servants, and herdsmen (often treated as outcasts)

GENERAL CASTE SYSTEM OF EARLY TIMES
(most to least important)
Persons of holy descent
Landowners and administrators
Priests
Craftsmen
Agricultural tenants and laborers
Herders
Despised persons

HIERARCHY OF THE PROFESSIONS IN VICTORIAN ENGLAND
(according D. Roberts's Professional Men: The Rise of the Professional Classes in Nineteenth Century England*)*
Ranking military
Professionals
Employers or managers
Junior professionals
Clerks

Retailers
Skilled laborers
Semiskilled laborers
Unskilled laborers
Soldiers or sailors

HOPI SOCIAL CLASSES

(from traditional Hopi culture, highest to lowest)

Mong-cinum: leaders of kivas (chambers for ceremonies); priests and high priests

Pavun-cinum: members of society who hold no office but take part in ceremonies

Sukaving-cinum: not members and do not take part in ceremonies

INCA POLITICAL HIERARCHY *(organized by tens: for every 10,000 people there were 1,331 officials)*

Emperor: absolute power over Tahuantinsuyu ("Land of the Four Quarters")
Court of administrators and advisers

Four Quarters: subdivided into complex tributary systems (waranga = 1,000 tributaries)

Apos: governor rulers of the Four Quarters; each with 10 districts; resided in Cuzco

Curacas: local leaders who resided in provinces and made up the bulk of the administrative class

Homokorakas: district governors who ruled 10,000 people each

Mallcu: headman of a large village who ruled 10 foremen

Pacha-koraka: foreman or straw boss who ruled 10 groups of workers

Ayulla: extended-family, landholding

Puric: able-bodied tax-paying Indian

INCA SOCIAL CLASSES

Orejones: noblemen

Curaca: village leader
Coya: queen
Guaso: farm workers, peasants
Yanacona: serfs
Chino: women of mixed blood
Mitimae: conquered races
Chuncho: jungle natives

INCA SOCIAL HIERARCHIES

Cacique: head of community made up of a group of ayllu
Ayllu: Inca community, localized group that traced descent
 patrilineally; land for each ayllu divided into three
 unequal parts: largest part for farming, other two for
 cult of the sun and one for the state
 Upper ayllu
 Lower ayllu
Age-grade system: 12 ranks, in which persons passed from one
 social status to another according to age

Hierarchy of Social Belonging

Incas by birth (twelve lineages that descended from the
 ruler Cuzco)
Inca by privilege or by decree
Commoners

Social Status Hierarchy

Inca the all-powerful
Royal family
Upper aristocracy
Imperial administrators
Petty nobility
Artisans
Farm laborers

INDIA CASTE HIERARCHY

Brahmans: priests and scholars
Kshatriyas: royals or warriors
Vaisyas: skilled traders, merchants, farmers, and minor officials
Sudras: peasants, unskilled workers, and laborers
Pariah (Dalits): outcasts or untouchables

MAFIA (COSA NOSTRA) HIERARCHY

Commission: heads of most powerful families
Don, Capo di Tutti Capi, or boss of all bosses: authority
 challenged only by commission
Bougata, or Underboss: equal to vice president or deputy director
Consigliere: counselor or adviser
Caporegime: captain or lieutenant, under the underboss,
 a go-between for the workers and the don
Soldier, Button Man: handle the "dirty work"

MAYAN CLASS SYSTEM *(formative period)*

King: all-powerful
Two-class system:
 **Elite priestly class of peaceful stargazers, calendar
 keepers, and rulers:** representatives of ruling
 dynasty—then nobles, priests, and warriors
 Large class of devout peasantry: worked in the fields and
 supported the elite with labor and produce (artists,
 artisans, traders; then peasants, slaves, bearers, laborers)

NATIVE AMERICAN POLITICAL HIERARCHY

Chief, headman, sachem: strongest or wisest man
 Peace chief: liaison between tribes
 Warrior chief or tree chief: responsible for nonpolitical
 activities
Shaman or medicine man: doctor who communed with
 supernatural spirits

Functionary: person chosen to oversee specific tasks in a tribe

Tribesman and tribeswoman: general member of tribe, including braves

Adoptee: prisoner or slave who became member of tribe to replace dead Indian

Slave: people claimed through wars with other tribes

NATIVE AMERICAN SOCIAL HIERARCHY

Nation or group: by common occupation, location, and language

Tribe, village, band: small settlements

Chiefs: at least two: civil chief in charge of affairs within tribe and a war chief to lead war parties against enemies

Tribal council

Clan: related persons who shared a common ancestor and family responsibilities (extended family of 100 or more members)

Clan chief

Council: men only, though women often helped choose council

Moiety, or half: family within the clans who competed or were assigned specific duties

Family: grandparents, parents, and their children

Fireside (Iroquois only): a mother and her children

Administrative Entities

Alliance of villages

Alliance council: representatives from each village

Village

Village council: representatives from each family

Chief: presiding officer and liaison for village or clan

ROMAN REPUBLIC CLASS SYSTEM

Populus Romanus: free inhabitants with voting privileges in the Comitia or Assembly

Latins: belonged to cities having the "Latin franchise," the cities of Latium that were conquered; fairly easy to gain full Roman citizenship

Italians or socii: inhabitants of allied and dependent states; no share in political affairs

ROMAN SOCIAL HIERARCHY

Emperor: rules over everyone

Senators and Patricians: descended from early landowners and political leaders

Equites (businessmen): qualified for this class by owning property

Plebeians, commoners: poor farmers and traders

Capite censi, proletarii: citizens who were free, but poor and not allowed to vote

Slave: could become a proletarius

ROMAN TERRITORY CLASS SYSTEM

Cives: Roman citizens

Peregrini: foreigners

 Provincials: people who lived outside Rome itself but within Roman territory; did not have full rights of Romans

 Slaves: owned by other people; no freedom or rights

Gens: chain of related family forming a clan

Family: led by paterfamilias (father) and included wife, children, sons' wives and children, and all their slaves

SOCIAL CLASSES PER KARL MARX

Aristocracy: superior through education, ability, wealth, or social prestige

Bourgeoisie: middle class, or in Marxist theory the property-owning class

 petite bourgeoisie (lower middle class, having least wealth and lowest social status)

Proletariat: industrial wage earners who do not possess capital or property and must sell their labor to survive

Lumpenproletariat: extremely poor and unemployed

SOCIAL ESTATES

(broad divisions of society, first recognized in the Middle Ages)

First estate: clergy of a country

Second estate: nobility of a country

Third estate: the commoners, townsmen, or middle class of a country

Fourth estate: the press; journalists

Fifth estate: sometimes defined as the trade unions or scholars

SOCIOLOGICAL CLASSES

Upper class: owners, managers, top public officials

Upper middle class: white-collar professionals with advanced post-secondary degrees

Middle class: nonmanual white-collar workers, owners of small businesses

Working class: manual laborers

Lower class, underclass: irregularly employed and rural poor, collective and state workers

SPARTA'S POLITICAL AND SOCIAL HIERARCHY

Hereditary kings: one each from two separate families; led the army and also carried out religious duties

Gerousia: council of kings and 28 elected old men who directed much of Spartan policy

Ephors: elected officials of the apella who had wide judicial and administrative powers, supervised the training and discipline of the citizens, and controlled the helots with the help of the secret police (crypteia)

Apella: assembly of all adult male citizens, men of Spartan birth; served in army and could vote

Spartiatai: governing class, rulers, and soldiers descended from the Dorians

Perioeci: free men allowed to trade and serve in the army but who had no political rights

Helots: descendants of Sparta's original inhabitants, serfs bound to the land who had to farm it for their masters

VIKING POLITICAL HIERARCHY

Althing: legislative assembly with sole legal and judicial authority (all freedmen of fixed domicile or representatives of the different cantons)

king: elected by the assembly, the Althing; also religious chief

chieftains: elected by the assembly, the Althing

specialized artisans: smiths, soldiers, merchants, carpenters, professional people

freedmen: owners of the land they cultivated (also called jarls)

slaves (thralls): born serfs, captured in war, or freedmen deprived of legal rights (people belonged to clans which evolved mainly through family relations)

WEBERIAN SOURCES OF SOCIAL POWER

(Max Weber was a German sociologist.)

Wealth: includes property such as buildings, lands, farms, houses, factories, as well as other assets

Prestige: the respect with which a person or status position is regarded by others

Power: the ability of people or groups to achieve their goals despite opposition from others

SOCIAL CLASSES IN FICTION

HIERARCHIES IN ALDOUS HUXLEY'S *BRAVE NEW WORLD*

Political

World controllers: ten, picked from among resident controllers

Resident controllers: rule nations

Secretaries
Second secretaries
Governors
Deputy governors
Superintendents
Assistant superintendents
Deputy assistant superintendents
Directors
Assistant directors
Chiefs
Managers
Chief justices and arch-community-songsters

Social (Each Caste Has "Plus" and "Minus" Levels)
Alphas (gray): very clever; genius; highest is Alpha Double-Plus
Betas (mulberry): intelligent
Gammas (green): stupid; lowest is Gamma-Minus
Deltas (khaki): perform menial labor only
Epsilons (black): very stupid; lowest is Epsilon-Minus Semi-
 Moron Savages, who live in primitive areas outside cities

POWER STRUCTURE IN GEORGE ORWELL'S *1984*
Big Brother: all-powerful leader
Thought Police: all-seeing discipliners
Inner Party: 6 million members from the population of Oceania,
 the "brain of the state"
Outer Party: commoners
The Low, or Proles: slave population of the equatorial regions

CASTE SYSTEM IN *THE PLANET OF THE APES*
(from the novel by Pierre Boulle on which the film series is based)
Gorillas: police, military, and hunters
Orangutans: administrators, politicians, and lawyers (and spiritual)
Chimpanzees: intellectuals and scientists

HIERARCHIES IN SIR THOMAS MORE'S *UTOPIA*

Political Hierarchy

National lietalk (parliament): each town sends three
representatives

Mayor: elected by Stywards from a candidate from each of the
town's four quarters

Bencheater: senior district controller, elected by Stywards

Styward, or District Controller: represents 30 households,
has one-year term; 200 Stywards per town

Household: organized into groups of 30

Social Hierarchy

Husband: head of household

Wife

Children

Students

Laborers

Slaves
 Free people from other countries
 Condemned prisoners from other countries
 Native-born Utopians who squandered the offerings
 of Utopia

SOCIAL SCIENCES AND SOCIAL STUDIES

BRANCHES OF SOCIAL SCIENCES

Anthropology

Archaeology (study of remains of past cultures and civilizations)
 Historic archaeology (reconstruction of sites supplemented
 by written sources)
 Prehistoric archaeology (study of cultures with no written
 languages)

 Protohistoric archaeology (study of cultures with some
 written record)
Cultural anthropology
 Ethnography (study of individual cultures)
 Ethnology (study of historical and structural views of
 human cultures)
 Comparative ethnology
 Folklore, mythology, musicology, etc.
 Economic anthropology (economic analyses of cultures)
 Ethnopsychology or cultural psychology
 (psychological features within cultures)
 Social anthropology (social features of cultures)
Linguistic anthropology (study of languages of cultures and
 civilizations)
Paleoanthropology (study of fossils to trace physical
 characteristics)
Physical anthropology (study of man as biological species)
 Anthropometry (measurement of body parts)
 Forensic anthropology (the application of anthropological
 knowledge in a legal setting)
 Genetics and growth studies
 Human evolution
 Primatology (study of primate behavior and societies)

Economics

Business administration
Consumer economics (behavior of consumers)
Economic geography (production and distribution of
 commodities)
Economic theory (theory of commercial activities,
 such as the production and consumption of goods
Economics (traditional, study of behavior of business
 and government units)

Finance
 Accounting
 Banking and financial services
 Public finance
International economics (international trade, monetary theory,
 and international finance)
Investment
 Securities
 Stock market
Mathematical economics
Labor economics (behavior of workers and employees)
Taxation

Geography

Cartography (mapping)
Human geography
 Cultural and social geography (cultural and social values,
 tools, and organization)
 Economic geography (how people satisfy their needs and
 make a living)
 Historical geography (evolution of present patterns)
 Linguistic geography (language characteristics)
 Medical geography (health and diseases, malnutrition, health-
 care facilities)
 Political geography (political organization)
 Population geography (distribution of population in relation to
 certain characteristics)
 Social geography (social characteristics)
 Urban geography (concentration in cities and metropolitan
 areas)
Physical geography
 Biogeography (distribution and ecology of plants and animals)
 Climatology and meteorology (study of the state of the
 atmosphere)

Ecology (science of relationships between organisms and environment)
Geomorphology (study of the forms and processes of land's surface)
Hydrography and oceanography (study of earth's waters)
Paleogeography (study and interpretation of ancient written documents)
Pedology (study of soil)
Phytogeography (concerning plants)
Resource management and environmental studies
Soil geography (study of distribution and types of soil)
Zoogeography (concerning animals)
Regional geography (associations within regions of all or some of the above elements)

History
Events
Historiography (historical research and presentation)
People, civilizations, and institutions
Philosophy of history

Linguistics
Historical linguistics (how language changes over time)
Structural linguistics (nature and structure of language as systems of units)
Phonetics (physical properties of speech)
Phonology (distribution and patterns of speech sounds)
Pragmatics (how language is used in communication)
Morphology (the forms language can take)
Syntax (natural rules or patterns that govern how sentences are formed)
Semantics (how languages structure and present meaning)
Language classification

Psycholinguistics (relationship between language and users'
 psychological processes)
Sociolinguistics (interactions of language and society)
Related fields
 Anthropological linguistics (relationship between language
 and culture)
 Applied linguistics (linguistic theory applied in teaching,
 psychology, lexicography, etc.)
 Computational linguistics (applications of computers in
 processing and analyzing language)
 Dialect geography (relationship of dialects to geography)
 Dialectology (study of dialects)
 Epigraphy (study of inscriptions)
 Evolutionary linguistics (study of origin and spread of language)
 Grammatology (study and science of systems of graphic script)
 Graphemics (study of alphabets)
 Metagraphemics (study of change in alphabets)
 Subgraphemics (study of pseudo-alphabets)
 Linguistic geography (regional variations of
 speech forms)
 Mathematical linguistics (applications of mathematical models
 and procedures to linguistic studies)
 Neurolinguistics (neurological processes underlying
 development and use of language)
 Paleography (interpretation of ancient written documents)
 Philosophy of language (exploration of the general nature and
 status of language)
 Social dialectology (relationship of dialects to society)
 Stylistics (use of elements of language style in particular
 contexts, as metaphor)

Political Science
Comparative law (differences, similarities, and interrelationships
 of different systems of law)

Game theory (behavior in strategic situations)
International relations (relations between nations)
Political behavior and theories
Political systems
Public administration (public policy, largely by the executive
 branch)
Public law (legal relationships between the state and individuals
 and with the relations among governmental agencies)
Public opinion

Psychology
Applied psychology
 Clinical psychology
 Consumer psychology
 Counseling psychology
 Engineering psychology
 Environmental psychology
 Industrial and organizational psychology
 Personnel psychology
 Psychiatry
Experimental and basic psychology
 Child psychology
 Cognitive psychology
 Comparative psychology
 Developmental psychology
 Educational psychology
 Personality psychology
 Physiological psychology
 Quantitative (psychometric) psychology
 Social psychology

Sociology
Applied sociology, social work, social service
Behaviorism

Biological sociology
Ethnic and racial relations
Globalization
Marriage and the family
Mass communication and public opinion
Population growth
Social concerns
 Correctional services, penology
 Criminology and delinquency
 Demography
 Poverty & Welfare
Social gerontology
Social inequality and stratification
Social organization and disorganization
Social psychology
Sociology of art
Sociology of childhood
Sociology of education
Sociology of family
Sociology of government and the military
Sociology of industry
Sociology of language
Sociology of law
Sociology of medicine
Sociology of politics
Sociology of sex or gender differences
Sociology of race
Sociology of religion

PALEO-SCIENCES

Paleoanthropology (study of fossils relating to physical
 characteristics)
 Paleodemography (study of populations and population
 changes in the past)

Paleography (study of ancient writing systems and writings)
Paleobiology: life activities of fossil organisms, also called
 paleontology
 Micropaleontology (paleontology of microfossils)
 Paleobiochemistry (organic chemistry of fossils)
 Paleobioclimatology (study of long-range effects of climate in
 the past)
 Paleobiogeography (study of the distribution of floras and faunas)
 Paleoecology (study of the relationship of organisms and
 environment in the past)
 Paleoichnology (study of trace fossils)
 Paleomorphology (study of the structure and form of fossil
 organisms)
 Paleopathology (study of disease in the past)
Paleobotany (study of fossil plants)
 Paleoagrostology (fossil grasses)
 Paleoalgology (fossil algae)
 Paleoethnobotany (plants used by ancient cultures)
 Paleomycology (fossil fungi)
 Paleopalynology (fossil pollen and spores)

Fossils of the Deinonychous have been found in Montana, Utah, and Wyoming.

Paleoclimatology (climatic conditions in the past)
Paleogeography (physical geography in the past)
 Paleofluminology (streams in the past)
 Paleogeology (geological features
 in the past)
 Paleogeomorphology (topographic features in the past)
 Paleolimnology (lakes in the past)
 Paleomagnetics (earth's magnetic field in the past)
 Paleooceanography (oceans in the past)
 Paleopedology (soils in the past)
 Paleotopography (topography in the past)
 Palcovolcanology (volcanic activity in the past)
Paleozoology (study of fossil animals)
 Invertebrate paleontology
 Paleoherpetology (fossil snakes)
 Paleomalacology (fossil mollusks)
 Vertebrate paleontology

STAGES OF GRIEF

(Elisabeth Kübler-Ross identified these in On Death and Dying, *1969, for those who are dying and who experience the death of a relative or friend, clockwise from the top.)*

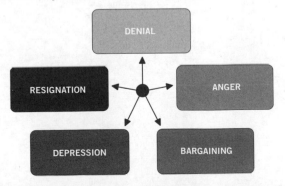

TACTICS OF NONVIOLENT ACTION
(expansion of Mohandas K. Gandhi's Three Principles of Nonviolent Resistance, by the activist Gene Sharp)

Nonviolent protest and persuasion: legal activities such as petitions, pickets, demonstrations, lobbying, vigils, leaflets

Nonviolent noncooperation: legal but somewhat obstructive activities such as boycotts, strikes, tax resistance, hunger strikes, factory slowdown, underground press

Nonviolent intervention: illegal but morally defensible activities such as physical obstruction, blockades, civil disobedience, sit-ins, giving sanctuary

THE ARTS

Things deprived suddenly of their putative meaning, the place assigned them in the ostensible order of things . . . make us laugh.

—Milan Kundera, *The Book of Laughter and Forgetting*

ARCHITECTURE

ARCHES

(in approximate order of development)

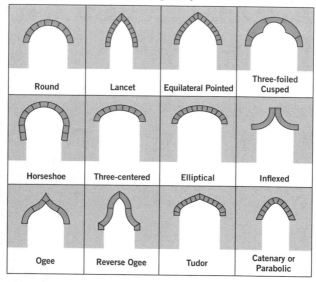

Round	Lancet	Equilateral Pointed	Three-foiled Cusped
Horseshoe	Three-centered	Elliptical	Inflexed
Ogee	Reverse Ogee	Tudor	Catenary or Parabolic

ARCHITECTURAL STYLES

Classical
Etruscan (750–100 B.C.)
Greek (600–300 B.C.)
Hellenistic (300–30 B.C.)
Roman (300 B.C.–A.D. 365)

Early Christian (European) Styles
Early Christian (313–c. 800)
Byzantine (330–1453)

Carolingian (c. 751–987)
Romanesque (800–1270)
Ottonian (919–1024)
Cistercian (1098–1270)
Gothic (1140–1534)
Rayonnant (1194–1400)
Flamboyant (1400–1500)

Early Christian (British) Styles
Anglo-Saxon (650–11th century)
Norman (1045–1180)
Gothic (1140–c. 1630)
 Decorated style (1290–c. 1375)
 Perpendicular (c. 1350–c. 1530)
Early English (c. 1175–c. 1250)

Early Christian (Spanish and Portuguese) Styles
Asturian (700–900)
Visigothic (711–914)
Mozarabic (800–1140)
Mudejar (1110–1500)
Manueline style (1450–1521)

Renaissance Styles
Italian Renaissance (1420–1600)
English Tudor (1485–1558)
English Elizabethan (1558–c. 1618)
Mannerist (c. 1530–c. 1600)

17th Century
Baroque (c. 1585–c. 1750)
American Dutch Colonial (1614–1664)
American English Colonial (1607–1700)
Jacobean (c. 1618–1625)

18th Century
Churrigueresque (c. 1680–1780)
Palladian (c. 1715–1770s)
Rococo (1720–1760)
Georgian (1714–1837)
Neoclassical (1750s–1840s)
Jeffersonian (1790s–1830s)
Federal (1790–1820s)

19th Century
Gothic Revival (c. 1750–c. 1900)
Greek Revival (1798–c. 1860)
Empire (1800–1830s)
Italianate (c. 1810–c. 1840s)
Exotic (1830s–c. 1920s)
Victorian (c. 1837–c. 1901)
Beaux Arts (c. 1865–c. 1913)
Classical (1890s–c. 1943)
Egyptian Revival (latter half of 19th century)
Arts and Crafts (c. 1895–c. 1943)

20th Century
Art Nouveau (1880s–1914)
Prairie style (c. 1900–c. 1920s)
International (1920s–)
Bauhaus (1919–1937)
Art Deco (1920s–1930s)
Chicago School (1884–1909)
Expressionism (c. 1905–1933)
Functionalism (1920s–1970s)
Futurist (c. 1910s–c. 1920s)
Post-Modernism (1970s–)

21st Century
Deconstructivist

Post-Modernism
Structuralist
Sustainable
Modern

BRANCHES OF ARCHITECTURE

Agricultural (barns, silos, stables)
Commercial and industrial (banks, factories, office buildings,
 refineries, stores)
Domestic and residential (apartments, castles, hotels, houses)
Educational and public welfare (hospitals, prisons, schools,
 universities)
Governmental (capitol buildings, courthouses, post offices,
 town halls)
Military (armories, forts)
Outdoor (racetracks, golf courses, parks)
Recreational (athletic facilities, auditoriums, libraries, museums,
 theatres)
Religious and commemorative (churches, monuments, mosques,
 shrines, synagogues, tombs, temples)

COLUMNS *(the classical order of ancient styles)*

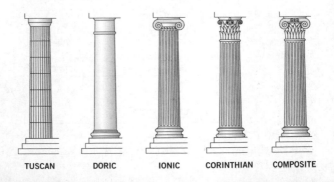

TUSCAN DORIC IONIC CORINTHIAN COMPOSITE

LEVELS OF ZIGGURAT

*(Ziggurats were stepped pyramids built by the Babylonians
with four corners oriented to the four directions; they
typically had seven terraces dedicated to seven deities; levels
listed from most important, at the top, to least important, at
the bottom.)*

Moon (silver)

Mercury (blue)

Venus (yellow)

Sun (gold)

Mars (red)

Jupiter (orange)

Saturn (black)

ROOFS

(arranged by number of sides, least to most complex)

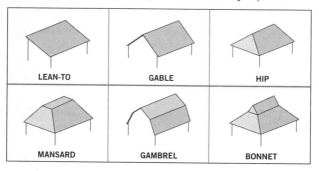

LEAN-TO GABLE HIP

MANSARD GAMBREL BONNET

BALLET

STARTING POSITIONS

*(Closed positions are first, third, and fifth; open positions are
second and fourth.)*

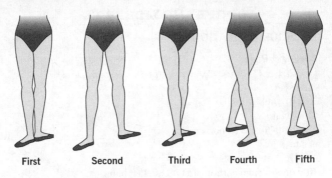

First Second Third Fourth Fifth

First position: heels touch; arms at sides, slightly curved

Second position: feet apart 12 inches; arms out and curved downward

Third position: feet parallel; right heel in front of left; one arm curved downward at side, the other out and curved downward

Fourth position: feet are at right angles to the direction of the body, the toes pointing out, with one foot forward and the other foot back; one arm curved downward and in front of the body, the other held above the head and curved toward the centerline

Fifth position: feet parallel, right foot fully in front of left; both arms held above the head and curving toward the centerline

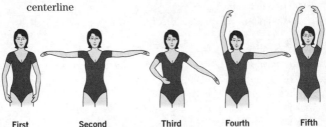

First Second Third Fourth Fifth

BOOKS AND LIBRARIES

BOOK IDENTIFICATION

Copyright Page
(Library of Congress Cataloging-in-Publication Data)
Publisher
Year of Publication
Copyright
All Rights Reserved notice
Printing
Author (last name, first name)
Title of book and author (first name, last name)
Subject(s) of book
Library of Congress classification and classification number, year
 of publication
International Standard Book Number (ISBN-13 digits)
International Standard Book Number (ISBN-10 digits)
Dewey Decimal classification [optional]

International Standard Book Number
(using this book's ISBN as an example)
978-0-7611-5044-2
978: GS1 prefix for global standardization
0: country code
7611: publisher name
5044: title of book
2: check digit used to prevent errors

BOOK SIZES
(octavo formats [sheets folded to make eight leaves]; in inches)

$5 \times 7\frac{3}{8}$	6×9	$7\frac{1}{4} \times 4\frac{7}{8}$
$5\frac{1}{4} \times 8\frac{1}{2}$	$6\frac{1}{8} \times 9\frac{1}{4}$	$8\frac{1}{2} \times 5\frac{1}{2}$
$5\frac{3}{8} \times 8$	$6\frac{1}{2} \times 4\frac{1}{8}$	12×19
$5\frac{1}{2} \times 8\frac{1}{2}$	7×11	

(quarto formats; in inches)

7 × 9	8¼ × 10⅞	9¾ × 7⅞
8 × 10	8½ × 11	11 × 8⅝

Other Formats

(height in inches)

Double elephant folio	25+	Duodecimo	7+
Atlas folio	25	Sextodecimo	6–7
Elephant folio	23	Vigesimo-quarto	5–6
Folio	13+	Trigesimo-secundo	4–5
Quarto	11–13	Fortyeightmo	4
Small quarto	10	Sixtyfourmo	3
Octavo	8–9	Miniature	less
Small octavo	7½–8		than 3

DEWEY DECIMAL SYSTEM

000–099	General Works (encyclopedias and other reference works)
100–199	Philosophy, psychology, ethics
200–299	Religion and mythology
300–399	Social sciences
400–499	Philology and language
500–599	Pure science
600–699	Technology
700–799	Fine arts
800–899	Literature
900–999	History, geography, biology, travel

LIBRARY DEPARTMENTS

Acquisitions
Cataloguing
Circulation
 Borrower registration
 Checkouts

 Check-ins
 Overdue books
Reference

LIBRARY OF CONGRESS SYSTEM OF CLASSIFICATION

A	General works, polygraphy
B	Philosophy, psychology, religion
C	Auxiliary sciences of history
D	Universal history
E–F	American, British, Dutch, French, and Latin American history
G	Geography, anthropology, recreation
H	Social sciences
J	Political science
K	Law
L	Education
M	Music
N	Fine arts
P	Language and literature
Q	Science
R	Medicine
S	Agriculture
T	Technology
U	Military science
V	Naval science
Z	Bibliography and library science

COLORS

PRIMARY COLORS
Red	Blue	Yellow

SECONDARY COLORS
Green	Orange	Purple

89

CRAYOLA'S 64 CRAYONS
(current group of 64, by year released)

1903
Black
Blue
Brown
Green
Orange
Red
Violet (Purple)
Yellow

1949
Apricot
Bittersweet
Blue-Green
Blue-Violet
Brick Red
Burnt Sienna
Carnation Pink
Cornflower
Gold
Gray

Green-Yellow
Magenta
Mahogany
Melon
Olive Green
Orchid
Periwinkle
Red-Orange
Red-Violet
Salmon
Sea Green
Silver
Spring Green
Tan
Turquoise Blue
Violet-Red
White
Yellow-Green
Yellow-Orange

1958
Burnt Orange
Cadet Blue
Forest Green
Goldenrod
Lavender
Plum
Raw Sienna
Sepia
Sky Blue

1962
Peach

1990
Cerulean
Dandelion
Wild Strawberry

1993
Asparagus

Granny Smith Apple
Macaroni and Cheese
Mauvelous
Pacific Blue
Purple Mountains' Majesty
Robin's Egg Blue
Tickle Me Pink
Timberwolf
Tumbleweed
Wisteria

1999
Chestnut

2000
Indigo
Scarlet

DANCE

MOVEMENTS OF A DANCE SUITE
(Traditionally, a suite is a four-part instrumental piece with movements in these dance tempos and rhythms.)
Allemande (duple meter)
Courante (triple time)
Sarabande (slow triple time)
Gigue (lively triple time)

LITERATURE

EIGHT REINDEER

*(original names from "The Night Before Christmas," also
known as "A Visit from St. Nicholas," by Clement Clark Moore)*

Dasher	Comet
Dancer	Cupid
Prancer	Dunder (now Donner)
Vixen	Blixem (now Blitzen)

ENGLISH LITERARY PERIODS

Old English period (300–1100): alliterative verse, elegiac and
heroic verse

Early Middle English period (1100–1300): didactic poetry,
verse romance, lyric

Late Middle English period (1300–1500): courtly poetry

Renaissance period (1400–1600): Elizabethan writing, early
Stuart

Restoration and Baroque period (1600–1700): chroniclers,
diarists, court wits

18th Century (1700–1800): political journalism, satire,
psychological novel

Romanticism (1800–1850): Romanticism

**Post-Romanticism, Enlightenment, and Victorian eras
(1850–1900):** Victorian literature, symbolism, Impressionism

Modern English period (1900–present): Edwardians,
Realism, social focus in novels

THE HARRY POTTER SERIES *(by J. K. Rowling)*

1998	*Harry Potter and the Sorcerer's Stone*
1999	*Harry Potter and the Chamber of Secrets*
1999	*Harry Potter and the Prisoner of Azkaban*
2000	*Harry Potter and the Goblet of Fire*
2003	*Harry Potter and the Order of the Phoenix*

2005 *Harry Potter and the Half-Blood Prince*
2007 *Harry Potter and the Deathly Hallows*

LEVELS OF MEANING
(methods for interpreting a piece of literature)
Allegorical (figurative)
Anagogical (spiritual)
Historical (literal)
Tropological (moral)

LITERARY POINTS OF VIEW
First person (I, we)
Second person (you)
Third person (he, she, they)

THE LORD OF THE RINGS SERIES *(by J.R.R. Tolkien)*
1954 *The Fellowship of the Ring*
1955 *The Two Towers*
1956 *The Return of the King*

SHAKESPEARE'S PLAYS *(in order of their publication)*
1588–1590 *Henry VI, Part 1*
1594 *Titus Andronicus*
1594 *Henry VI, Part 2*
1594 *The Taming of the Shrew*
1595 *Henry VI, Part 3*
1597 *Romeo and Juliet*
1597 *Richard II*
1597 *Richard III*
1598 *Henry IV, Part 1*
1598 *Love's Labours Lost*
1600 *Henry IV, Part 2*
1600 *A Midsummer Night's Dream*
1600 *The Merchant of Venice*

1600	*Much Ado About Nothing*
1600	*Henry V*
1602	*Sir John Falstaff and the Merry Wives of Windsor*
1604	*Hamlet*
1608	*King Lear*
1609	*Pericles, Prince of Tyre*
1609	*Troilus and Cressida*

Published Posthumously

| 1622 | *Othello* |
| 1623 | First Folio (36 plays) *Henry IV, Part 1, The Two Gentlemen of Verona, The Comedy of Errors, King John, As You Like It, Julius Caesar, Twelfth Night, Measure for Measure, All's Well That Ends Well, Macbeth, Timon of Athens, Antony and Cleopatra, Coriolanus, Cymbeline, The Winter's Tale, The Tempest, Henry VIII* |

SEVEN AGES OF MAN

(from Shakespeare's As You Like It*)*

Infant
Schoolboy
Lover
Soldier
Justice
Pantaloon
Second childishness

MOTION PICTURES

ACADEMY AWARD CATEGORIES

(in usual order awarded)

Achievement in Costume Design

Best Animated Feature Film
Achievement in Makeup
Best Visual Effects
Best Art Direction
Best Supporting Actor
Best Live-Action Short Film
Best Animated Short Film
Best Supporting Actress
Best Adapted Screenplay
Achievement in Sound Editing
Achievement in Sound Mixing
Best Actress
Best Film Editing
Best Foreign-Language Film
Best Original Song
Achievement in Cinematography
Best Original Score
Best Documentary Short
Best Documentary Feature
Best Original Screenplay
Best Actor
Achievement in Directing
Best Picture

MOTION PICTURE RATINGS

(from the Code and Rating Administration, Motion Picture Assocation of America)

G: "general audience"; anyone admitted

PG: "parental guidance"; some material may not be suitable for children under 13

PG-13: parents strongly cautioned; some material may not be suitable for children under 13 (formerly called M, then GP)

R: persons under 17 admitted only if accompanied by a parent or adult guardian

NC-17: no one under 17 admitted (formerly called X)
NR: no rating
XXX: an unofficial symbol used by motion-picture exhibitors to
 indicate sexually explicit films

THE SEVEN DWARFS

(dwarfs' names in the Disney film, Snow White and the
Seven Dwarfs*)*
Bashful
Doc
Dopey
Grumpy
Happy
Sleepy
Sneezy

MUSIC

BRASS INSTRUMENT TUBE LENGTHS

Tuba	13–14 inches
French horn	12–13 inches
Trombone	9 inches
Trumpet	4–5 inches

CATEGORIES OF SOUND

*(categories created by Pierre Schaeffer, who used them for
taping a musical composition)*
Dynamic
Gain
Harmonic timbre
Inflection
Mass
Mass profile
Melodic profile

CLASSICAL MUSIC ERAS
Dark Ages (A.D. 475–1000)
High Middle Ages (1000–1350)
Late Middle Ages (1350–1500)
Early Renaissance (1400–1517)
Late Renaissance (1517–1600)
Italian Baroque (1600–1750)
German-English-French Baroque (1650–1750)
Rococo (1700–1750)
Classical (1750–1820)
Early Romantic (1790–1820)
Late Romantic (1850–1900)
Modern (1900–1945)
Contemporary (1945–present)

CLASSICAL ORCHESTRA INSTRUMENTS
(nineteenth century ensemble, in seating order)

String Section
18 first violins
16 second violins
12 violas
12 cellos
8–10 double basses or contrabasses

Woodwind Section
3 flutes
1 piccolo
3 oboes
1 English horn
3 clarinets
1 bass clarinet
3 bassoons
1 contrabassoon

Brass Section

4 horns

4 trumpets

3 trombones

1 tuba

Percussion Section

Definite Pitch

　1 set of 2 or 3 timpani

　1 glockenspiel

　1 celesta

　1 xylophone

　1 set of chimes

Indefinite Pitch

　1 side or snare drum

　1 bass drum

　1 tambourine

　1 triangle

　1 set of cymbals

COLORED NOISES' FREQUENCIES

*(Spectral density [power distribution in the frequency spectrum]
is such a property, which can be used to distinguish different
types of noise; there is also orange noise, quasi-stationary noise
with a finite power spectrum with a finite number of small bands
of zero energy dispersed throughout a continuous spectrum.)*

Red or brown noise: –6 decibels per octave (dB/oct)

Pink noise: 18–10,000 Hz (Hertz), –3 dB/oct

White noise: 18–22,000 Hz, 0 dB/oct

Blue or azure noise: 10,000–22,000 Hz, +3 dB/oct

Purple or violet noise: +6 dB/oct

Black noise: above 20,000 Hz, silence

Gray noise: 7–500 Hz

Green noise: 500–2,000 Hz

FIVE ELEMENTS OF MUSIC

(according to Western music theory)

Form

Harmony

Interpretation (timbre, color)

Melody

Rhythm

INDICATIONS OF VOLUME

Fortississimo: as loudly as possible (*fff*)

Fortissimo: very loudly (*ff*)

Forte: loudly (*f*)

Mezzoforte: moderately loudly (*mf*)

Mezzo: medium loudly (*m*)

Mezzopiano: medium softly (*mp*)

Piano: softly (*p*)

Pianissimo: very softly (*pp*)

Pianississimo: as softly as possible (*ppp*)

Transitions

Crescendo: gradually louder (*cresc.*)

Decrescendo: gradually softer (*decresc.*)

Diminuendo: diminishing (dim.)

Sforzando, sforzano: forcing, accented (*sf*, *sfz*)

Rinforzando: reinforcing (*rfz*)

Forte piano: loud, then soft (*fp*)

Forzando: forcing, a sudden accent (*fz*)

Piu forte: louder (*pf*)

EIGHT SEAS OF THE BEATLES' FILM
YELLOW SUBMARINE

(in order of travel)

Time

Music

Science
Monsters
Heads
Nothing
Green
Holes

INTERVALS IN WESTERN MUSIC
(An interval is the number of half steps between two notes within an octave.)
Prime, or unison, perfect unison
 (first two notes of "Happy Birthday")
Minor second, or half step (first two notes of "Stormy Weather")
Major second, or whole step
 (second and third notes of "Happy Birthday")
Minor third (first two notes of "Hey Jude")
Major third (first two notes of "Beethoven's Fifth Symphony")
Fourth or perfect fourth ("Here Comes the Bride")
Tritone, or augmented fourth, diminished fifth, Diabolos in
 Musica (first two notes of "The Simpsons")
Fifth or perfect fifth ("Star Wars")
Minor sixth ("Theme from Love Story")
Major sixth ("My Bonny Lies Over the Ocean")
Minor seventh ("Somewhere")
Major seventh (first and third notes of "Bali Hai")
Octave—also eighth or perfect octave ("Over the Rainbow")

MODES
(The musical scales used before the Renaissance; can be played with the white keys of a piano, starting with the note indicated; modern examples are given in parentheses.)
Aeolian; A minor ("The Ants Go Marching")
Dorian mode; D minor ("Greensleeves")
Ionian mode; C major ("Happy Birthday")

Locrian; B minor (no example; too unstable)
Lydian; F major ("Star-Spangled Banner")
Mixolydian; G major ("Norwegian Wood")
Phrygian; E minor ("White Rabbit")

MUSICAL INSTRUMENT CLASSIFICATION
*(a categorization of musical instruments into families based
on the nature of the initial vibrating body, by Erich Moritz Von
Hornbostel and Curt Sachs, in 1914)*
Aerophones (vibrating element is a column of air)
 Free: harmonica, melodeon
 Wind instruments: trumpet, flute, clarinet, oboe, recorder
Chordophones (vibrating part is a string)
 Simple chordophones or zithers: harpsichord, piano
 Composite chordophones: lutes, guitar, violin, harps,
 lyres
Electrophones (sound produced electronically)
 Monophonic: trautonium
 Polyphonic: synthesizers
Idiophones (vibrating body is solid material)
 Struck: cymbals, triangle, castanets
 Plucked: Jew's harp, thumb piano
 Friction: scraper, rattle, musical glasses
 Blown: blown sticks, Aolsklavier
Membranophones (sound produced by membrane)
 Struck: kettledrum, bass drum
 Plucked: Indian gopiyantra
 Friction: found in Africa, Venezuela
 Singing membranes: kazoo

MUSICAL INSTRUMENT FAMILIES
Electronic instruments (electrophones)
 Monophonic electrophone: trautonium
 Polyphonic: synthesizers

Keyboard instruments
 Simple chordophones: harpsichord, piano, clavichord
 Aerophones: pipe organ, reed organ

Percussion instruments
 Idiophones: cymbals, castanets, triangle, xylophone,
 glockenspiel, bells
 Membranophones: side drum, bass drum,
 timpani, kazoo

Stringed instruments (composite chordophones)
 Lutes: lute, guitar, violin
 Violin family: violin, viola, violoncello or cello,
 double bass
 Zithers: harpsichord, piano
 Lyres: Greek kithara, Welsh crwth
 Harps

Wind instruments
 Free aerophones: harmonica, melodeon
 Flutes: recorder, flute
 Reedpipes: clarinet, saxophone, oboe, bassoon
 Lipped aerophones: horn, cornet, trumpet, trombone,
 tuba

MUSICAL NOTATION

Breve: double whole note (Latin: brevis)
Semibreve: whole note (Latin: semibrevis)
Minim: half-note (Latin: minima)
Crotchet: quarter note (Latin: semiminima)
Quaver: eighth note (Latin: fusa)
Semiquaver: sixteenth note (Latin: semifusa)
Demisemiquaver: thirty second note (Latin: fusella)
Hemidemisemiquaver: sixty fourth note (Latin: fusellala)

MUSICAL NOTES

NOTE SYMBOLS

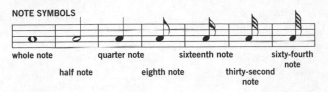

whole note quarter note sixteenth note sixty-fourth note

half note eighth note thirty-second note

ORNAMENTS

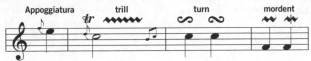

Appoggiatura trill turn mordent

ACCIDENTALS

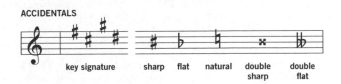

key signature sharp flat natural double sharp double flat

REST SYMBOLS

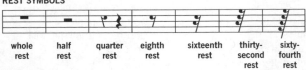

whole rest half rest quarter rest eighth rest sixteenth rest thirty-second rest sixty-fourth rest

CHORD OTHER SIGNS

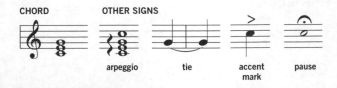

arpeggio tie accent mark pause

MUSICAL RANGES OF INSTRUMENTS

Keyboard

Church organ (up to 9 octaves) | Harpsichord (5)
Concert organ (8) | Spinet (4)
Upright piano (7½) | Clavichord (3–5)
Grand piano (7½) | Glockenspiel (2½–4)

String

Harp (5½ octaves) | Guitar (3) | Autoharp (2)
Cello (4) | Rebec (3) | Cittern (2)
Viola (4) | Sitar (3) | Lute (2)
Banjo (3) | Violin (3) | Mandolin (2)
Bouzouki (3) | Welsh or Irish | Ukulele (2)
Double bass (3) | harp (3) | Viola da gamba (2)
Dulcimer (3) | Zither (2–4) | Lyre (1)

Woodwind

double (contra-)bassoon | baritone oboe (2½)
 (3½ octaves) | bass oboe (2½)
bassoon (3½) | soprano saxophone (2½)
clarinet (3¼) | alto saxophone (2½)
bass clarinet (3¼) | melody saxophone (2½)
piccolo (3) | tenor saxophone (2½)
flute (3) | baritone saxophone (2½)
alto flute (3) | soprano recorder (2½)
oboe (2½) |

Percussion

(rhythmic sound [sounds at written pitch])
bass drum | tom-tom
snare drum, tambourine | bongo
cymbals, triangle | block
tam-tam, gong

(tuneable)

xylophone (3–4 octaves)
marimba (3)
vibraphone (3)
chimes/tubular bells (1½)

glockenspiel/metallophone
(1–1½)
Caribbean steel drums,
set of six (less than 1)

MUSICAL TEMPOS

Larghissimo: as slow as possible
Largo: very slow and dignified, sustained
Largamente: slow, broad
Larghetto: diminutive of largo and slightly faster
Grave: slow with solemnity
Lento: slow
Adagissimo: very slow, almost extremely slow
Adagio: slow, at ease
Adagietto: diminutive of adagio and slightly faster
Andante: slow walking pace
Andantino: steady walking pace
Moderato: brisk walking pace
Allegretto: with animation
Allegramente: lightly, gaily
Allegro: lively
Vivace: fast
Vivacissimo: very quick
Presto: very fast
Prestissimo: extremely fast

Tempo Changes

Accelerando: accelerating
Poco a poco: little by little
Stringendo: increasing speed and intensity
Ritardando: retarding the tempo
Morendo: dying away
Tempo primo, a tempo: return to first tempo
L'istesso tempo: same tempo

NUMBER OF MUSICIANS

1: soloist
2: duet
3: trio
4: quartet
5: quintet
6: sextet

7: septet
8: octet
9: nonet
10: dectet
11: undectet
12: duodectet

PIANO NOTES

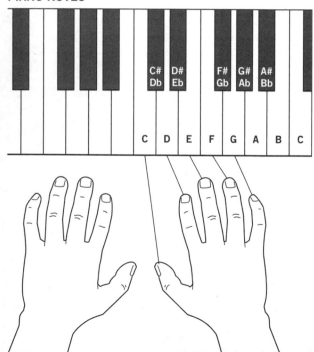

PIANO SIZES

Horizontal, or Grand *(length of box)*
Concert grand	8 feet and longer
Conservatory	5 ft 4 in–7 ft 11 in
Baby Grand	5 ft 2 in or less
Studio	5 ft 1 in–5 ft 3 in

Vertical *(width of box)*
Upright	49–60 in
Studio	45–48 in
Console	40–43 in
Spinet	35–39 in

RUDIMENTS OF DRUMMING

(as mastered)
Single-stroke roll
Double-stroke roll
Five-stroke roll
Seven-stroke roll
Nine-stroke roll
Ten-stroke roll
Eleven-stroke roll
Thirteen-stroke roll
Fifteen-stroke roll
Flam
Flam tap
Flamaque
Flam accent
Flam paradiddle
Ratamaque
Double ratamaque
Triple ratamaque
Drag
Double drag

Paradiddle
Double paradiddle
Paradiddle-diddle
Drag paradiddle
Drag paradiddle-diddle
Lesson 25
Ruff

SCALES OF BAROQUE MUSIC
(major to minor; basic scales in which nearly all baroque and
classical music was composed; in the key of C)
Major scale:
 C—D—E—F—G—A—B—C
Pure minor scale:
 C—D—E-flat—F—G—A-flat—B-flat—C
Melodic minor scale, ascending:
 C—D—E-flat—F—G—A—B—C
Melodic minor scale, descending:
 C—B-flat—A-flat—G—F—E-flat—D—C
Harmonic minor scale:
 C—D—E-flat—F—G—A-flat—B—C

SCALES OF JAPANESE MUSIC
(major to minor; the Four Sen are scales in Japanese classical
music; optional tones are in parentheses.)
Ryo-sen: D—E—F-sharp (G-sharp)—A—B (C-sharp)—D
Ritsu-sen: D—E (F)—G—A—B (C)—D
Yo-sen: D—F—G—A—C—D
In-sen: D—E-flat—G—A—B-flat—D

SCHENKER'S DEEP STRUCTURE
(The German pianist Heinrich Schenker's Deep Structure theory
states that all songs can be reduced to one set of components.)
Foreground: surface sounds or the music as it is played

Middleground: the layers that are progressively farther from the surface

Background: the most basic level of the music, far beneath the surface and based on a few simple progressions that are the foundation of the entire work

SOLFÈGE SCALE
(to teach the notes on major musical scale)

Do	Sol
Re	La
Mi	Ti
Fa	

SONATA FORM
(Typically used in the first movement of a symphony; these are the successive elements.)

Exposition
Development
Recapitulation
Coda (optional)

SYMPHONY ORCHESTRA INSTRUMENTS

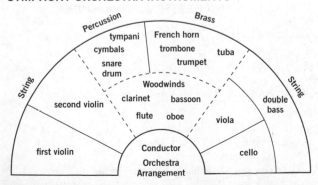

SYMPHONY ORCHESTRA INSTRUMENTS *(in seating order)*

String Section
Violin
Viola
Cello
Double bass

Woodwind Section
Piccolo
Flute
Clarinet
Bass clarinet
English horn
Bassoon
Oboe
Contrabassoon

Brass Section
Saxophone
Cornet
Trumpet
French horn
Trombone
Tuba
Bass tuba

Percussion Section
Timpani
Xylophone
Snare drum
Bass drum
Bells
Tom-tom
Castanets
Triangle
Tambourine
Cymbals
Gong
Chime
Glockenspiel
Piano

THREE CLEFS' PITCHES (SPACES AND LINES)
(high to low)
Treble: G A B C D E F G A
Alto: F G A B C D E F G
Bass: G A B C D E F G A

VOCAL RANGES *(high to low)*

Female
Soprano: highest female voice
 Coloratura: high, flexible; ornamented
 Soubrette: light, bright, sweet
 Lyric (leggiero): medium, cantabile singing

 Lyric spinto: full, bright
 Lyric spogato (sfogato): high, reedy
 Dramatic: largest soprano voice
 Dramatic dugazon: powerful but sly
 Dramatic falcon: with great flare
Mezzo-soprano: between soprano and alto
Alto or contralto: lowest female voice
 Dramatic: largest and lowest female voice

Male
Tenor: highest male voice
 Leggiero or lyric tenor: medium-pitch cantabile
 Counter tenor: extremely high
 Trial: high and nasal
 Tenor di grazia: high and graceful
 Heldentenor: largest tenor voice, Wagnerian
 Tenor di forza: more heroic
 Tenor robusto: full, vigorous
 Tenor spinto: high but dramatic
 Tenor buffo: low tenor; comic
Baritone: medium pitch
 Baritone-martin: high baritone
 Bass-baritone: between baritone and bass
Bass or Basso: lowest male voice
 Basso cantante: lyric bass
 Basso buffo: comic
 Basso profundo or Contra-basso: deep, dark; lowest voice

PAINTING AND SCULPTURE

STYLES AND PERIODS

Prehistoric Art
Paleolithic art (35,000–10,000 years ago)

Mesopotamian art (6000–539 B.C.)
Neolithic (c. 8000–3000 B.C.)

Egyptian and Classical Art
Egyptian art (3000 B.C.–A.D. 300)
Ancient Greek-Hellenistic (323–31 B.C.)
Roman art (500 B.C.–A.D. 300)

Christianity and Dark Ages (300–1200)
Migration period (150–1000)
Byzantine art (330–1450)
Carolingian art (800–870)
Ottonian art (870–1050)
Romanesque art (1050–1200)
Islamic art (7th–17th centuries)

Middle Ages
Gothic art (1200–1450)

Renaissance and early 18th century (1450–1750)
Renaissance (c. 1300–1545)
Mannerism (c. 1520–1700)
Baroque art (c. 1600–1720)

Late 18th and early 19th centuries
Rococo art (c. 1735–1765)
Neo-classicism (c. 1750–1850)
Romanticism (c. 1780–1850)
Realism (c. 1830–1880)
Pre-Raphaelite (1848–1856)

Late 19th and early 20th centuries
Arts and Crafts Movement (c. 1870–1900)
Art Nouveau (c. 1890–1915)

Impressionism (1874–1886)
Symbolism (c. 1880–1905)
Pointillism (c. 1880–1915)
Post-Impressionism (c. 1880–1910)

20th century

Fauvism (c. 1905–1907)
Die Brücke (The Bridge) (c. 1905–1913)
Expressionism (c. 1905–1925)
Cubism (c. 1907–1923)
Futurism (c. 1909–1919)
School of Paris (c. 1910–1950)
Der Blaue Reiter (c. 1911–1914)
Dada (c. 1915–1923)
Bauhaus School (c. 1919–1933)
Surrealism (c. 1924)
Art Deco (1925–1939)
Kinetic art and mobiles (c. 1930)
Abstract Expressionism (c. 1940)
New York School (c. 1945–1960)
Color field (c. 1950s)
Op art (c. 1950)
Pop art (c. 1955)
Minimal art (c. 1960)
Conceptual (c. 1960s)

21st century
Painting:
Hard-edge painting
Geometric abstraction
Hyperrealism
Photorealism
Expressionism
Minimalism

Lyrical abstraction
Pop art
Op art
Abstract Expressionism
Monochrome painting
Neo-expressionism
Collage
Intermedia painting
Assemblage painting
Computer art painting
Postmodern painting
Neo-Dada painting
Shaped canvas painting
Environmental mural painting
Traditional figure painting
Landscape painting
Portrait painting

Sculpture:
Ice and snow sculpture
LEGO sculpture
Light sculpture
Kinetic art
Sand sculpture
Sound sculpture
Weightless sculpture

PERFORMING ARTS

MAJOR AREAS

Broadcasting
Dance
Motion pictures

Music
Popular entertainment
Theater

POETRY

POETIC METER AND VERSE LENGTHS

(by foot; the two or more syllables that together make up the smallest unit of rhythm in a poem)

Monometer	one foot
Dimeter	two feet
Trimeter	three feet
Tetrameter	four feet
Pentameter	five feet
Hexameter	six feet
Heptameter	seven feet
Octameter	eight feet

POETRY SYLLABLES AND METRIC PATTERNS

Iamb: one short, one long syllable in quantitative meter; one unstressed, one stressed syllable in accentual meter

Trochee: one long, one short

Dactyl: one long, two short

Amphibrac: short, long, short in quantitative meter; unstressed, stressed, unstressed in accentual meter

Amphimacer: long, short, long

Anapest: two short, one long

Spondee: two long

TELEVISION

TELEVISION RATINGS

TV-Y: All Children
TV-Y7: Children ages 7 and up
TV-Y7-FV: Children ages 7 and up; with Fantasy Violence
TV-G: General Audience

TV-PG: Parental Guidance Suggested
TV-14: Parents Strongly Cautioned
TV-M: Mature Audience Only

THEATER

PLAY STRUCTURE

Action point; exposition

Rising action

Conflict; resulting action

Climax

Falling action

Transformation

THEATER SEATING

Orchestra seats: closest to stage

Balcony

 mezzanine; first balcony: lowest of two balconies

 loge: front section of mezzanine

 gallery; second, upper, or peanut balcony: highest of
 two balconies

VISUAL ARTS

BRANCHES

Architecture

Conceptual art

Dance

Decorative arts
 and crafts

Drawing

Fashion design

Filmmaking

Functional design

Garden and
 landscape
 design

Graphic arts

Literature

Mixed Media

Music

Painting

Photography

Printmaking

Sculpture

Web design

BUSINESS & ECONOMICS

In a hierarchy, every employee tends to rise to his level of incompetence.

—Laurence Johnston Peter, *The Peter Principle*

ACCOUNTING, BUDGETING, AND PLANNING

BUDGET TYPES

Capital budgets: proposed outlays for investments in land, plant, equipment, furniture, fixtures

Fixed, static, forecast budgets: developed for only one level of activity

Long-term budgets: 5–20 years long

Operating budgets: items involved in regular operation of firm

Programmed budgets: expenses subject to management's discretion, such as research and development or advertising

Short-term budget: usually covers period of a year

Continuous or rolling budgets (current month and following 11 instead of calendar or fiscal year)

Variable budgets: figures developed to fit various levels of activity

PERSONAL OR HOUSEHOLD BUDGET

Income Sources
Salaries: total in household
Bonuses, tips
Investments: interest, dividends, capital gains, real estate income

Fixed Outlays
Housing: rent or mortgage payments
Utilities: gas, electric, water, telephone
Taxes: federal, state, and local income; local real estate; Social Security
Interest payments: car, bank loan, credit card, other loans
Principal payments: amounts of borrowed principal repaid
Insurance: health, life, property

Education: tuition, supplies, room and board
Personal expenses
Contributions
Food
Transportation

Variable Outlays
Clothing
Entertainment
Vacations and recreation
Furniture, appliances, and home improvements
Health and beauty
Savings (general or specific for future purchases or
 objectives)
Miscellaneous

PERSONAL NET WORTH
(net worth equals total assets minus total liabilities)

Assets
Cash on hand and liquid assets
 Checking and savings accounts
 Cash value of life insurance
 U.S. savings bonds
 Equity in pension funds
 Money market funds
 Brokerage funds
 Trusts
 Debts owed you
 Other
Personal holdings
 Car(s) (current value)
 Home(s)
 Boat(s)
 Major appliances

Furs and jewelry
Antiques and collectibles
Art
Other
Investments
Common stocks
Preferred stocks
Corporate and municipal bonds
Mutual funds
Certificates of deposit
Business investments
Real estate investments
IRAs
Other

Liabilities
Bills due
Revolving charge and bank-card debts
Taxes due
Outstanding mortgage
Outstanding loans (bank, insurance, etc.)
Stock margin accounts payable
Other debts

AGRICULTURE

AGRICULTURAL SCIENCES
Agricultural economics and management
Agricultural finance
Agricultural law
Agricultural marketing
Agricultural policy
Farm and agribusiness management
Rural sociology

Agricultural engineering
 Mechanical
 Electrical
 Environmental
 Civil engineering
 Construction technology
 Hydraulics
 Soil mechanics
Agricultural meteorology
Animal production
Animal sciences
 Animal ecology and ethology
 Animal health; veterinary science
 Animal nutrition
 Applied animal physiology
 Breeding and genetics
 Food animal pathology
 Livestock and poultry management
Aquaculture
Ergonomics research (study of human adjustment
 and adaptation to machines)
Food sciences and postharvest technologies
 (processing, storage, distribution, and
 marketing of agricultural commodities
 and by-products)
Irrigation and water management
Plant production
 Applied plant physiology
 Breeding and genetics
 Crop management
 Plant ecology
 Plant nutrition
 Plant pathology
 Weed science

Soil and water sciences
 Geological generation of soil
 Soil and water physics
 Soil and water chemistry
 Soil fertility
Waste management
Water science

BANKING

NUMBERS PRINTED ON A CHECK
(number of digits may vary from bank to bank)

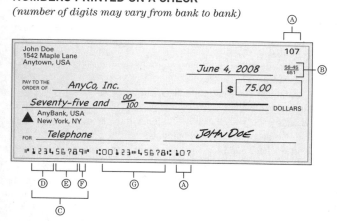

A. Serial number of check
B. Fraction code for manually processing check
C. Bank routing number
D. Federal reserve routing symbol
E. American Bankers Association Institution ID
F. Check digit
G. Customer account number

BUSINESS MEETINGS

ORDER OF BUSINESS
(according to Robert's Rules of Order*)*
1. Reading the minutes of the previous meeting (and their approval)
2. Reports of boards standing committees
3. Reports of special (select) committees
4. Unfinished business and general orders
5. New business

ECONOMICS

BUSINESS CYCLE
(alternating periods of business prosperity and depression)
Crisis: collapse after a period of prosperity—inflation, extravagance, and high prices
Emergency liquidation: quantities of goods placed on the market for whatever price they will bring
Depression: prices are low, curtailment of production, widespread unemployment, reduction or elimination of profits
Readjustment: irregular and uneven price movements after bottom has been reached; sharp competition, lower production costs, elimination of the inefficient
Recuperation or revival: deflation completed, bank reserves high, interest rates low
Prosperity: industry picks up, more labor and capital are employed, higher wages, interest rates rise; large volume of business
Overextension and speculation: expansion tightens credit and raises interest rates, prices rise, profiteering sets in, credit becomes inflated, costs rise more than selling prices and speculation makes prices higher than warranted

BUSINESS PHASES

(the fluctuations of economic activity within a long-term growth trend)
Expansion (recovery, starting from the trough)
Prosperity (peak)
Recession (decline)
Depression (trough)

FACTORY DIVISIONS

CAR FACTORY STRUCTURE

Management
Designer: idea-person
Machine operator: works machines that cut out parts
 and weld them together
Supervisor: oversees assembly-line workers
Assembly-line worker: works with a team to
 assemble parts
Quality tester: checks finished car and ensures everything
 works correctly
Driver: transports new cars to their destinations
 (car dealers)

GOLD

KARAT RANKS

(A karat is $\frac{1}{24}$ part, or 4.1667 percent, of the whole mix; thus, 16-karat gold is 16 parts gold and 8 parts alloying metal.)
24 k: 100% pure, fine gold
22 k: 91.75%
18 k: 75%
14 k: 58.3%

12 k: 50%
10 k: 41.7% (also gold-plated)
9 k: 37.5% (not legally gold)
8 k: 33.3% (not legally gold)

INDUSTRY

INDUSTRY CLASSIFICATION, NONFARM *(U.S. Census)*

Private

Goods-producing
 Natural resources and mining
 Construction
 Manufacturing

Service-producing
 Transportation and utilities
 Wholesale trade
 Retail trade
 Information
 Financial activities
 Professional and business services
 Education and health services
 Leisure and hospitality
 Other services

Government
 Federal
 State
 Local

INSURANCE

CLASSIFICATIONS

Perils Covered
Accident
Crime
Fire
Flood
Old age
Riot and civil commotion
Sickness
Storm

Property Covered
Buildings
Contents
Dwellings

Money
Vehicles

Risks Covered
Liability
Malpractice
Personal
Property

Losses Covered
Expense reimbursement
Income replacement
Replacement value

COMPULSORY INSURANCE

Government
 Personal risks: civil service retirement systems
 Property risks: Federal Deposit Insurance Corporation
 Liability risks: Federal Employees' Compensation Act
Private
 Personal risks: temporary nonoccupational disability insurance
 Liability risks: automobile insurance

VOLUNTARY INSURANCE

Government
 Personal risks: Veterans Administration
 Property risks: Federal Housing Administration
Private
 Liability risks: liability insurance on car, home, business
 Personal risks: life insurance
 Property risks: income replacement

MEDIA

ADVERTISING MEDIA

Print
Direct mail: promotional advertising mailed to homes and businesses
Magazines: consumer, business, and professional
Newspapers: local, national, business
Yellow Pages: national, local

Broadcast
Radio: network, local, spot
Television: network, cable network, syndication time; national spot, local spot
Internet: podcasting, Internet radio

Transit
Outdoor advertising, billboards

Electronic
Electronic mail
Internet and World Wide Web (websites, blogs, electronic catalogs)

Other
Cinema
Fringe media: hot-air balloons, parking meters, supermarket carts, milk cartons, window displays, buses
Point-of-purchase and sales promotions
Special sales

EDITORIAL SEQUENCE OF NEWSPAPER
1. News received
2. Story assessed by city editor
3. City editor informs news editor

4. Reporter assigned
5. Photographer assigned by picture editor (as appropriate)
6. Reporter covers event, photographer may assist
7. News editor decides story's placement in paper
8. Staff writer may assist with research and writing
9. Reporter files story
10. Photographer prepares prints
11. Page is laid out by makeup editor
12. Copy reader at copy desk checks reporter's story, writes headline, marks copy for compositor
13. News editor reviews story and sends to the composing room
14. Managing editor and chief editors review the day and decide what to include in the next edition

SIX QUESTIONS ASKED BY REPORTERS
Who
What
Where
When
How
Why

MONEY

COIN DENOMINATIONS
$1: President Dwight Eisenhower (silver dollar, discontinued)
$1: Susan B. Anthony (discontinued)
$1: Sacagawea
$1: President George Washington
$ 0.50: President John F. Kennedy
$ 0.25: President George Washington
$ 0.10: President Franklin D. Roosevelt
$ 0.05: President Thomas Jefferson
$ 0.01: President Abraham Lincoln

U.S. STATE QUARTERS RELEASES

(Starting on January 4, 1999, the new U.S. quarters were made available in the order of their date of statehood; the final five are scheduled to be released in 2008.)

1999: Delaware
Pennsylvania
New Jersey
Georgia
Connecticut

2000: Massachusetts
Maryland
South Carolina
New Hampshire
Virginia

2001: New York
North Carolina
Rhode Island
Vermont
Kentucky

2002: Tennessee
Ohio
Louisiana
Indiana
Mississippi

2003: Illinois
Alabama
Maine
Missouri
Arkansas

2004: Michigan
Florida
Texas
Iowa
Wisconsin

2005: California
Minnesota
Oregon
Kansas
West Virginia

2006: Nevada
Nebraska
Colorado
North Dakota
South Dakota

2007: Montana
Washington
Idaho
Wyoming
Utah

2008: Oklahoma
New Mexico
Arizona
Alaska
Hawaii

Colorado

New York

Georgia

Oklahoma

DENOMINATIONS

Discontinued in 1969

$100,000 note: President Woodrow Wilson;
 back: ornate 100,000

$10,000: Treasury Secretary Salmon P. Chase
 (1861–1864); back: ornate 10,000

$5,000: President James Madison; back: ornate 5000

$1,000: President Grover Cleveland; back: ornate 1,000

$500: President William McKinley; back: ornate 500

Currently in Circulation

$100: Benjamin Franklin; back: Independence Hall

$50: President Ulysses S. Grant; back: U.S. Capitol

$20: President Andrew Jackson; back: White House

$10: Alexander Hamilton; back: U.S. Treasury Building

$ 5: President Abraham Lincoln; back: Lincoln Memorial

$ 2: President Thomas Jefferson; back: "The Signing of the
 Declaration of Independence"

$ 1: President George Washington; back: "One" and obverse of
 Great Seal

PAPER DENOMINATIONS BY
FEDERAL RESERVE BRANCH

A1: Boston

B2: New York

C3: Philadelphia

D4: Cleveland

E5: Richmond
F6: Atlanta
G7: Chicago
H8: St. Louis
I9: Minneapolis
J10: Kansas City
K11: Dallas
L12: San Francisco

SAVINGS BONDS
$50: George Washington
$75: John Adams
$100: Thomas Jefferson
$200: James Madison
$500: Alexander Hamilton
$1,000: Benjamin Franklin
$5,000: Paul Revere
$10,000: James Wilson

TREASURY BILLS
$1,000: Hugh McCulloch
$5,000: John G. Carlisle
$10,000: John Sherman
$50,000: Carter Glass
$100,000: Albert Gallatin
$1,000,000: Oliver Wolcott

TREASURY BONDS
$50: Thomas Jefferson
$100: Andrew Jackson
$500: George Washington
$1,000: Abraham Lincoln
$5,000: James Monroe
$10,000: Grover Cleveland

$100,000: Ulysses S. Grant
$1,000,000: Theodore Roosevelt

TREASURY NOTES
$1,000: Abraham Lincoln
$5,000: James Monroe
$10,000: Grover Cleveland
$100,000: Ulysses S. Grant
$1,000,000: Theodore Roosevelt
$100,000,000: James Madison
$500,000,000: William McKinley

UNIVERSAL PRODUCT CODE

BAR CODE CONFIGURATION
(meaning of figure sequence from left to right)
Digit 1: Number system character, which identifies the product;
for example, 0 = national brands except the following, 2
= variable weight (cheese, vegetables, meat), 3 = drugs
or health care, 4 = discounted goods, 5 = coupons
Digits 2–6: Product's manufacturer, number assigned by
Uniform Code Council

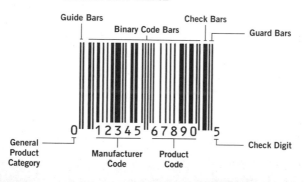

Digits 7–11: Product description by weight and size, color, other features

Digit 12: Check digit—the other numbers, when added, multiplied, and subtracted in a certain way, must total this number; any other number indicates a mistake.

U.S. SYSTEM OF TAXATION

CLASSIFICATION OF TAXES

National government: personal and corporate income taxes; excise taxes, etc.

State government: income tax, sales taxes; excise tax on tobacco, motor vehicles, gasoline, alcoholic beverages

Local government: property tax, income tax

FEDERAL TAX SYSTEM

Estate and gift tax

Excise tax

 Alcohol tax

 Coal tax

 Communications and air transportation taxes

 Documentary stamp taxes

 Environmental taxes

 Export exemption certificate tax

 Facilities and services tax

 Firearms tax

 Fuel tax

 Gas guzzler tax

 Highway vehicle use tax

 Luxury items tax

 Manufacturers' taxes

 Recreational equipment tax

 Ship passenger tax

 Special fuels tax

 Tax on heavy trucks, trailers, and tractors
 Tax on motor vehicles sold at retail
 Tobacco tax
 Wagering taxes
Income tax
Railroad retirement tax
Self-employment tax
Social Security tax (FICA)
Hospital insurance (Medicare)
Old-age, survivors, and disability insurance (OASDI)
Unemployment compensation tax (FUTA)

STATE AND LOCAL TAX SYSTEM
Alcoholic beverages tax
Capital values and franchise tax (capital gains)
Cigarette tax
Gasoline tax
Income tax (most states; some local levels)
Inheritance, estate, and gift tax
Personal property tax
Pollution control tax
Property tax
Real estate tax
Sales and uses tax
Severance tax
Unemployment insurance tax

HOME LIFE

I love all forms of taxonomy—lists, categories, compartments, containers, boundaries . . . I love doing errands, and what I especially love about doing errands is crossing things off my errand list . . .

—David Shields, *Remote*

BIRTHDAYS AND ANNIVERSARIES

ANNIVERSARY GIFTS *(traditional American; modern)*

1st	Paper or plastic; cotton or clocks	11th	Steel; fashion jewelry
2nd	Cotton or calico; paper or china	12th	Silk or fine linen; pearl, colored gems
3rd	Leather or crystal; glass	13th	Lace; textiles or furs
4th	Linen, silk, or synthetics, iron or appliances; fruit or flowers	14th	Ivory; gold jewelry
		15th	Crystal or glass; watches
5th	Wood or silverware	20th	China; platinum
6th	Iron, sugar, or wood	25th	Silver; sterling silver
7th	Wool, copper or brass desk sets	30th	Pearl; diamond
		35th	Coral or jade; jade
8th	Bronze, electrical appliances, linens, lace	40th	Ruby or garnets; ruby
		45th	Sapphire or tourmalines; sapphire
9th	Pottery, china, copper, or leather	50th	Gold; gold
		55th	Emerald or turquoise; emerald
10th	Tin or aluminum; diamond	60th	Diamond or gold; gold
		70th	Platinum

ANNIVERSARY JEWELS

(from the Jewelry Industry Council)

1st	Gold jewelry	9th	Lapis lazuli
2nd	Garnet	10th	Diamond jewelry
3rd	Pearls	11th	Turquoise
4th	Blue topaz	12th	Jade
5th	Sapphire	13th	Citrine
6th	Amethyst	14th	Opal
7th	Onyx	15th	Ruby
8th	Tourmaline	16th	Peridot

17th	Watch	35th	Emerald
18th	Cat's-eye	40th	Ruby
19th	Aquamarine	45th	Sapphire
20th	Emerald	50th	Golden jubilee
25th	Silver jubilee	55th	Alexandrite
30th	Pearl jubilee	60th	Diamond jubilee

BIRTHDAY FLOWERS

January	Carnation, snowdrop
February	Violet, primrose
March	Jonquil, violet
April	Daisy, sweet pea
May	Hawthorn, lily of the valley
June	Rose, honeysuckle
July	Larkspur, water lily
August	Gladiolus, poppy
September	Morning glory, aster
October	Calendula, cosmos
November	Chrysanthemum
December	Narcissus, holly, poinsettia

BIRTHSTONES *(ancient; modern)*

January	Garnet
February	Amethyst
March	Jasper; bloodstone or aquamarine
April	Sapphire; diamond
May	Agate; emerald
June	Emerald; pearl, moonstone, or alexandrite
July	Onyx; ruby
August	Carnelian; sardonyx or peridot
September	Chrysolite; sapphire
October	Aquamarine; opal or tourmaline
November	Topaz, citrine
December	Lapis lazuli; turquoise or zircon

MOTHER GOOSE'S DAYS OF BIRTH

Monday's child fair of face
Tuesday's child full of grace
Wednesday's child full of woe
Thursday's child has far to go
Friday's child loving and giving
Saturday's child works hard for a living
Sunday's child bonny and blithe, good and gay

ZODIAC

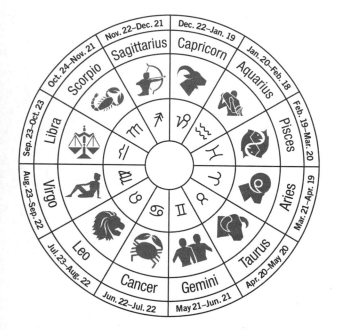

CLOTHES

CLOTHING SIZES

Women's clothing

USA	0	2	4	6	8	10	12	14	16	18	20
UK	4	6	8	10	12	14	16	18	20	22	24
EU	30	32	34	36	38	40	42	44	46	48	50

Women's Shirts

USA	30	32	34	36	38	40	42	44
UK	32	34	36	38	40	42	44	46
EU	38	40	42	44	46	48	50	52

Women's shoes

USA	5	5½	6	6½	7	7½	8	8½	9	9½	10
UK	2½	3	3½	4	4½	5	5½	6	6½	7	7½
EU	35	35½	36	37	37½	38	38½	39	40	41	42

Men's Suits and overcoats

USA	34	36	38	40	42	44	46	48	50
UK	44	46	48	50	52	54	56	58	60
EU	44	46	48	50	52	54	56	58	60

Men's shirts (neck size)

USA	12	12½	13	13½	14	14½	15	15½	16	16½	17	17½
UK	31	32	33	34/35	36	37	38	39	40	41	42	43
EU	31	32	33	34/35	36	37	38	39	40	41	42	43

Men's shoes

USA	6	6½	7	7½	8	8½	9	9½	10	10½	11	11½	12
UK	5½	6	6½	7	7½	8	8½	9	9½	10	10½	11	11½
EU	37½	38		38½	39	40	41	42	43	44	45	45	46

FABRIC CARE CODING SYSTEM

MACHINE WASH	BLEACH	TUMBLE DRY	DRY	IRON	DRY CLEAN
TEMP		**TEMP**		**TEMP**	
Cool/Cold	Any Bleach	No Heat	Line Dry	Low	Dry Clean
Warm	Only Non-chlorine Bleach	Low	Drip Dry	Medium	No Dry Clean
Hot	No Bleach	Medium	Dry Flat	High	
CYCLE		High	Dry in Shade	No Steam	
Permanent Press		Any Heat	Do Not Dry	No Iron	
		CYCLE			
Normal		Normal	Do Not Wring		
Delicate/Gentle		Permanent Press			
Do Not Wash		Delicate			
Hand Wash		No Tumble			

LUGGAGE SIZES *(largest to smallest)*
Steamer trunk
Footlocker
Pullman (25-inch to 34-inch)
Wheeled wardrobe
Garment bag
21-inch carry-on or flight bag or piggyback
Duffel–extra large
Duffel–large
Duffel–medium
Duffel–small
Boarding bag
Tote or satchel
Beauty case or cosmetic case

DINING PREPARATION

COOKWARE
Angel food cake pan (10 inch)
Baker (round, oval, or
 rectangular)
Baking pan (11–15 inches,
 10–18 cups)
Bread or loaf pan
Bundt cake pan (6–12 cups)
Casserole (from 1 pint to
 10 quarts)
Charlotte mold (8 cup, 2 quart)
Cookie sheet (12–25 inches)
Crepe pan (5–8 inches)
Dutch oven (7, 9, 13 quart)
Gratin dish (4–20 oz)
Griddle (8–12 inches)
Loaf pan (8–9 inches)

Omelet pan (8–10 inches)
Pie pan (9 inch)
Roasting pan (13–20 inches)
Round cake pan (8.5–12
 inches)
Sauce pot (4–8 quarts)
Saucepan with cover
 (from 1 pint to 5 quarts)
Sauté pan (8–14 inches
 diameter)
Skillet, frying pan
 (6–12 inches)
Springform pan (8–9 inches)
Square cake pan (6–18 inches)
Stockpot (8–20 quarts)
Wok (8–36 inches)

DINNER PLACE SETTING

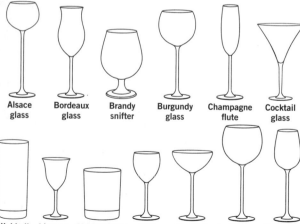

A. Napkin
B. Salad plate
C. Salad fork
D. Dinner fork

E. Dessert fork
F. First-course bowl and liner plate

G. Water goblet
H. Wine glass
I. Dinner knife
J. Soup spoon

K. Teaspoon
L. Dinner or service plate

GLASSES

Alsace glass

Bordeaux glass

Brandy snifter

Burgundy glass

Champagne flute

Cocktail glass

Highball glass

Liqueur glass

Old-fashioned glass

Port glass

Sparking wine glass

Water goblet

White wine glass

KITCHEN UTENSILS *(by function)*

Cutting
Baller
Chopper
Cleaver
Cookie cutter
Corer
Cutter
Grater
Knife
Mandoline
Mincer
Peeler
Scissors-shear
Shredder
Slicer
Slicing machine

Handling and Spreading
Chopstick
Ladle
Lifter
Paddle
Pastry brush
Scoop
Sifter
Skimmer
Spatula
Spoon
Tong
Turner

Measuring
Cup
Scale
Spoon
Thermometer

Opening
Can opener
Church key
Corkscrew

Piercing
Forks
Needles
Pick
Pricker
Skewer
Tester

Pounding, Pressing, and Pureeing
Cracker
Crusher
Food mill
Grinder
Juicer
Masher
Mortar and pestle
Pounder
Ricer
Rolling pin

Separating and Mixing
Beater
Blender
Colander
Dredger
Homogenizer
Mixer
Processor
Separator
Shaker
Sieve
Sifter
Spinner
Strainer
Whisk

NAPKINS

Cocktail	4 × 4 inches or less
Luncheon	6 × 6 inches or less
Dinner	7 × 7 inches or less

OVEN TEMPERATURES

175–225°F	warm	450–475°F	very hot
250–275°F	very slow	475°F+	extremely
300–325°F	slow		hot; broil
350–375°F	moderate	500°F	broil
400–425°F	hot		

SILVERWARE *(largest to smallest)*

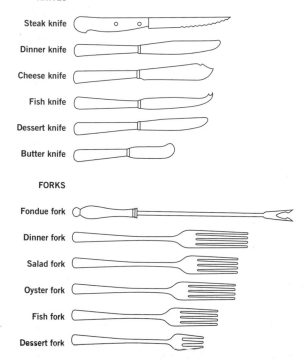

KNIVES

Steak knife

Dinner knife

Cheese knife

Fish knife

Dessert knife

Butter knife

FORKS

Fondue fork

Dinner fork

Salad fork

Oyster fork

Fish fork

Dessert fork

SPOONS

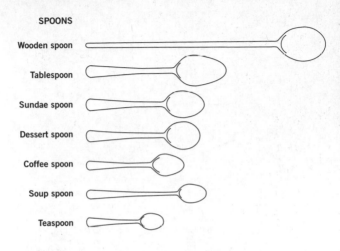

Wooden spoon

Tablespoon

Sundae spoon

Dessert spoon

Coffee spoon

Soup spoon

Teaspoon

FOODS AND DRINKS

BASIC FOOD GROUPS

(Nutrition science has changed and evolved since the days of the "Basic Four" food groups.)

Vegetables and fruits (and their juices); at least 7 servings per day recommended

Breads and cereals (foods based on whole grains or enriched flour or meal); 6–8 servings

Milk and milk products (milk, yogurt, cheese, ice milk, ice cream, and foods prepared with milk); 2–3 servings

Meats and meat alternates (meats, dry beans or peas, soybeans, lentils, eggs, nuts, seeds, peanut butter); 2 servings

Fats, sweets, and alcohol (butter, fats, oils, mayonnaise, and salad dressings; concentrated sweets; highly sugared beverages; unenriched, refined-flour products; bacon; salt pork); use sparingly

BEEF CUTS

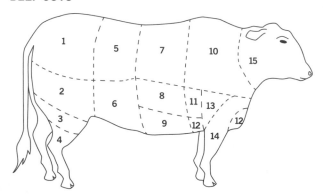

1. Rump	6. Flank	11. Cross ribs,
2. Round	7. Ribs	12. Brisket
3. Second-cut round	8. Plate	13. Shoulder clod
4. Hindshank	9. Navel	14. Foreshank
5. Loin	10. Chuck	15. Neck

BREWING BEER

1. Grains are malted. The process involves steeping and aerating barley, allowing it to germinate, and then drying and curing the malt.
2. Malt is transferred to mash tub, water and mixtures of other grains are combined, in preparation for the fermentation process.
3. Filtering of unfermented malt, or wort.
4. Wort is boiled in brew kettles. At start of this step, hops are added for flavor, then removed at the end. Wort is placed in fermenting tank.
5. Yeast added in starter tank.
6. Brew ferments in fermenting tank for about a week.
7. After fermentation, yeast is removed, and brew is transferred to aging tank for several weeks of storage.

8. Final filtering.

9. Packaging. Beer is pasteurized and transferred to cans and bottles.

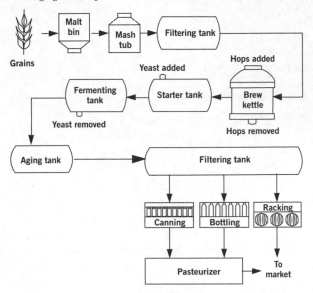

CAFFEINE CONTENT OF BEVERAGES

Decaffeinated coffee (5 oz)	2–5 mg
Hot chocolate (5 oz)	2–10 mg
Cola (12 oz)	30–50 mg
Green tea (8 oz)	30–50 mg
Instant tea (5 oz)	31 mg
Tea (5 oz)	40–100 mg
Double espresso (2 oz)	45–100 mg
Brewed coffee (8 oz)	60–120 mg
Instant coffee (8 oz)	60–70 mg
Energy drink (8 oz)	80 mg

DONENESS LEVELS OF MEAT

Rare
Medium-rare
Medium
Medium-well
Well done
Very well done

EGG SIZE AND QUALITY

By Weight
(one dozen)

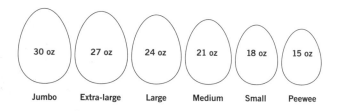

Jumbo	Extra-large	Large	Medium	Small	Peewee
30 oz	27 oz	24 oz	21 oz	18 oz	15 oz

By Quality
AA
A
B

FIBER CONTENT OF FOODS
(grams of dietary fiber per 100 grams of food)

Wheat bran	44	Peanuts, raw	8
All-Bran	32	Oatmeal	2
Prunes	7	Spaghetti, cooked	2
Lentils	8	White flour	2.5
Corn flakes	4.5	Apple, fresh	2.5

FOOD CLASSES

(classifications developed by the U.S. Department of Agriculture)
Cereals and cereal products
Starchy roots
Legumes (pulses)
Other vegetables
Fruits
Nuts and seeds
Sugars, syrups, sweets, and preserves
Meat, including poultry, and meat products
Seafood (fishes and shellfish)
Eggs and fish roe
Milk, cream, and cheese
Fats and oils
Herbs and spices
Nonalcoholic, nondairy beverages
Alcoholic beverages
Dietary preparations
Miscellaneous (e.g., salt, vinegar)

FOOD COMMODITIES

(classification used in U.S. Census)
Red meat
 Beef
 Veal
 Lamb and mutton
 Pork
Fish and shellfish
 Fresh and frozen
 Canned
 Cured, smoked
Poultry products
 Chicken
 Turkey

Eggs
Dairy products
 Fluid milk and cream
 Beverage milks
 Whole milk
 Lowfat milk
 Skim milk
 Buttermilk
 Yogurt
 Cream
 Sour cream and dip
 Condensed and evaporated milk
 Cheese
 Cottage cheese
 Ice cream
 Ice milk
Fats and oils
 Butter
 Margarine
 Lard
 Edible tallow
 Shortening
 Salad and cooking oils
 Other edible fats and oils
Flour and cereal products
 Wheat flour
 Rye flour
 Rice, milled
 Corn products
 Oat products
 Barley products
Caloric sweeteners
 Sugar
 Corn sweeteners

 Low-calorie sweeteners
Other
 Cocoa beans
 Coffee
 Peanuts
 Tree nuts

FOOD GRADES
(classifications developed by the U.S. Department of Agriculture)
Beef, veal, lamb
 Prime
 Choice
 Good (for veal/calf)
 Standard (for veal/calf) or Select (for beef)
 Commercial
 Utility
 Cutter
 Canner
Poultry
 Grade A
 Grade B
 Grade C
Fish
 Grade A
 Grade B
 Grade C
Pork
 Acceptable
 Unacceptable
Eggs and butter
 Grade AA
 Grade A
 Grade B

Fruits and vegetables, fresh (may vary for certain products)
 U.S. Fancy
 U.S. No. 1
 U.S. No. 2
Fruits and vegetables, canned;
 frozen juices; jams and jellies
 (may vary for certain products)
 Grade A
 Grade B
 Grade C

McDONALD'S BIG MAC ASSEMBLY

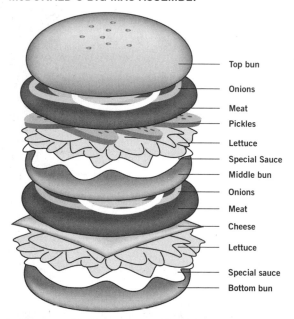

Top bun

Onions

Meat

Pickles

Lettuce

Special Sauce

Middle bun

Onions

Meat

Cheese

Lettuce

Special sauce

Bottom bun

OLIVES *(number of olives per pound)*

Leviathian	1
Super Colossal	less than 41 olives per pound
Colossal	41–50
Jumbo	51–60
Extra Large	65–90; for a few varieties, 65–75
Large	91–105
Medium	106–121
Small	128–140

VEGETARIAN TYPES

(by degree of avoidance of animal products)

Semivegetarian: eats dairy products, eggs, fish, chicken

Pesco-vegetarian: eats dairy products, eggs, fish

Lacto-ovo-vegetarian or ovo-lacto-vegetarian: eats dairy products, eggs

Lacto-vegetarian: eats dairy products

Ovo-vegetarian: eats eggs

Vegan: eats no animal products of any kind

WINES *(common types by grape variety)*

Reds	Whites
Cabernet Sauvignon	Chardonnay
Chianti	Chenin blanc
Gamay	Gewürztraminer
Lambrusco	Pinot blanc
Merlot	Pinot grigio
Montepulciano	Riesling
Nebbiolo	Sauvignon blanc
Pinot noir	Scheuerbe
Sangiovese	Viognier
Syrah or Shiraz	
Tempranillo	
Zinfandel	

WINE TASTING
(six techniques for evaluating wine)
See (examine the wine)
Smell and sniff
Swirl
Sip
Savor and swish in mouth
Swallow

FRAGRANCES

(by fragrance concentration, percentage of aromatic compounds)

Perfume	20–40%
Eau de parfum	10–15%
Toilet water	5–20%
Eau de cologne	2–7%

HOLIDAYS

ANNUAL U.S. FEDERAL HOLIDAYS
New Year's Day: January 1
Birthday of Martin Luther King, Jr.: third Monday of January
Washington's Birthday: third Monday in February
Memorial Day: last Monday in May
Independence Day: July 4
Labor Day: first Monday of September
Columbus Day: second Monday in October
Veterans Day: November 11
Thanksgiving Day: fourth Thursday of November
Christmas: December 25

HOLIDAY COLOR SEQUENCE OF EMPIRE STATE BUILDING

(This is the principal lighting sequence for the building. The building is also lit for other occasions and minor holidays.)

Martin Luther King Day:
red, black, green
Valentine's Day: red
Presidents Day: red, white, blue
St. Patrick's Day: green
Easter: yellow, white
Memorial Day: red, white, blue
Independence Day: red, white, blue
Labor Day: red, white, blue
Eid ul-Fitr: green
Columbus Day: red, white, green
Election Day: red, white, blue
Veterans Day: red, white, blue
Hanukkah: blue, white, blue
Christmas: red, green

LIGHTS

LIGHTBULB BASES *(by diameter)*
Mogul, 1¹⁹⁄₃₂-in: High-wattage bulbs like outdoor security lights
Ad-Medium, 1⁵⁄₃₂-in: Sign bulbs
Medium/Edison, 1¹⁄₁₆-in: Household bulbs
Intermediate, ⅝-in: Refrigerators and appliances
Candelabra, ½-in: Large Christmas tree lights
Min-can, ⁷⁄₁₆-in: Special high-intensity lights
Miniature, ⅜-in: Night-lights and small
Christmas tree lights
Midget: Smaller signal lights

LINENS

BLANKETS

Crib	28 × 52 in to 45 × 60 in
Stadium	50 × 60 in to 54 × 72 in
Twin	60 × 90 in
Double	80 × 90 in
Queen	90 × 90 in to 100 × 90 in
King	108 × 90 in to 108 × 100 in

PILLOWS

Standard	20 × 26 in
Queen	20 × 30 in to 22 × 34 in
King	20 × 36 in
European square	26 × 26 in

MATTRESS AND FITTED-SHEETS SIZES

Crib	28 × 52 in
Twin	39 × 75–76 in
Long twin	39 × 80 in
Full or double	54 × 75 in to 54 × 76 in
Queen	60 × 80 in
King	78 × 80 in to 79 × 80 in
California king	72 × 84 in

TOWELS

Wash cloth	12 × 12 in to 14 × 14 in
Fingertip or guest towel	11 × 18 in to 11 × 21 in
Hand towel	16 × 28 in to 18 × 32 in
Bath mat	22 × 36 in to 24 × 35 in
Bath towel	25 × 48 in to 30 × 56 in
Bath sheet	35 × 60 in to 40 × 75 in

PAINTS

TYPES OF PAINT

Degree of Sheen
(least to most shine)
Flat
Satin or eggshell
Semigloss
Gloss

Base
Acrylic
Alkyd
Latex
Oil

PHOTOGRAPHY

FILM SPEEDS AND RECOMMENDED USE

*(International Organization for Standardization [ISO]
numbers. New digital cameras measure in 1–14 megapixels
and these cameras have an ISO sensitivity range of
100–3,200.)*

100: sunny days or with flash
200: all-purpose and with flash
400: low-light conditions or with telephoto lens
1,600: very dim light (as in museums where no flash is allowed)

RECYCLING

RECYCLING CODES

 PETE, polyethylene terephthalate (soda
bottles, water bottles, vinegar bottles, medicine
containers, backing for photography film)

 HDPE, high-density polyethylene (containers
for laundry and dish detergent, fabric softeners,
bleach, milk, shampoo, hair conditioner, motor oil;
newer bulletproof vests; various toys)

 V, polyvinylchloride (pipes, shower curtains, meat wraps, cooking oil bottles, baby bottle nipples, shrink wrap, clear medical tubing, vinyl dashboards and seat covers, coffee containers)

 LDPE, low-density polyethylene (wrapping films, grocery bags, sandwich bags)

 PP, polypropylene (Tupperware, syrup bottles, yogurt tubs, diapers, outdoor carpeting)

 PS, polystyrene (coffee cups, clear and colored disposable cutlery and cups, bakery shells, meat trays, "cheap" hubcaps, packing peanuts, styrofoam insulation)

 OTHER

TOOLS

CHAIN SAW CLASSIFICATIONS

Mini-saw (6–9 pounds)	Medium-duty (13–18 pounds)
Light-duty (9–13 pounds)	Heavy-duty (over 18 pounds)

TOOLS BY TYPE
Boring and Digging Tools

Adze	Chisel
Auger	Digger
Awl	Drill
Brace	Driver

Fork
Gimlet
Gouge
Grubbing mattock
Hoe
Jig
Mason's bolster
Mattock
Nail set
Parting tool

Pickax
Point
Press
Punch
Shovel
Spade
Taper reamer
Tooler
Trowel
Wheel pricker

Cutting Tools

Ax
Back saw
Band saw
Bench hook
Bolt cutter
Chain saw
Coping saw
Cutoff saw
Die
Folding saw
Glass cutter
Hack saw
Hand saw
Hatchet
Jigsaw
Keyhole saw
Knive
Log saw
Machete
Miter box
One-man crosscut saw
Pipe cutter
Plane

Portable circular saw
Pruner
Razor
Rcamer
Router
Saber saw
Scissor
Scorp
Scraper
Scythe
Shaver
Shear
Sickle
Snip
Spokeshave
Table saw
Tap
Tile cutter
Trimmer
Tree saw
Two-man crosscut saw
Wire stripper

Grinding and Sharpening Tools

File	Sander
Grinder	Sanding block
Point and wheel	Sharpener
Rasp	Stone

Holding, Grasping, and Torsion Tools

Box wrench	Open-end wrench
Clamps	Pipe wrench
Crescent wrench	Pliers
Flat-nosed pliers	Socket wrench
Holdfast	Vise
Monkey wrench	Woodcarver's screw
Needle-nosed pliers	

Measuring and Marking Tools

Caliper	Plumb bob
Chalk line	Rule
Compass	Square
Gauge	Straight edge
Level	Tape measure

Striking, Pushing, and Pulling Tools

Auger	Pipe burring reamer
Crowbar	Plunger
Cultivator	Rake
Flared-tip screwdriver	Riveter
Hammer	Screwdriver
Mallet	Spring tube bender
Phillips head screwdriver	

HAMMER TYPES

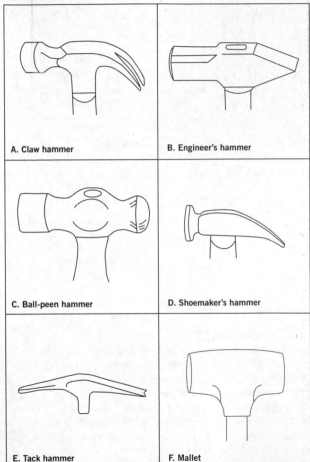

A. Claw hammer

B. Engineer's hammer

C. Ball-peen hammer

D. Shoemaker's hammer

E. Tack hammer

F. Mallet

HINGE TYPES

Butt hinge

Strap hinge

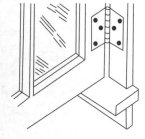

Blackflap hinge

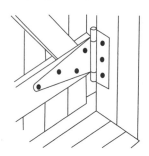

T hinge

SANDPAPER GRADES

500 and above: superfine (finest grit available)

320–400: extra fine (smoothing paints, metal and glass polishing)

220–280: very fine (fine sanding of wood)

120–180: fine (general woodworking, smoothing joints, autobody finishing, prepaint finish for furniture)

60–100: medium (coarse sanding for wood, stripping wood floors and painted furniture, rough metal work and finishing)

30–50: coarse (de-rusting metals, stripping housepaint)

16–24: very coarse (removing rust, paint, etc.)

NAIL SIZES

Designation	Nail Length (Inches)	Gauge (Wire Measure)
2d	1	15
3d	1¼	14
4d	1½	12½
5d	1¾	12½
6d	2	11½
7d	2¼	11½
8d	2½	10¼
9d	2½	10¼
10d	3	9
12d	3¼	9
16d	3¼	8
20d	4	6
30d	4½	5
40d	5	4
50d	5½	3
60d	6	2

NAIL TYPES

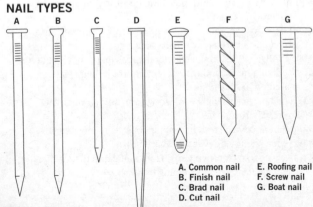

A. Common nail
B. Finish nail
C. Brad nail
D. Cut nail
E. Roofing nail
F. Screw nail
G. Boat nail

SCREW TYPES

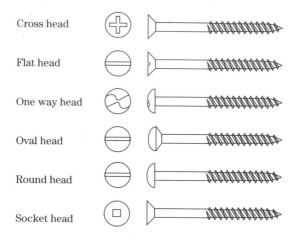

Cross head

Flat head

One way head

Oval head

Round head

Socket head

STEEL WOOL GRADES

#0000 or #4/0: superfine (polishing furniture finishes before applying top coat)

#000 or #3/0: extra fine (removing rust from chrome; surface preparation between varnish coats)

#00, #2/0: fine (cleaning wood floors; polishing copper and brass)

#0: medium fine (cleaning metal before soldering; cleaning aluminum pots and pans)

#1: medium (preparing walls, wood for painting; removing rust from cast iron)

#2: medium coarse (rough cleaning jobs, as on masonry)

#3: coarse (removing paint and varnish)

#4: extra coarse (removing rust from metal and tile; engine cleaning; heavy-duty stripping of finishes)

SPORTS & RECREATION

Sport is imposing order on what was chaos.

—Anthony Storr

ARCHERY

FIELD ARCHERY

Ring Points
Black center spot: 5 points
White inner ring: 4 points
Black outer ring: 3 points

TARGET ARCHERY

Ring Points
White outer ring: 1 point
White inner ring: 2 points
Black ring: 3 points
Black inner ring: 4 points
Blue ring: 5 points
Blue inner ring: 6 points
Red ring: 7 points
Red inner ring: 8 points
Gold ring: 9 points
Bull's-eye (gold inner ring): 10 points

AUTO RACING

AUTO RACING FLAGS

Green: start
Red: stop
Yellow: caution
Yellow with red stripes: caution due to slippery track
Black: leave the track
Black with orange disk: stop due to mechanical problems
Black and white divided diagonally: stop due to
 unsportsmanlike behavior

Blue with yellow stripe: move to the outside
White: one lap to go
Checkered: finish

BASEBALL

BASEBALL DIAMOND DIMENSIONS

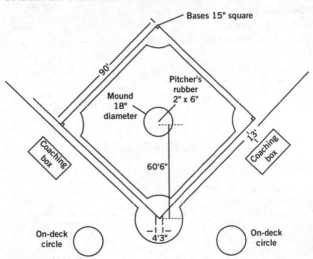

BASEBALL POSITIONS

Pitcher	Shortstop
Catcher	Left field
First base	Center field
Second base	Right field
Third base	

TRIPLE CROWN *(awarded to a player holding the annual record in the following categories)*
Batting average
Home runs
Runs batted in

WHO'S ON FIRST? *(from the Abbott and Costello film* The Naughty Nineties; *no right fielder is in the routine)*
First Base: Who
Second Base: What
Third Base: I Don't Know
Left Field: Why
Center Field: Because
Pitcher: Tomorrow
Catcher: Today
Shortstop: I Don't Care

BASKETBALL

BASKETBALL COURT *(dimensions according to NBA)*

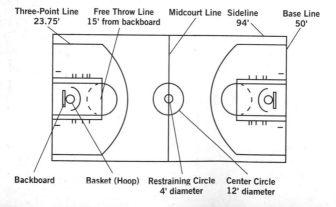

Three-Point Line 23.75' Free Throw Line 15' from backboard Midcourt Line Sideline 94' Base Line 50'

Backboard Basket (Hoop) Restraining Circle 4' diameter Center Circle 12' diameter

BASKETBALL POSITIONS
Center
Power forward
Small forward
Shooting guard
Point guard

BILLIARDS

BILLIARD BALLS
(balls 9 to 15 are white with a colored strip)

1 and 9: yellow **6 and 14:** green
2 and 10: blue **7 and 15:** brown
3 and 11: red **8:** black
4 and 12: purple **Cue:** white
5 and 13: orange

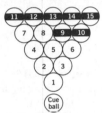

GAMES

14.1 CONTINUOUS POOL
The #1 ball is placed on the racker's right corner, the #5 ball is placed on the racker's left corner. The other balls are placed randomly.

EIGHT BALL POOL
The #8 ball is placed in the center of the triangle, a stripe ball in one corner of the rack and a solid ball in the other corner. The remaining balls are placed randomly.

SNOOKER POOL
Red ball: 1 point
Yellow ball: 2 points
Green: 3 points
Brown: 4 points
Blue: 5 points
Pink: 6 points
Black: 7 points

BILLIARDS SHOTS

Bank shot: hitting the object ball which then hits the rail
Break: hitting a full rack of balls
Combination (or Billiard) shot: using the cue ball to hit another ball and then the object ball
Jump shot: hitting the cue ball low so that it jumps
Massé shot: hitting the cue ball high so that it curves
Off the rail shot: hitting the rail with the cue ball and then hitting the object ball
Rail shot: cue ball is touching the rail
Straight shot: hitting the object ball with the cue ball
Stop shot: a shot in which the cue ball stops immediately on impact with the object ball

BOARD GAMES

CHESS

Chess Piece Rankings *(highest to lowest)*

king queen rook bishop knight pawn

Chess Power Values

Queen: 9 (can move in any direction, any unobstructed distance)

Rook: 5 (can move forward, backward, sideways for any
unobstructed distance)

Bishop: 3 (can move forward or backward diagonally for any
unobstructed distance)

Knight: 3 (can move two squares in any direction except
diagonally, then one square at a right angle)

Pawn: 1 (can only move forward; opening move one or two
squares, succeeding moves only one square)

Note: King can move in any direction, one square at a time

Chessboard Setup

A chessboard consists of 64 squares
in rows of alternating colors.

Player Rankings

(number of career points earned according to World Chess Federation)

Class C	under 1,600
Class B	1,600–1,799
Class A	1,800–1,999
Expert (Candidate Master)	2,000–2,199
Master (National Master)	2,200–2,399
Senior Master (International Master)	2,400–2,599
Grandmaster	2,600+

MAGIC 8-BALL MESSAGES

(varying sequence of the twenty sides of the icosahedron)

As I see it, yes.
Ask again later.
Better not tell you now.
Cannot predict now.
Concentrate and ask again.
Don't count on it.
It is certain.
It is decidedly so.
Most likely.
My reply is no.
My sources say no.
Outlook not so good.
Outlook good.
Reply hazy, try again.
Signs point to yes.
Very doubtful.
Without a doubt.
Yes.
Yes—definitely.
You may rely on it.

MAH-JONGG SUITS

(the ancient Chinese game has 144 tiles)

Suited Tiles

Bamboos: 4 each, numbered 1–9
Circles: 4 each, numbered 1–9
Characters: 4 each, numbered 1–9

Honors Tiles

Dragons: 4 each of green, red, and white dragons
Winds: 4 each of east, north, south, west

Flower Tiles

Flowers: 4 each, numbered 1–4
Seasons: 4 each, numbered 1–4

MONOPOLY

(clockwise from "Go"; standard American edition of the Parker Brothers game)

Go (collect $200)
Mediterranean Avenue ($60)
Community Chest
Baltic Avenue ($60)
Income tax, pay 10% or $200
Reading Railroad ($200)
Oriental Avenue ($100)
Chance
Vermont Avenue ($100)
Connecticut Avenue ($120)
In jail or just visiting
St. Charles Place ($140)
Electric Company ($150)
States Avenue ($140)
Virginia Avenue ($160)
Pennsylvania Railroad ($200)
St. James Place ($180)
Community Chest
Tennessee Avenue ($180)
New York Avenue ($200)
Free parking
Kentucky Avenue ($220)
Chance
Indiana Avenue ($220)
Illinois Avenue ($240)
B & O Railroad ($200)
Atlantic Avenue ($260)
Ventnor Avenue ($260)
Water Works ($150)
Marvin Gardens ($280)
Go to jail
Pacific Avenue ($300)
North Carolina Avenue ($300)
Community Chest
Pennsylvania Avenue ($320)
Short Line Railroad ($200)
Chance
Park Place ($350)
Luxury tax, pay $75
Boardwalk ($400)

SCRABBLE™

Letter Values

By number of tiles:		By letter value:	
E	12	Q, Z	10
A, I	9	J, X	8
O	8	K	5
N, R, T	6	F, H, V, W, Y	4
D, L, S, U	4	B, C, M, P	3
G	3	D, G	2
B, C, F, H, M	2	A, E, I, L, N	1
P, V, W, Y, blank	2	O, R, S, T, U	1
J, K, Q, X, Z	1	blank	0

BOWLING

PIN PLACEMENT

The ten pins, arranged in this order, must be 15 inches tall and weigh 3 pounds, 6 ounces, to be approved by the United States Bowling Congress.

BOXING

WEIGHT DIVISIONS

Amateur (Olympics)

Junior (light) flyweight	up to 106 lb (48 kg)
Flyweight	up to 112 lb (51 kg)
Bantamweight	up to 119 lb (54 kg)
Featherweight	up to 125 lb (57 kg)
Lightweight	up to 132 lb (60 kg)

Junior (light) welterweight or super lightweight	up to 140 lb (63.5 kg)
Welterweight	up to 147 lb (67 kg)
Junior (light) middleweight or super welterweight	up to 157 lb (71 kg)
Middleweight	up to 165 lb (75 kg)
Light heavyweight	up to 179 lb (81 kg)
Heavyweight	up to 201 lb (91 kg)
Super heavyweight	201+ lb (91+ kg)

Professional

Strawweight, Minimum	up to 105 lb
Junior (light) flyweight	up to 108 lb (49 kg)
Flyweight	up to 112 lb (51 kg)
Junior bantamweight or super flyweight	up to 115 lb
Bantamweight	up to 118 lb (53.5 kg)
Junior featherweight or super bantamweight	up to 122 lb
Featherweight	up to 126 lb (57 kg)
Junior lightweight or super featherweight	up to 130 lb (59 kg)
Lightweight	up to 135 lb (61.2 kg)
Junior (light) welterweight or super lightweight	up to 140 lb (63.5 kg)
Welterweight	up to 147 lb (66.5 kg)
Junior (light) middleweight or super welterweight	up to 154 lb (70 kg)
Middleweight	up to 160 lb (72.5 kg)
Super middleweight	up to 168 lb
Light heavyweight	up to 175 lb (79.4 kg)
Cruiserweight or junior heavyweight	up to 195 lb (88.45 kg)
Heavyweight	195+ lb (88.45+ kg)

BULLFIGHTING

BULLFIGHTERS AND STAGES OF A BULLFIGHT
Paseo (parade of matadors and assistants)
Banderilleros (assistants on foot; taunt the bull)
Matador (bullfighter; tests the bull's temperament)
Picadores (assistants on horseback; thrust long lances at bull)
Banderilleros (place brightly colored ribboned dart sticks
 [banderillas] in the bull's neck and back)
Matador (comes in for the kill)

CARD GAMES

BRIDGE

Bidding Order
Pass: no bid
Bid: offer to win a number of "odd tricks," tricks in excess of 6
 (first 6 = "book")
Double: increase the scoring value
Redouble: further increasing the scoring value of the trick

Point Scale
Rating point
Master point: 100 rating points in a club game
Black point: 100 rating points in sectional and regional play
Red point: 100 rating points in national and North American
 competition
Gold point: 100 rating points in a national victory
Player point: points accumulated over a career

Player Rankings
Rookie: 0–4 master points
Junior Master: 5–19 master points
Club Master: 20–49 master points

Sectional Master: 50–99 master points
Regional Master: 100–199 master points, of which 15 must be
 silver plus 5 red or gold
Advanced Senior Master: 200–299 master points, of which
 5 must be gold, 15 must be red or gold, and 25 must be silver
Life Master: 300 master points, of which 25 must be gold,
 25 must be red or gold, 50 must be silver, and 50 must be black

POKER

Chips
White chips: lowest value
Red chips: 5 white chips
Blue chips: 10 or 20 white chips (agreed by table)
Yellow or black: 100 white chips

Hands *(highest to lowest)*

ROYAL FLUSH:
ace, king, queen, jack,
10 of same suit

STRAIGHT FLUSH:
5 cards of a suit in
sequence (e.g., 7, 8, 9,
10, jack, all of spades)

FOUR-OF-A-KIND:
4 cards of the same
rank (e.g., 5 of hearts,
diamonds, spades, and
clubs)

FULL HOUSE: 3 of a
kind (e.g., three aces)
and a pair of another
kind (e.g., two 10s)

FLUSH: 5 cards of the
same suit, but not in
sequence

STRAIGHT: 5 cards in
sequence, regardless
of suit

THREE-OF-A-KIND: 3 cards of the same rank

TWO PAIR: 2 sets of 2 cards of the same rank

ONE PAIR: 2 cards of the same rank

HIGH CARD: highest-ranking card in a hand

COIN COLLECTING

CONDITION OF COIN *(worst to best)*

Fair: the coin can be barely identified

Good: very worn, but the outline of the design is still visible

Very good: design shows clearly, but detail is worn away

Fine: shows signs of wear

Very fine: shows slight wear

Extra fine: almost perfect

Uncirculated: mint condition, only marks caused by coins rubbing together

Proof: mirrorlike finish and struck from polished dies, especially for collectors

CRICKET

CRICKET POSITIONS

Bowler	Second slip	Cover-point	Square leg
Wicketkeeper	Gully	Mid-off	Deep fine leg
First slip	Third man	Mid-on	

DARTS

SCORING
Bull's-eye (inner or double ring): 50 points
Ring outside bull's-eye (single outer ring): 25 points

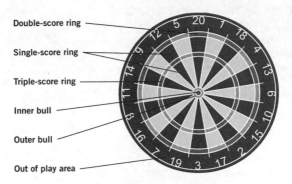

Double-score ring
Single-score ring
Triple-score ring
Inner bull
Outer bull
Out of play area

EQUESTRIAN SPORTS

HORSE GAITS
Walk: four beats, each hitting ground separately—left hind, left
fore, right hind, right fore
Trot: two beats—left hind and right fore together, right hind and
left fore together
Canter: three beats—left hind, left fore and right hind together,
then right fore
Gallop: four beats—same as walk then all four come off the
ground

THREE-DAY EVENT
First day: dressage
Second day: endurance ride, cross-country race, and steeplechase
Third day: jumping (through a ring)

TRIPLE CROWN RACING
Kentucky Derby (early May)
Preakness Stakes (mid-May)
Belmont Stakes (early June)

TRIPLE CROWN, HARNESS RACING
(The first harness racing Triple Crown, for three-year-old trotters, was created in 1955; the pacing series started in 1959.)
Pacers
Cane Pace, Freehold, NJ
Little Brown Jug, Delaware, OH
Messenger Stakes, Yonkers, NY

Trotters
Hambletonian, East Rutherford, NJ
Kentucky Futurity, Lexington, KY
Yonkers Trot, Yonkers, NY

FOOTBALL

FOOTBALL POSITIONS
Principal Positions
Quarterback
Fullback
Tailback or running back or halfback
Wide receiver or split end
Tight end
Slotback or flanker
Left tackle
Right tackle
Left guard
Right guard
Center
Wingback

Other Terms

Cornerback (nickelback)

Defensive back

Defensive end

Defensive tackle

Field-goal kicker

Free safety

Inside linebacker

Kicker, linebacker

Outside linebacker

Punter

Safety

Strong safety

FOOTBALL FIELD

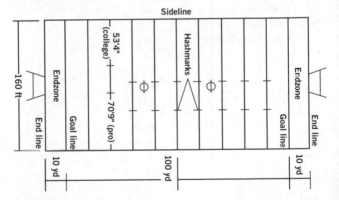

SCORING

Touchdown: 6 points

Field goal: 3 points

Safety: 2 points

Two-point conversion:
2 points

**Point after touchdown
(kick):** 1 point

UNIFORM NUMBERS

Quarterbacks, kickers, punters, receivers: 1–19

Running backs, cornerbacks, safeties: 20–49

Guards, centers, tackles: 50–79

Ends and wide receivers: 80–89

GOLF

AUGUSTA NATIONAL GOLF COURSE HOLE NAMES
(named for the shrubs, trees, and flowers found on the course)

1st	Tea Olive	10th	Camellia
2nd	Pink Dogwood	11th	White Dogwood
3rd	Flowering Peach	12th	Golden Bell
4th	Flowering Crab Apple	13th	Azalea
5th	Magnolia	14th	Chinese Fir
6th	Jupiter	15th	Firethorn
7th	Pampas	16th	Redbud
8th	Yellow Jasmine	17th	Nandina
9th	Carolina Cherry	18th	Holly

CLUBS

Irons
(by shaft length, longest to shortest)
1-iron
2-iron
3-iron
4-iron
5-iron
6-iron
7-iron
8-iron
9-iron
putter

Woods
(by shaft length, longest to shortest)
driver
2-wood
3-wood
4-wood
5-wood
6-wood
7-wood
8-wood
9-wood

Wedges
(by degree of loft)
pitching wedge (46–48°)
approach or gap wedge (52°)
sand wedge (56°)
lob wedge (60°)
high-lob wedge (64°)

PGA TOURNAMENTS

Masters (April)
United States Open (June)

British Open (July)
PGA Championship (August)

SCORING *(USGA standards)*

Men

Par 3: up to 250 yards
Par 4: 251–470 yards
Par 5: 471 yards and over

Women

Par 3: up to 210 yards
Par 4: 211–400 yards
Par 5: 401–575 yards
Par 6: 576 yards and over

Per Hole

Ace: hole-in-one: hole scored in one stroke
Eagle: two strokes under par for a hole
Birdie: one stroke under par on a hole
Bogey: one stroke over par for a hole
Double bogey: two strokes over par for a hole

HOCKEY

ICE HOCKEY RINK

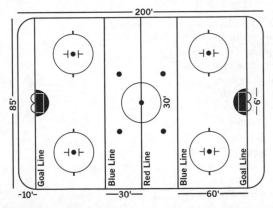

HOCKEY POSITIONS

Center	Left defenseman
Left wing	Right defenseman
Right wing	Goalie (goaltender)

MARTIAL ARTS

AIKIDO GRADES

Japanese
First kyu: brown belt
Second to sixth kyus: white belt

Outside Japan
First kyo: yellow belt
Second kyo: orange belt
Third kyo: green belt
Fourth kyo: blue belt
Fifth kyo: brown belt

JUDO LEVELS OF PROFICIENCY
(There are two groups of "grades.")

Kyu (Pupil) Grades *(lowest to highest)*
Absolute beginner: red belt
Beginner (6th): white belt
5th: yellow belt
4th: orange belt
3rd: green belt
2nd: blue belt
1st: brown belt

Dan (Degree) Grades *(lowest to highest)*
1st–5th: plain black belt
6th–8th: red-and-white belt
9th: red-and-black belt

10th: red belt (almost never conferred on anyone, except the founder of a style)

JUDO WEIGHT CATEGORIES

Class	Weight (Men)	Weight (Women)
Extra lightweight	up to 132 lb	up to 106 lb
Half-lightweight	up to 143 lb	up to 115 lb
Lightweight	up to 161 lb	up to 125.6 lb
Half-middleweight	up to 178 lb	up to 139 lb
Middleweight	up to 198 lb	up to 154 lb
Half-heavyweight	up to 220 lb	up to 172 lb
Heavyweight	over 220 lb	over 172 lb

KARATE RANKS *(According to the U.S. American Karate Federation, 18 reviews or promotions are required to reach the next skill level; listed lowest to highest.)*

10th Kyu: White belt
9th Kyu: Orange belt
8th Kyu: Yellow belt
7th Kyu: Blue belt
6th Kyu: Green belt
4th/5th Kyu: Purple belt
1st/2nd/3rd Kyu: Brown belt
Shodan ho: 1st Dan, probation
Shodan: Black belt, 1st degree
Nidan: Black belt, 2nd degree
Sandan: Black belt, 3rd degree
Yondan: Black belt, 4th degree
Godan: Black belt, 5th degree
Rokudan: Black belt, 6th degree
Shichidan: Black belt, 7th degree
Hachidan: Black belt, 8th degree
Kudan: Black belt, 9th degree
Jodan: Black belt, 10th degree

MARTIAL ARTS DAN GRADES

(Higher grades are conferred on those qualified to wear the black belt. Depending on the schools and techniques, there are 5–12 Dan grades.)

1st Dan: student
2nd Dan: disciple
3rd Dan: confirmed disciple
4th Dan: expert
5th, 6th Dan: spiritual expert
7th–10th Dan: expert becomes specialist (master: 9th, 10th Dans)

TAEKWONDO GRADES

(least to most experienced)

Keup (Kup or Kyu) Grades

10th: white belt
9th: white with yellow bar
8th: yellow
7th: yellow with green bar
6th: green
5th: green with blue bar
4th: blue
3rd: blue with brown bar
2nd: brown
1st: brown with black bar

Dan Grades of Black Belt

1st Dan: student
2nd Dan: disciple
3rd Dan: accepted disciple
4th Dan: expert
5th Dan: expert
6th Dan: expert
7th, 8th Dan: expert
9th, 10th Dan: master

MOTORCAR RACING

RACING AND CIRCUIT CARS

Formula One: up to 3,000 cc unsupercharged, 1,500 cc supercharged, max. 12 cylinders
Formula Three: up to 2,000 cc, 4-cylinder
Formula Ford: production 1,600 cc Duratec engines
Formula Vee, Super Vee: production 1,300 cc or 1,600 cc Volkswagen engines

Formula 5000: mass-production 5,000 cc engines

Indy Cars: up to 4,490 cc unsupercharged, 2,999 cc supercharged

Formula B, Formula Atlantic: single-seater, production 1,100–1,600 cc engines

Group One: series-production 4-seater sports touring cars

Group Two: limited-production 4-seater sports touring cars

Group Three: series-production 2-seater sports grand tourers

Group Four: limited-production 2-seater sports grand tourers

Group Five: long-distance open 2-seater sports cars

U.S. STOCK CAR RACING

Standard size: maximum engine capacity 7 liters (430 cubic inches), minimum wheelbase 119 inches (3.0226 meters); bodies as standard

Intermediate size: maximum engine capacity 7 liters (430 cubic inches), wheelbase 115–119 inches (2.921–3.0226 meters)

OLYMPIC GAMES—SUMMER

(as scheduled for the 2008 games in Beijing)

ARCHERY

Men and Women

Individual round (70 m)

Team round (70 m)

ATHLETICS

Men

100 meters	800 meters
200 meters	1,500 meters
400 meters	5,000 meters

10,000 meters
110-meter hurdles
400-meter hurdles
3,000-meter steeplechase
20 km walk
50 km walk
4 × 100-meter relay
4 × 400-meter relay
Marathon

High jump
Long jump
Triple jump
Pole vault
Shot put
Discus
Javelin
Hammer throw
Decathlon

Women

100 meters
200 meters
400 meters
800 meters
1,500 meters
5,000 meters
10,000 meters
20 km walk
100-meter hurdles
400-meter hurdles
4 × 100-meter relay

4 × 400-meter relay
Marathon
High jump
Long jump
Hammer throw
Pole vault
Triple jump
Shot put
Discus
Javelin
Heptathlon

Decathlon Sequence

100-meter dash
Long jump
Shot put
High jump
400-meter dash

110-meter hurdles
Discus
Pole vault
Javelin
1,500-meter run

Heptathlon Sequence

100-meter hurdles
High jump
Shot put
200-meter dash

Long jump
Javelin
800-meter run

BADMINTON

Men and Women
Singles
Doubles
Mixed doubles

BASEBALL

Men
8-team tournament

BASKETBALL

Men and Women
12-team tournament

BEACH VOLLEYBALL

Men and Women
24 pairs

BOXING CLASSES

Light flyweight	up to 48 kg
Flyweight	up to 51 kg
Bantamweight	up to 54 kg
Featherweight	up to 57 kg
Lightweight	up to 60 kg
Light welterweight	up to 64 kg
Welterweight	up to 67 kg
Light middleweight	up to 71 kg
Middleweight	up to 75 kg
Light heavyweight	up to 81 kg
Heavyweight	up to 91 kg
Super heavyweight	over 91 kg

CANOEING AND KAYAKING

Men

Flatwater

 C-1 500 meters
 C-1 1,000 meters
 C-2 500 meters
 C-2 1,000 meters
 K-1 500 meters
 K-1 1,000 meters
 K-2 500 meters
 K-2 1,000 meters
 K-4 1,000 meters

Slalom

 C-1 (single)
 C-2 (double)
 K-1 (single)

Women

Flatwater

 K-1 500 meters
 K-2 500 meters
 K-4 500 meters

Slalom

 K-1 (single)

CYCLING

Men

Track

 Individual sprint
 Individual pursuit
 Points race
 Olympic sprint
 Madison
 Keirin
 Team pursuit

Road

 Individual time trial
 Individual race

Mountain bike

 Cross-country

BMX

 Individual race

Women

Track

 Individual sprint
 Individual pursuit
 Points race

Road

 Individual race
 Individual time trial

Mountain bike

 Cross-country

BMX

 Individual race

DIVING

Men and Women
Springboard (3 meters)
Platform (10 meters)
Synchronized diving springboard (3 meters)
Synchronized diving platform (10 meters)

EQUESTRIAN

Individual jumping
Team jumping
Individual dressage
Team dressage
Individual eventing
Team eventing

FENCING

Men
Individual foil
Individual sabre
Team sabre
Individual epée
Team epée

Women
Individual foil
Team foil
Individual epée
Individual sabre
Team sabre

HANDBALL

Men and Women
12-team tournament

HOCKEY

Men
12-team tournament

Women
12-team tournament

GYMNASTICS

Men

Artistic
 Team competition
 Individual all-around
 Floor exercise
 Pommel horse
 Rings
 Vault
 Parallel bars
 Horizontal bar
Trampoline
 Individual

Women

Artistic
 Team competition
 Individual all-around
 Vault
 Uneven parallel bars
 Balance beam
 Floor exercise
Trampoline
 Individual
Rhythmic
 Individual all-around
 Team competition

JUDO

Men

up to 60 kg
60 to 66 kg
66 to 73 kg
73 to 81 kg
81 to 90 kg
90 to 100 kg
over 100 kg

Women

up to 48 kg
48 to 52 kg
52 to 57 kg
57 to 63 kg
63 to 70 kg
70 to 78 kg
over 78 kg

MODERN PENTATHLON

Men and Women

Individual competition
 (shooting, fencing, swimming, equestrian,
 cross-country running)

ROWING

Men

Single sculls
Pair without coxswain
Double sculls
Four without coxswain
Quadruple sculls without
 coxswain
Eight with coxswain
Lightweight double sculls
Lightweight coxless fours

Women

Single sculls
Pair without coxswain
Double sculls
Quadruple sculls without
 coxswain
Eight with coxswain
Lightweight double sculls

SAILING

Men

Star–Keelboat
Laser–One Person Dinghy
470–Two Person Dinghy
RS:X–Windsurfer

Women

Yngling–Keelboat
Laser Radial–One Person
 Dinghy
470–Two Person Dinghy
RS:X–Windsurfer

Open Events

49er–Skiff
Finn–Heavyweight Dinghy
Tornado–Multihull

SHOOTING

Men

Rapid-fire pistol, 25 meters
Pistol, 50 meters
Air pistol, 10 meters
Rifle three positions,
 50 meters

Rifle prone, 50 meters
Air rifle, 10 meters
Double trap
Trap
Skeet

Women

Air rifle, 10 meters
Rifle three positions,
 50 meters
Pistol, 25 meters

Air pistol, 10 meters
Trap
Skeet

SOCCER (FOOTBALL)

Men
16-team tournament

Women
8-team tournament

SOFTBALL

Women
8-team tournament

SWIMMING

Men and Women
50-meter freestyle
100-meter freestyle
200-meter freestyle
400-meter freestyle
1,500-meter freestyle
100-meter backstroke
200-meter backstroke
100-meter breaststroke
200-meter breaststroke

100-meter butterfly
200-meter butterfly
200-meter individual medley
400-meter individual medley
4 × 100-meter freestyle relay
4 × 200-meter freestyle relay
4 × 100-meter medley relay
10-kilometer marathon

SYNCHRONIZED SWIMMING

Women
Duet event
Team event

TABLE TENNIS

Men and Women
Singles
Team

TAEKWONDO

Men	**Women**
Under 58 kg	Under 49 kg
Under 68 kg	Under 57 kg
Under 80 kg	Under 67 kg
Over 80 kg	Over 67 kg

TENNIS

Men and Women
Singles
Doubles

TRIATHLON

Men and Women
Individual tournament

VOLLEYBALL

Men and Women
12-team tournament
Beach volleyball (24 pairs)

WATER POLO

Men and Women
12-team tournament

WEIGHT LIFTING

Men	Women
Up to 56 kg	Up to 48 kg
Up to 62 kg	Up to 53 kg
Up to 69 kg	Up to 58 kg
Up to 77 kg	Up to 63 kg
Up to 85 kg	Up to 69 kg
Up to 94 kg	Up to 75 kg
Up to 105 kg	Over 75 kg
Over 105 kg	

WRESTLING

Men
Freestyle
 Under 55 kg
 55 to 60 kg
 60 to 66 kg
 66 to 74 kg
 74 to 84 kg
 84 to 96 kg
 96 to 120 kg
Greco-Roman
 Under 55 kg
 55 to 60 kg

 60 to 66 kg
 66 to 74 kg
 74 to 84 kg
 84 to 96 kg
 96 to 120 kg

Women
Freestyle
 Under 48 kg Women
 48 to 55 kg Women
 55 to 63 kg Women
 63 to 72 kg Women

OLYMPIC GAMES—WINTER

(as scheduled for the 2010 games in Vancouver)

BIATHLON

Men	Women
10 km sprint	7.5 km sprint
20 km individual	15 km individual
12.5 km pursuit	10 km pursuit

Men	Women
4 × 7.5 km relay	4 × 6 km relay
15 km mass start	12.5 km mass start

BOBSLEIGH

Men	Women
Two-man	Two-man
Four-man	

CURLING

Men's tournament
Women's tournament

FIGURE SKATING

Men's singles
Women's singles
Pairs
Ice dancing

ICE HOCKEY

Men's tournament
Women's tournament

ICE SLEDGE HOCKEY

Men's tournament

LUGE

Men	Women
Singles	Singles
Double (can be co-ed)	

SKELETON

Men and Women

SKIING

Men
Alpine
 Downhill
 Slalom
 Giant slalom
 Super giant
 Super combined
Cross-country
 15 km individual
 15 + 15 km pursuit
 50 km mass start
 4×10 km relay
 Individual sprint
 Team sprint
Freestyle
 Aerials
 Moguls
 Ski cross
Jumping
 Individual normal hill
 Individual large hill
 Team large hill
Nordic combined
 Individual normal hill/15 km
 Sprint large hill/7.5 km
 Team large hill/4×5 km

Women
Alpine
 Downhill
 Slalom
 Giant slalom
 Super giant
 Super combined
Freestyle
 Aerials
 Moguls
 Ski cross
Cross-country
 10 km individual
 7.5 + 7.5 km pursuit
 30 km mass start
 4×5 km relay
 Individual sprint
 Team sprint

SNOWBOARDING

Men and Women
Halfpipe
Parallel giant slalom
Snowboard cross

SPEEDSKATING

Men	Women
Men	**Women**
Long track	Long track
500 meters	500 meters
1,000 meters	1,000 meters
1,500 meters	1,500 meters
5,000 meters	3,000 meters
10,000 meters	5,000 meters
Team pursuit	Team pursuit
Short track	Short track
500 meters	500 meters
1,000 meters	1,000 meters
1,500 meters	1,500 meters
5,000-meter relay	3,000-meter relay

OLYMPIC MEDALS

First: gold
Second: silver
Third: bronze

RUGBY

RUGBY LEAGUE SCORING RANGE

Try	3 points
Penalty goal	2 points
Conversion	2 points
Dropped goal	1 point

RUGBY LEAGUE POSITIONS

Full back

Right wing three-quarter

Right center three-quarter

Left center three-quarter

Left wing three-quarter

Stand-off-half

Scrum-half

Front row prop forward

Hooker

Front row forward

Second row forward

Second row forward

Loose forward, or the lock

RUGBY UNION SCORING RANGE

Try	5 points
Dropped goal	3 points
Penalty goal	3 points
Conversion	2 points

RUGBY UNION POSITIONS

Prop forward

Hooker

Prop forward

Lock forward

Lock forward

Flank forward

Flank forward

No. 8 forward

Scrum half back

Stand off or outside half back

Left wing three-quarter back

Left center three-quarter back

Right center three-quarter
 back

Right wing three-quarter back

Full back

SKIING

SYMBOLS INDICATING DIFFICULTY OF SLOPE

Beginner (easiest)	green circle
Intermediate	blue square
Difficult	black diamond
Expert	double black diamond

SOCCER

SOCCER POSITIONS

Right wing	Left defense
Left wing	Center
Right defense	Goalie

SOFTBALL

POSITIONS

Pitcher	Right field
Catcher	Right center
First base	Left field
Second base	Left center
Third base	Shortstop

SWIMMING

DIVING CLASSIFICATION

(Groups I–V are performed in both springboard and platform competitions, but Group VI is exclusive to platform competitions.)

Group I: forward dives
Group II: backward dives
Group III: reverse dives
Group IV: inward dives (cutaways)
Group V: twisting dives
Group VI: arm-stand dives

MEDLEY ORDER

Butterfly
Backstroke
Breaststroke
Freestyle

TENNIS

GRAND SLAM OF TENNIS
Australian Open (January)
French Open (May)
Wimbledon Championships (June)
United States Open (August)

SCORING
Love	Zero
15	First point
30	Second point
40	Third point
-all (e.g., 40-all)	Tied at score
Deuce	Tie score on third point
Advantage	One point won after deuce
Game	Fourth or winning point

TENNIS COURT

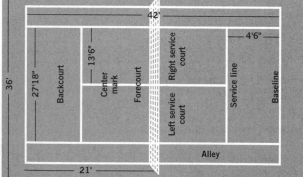

WEIGHT LIFTING

DISKS *(color-coded Olympic disks)*

25 kg	Red	5 kg	White
20 kg	Blue	2.5 kg	Black
15 kg	Yellow (or green	1.25 kg	Chrome
	when there is no	0.5 kg	Chrome
	50 kg)	0.25 kg	Chrome
10 kg	Green		

WEIGHT CLASSES *(according to the Amateur Athletic Union)*

Bantamweight	under 123¼
Featherweight	123¼–132
Lightweight	132–148½
Middleweight	148½–165¼
Light heavyweight	165–181¼
Middle heavyweight	181½–198¼
Heavyweight	over 198¼ pounds

WHITEWATER RAFTING

RATINGS FOR RIVER DIFFICULTY

(from the American Whitewater Affiliation)

Class I: Easy (fast-moving water with riffles and small waves)

Class II: Novice (straightforward rapids with wide, clear channels)

Class III: Intermediate (rapids with moderate, irregular waves that may be difficult to avoid)

Class IV: Advanced (intense, powerful but predictable rapids requiring precise boat handling in turbulent water)

Class V: Expert (extremely long, obstructed, or very violent rapids which expose paddler to above-average endangerment)

Class VI: Extreme (extremes of difficulty, unpredictability, and danger; consequences of errors are very severe and rescue may be impossible)

WRESTLING

SUMO RANKINGS *(lowest to highest; wrestlers promoted if they win 8 or more of the 15 bouts that make up one tournament)*

Jo-no-kuchi: 1st level
Jo-nidan: 2nd level
Sandanme: 3rd level
Maku-shita: 4th level
Juryo: 5th level
Maegashira: 1st rank
Komusubi: 2nd rank
Sekiwake: 3rd rank
Ozeki: champion; demoted if they record two successive makekoshi (eight or more losses)
Yokozuna: grand champion (cannot be demoted, but retire as soon as their performance starts to become unworthy of their rank)

WRESTLING WEIGHT CLASSES
(according to the Amateur Athletic Union)

Flyweight	up to 114½
Bantamweight	114½–125¾
Featherweight	125¾–136½
Lightweight	136¾–147½
Welterweight	147¾–160½
Middleweight	160¾–174
Light heavyweight	174¼–191
Heavyweight	over 191 pounds

YACHTING

INSHORE YACHTING CLASSES *(the customary classes that are also used in the Olympic Games)*
Tornado: plywood or fiberglass catamaran crewed by two; overall length 20 feet (6.096 meters)

Finn: fiberglass dinghy with a centerboard crewed by one; overall length 14 feet 9 inches (4.5 meters)

470: fiberglass dinghy with a centerboard crewed by two; overall length 15 feet 4¾ inches (4.7 meters)

Laser: fiberglass dinghy with a centerboard crewed by one; overall length 13 feet 10½ inches (4.23 meters)

Flying Dutchman: plywood or fiberglass dinghy with a centerboard crewed by two; overall length 19 feet 10 inches (6.04 meters)

Tempest: fiberglass keel yacht crewed by two; overall length 21 feet 11 inches (6.7 meters)

Soling: fiberglass keel yacht crewed by three; overall length 26 feet 9 inches (8.16 meters)

OCEAN OR OFFSHORE CLASSES
(the larger boats typically require a larger crew)
Class I: 33 feet to 70 feet (10.05–21.34 meters)
Class II: 29 feet to 32 feet 11 inches (8.84–10.03 meters)
Class III: 25 feet 6 inches to 28 feet 11 inches (7.77–8.8 meters)
Class IV: 23 feet to 25 feet 5 inches (7.01–7.75 meters)
Class V: 21 feet to 22 feet 11 inches (6.4–7 meters)

YOGA

CHAKRAS *(These are centers of energy within the body, stacked in a column, from top to bottom.)*
Crown: white or violet, sahasrara, space/thought
Third eye: indigo, ajna, time and light
Throat: azure blue, visuddha, life and sound
Heart or lung: green, anahata, air
Solar plexus: yellow, manipura, fire
Sacrum: orange, svadhisthana, water
Root: red, muladhara, earth

STEPS TO ATTAINMENT IN ASTAUNGA YOGA

Yama: Control of self
Niyama: Purity of thought
Asana: Control of the body
Pranayama: Absorption of vital forces
Pratyahara: Introspection
Dharana: Concentration
Dhyana: Meditation
Samadhi: Ecstasy

YOGA SUN SALUTATION

(The basic yoga sequence of "stations" comprises eight different postures in various orders.)

1. Stand in Mountain Pose.
2. Inhale and raise your arms above your head into Volcano Pose.
3. Exhale and swan-dive forward into Standing Forward Bend.
4. Inhale and lift into Extended Standing Forward Bend.
5. Exhale and bend your knees, then reach your right leg back into Lunge. Inhale.
6. Exhale and move into Plank Pose (or Push-up Pose).
7. Inhale and arch up into Upward-Facing Dog.
8. Exhale and let the legs pull you backward into Downward-Facing Dog. Breathe.
9. Exhale and reach your right foot forward into Lunge. Inhale.
10. Exhale and step your left foot forward into Extended Standing Forward Bend. Inhale.
11. Exhale and release into Standing Forward Bend.
12. Inhale and rise up into Powerful Pose. Exhale.
13. Inhale and rise up into Volcano Pose.
14. Exhale and release your arms into Mountain Pose.
15. Repeat the entire series on your left side, using your left foot to reach back into Lunge and your left foot to reach forward to return to Lunge.

CHAPTER 13

GENERAL KNOWLEDGE & PHILOSOPHY

The human understanding is of its nature prone to suppose the existence of more order and regularity in the world than it finds.

—Francis Bacon, *Novum Organum*

MARCUS AGRIPPA (63–12 B.C.)

(Roman statesman, general, and engineer)

TROPES OF SKEPTICISM

Dissent: Disagreement among philosophers concerning what, if anything, can be known.

Progress ad infinitum: Every proof requires premises which in turn must be proved.

Relation: All data are relative: sensation to the sentient being, reason to the intelligent being.

Assumption: We try to avoid regress by positing hypotheses, the truth of the hypotheses not yet determined. We cannot accept as true the conclusions following from them.

Circularity: There is a vicious cycle in attempting to establish the sensible by reason, since reason itself needs to be established on the basis of sense.

ARISTOTLE (384–322 B.C.)

(Greek philosopher, pupil of Plato, and tutor of Alexander the Great)

ATTITUDES, VICES, VIRTUES

(lists appeared in Aristotle's writings on ethics)

Activity or Attitude	Vice of Excess	
Facing death	Rashness	Proper pride
Experiencing	Self-indulgence	Truth telling
pleasure	Prodigality	Ready wit
or pain	Empty vanity	
Giving and taking	Boastfulness	**Vice of Defect**
money	Buffoonery	Cowardice
Attitude toward		Insensibility
honor or	**Virtue**	Meanness
dishonor	Courage	Undue humility
Assertion	Temperance	Mock modesty
Giving amusement	Liberality	Boorishness

FOUR CAUSES
(causes or types of relationships that produce an effect or result)
Material cause: that out of which something is made
Efficient cause: that by which something is made
Formal cause: that of which something is made
Final cause: that for the sake of which something is made

POLITICAL ENTITIES

Good States	Bad States
Monarchies	Tyrannies
Aristocracies	Oligarchies
Polities (constitutional governments)	Radical democracies

SCIENCES
Practical philosophy: ethics and political science
Productive philosophy: rhetoric, aesthetics, and literary criticism
Theoretical or speculative philosophy: theological, physical and metaphysical, and biopsychological

SPHERES OF THE UNIVERSE

Ocean	Planetary spheres
The firmament	Fixed stars
Water	Primum mobile (prime mover; outermost sphere)
Air	
Fire	

TEN FUNDAMENTAL CATEGORIES
(by which everything in the universe can be defined)

Substance	Being acted on
Quantity	Having, possessing
Quality	Position
Relation	Somewhere
Acting	Sometime

THREE DIMENSIONS OF HUMANS

Man the artist or artisan, producer of all sorts of things

Man the moral or social being, who can do right or wrong, achieve or fail to attain happiness

Man the learner, acquiring knowledge of all sorts

FRANCIS BACON (1561–1626)

(English essayist, philosopher, and statesman)

FALSE IDEAS THAT HANDICAP HUMANS

(from Novum Organum, *1620)*

Idols of the Tribe (conventional beliefs that satisfy the emotions)

Idols of the Cave (erroneous conceptions resulting from individual predilections)

Idols of the Market Place (confused ideas resulting from the nonsensical or loose use of language)

Idols of the Theater (various systems of philosophy or other dogmatic, improperly founded assertions)

TAXONOMY OF KNOWLEDGE

(published in 1620 as a plan for "The Great Instauration")

External nature (sections 1–40)

 Astronomy

 Meteorology

 Geography

 The greater masses: Fire, Air, Water, and Earth

 Species: mineral, vegetable, and animal

Humans (sections 41–58)

 Anatomy

 Physiology

 Structure and powers

 Actions: voluntary and involuntary

Humans' Action on Nature

 Medicine

Surgery
Chemistry
Vision and visual arts
Hearing, sound, and music
Smell and smells
Taste and tastes
Touch and the objects of touch (including physical love)
Pleasure and pain
The emotions
The intellectual faculties
Food, drink, etc.
The care of the person
Clothing
Architecture
Transport
Printing, books, and writing
Agriculture
Navigation
Other arts of peace
The arts of war
The history of machines
Arithmetic
Geometry
The miscellaneous history of common experiments that have
 not grown into an art

SAMUEL COLERIDGE (1772–1834)

(English poet and philosopher)

THE ENCYCLOPAEDIA METROPOLITANA

First Division
Pure Sciences (2 volumes)

Formal
 Universal Grammar and Philology, or the forms of Languages
 Logic, particular and universal, or the forms of Conceptions
 and their combinations
 Mathematics (Geometry, Arithmetic, Algebra, etc.), or the
 forms and constructions of Figure and Number
Real
 Metaphysics, or the universal principles and conditions
 of Experience, having for its object the Reality of our
 speculative knowledge in general
 Morals, or the principles and conditions of the coincidence
 of the individual will with the universal reason, having
 for its object the Reality of our practical knowledge
 (hence, in a lower stage, Politics and Human Law)
 Theology, or the union of both in their application to God,
 the Supreme Reality

Second Division
Mixed and Applied Sciences (6 volumes)
 Mixed
 Mechanics
 Hydrostatics
 Pneumatics
 Optics
 Astronomy
 Applied
 Experimental Philosophy
 Magnetism
 Electricity, including Galvanism
 Chemistry
 Light
 Heat
 Colour
 Meteorology

The Fine Arts
 Poetry, introduced by Psychology
 Painting
 Music
 Sculpture
 Architecture
The Useful Arts
 Agriculture, introduced by Political Economy
 Commerce
 Manufactures
Natural History
 Introduced by Physiology in its widest sense
 Inanimate, including Crystallography, Geology, Mineralogy
 Insentient, including Phytonomy, Botany
 Animate, including Zoology
Application of Natural History
 Anatomy
 Surgery
 Materia Medica
 Pharmacy
 Medicine
 Surgery

Third Division
Biographical and Historical (8 volumes)
 Biography chronologically arranged, interspersed with
 introductory chapters of National History, Political
 Geography and Chronology, and accompanied with
 correspondent Maps and Charts

Fourth Division
Miscellaneous and Lexicographical (8 volumes)
 Alphabetical, Miscellaneous, and Supplementary, containing
 a Gazetteer or complete Vocabulary of Geography,

and a Philosophical and Etymological Lexicon of the English Language, or the History of English Words; the citations arranged according to the Age of the Works from which they are selected, yet with every attention to the independent beauty or value of the sentences chosen which is consistent with the higher ends of a clear insight into the original and acquired meaning of every word.

RENÉ DESCARTES (1596–1650)

(French philosopher, scientist, and writer)

CLASSIFICATION OF IDEAS

Innate ideas originate from within, such as idea of self.

Adventitious ideas come, or seem to come, through the senses.

Factitious ideas are made up from the elements of the ideas of other things.

DEMOCRITUS (c. 460–370 B.C.)

(Greek philosopher)

FRAGMENTS

Inherent properties of atoms

Size

Shape

Solidity

Qualities attributed to sensations

Color

Sweetness

Bitterness

EMPEDOCLES (c. 490–430 B.C.)

(Greek philosopher)

FOUR ELEMENTS
Earth
Fire
Water
Wind and Air

EPICTETUS (c. A.D. 60–120)

(Greek Stoic philosopher and teacher, mainly in Rome)

THREE THESES
Every creature strives for its own natural good.
Because man's essence lies in his soul, his natural good is moral or spiritual.
Undeveloped when he comes into the world, man must use discipline to achieve his natural good.

EPICURUS (c. 342–270 B.C.)

(Greek philosopher)

THREE NEEDS OF MAN
Equanimity
Bodily health and comfort
The exigencies of life

GAIUS (c. 110–180)

(Roman jurist)

CLASSIFICATION OF THINGS BY LAW
Divine right (divini juris)

Human right (humani juris)
Public right (publici juris)
Individual right (res singulorum)
Categories governed by other legal systems:
 Movable and immovable property
 Other natural resources
 Possession of intangible things
 Possession of tangible things
 Religious things
 The human body
 Things common to all
 Things that cannot be possessed; things that belong to
 no one
 Water
 Wild animals

MARTIN HEIDEGGER (1889–1976)

(German philosopher and writer)

THREE FUNDAMENTAL FEATURES OF MAN
Factuality (he is already involved in the world)
Existentiality (he is a project and a possibility)
Fallenness (he has tendency to become a mere presence in the
 world, failing to make the most of his possibilities)

HIPPOCRATES (c. 460–c. 377 b.c.)

(Greek physician, "Father of Medicine")

FOUR HUMORS OR TEMPERAMENTS
Sanguine (blood), or cheerful
Phlegmatic (phlegm), or unexcitable
Choleric (yellow bile), or quick to anger
Melancholic (black bile), or depressed

I CHING

THE TAO OF ORGANIZATION

(table of contents of the hexagrams used in this ancient Chinese manual of divination)

Creative 1c	Temptation 2c	Community 3c	Conduct 4c	Restrained 5c	Sovereignty 24c	Resolution 7c	Retreat 8c
Innocence 9c	Insight 10c	Potent Energy 11c	Great Power 12c	Conflict 13c	Family 14c	Opposition 15c	Calc. Waiting 16c
Gentle 17c	Synergy 18c	Joyous 19c	Cauldron 20c	Revolution 21c	Critical Mass 22c	Stagnation 23c	Increase 24c
Decrease 25c	Peace 26c	Dispersion 27c	Grace 28c	Subordinate 29c	Developing 30c	Reform 31c	Limitations 32c
Decay 33c	Abundance 34c	Traveling 35c	Following 36c	Enduring 37c	Attraction 38c	Adversity 39c	The Well 40c
After End 41c	Before End 42c	Contemplation 43c	Nourishment 44c	Promotion 45c	Inexperience 46c	Darkening Light 47c	Meditation 48c
Shocking 49c	Progress 50c	Difficult Begin 51c	Advancement 52c	Conscientious 53c	Assemble 54c	Danger 55c	Obstacles 56c
Liberation 57c	Returning 58c	The Army 59c	Modesty 60c	Harmonize 61c	Unity 62c	Split Apart 63c	Receptive 64c

IMMANUEL KANT (1724–1804)

(German philosopher)

ARGUMENTS FOR GOD
Cosmological: If there exists anything, there must exist an
 absolutely necessary Being.
Physico-Theological: Concludes from order, beauty, and fitness
 of the world to a sublime and wise intelligence as its cause.
Ontological: Holds that to deny the existence of the most
 real Being is to utter a contradiction, which follows
 only if existence is taken to be a predicate, property, or
 characteristic similar to all others (e.g., whiteness).

FOUR ANTINOMIES OF REASON
The world has a beginning in time, and is limited with regard to space.
Everything compound consists of simple parts, and nothing
 exists anywhere but the simple, or what is composed of it.
There is freedom in the world, and not everything takes place
 according to the laws of nature.
There exists an absolutely necessary being belonging to the
 world either as part of it, or as the cause of it.

FOUR SETS OF PRINCIPLES
Quantity: axioms of intuition
Quality: anticipations of
 perception

Relation: analogies of
 experience
Modality: postulates of
 empirical thought

SØREN KIERKEGAARD (1813–1855)

(Danish philosopher and theologian)

THREE GROUPS OF MEN
Aesthetes: want entertainment, pleasure, freedom from boredom
Ethical men: live for the sake of duty
Religious men: live in order to obey God

JOHN LOCKE (1632–1704)

(English philosopher)

QUALITIES OF OBJECTS
(from "An Essay Concerning Human Understanding," 1690)

Primary Qualities	Secondary Qualities
Solidity	Color
Extension	Odor
Figure	Sound
Mobility	Taste
Number	Tactile qualities
Size	
Rest	

MEDIEVAL EUROPEAN UNIVERSITIES

SEVEN LIBERAL ARTS

Quadrivium (Upper Division)	Trivium (Lower Division)
Arithmetic	Grammar
Astronomy	Logic and metaphysics
Geometry and geography	Rhetoric
Music and poetry	

FRIEDRICH NIETZSCHE (1844–1900)

(German philosopher)

SLAVE VS. MASTER
(from "Slave and Master Morality," an analysis of interpersonal dynamics)

Resentful/expresses anger directly
Reactionary (negative)/creative (positive)
Other-directed/self-directed
Other-worldly/this-worldly

Self-deceptive/self-aware
Humble (meek)/proud (not vain)
Altruistic/egoistic
Prudent/experimental
Democratic (self-indulgent)/aristocratic (value hierarchy)
Confessional/discreet (masked)
Morality of principles/morality of persons
Weak-willed/strong-willed
Good (weakness) vs. evil (strength)/good (strength) vs.
 bad (weakness)

PHILOSOPHY

BRANCHES OF PHILOSOPHY

Aesthetics (theory of beauty, art, taste, standard, judgment,
 criticism)
Epistemology (theory of knowledge, truth, theory, method,
 evidence, analysis)
Ethics (theory of good, right, duty, responsibility, utility)
Logic (theory of argument, validity, proof, definition,
 consistency)
Metaphyics (theory of existence, essence, space, time, self,
 God, cause)

PHILOSOPHIES OF KNOWLEDGE

Philosophy of art
Philosophy of education
Philosophy of history
Philosophy of law
Philosophy of linguistics
Philosophy of logic
Philosophy of man
Philosophy of mathcmatics

Philosophy of mind
Philosophy of nature
Philosophy of biology
Philosophy of physics
Philosophy of politics
Philosophy of religion
Philosophy of science

PHILOSOPHICAL SCHOOLS

Ancient and Medieval Schools

Aristotelianism (how Aristotle deals with logic, metaphysics, ethics, poetics, politics, natural science)

Atomism (theory that minute, discrete, finite, and indivisible elements are the ultimate constituents of all matter)

Cynicism (theory that the purpose of life is to be virtuous and suffering is caused by false judgment)

Eleaticism (Zeno and Parmenides' investigation of the phenomenal world, especially with reference to the phenomena of change)

Epicureanism (Epicurus' doctrine of hedonism)

Hedonism (that pleasure is of ultimate importance)

Platonism (doctrine that abstract concepts exist independent of their names)

Pythagoreanism (doctrine that the universe is the manifestation of various combinations of mathematical ratios)

Realism (doctrine that universals have a real objective existence)

Scholasticism (based on Aristotle's and Aquinas's idea that reason and faith are compatible)

Skepticism (absolute or ultimate knowledge is impossible, either in a particular domain or in general)

Sophism (winning arguments through crafty rhetoric rather than in pursuing truth)

Stoicism (based on Zeno's belief that people should strictly restrain their emotions in order to attain happiness and wisdom; hence, they refused to demonstrate either joy or sorrow)

Modern Schools

Analytic and linguistic philosophy (based on Wittgenstein and marked by close attention paid to the way words are used in order to clarify concepts and to eliminate confusions arising from mystifying preconceptions about language)

Empiricism (doctrine that all knowledge is derived from sense
 experience)
Existentialism (philosophy associated especially with Heidegger,
 Jaspers, Marcel, and Sartre, and opposed to rationalism and
 empiricism, that stresses the individual's unique position as
 a self-determining agent responsible for the authenticity of
 his or her choices)
Idealism (theory that the object of external perception, in itself
 or as perceived, consists of ideas; ideas are the only reality)
Materialism (theory that physical matter is the only reality and
 that everything, including thought, feeling, mind, and will,
 can be explained in terms of matter and physical phenomena;
 matter is the only reality)
Phenomenology (doctrine proposed by Edmund Husserl based
 on the study of human experience in which considerations
 of objective reality are not taken into account)
Positivism, logical positivism, and logical empiricism
 (Comte's philsophy, concerned with positive facts and
 phenomena; primacy of observation in assessing the truth
 of statements of fact and holding that metaphysical and
 subjective arguments not based on observable data are
 meaningless)
Pragmatism (doctrine that the meaning of an idea or a
 proposition lies in its bservable practical consequences)
Rationalism (doctrine that reason alone is a source of
 knowledge and is independent of experience and all
 knowledge is expressible in self-evident propositions
 or their consequences)
Realism (doctrine, opposed to idealism, that physical objects
 exist independently of their being perceived)
Utilitarianism (doctrine that the useful is the good; especially
 as elaborated by Jeremy Bentham and James Mill; the aim
 was said to be the greatest happiness for the
 greatest number)

PLINY (A.D. 23–79)

(Roman naturalist, encyclopedist, and writer)

NATURAL HISTORY
(arrangement of the 37 books of Historia Naturalis*)*
 1: Preface, contents in detail
 2: The world, godhead, stars, planets, meteors, sun, climate, tides, volcanoes, fire (cosmography, astronomy, meteorology)
 3–6: Physical and historical geography: places and people (geography, ethnography, anthropology)
 7: The human race, birth and death, oddities and freaks, women, bodily capacities (man, inventions)
 8: Land animals
 9: Sea creatures
 10: Birds
 11: Insects
 12–19: Trees, vines and wine, crops and agriculture (botany)
 20–32: Medicines and drugs (medicine, pharmacology, magic)
 33–34: Metals (metallurgy)
 35: Painting (fine arts)
 36–37: Minerals, mountains, gems, jewelry (mineralogy)

PYTHAGORAS (c. 582–500 B.C.)

(Greek philosopher and mathematician)

CYCLE OF LIFE *(six stages in cycle of existence)*
Birth
Growth
Maturity
Decay
Death
Reincarnation

SAGES

CHINESE SAGES *(most to least respected)*

Science
Medicine
Astrology
Politics
Physical fitness
Military skill
Sports
Music
Military strategy

SEVEN SAGES OF GREECE *(seven wise men of ancient Greece)*

Solon of Athens
Thales of Miletus
Pittacus of Mitylene
Bias of Priene in Caria
Chilon of Sparta
Cleobulus, tyrant of Lindus
 in Rhodes
Myson of Chen

SAINT AUGUSTINE (354–430)

(philosopher and one of the Early Fathers of the Christian Church)

DIVISIONS OF PAGAN KNOWLEDGE

Works of mankind
On their own
Luxuries
Utilitarian
In collaboration with demons
Magic
Soothsaying
Omens
Superstitious practices
Natural works, and those
 divinely inspired
By reasoning
Logic
Rhetoric
Mathematics
Via the senses
History
Natural history
Astronomy
Useful arts
Crafts
Professions
Sports

SOCRATES (c. 469–399 B.C.)

(Athenian philosopher)

DEFINITION OF HOLINESS
The Form, holiness, exists as an objective entity.
This Form is a universal, the same in everything holy.
It is the essence, or essential cause, of holy things.
It serves as a universal and objective standard for judging what
 things are holy and what things are not.

BENEDICT DE SPINOZA (1632–1677)

(Dutch philosopher)

STAGES OF INTELLECTUAL SALVATION
1. On the level of imagination, where our intellectual life begins, we
 combine and fuse images, achieving a mixture of specious and
 true universals. The mind can order these and the foundation of
 scientific knowledge discovered. One begins to free oneself from
 the excessive temporality of the flux of images.
2. One arrives at science, ratio as Spinoza calls it. Since scientific
 laws apply to all times and places, the person who is able to
 understand this lives in more than just his/her own time and
 place. The person lives more broadly and deeply.

THE SCIENTIFIC PROCESS

STEPS OF THE SCIENTIFIC PROCESS
Identify a problelm and ask a question
Formulate a theory or hypothesis
Test the theory or hypothesis
Analyze the results
Draw a conclusion
Publish and communicate the findings and results

PAUL TILLICH (1886–1965)

(German-born American philosopher and theologian)

THREE TYPES OF ANXIETY
(from "The Courage to Be," 1952)
Ontic anxiety: the anxiety of fate and death
Moral anxiety: the anxiety of guilt and condemnation
Spiritual anxiety: the anxiety of emptiness and
 meaninglessness

ALFRED NORTH WHITEHEAD (1861–1947)

(English philosopher and mathematician, in the U.S. after 1924)

CATEGORIES OF EXISTENCE
(from "Process and Reality," 1929)

Actual entities	Subjective forms	Multiplicities
Prehensions	Eternal objects	Contrasts
Nexuses	Propositions	

LUDWIG WITTGENSTEIN (1889–1951)

(Austrian philosopher)

METHOD FOR OVERCOMING PUZZLEMENT
One selects a set of concepts which may cause difficulty, leading
 us to make paradoxical statements with respect to them.
One examines repeated instances of the normal use of these
 concepts in an effort to banish the philosophical puzzlement.
One reveals the nature of the language games being played in
 the instances of usage by inventing new language games for
 purposes of comparison.
When we see that everything is open to view, and there is nothing
 further to explain, it is a sign that, with respect to the concepts
 in question, we have overcome our intellectual bewitchment.

WONDERS OF THE WORLD

SEVEN WONDERS OF THE ANCIENT WORLD

Great Pyramid of Cheops,
Egypt

The Lighthouse on the Isle
of Pharos, Egypt

The Hanging Gardens of
Babylon, present-day Iraq

The Colossus of Rhodes on
the Isle of Rhodes, Greece

The Temple of Diana at
Ephesus, Greece

The Statue of Zeus at
Olympia, Greece

The Tomb of King Mausolus
at Halicarnassus, Greece

The earliest documented list of
these monuments was compiled
by Antipater of Sidon, a Greek
poet, in the second century B.C.

NEW SEVEN WONDERS OF THE WORLD

Chichén Itzá, Mexico

Machu Picchu, Peru

The Great Wall of China, northern China

The "Christ the Redeemer" statue, Rio de Janeiro, Brazil

The Taj Mahal, India

Petra, Jordan

The Colosseum, Rome

Selected by New Open World Corporation in 2007.

SEVEN WONDERS OF THE MODERN WORLD

The Empire State Building, New York City

The CN Tower, Toronto

The Italpu Hydroelectric Dam, Paraná River (between Brazil and Paraguay)

The Delta North Sea Protection Works, Netherlands

The Panama Canal, Panama

The Golden Gate Bridge, San Francisco

The Channel Tunnel, Strait of Dover (connects United Kingdom and France)

Selected by the American Society of Civil Engineers in 1994.

INDEX

ABOUT THE AUTHOR

Barbara Ann Kipfer is the author of more than 40 books, including the bestselling *14,000 Things to be Happy About* as well as *The Wish List*, *Instant Karma*, *8,789 Words of Wisdom*, and *Self-Meditation*. Barbara has an MPhil and PhD in Linguistics, a PhD in Archaeology, and an MA and PhD in Buddhist Studies. She is Chief Lexicographer of Dictionary.com, is a Registered Professional Archaeologist, and has taught meditation. Her website is http://www.thingstobehappyabout.com.